FOR THE LOVE OF
IRELAND'S
BUILDINGS

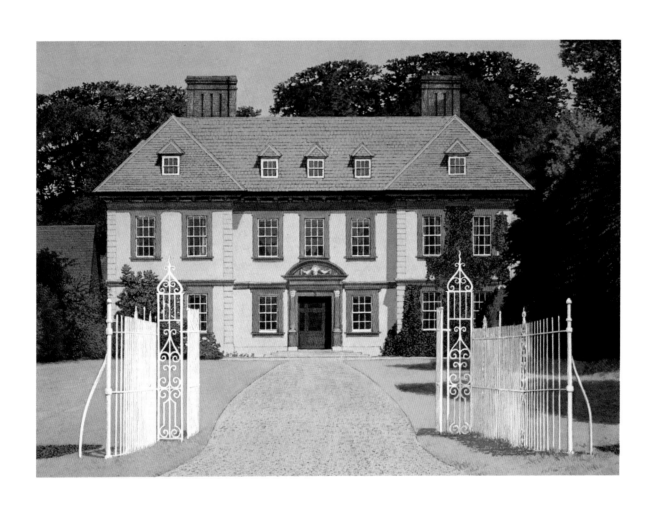

Michael Lunt designed for several leading Dublin advertising agencies during the 1950s and 1960s until he became an independent graphic designer in 1968. His experience spans a period of technological revolution: from early days working with T-squares and metal type to today's digital world.

Roadstone, and later CRH, of which Roadstone was a founder member, became Michael Lunt's principal client and patron. He designed his first *Roadstone Calendar* in 1962, continuing with the commission for the next forty-nine years. The *Roadstone Calendar* hung in thousands of Irish homes and businesses, and the art reflects the artist's love of Ireland's built heritage.

Michael Lunt also taught design at the National College of Art and Design in Dublin and Dún Laoghaire Institute of Art, Design and Technology, while executing major projects for AIB and IDA and creating the initial design for the magazine *Technology Ireland* for the IIRS (Institute for Industrial Research and Standards).

Having spent most of his working life in Dublin, Michael Lunt is now retired and lives in Wexford.

FOR THE LOVE OF
IRELAND'S
BUILDINGS

Treasures from fifty years of the Roadstone Calendar

Michael Lunt

THE O'BRIEN PRESS
DUBLIN

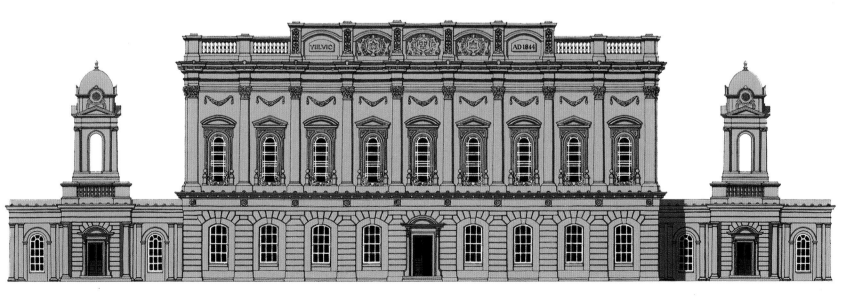

First published 2023 by
The O'Brien Press Ltd,
12 Terenure Road East, Rathgar,
Dublin 6, D06 HD27, Ireland.
Tel: +353 1 4923333; Fax: +353 1 4922777
E-mail: books@obrien.ie
Website: obrien.ie

The O'Brien Press is a member of Publishing Ireland.

ISBN: 978-1-78849-446-5

Text © Roadstone Wood Ltd 1962–2023
Artwork © Michael Lunt
The moral rights of the author have been asserted.
Editing, design and layout © The O'Brien Press 2023
Map artwork by Anú Design • www.anu-design.com
Cover and text design by Emma Byrne

The author and publisher would like to thank the following for permission to reproduce abridged captions from the orignal Roadstone calendars:
Roadstone/CRH plc, Sean Rothery, Bernard Share, John de Courcy Ireland, Dick Warner and Patrick Wyse Jackson.
The author and publisher have endeavoured to establish the origin of all images and text. If any involuntary infringmenet of copyright has occurred,
sincere apologies are offered, and the owners of such copyright are requested to contact the publisher.

8 7 6 5 4 3 2 1
27 26 25 24 23

Printed by EDELVIVES, Spain.
The paper in this book is produced using pulp from managed forests.

Image on page 1: Beaulieu House, County Louth.

Celebrating 75 years 1949-2024

Published in:

DEDICATIONS
To Jim Culliton, Tom and Donal Roche

ACKNOWLEDGMENTS

The calendar was the brainchild of Donal Roche, co-founder of Roadstone Limited with his brother Tom. Donal championed the *Roadstone Calendar* in its early years; later Jim Culliton gave it the direction and momentum that has carried it through to this day.

Many people contributed to the calendar over the years by providing ideas and information, by opening doors, by supplying technical backup, and most importantly by writing the words. For over thirty years Dr Sean Rothery, architect, lecturer and writer, was fundamental in identifying suitable content and providing the text. His encyclopedic knowledge of Irish architecture was invaluable. The many others that have made significant contributions to the calendar over the years include: Dr Ron Cox, Professor Sean de Courcy, Dr John de Courcy Ireland, Elizabeth Healy, Ruth Heard, Alfred Montgomery, Kevin Murray, Dr Sandra O'Connell, Bernard Share, Margaret Sweeney, Dr Patrick Wallace, Dick Warner, Dr Patrick Wyse Jackson.

I am deeply indebted to Roadstone for this uniquely enduring commission. Of the many staff members past and present who have given their support to the project the following individuals deserve mention: Domhall Blair, Christy Creevy, Denis Kidney, Brian Mulloy, Art Shirran and Des White.

In Cork, Richard Wood gave invaluable guidance on several occasions.

To all of the above and to those not listed here, I wish to acknowledge my gratitude for the help, patience and encouragement that I have always received.

It is thanks to Michael O'Brien that this book has reached completion. From our first meeting he was enthusiastic, encouraging and keen to publish. Sadly, Michael did not live to enjoy the outcome of his determination. *For the Love of Ireland's Buildings* is a testament to his energy and spirit.

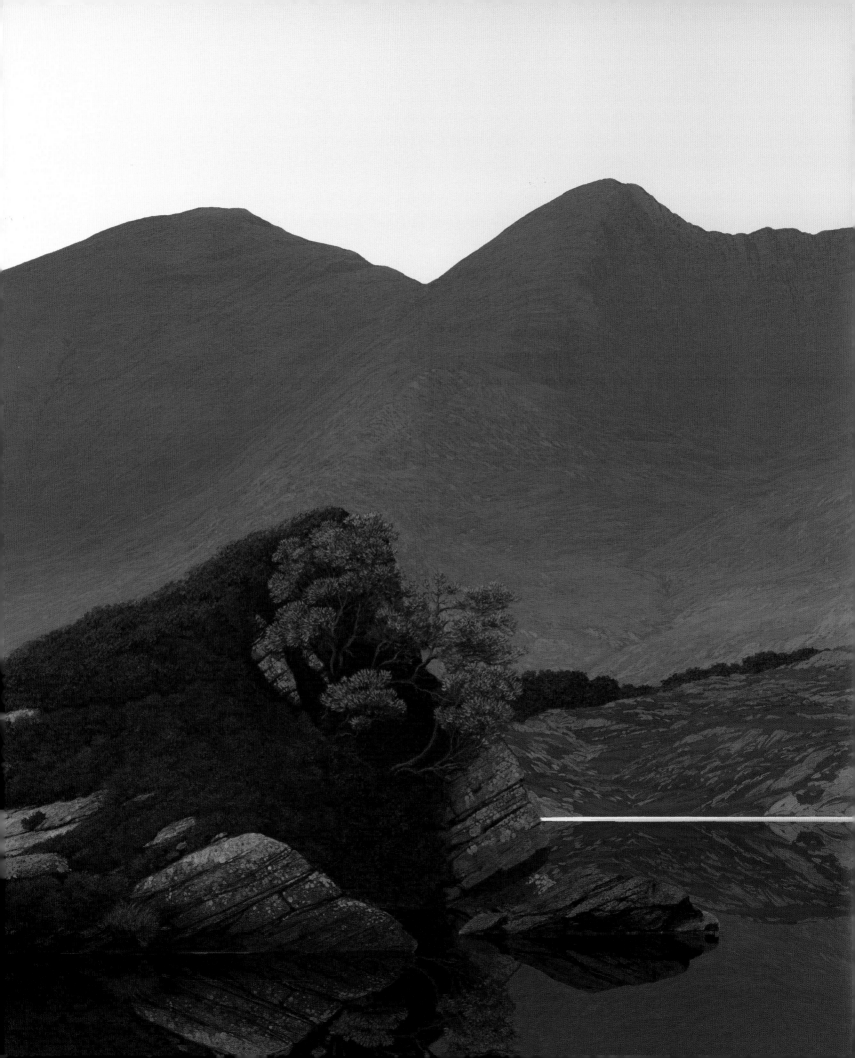

CONTENTS

Arbutus, Upper Lake, Killarney, County Kerry.
From the 1988 Roadstone Calendar.

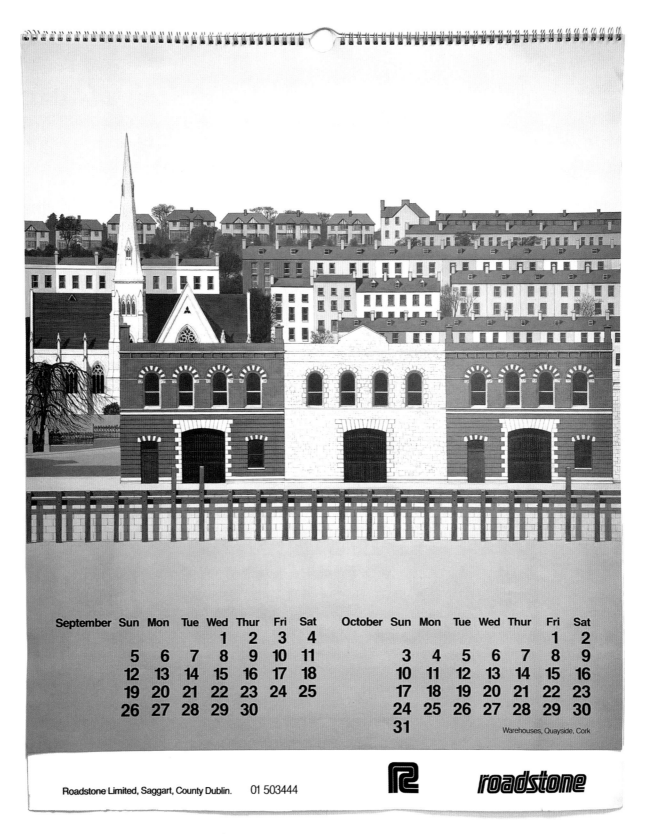

September	Sun	Mon	Tue	Wed	Thur	Fri	Sat	October	Sun	Mon	Tue	Wed	Thur	Fri	Sat
				1	2	3	4							1	2
	5	6	7	8	9	10	11		3	4	5	6	7	8	9
	12	13	14	15	16	17	18		10	11	12	13	14	15	16
	19	20	21	22	23	24	25		17	18	19	20	21	22	23
	26	27	28	29	30				24	25	26	27	28	29	30
									31						

Warehouses, Quayside, Cork

Roadstone Limited, Saggart, County Dublin. 01 503444

R **roadstone**

1982 Roadstone Calendar, *warehouses, Cork.*

FOREWORD

Dear Reader

It is with great pleasure that I pen the foreword for this exquisite collection of artwork from Michael Lunt.

Michael's artistic achievements need little introduction. For fifty years, his work featured in Roadstone's annual calendar, a compendium of architecture and materials that have defined Ireland's built environment. Throughout that time, Michael's creative work also found its way into the annual reports of CRH, Roadstone's parent company and now a global leader in the building materials industry.

Ireland's urban landscapes have changed enormously in this period, and those changes are documented in this superb collection of works, brought together for the first time. Across each chapter of the book, Michael's art pays homage to the architecture of a different part of Ireland, in a celebration of the history and amazing diversity of our nation's built environment.

At CRH we are proud to support Michael in this endeavour and I wish to congratulate him on the publication of this book. This is not just a celebration of Michael's passion for the art and the architecture of Ireland. It inspires us to continue to build a beautiful and sustainable future.

Albert Manifold
Chief Executive, CRH

INTRODUCTION

From a young age my conscious eye was opened to the built world around me. Every journey was an encounter with some-one's mark on the landscape. Over time I learnt to put words and feelings on what I saw; and with more time I came to relate what I saw to a world I studied. And with more time again, I cherish the simultaneous experiences that come from seeing, feeling, knowing and inhabiting the built world around me.

As this wheel of perception keeps turning, every so often one is simply taken with beauty in built form. That moment is an experience of immense sustenance. Some places will never fail to trigger this sensation. I feel deeply enriched by this experience.

The drawings in this book seek to transmit these aesthetic experiences to the viewer. The book is about communicating the important message of beauty in built form – in a street, a landscape, a ruin, a bridge, a harbour, in places created within living memory or as witnessed in the enduring constructions of more ancient societies. Given how our physical environment influences us – carries collective memories, is a manifestation of human endeavour and intent, enables communication, and much more besides – it is important to give time to reflect on the beautiful buildings, streets and cultural landscapes we have in Ireland and to take pleasure and enjoyment from these. And, through doing so, we do well to ponder on other insights we might gain from such looking.

JEWELS – DESIGN, CRAFT, INTENT

This book depicts many jewels within the collection of buildings, archaeological monuments and special places on this island. Two are UNESCO-designated World Heritage Sites (Newgrange and Skellig Michael), a global endorsement that these places are of an outstanding value to the whole world. And yet at their essence, and foremost, their importance is local.

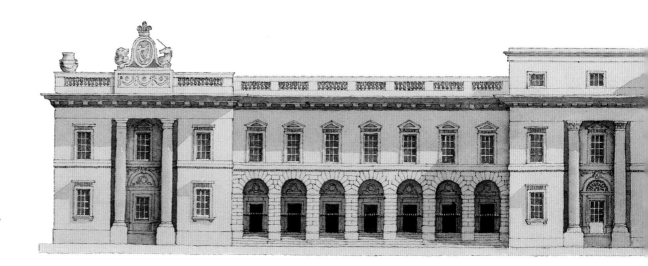

The Custom House, Dubliners' favourite building.

Single masterpiece buildings are present in all regions. These go beyond the basic provisions demanded by their function and give so much more. Consider the artful use of proportion; the play of light on a façade's chosen materials or how that same light falls deep into and illuminates interior spaces; the sculpted elements that give profile and depth or add decoration and symbolism, or perhaps the interplay of simplicity of some elements countered by complexity of others. One such example is the Custom House on Dublin's River Liffey, a majestic building extending the full length of the quay. The exterior is beautifully hewn in a soft, creamy grey Portland limestone, exquisitely proportioned and sculpted with a playfully provocative placing of Irish coats of arms on the balustraded parapets above the two end pavilions.

Buildings constructed for everyday purposes of communities – markets (Butter Market Exchange, Cork), train stations (Bagenalstown and Carlow), schools (Vicarstown) – are elevated to another level of distinction by adopting certain architectural styles, fashionable in their time – Classical, Jacobean Revival, Arts and Crafts, amongst many others. They are embellished with considered articulation of windows, roof lines, chimneys, all using high-quality materials laid in place by accomplished and skilled craftsmen, to the designs of gifted architects and, critically, enabled through the vision and pride of the varying commissioning bodies. This triangular force for good is also seen beyond buildings in the illustrated bridges (Drumsna, Athlone, Drogheda) straddling the Rivers Shannon and Boyne. Not satisfied by bridging alone – a profound feat – these gravity challengers are furnished and shaped to impress and leave indelible marks on the mind's eye.

Other buildings appear to exist beyond function entirely, their raison d'être to give maximum delight as carefully placed works of art in the landscape. Follies such as the Temple of the Winds at Mount Stewart in County Down and the Casino at Marino in Dublin are like jewel boxes approaching perfect proportion. The latter is cleverly deceptive, concealing sixteen rooms on three floors in what appears as a single-storey, single-volume structure. The former is an eight-sided lantern, perched overlooking Strangford Lough, a calm, grounded homage of sorts to the mythical wind gods.

Material and Making

Natural light is often considered the primary material of architecture. It defines how spaces and buildings are perceived in relation to scale, texture, materiality and atmosphere. It brings the physical materials alive, through casting light and shadow, reflecting and refracting colour or glow, and through the contrast of voids and solids (windows and walls). In this book we are primarily looking at the exterior world. The dialogue between material and immaterial (light) may have been consciously orchestrated by the designer.

A fine example of this is the Venetian Palazzo-style Museum Building (School of Engineering) in Trinity College Dublin with its Irish marble roundels of delicate pinks and greens, framed by lacelike stone surrounds; its deep projecting roof eaves, supported on finely carved stone brackets and the sublimely carved foilage – oak, ivy, acanthus, shamrock, lilies, lotuses – along with birds, of the gifted O'Shea brothers from Cork. Light, shadow and colour accentuate the rich detailed artwork and bring it alive.

A more modern example is the School of Engineering's immediate neighbour, the 1967 concrete tour-de-force Library, which is all push-and-pull planes of board-marked concrete and luxurious bronze-framed windows. One of the many defining qualities of this building is the superlative materiality, grounded in the designers' judgement in specification and detail, along with the builder's mastery in making. The almost flawless condition of the external façade today is a tribute to their combined expert skill.

The palette of materials found across all the buildings and structures depicted is relatively small – stone, brick, timber, wheat/straw, metal, which is often, but not always, locally sourced. What stands out is the skills of craftmanship employed throughout. This skill was often handed down through generations and is expressive of a knowledge that combines hand and mind. The ability to carve stone, join timber, scallop thatch, forge iron is certainly physical. However, knowing the stone coursing to use on the wildly exposed western seaboard, setting out the rubbed bricks to the flat-arched window head of an 18th-century townhouse, closing in the straw roof against a stepped, west-facing Mayo cottage gable, or finely judging the foundations and wall thicknesses to hold up a village street on a hill – this is the result of a tacit wisdom. Traditional construction knowledge follows time-honoured technologies, and these shift and evolve as imported innovations fuse with implicit knowledge.

Buildings in Landscape – Context and Movement

Many of the drawings in this book extract the subject buildings from their physical context – rendering pure, somewhat abstract material and form in white space. Others depict the reality of the buildings sitting within a wider setting. A relationship evolves over time, one conversing with the other. A building might nestle into the landscape, almost absorbed by it. Others, such as the stone-roofed cottage of east Clare, become a tacit expression of the geology in which they sit. Ancient structures like Dun Aengus are crumbling and they are intelligently responsive to Ireland's exposed climate. At times, there

Continuous habitation on the same site is a fascinating reminder that we inherit the past and hold the present heritage for future generations. Ireland abounds in examples of continuous use of a site for many centuries.

Extremely long habitation is sometimes evident by the dramatic siting of an 18th- or 19th-century house close to an early motte and bailey of the Norman invader. Stone castles cannot have provided very comfortable living quarters, being draughty and difficult to heat. When times became more settled many castles were converted to fortified houses and at later stages more practical houses were added on to the original castle. A splendid example of the evolving life of a building is Kilbline Castle in County Kilkenny, continuously inhabited since the early 16th century. The tower house provides a complete contrast with the rural character of the built-on house extensions, and yet the whole complex is in harmony with the countryside.

Sean Rothery, 1977

is a clever juxtaposition taking place. The sharp geometry of the medieval stone gable of St Kevin's Church in Glendalough, County Wicklow, contrasts strikingly against the surrounding filigree trees, while all features point upwards, moving eyes sky- and heavenwards. Some of the structures depicted in this book present a formal geometry against the landscape; for others the landscape appears to absorb back the materials it once provided to make the building – evidence of the contract with nature.

Harbours and lighthouses derive form from their location. The massive protective embrace of the east and west piers at Dún Laoghaire Harbour provide safe waters within a deceptively treacherous Dublin Bay. Long, low and solid, the two canted arms stretch out to sublime and sensually rounded terminations. Hewn in local granite and remarkably resilient over

their more than 175 years, the piers resist wave after wave. Dublin's Great South Wall, an ingenuous and radical piece of early 18th-century engineering, which helped form the deep-water channel into Dublin Port and continues to perform this essential function today, is a vital piece of national infrastructure. The landmark round red lighthouse at its tip is a welcome destination for boats and walkers. In Wexford, the Hook Head lighthouse is tapered and rotund to deflect all wind directions, a giant rising up beside the low accommodation buildings that sit calmly nearby on even ground.

Somehow all these structures seem to belong where they sit, as if the receiving landscape made space for them, or perhaps it is the structures that have carved and shaped the landscape. Either way, our enjoyment of these places derives not just from the building forms, but also from the whole picture that we absorb.

Ballyhack and Passage East sit on either side of River Suir estuary and form a rather special example of this cultural landscape phenomenon. The harbour, at the heart of each village, is an effective village square. It is overlooked and formed by enclosing buildings – in groups, and individual – and both harbours are backdropped by gentle cultivated hills and single striking monuments. For Ballyhack it is a Norman tower house, in Passage East, a simple stone barn church someway above the town on the brow of the hill. Between both villages, with their outward-looking harbours, a watery space that somehow belongs to both is captured. This relationship – the way the villages have developed, the location and existence of church and castle, the interplay between the natural and cultural worlds – is a cultural landscape.

TIME AND ACCUMULATION

Many of the places we visit on these pages have evolved over time – sometimes visibly displaying their phases of development like growth rings of a tree, or geological seams. Sometimes the change is almost imperceptible, or seamless. In other instances change is underlined by dramatic shifts in scale, or material. Some buildings have completely transformed from their renderings here – reimagined and reordered, or absorbed within vastly expanded complexes, as we see in Dublin airport. Others appear to have never changed, a stubborn resistance, or perhaps a remarkable resilience. However, what time does to buildings – individual and collective – is it hosts stories and events, played out by the various inhabitants and visitors, and transforms them into places.

This sense of layering and place is amplified in our villages, towns and cities, where order and disorder can appear together and create a delightful harmony. Roundstone is a charming collection of disparate buildings and ages that come together to straddle a hill and all strive to present a public face onto street, harbour or sea. More clamorous, the stepped terraces of Cobh and Cork (Pope's Quay and Shandon Bell Tower) are wonderfully capriccio-like in their variety of building and colour. The impact of topography is exploited in both by the remarkable landmark towers and spires. There is a musicality to the urban rhythms of all these towns, where a journey experienced walking through their streets will trigger visual and sensual responses, with colour, sound, light and weather all at play.

What is also palpable in all the urban examples portrayed is architectural coherence. This order is not by accident. The

streets here – be it Henrietta Street, Dublin's earliest Georgian Street, the streets of Youghal or Westport, or any of the above-mentioned towns – all follow some level of plan or prescribed order with regards to plot sizes, building lines, general heights and materials. Some of this order is a result of prevailing construction technologies, available materials and building know-how at the time. In all, there is a design consciousness and intent, which at its simplest sets out to make streets and squares, and more ambitiously plans an entire urban area. Henrietta Street is part of, and a precursor to the Georgian city of Dublin. Westport and Kingston Square in Mitchelstown both exhibit this wider urban design vision. Applying today's social values, one might question the imposition of a single vision, absent of any democratic process. Nonetheless, what has endured are the finely proportioned spaces of human scale which enable three important dimensions of good public realm: diversity, accessibility and proximity.

Using What We have

The durability of almost all the buildings presented here – only one, the much-lamented Retort House in the old Dublin Gasworks site, has been demolished – has much to teach us. Many were built before the easy availability of fossil fuels, and many continue to function either as originally intended, or have been readily adapted for new purposes. Most are built of local materials, and most of these are natural (of the earth), and therefore readily returned to the earth or capable of being recycled.

The towns contain much more than built fabric; there is an infrastructure – social, economic, cultural, and of communication. Services comprise the roads, streets, drains and power lines, along with the shops, libraries, banks, schools, public houses, and so on, and the public spaces, meeting spaces and spaces of play and shared activity. Along with these is the shared infrastructure of histories, special events – good and difficult – which make up a community's social memory. We lose, or fail to use, all this at our peril. At a time when we need to enable and create cohesive, sustainable communities to serve a growing population, all the while minimising the amount of carbon we expend, we need to use our existing buildings and towns as best we can. Put simply, the more of what is already built that we use, the less carbon we spend building new.

What this book advocates to me, therefore, in the care and love given to the drawings, paintings and prints of all the buildings and places presented, is both the immeasurable values we draw from a beautiful environment, when we take the time to look, and the immense benefits to be gained from their care, their use and their enjoyment.

Gráinne Shaffrey
Architect

THE *ROADSTONE CALENDAR*

For over fifty years Roadstone published a calendar celebrating the best of Ireland's architecture and engineering. For forty-nine of those years it was my good fortune and privilege to be responsible for the design of the calendar. This book is a personal selection of the paintings and drawings from those years, assembled to reflect my love of the Irish landscape and its built heritage.

Donal Roche with his brother Tom was a founder of the company that would become Roadstone Limited in 1949, and, after the merger with Irish Cement in 1970, the company became Cement Roadstone Holdings, now CRH plc. The company operated quarries throughout Ireland, manufacturing and supplying materials for building and road construction. At the time Donal first came into Group 3, a newly formed design consultancy where I was working, my knowledge of Roadstone was limited to the familiar sight in the streets of Dublin in those days of their big yellow trucks. To help me, Donal brought with him two calendars from previous years, the format being a single large picture in full colour with a tear-off date pad at the base. In the case of the two earlier calendars the artists – Fergus O'Ryan and Jan de Fouw – had chosen to depict Roadstone activities. My memory is hazy but I think one was of a sand and gravel plant, the other a road-surfacing scene.

At that time the process best suited to printing large formats in small quantities was silk-screen, I was to stay with this process for the next four years. In the early 1960s, a limitation of the silk-screen process was that colours were flat with no graduation of tone, and each colour required a separate printing. In 1966 I changed over to offset litho printing to take advantage of the full-colour reproduction process.

Donal Roche retained a close interest in the calendar over the years but handed control over to Jim Culliton, who was, at that time, marketing manager for Roadstone. In time, Jim was appointed Chief Executive of CRH, which is today a major international company. The trust and encouragement shown to me by Donal and Jim gave me great freedom. Their only stipulation was that the subject matter must reflect the nature of the business of Roadstone and its clients. This trust continued with their successors in Roadstone.

In later years, once the theme for the year was agreed between us, the company's next sight of the calendar would be the printed copy. The subject of my first calendar, prompted by the big yellow trucks, was a historic montage of road vehicles, the 1950s and 60s being represented by the Roadstone Atkinson truck and my own Morris Mini Minor.

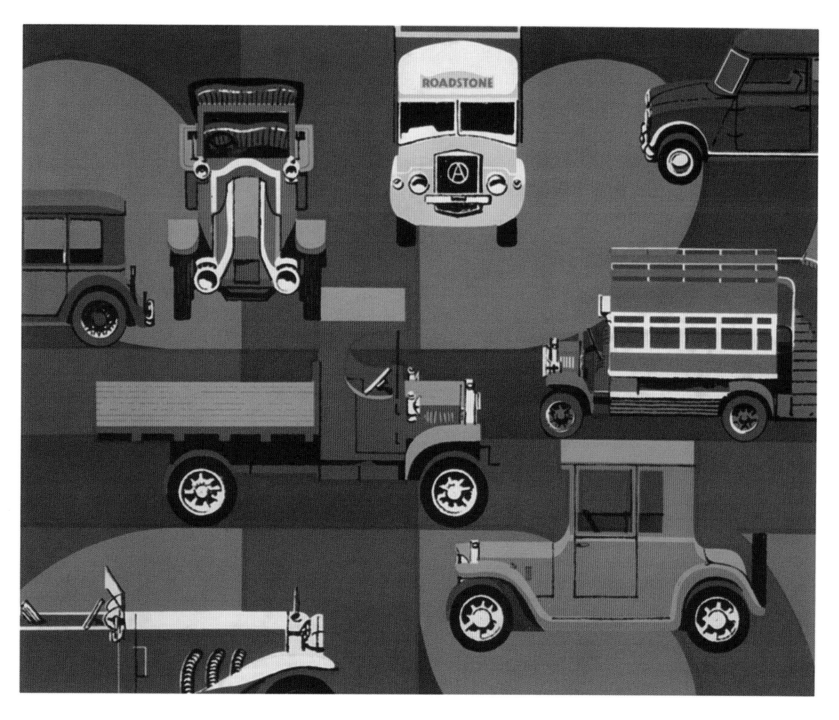

*Detail from the first calendar designed by Michael Lunt, showing the iconic yellow
Roadstone Atkinson truck and the artist's own Morris Mini Minor (top right).*

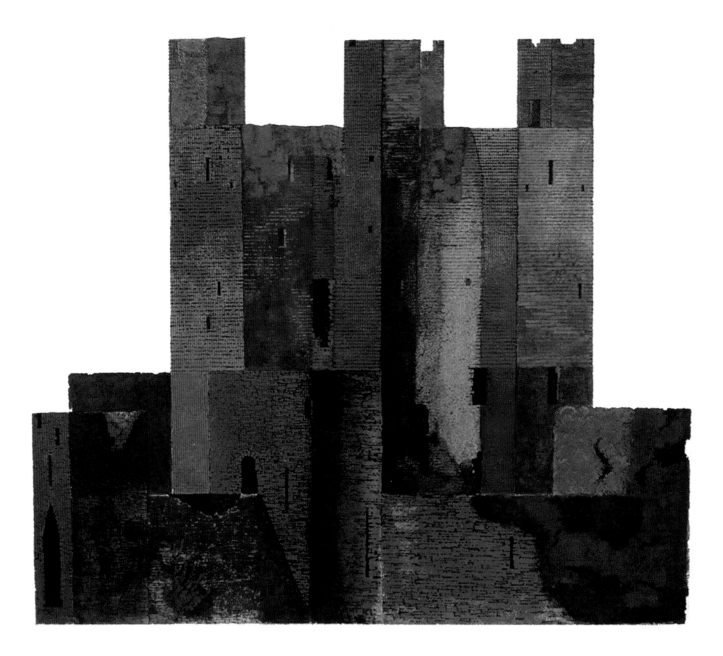

Looking back to the 1960s, I realise that in seeking a suitable treatment for the calendar pictures I may have been trying too hard to be different. Were I teaching today, I would stress to students that they direct their energies towards achieving a better result rather than towards trying to be original. An example of this latter approach is evident in my painting of Trim Castle in the 1967 calendar, a subject I came back to in 1981 with a much more conventional treatment, though I must confess that today my preference is for the earlier version.

The painting of St Kevin's Church in Glendalough, also from 1967, reveals a recognisable characteristic of my pictures with architectural subjects. Where possible, I would avoid perspective. My justification for this was twofold: firstly I wanted to retain as far as I could the true proportions of the actual building and I would go to great pains to do so (in some cases counting the number of brick courses in an elevation in order to get it right), and secondly I was endeavouring to marry

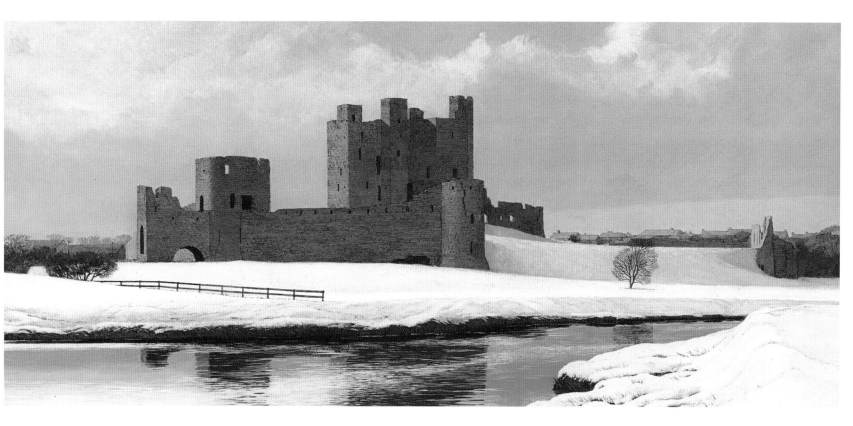

Above and opposite: Trim Castle, County Meath.

Various styles were employed through the years of the Roadstone Calendar. *An atmospheric abstract image of Trim Castle was created for the 1967 calendar (opposite) by the use of strong colours and the elimination of perspective. The more conventional treatment of the picture published in the 1981 calendar (above) gives a truer depiction of Trim Castle, the strong horizontal lines of the composition bringing a sense of calm to the scene in contrast to the more disturbing image opposite.*

the three-dimensional nature of the subject matter with the two dimensions of the piece of paper on which the final picture would be printed. Though I regard the Glendalough painting as one of my best early efforts, I can see that the lack of perspective has led to an unwanted effect – the church looks bigger in the picture than it does in reality. Part of the charm of St Kevin's Church is its small size. The lack of perspective also creates a strong horizontal emphasis. In the early years, I was not aware of this emphasis in the compositions, but with hindsight I recognise that I have always had a strong preference for the stability that the horizontality provides.

The words that accompany the pictures in the 1967 calendar were written by Sean Rothery. We first met at an Irish Mountaineering Club Easter gathering at a camp site in Lough Barra in Donegal. Sean, an architect and lecturer, had returned recently with his young family from a period working in East Africa. Apart from providing the text for the calendar for

many years, Sean would also use his wide knowledge of Irish architecture to point me in the right direction when looking for appropriate subjects.

Working on the *Roadstone Calendar* over so many years has brought many joys and benefits into my life. There were of course anxious times when deadlines were looming. However, the first pleasure of each year was when Donal Roche and Jim Culliton would take me to lunch in Jury's Hotel in Dame Street to initiate the process for that year's calendar. The venue for the meeting was also out of consideration for my situation. I was employed in those days by O'Kennedy Brindley and the calendar was a nixer. At that time, the bar in Jury's, an intact 19th-century pub, was a joy. With its splendid Victorian interior, it must have been the most beautiful bar in Dublin. Sadly, when Jury's was closed, the bar's fittings were sold and taken to Switzerland to be reassembled in the James Joyce Pub in Zurich. It is comendable that the collection has been saved and put to use, but the arrangement in Zurich does not have the completeness and coherence of the Dame Street original.

It was also in Jury's in 1968 that Jim Culliton told me of his plans for Roadstone. He outlined a number of print items that he would like me to design. This promise of future work helped me to decide to leave OKB and to go freelance full time. Once again lady luck came my way; the very next morning after my lunch with Jim, I got a phone call asking me whether I would be interested in a part-time teaching post in the National College of Art. As this would mean a small monthly cheque that should greatly ease the change from full-time employment to the uncertainty of freelance, I was delighted to be able to take up the offer.

The first and one of the most enjoyable parts of working on the *Roadstone Calendar* was the initial research. A theme would be chosen, such as roads or bridges, often with a historical bias. A requirement of the brief was that the choice of subjects should reflect the geographical spread of the company. In the forty-nine years of doing the calendar, I was permitted to look beyond Ireland on only three occasions and in two of the three there was a determining Irish connection. The outcome of innumerable trips around Ireland in search of outstanding or interesting man-made structures has been the foundation of an abiding love of both the Irish landscape and its architecture.

The following pages take a clockwise trip around Ireland, beginning in Dublin. These pictures from the *Roadstone Calendar* depict and celebrate the many places where man has made a valuable impact on the Irish scene.

Michael Lunt

Opposite: St Kevin's Church, Glendalough, County Wicklow, from the 1967 calendar.

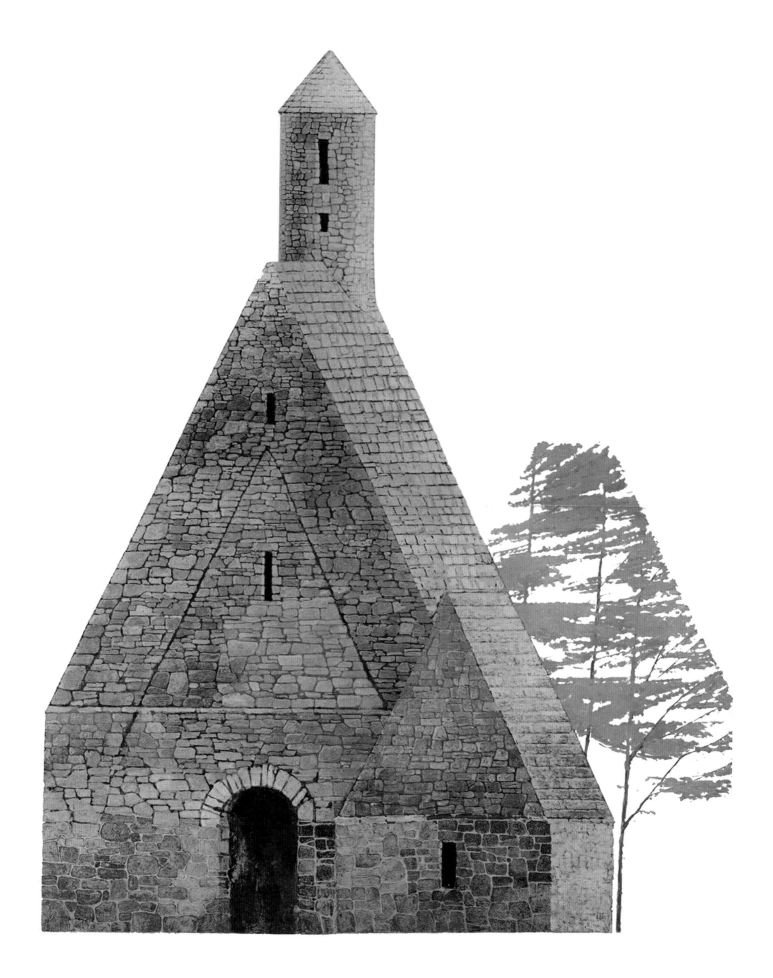

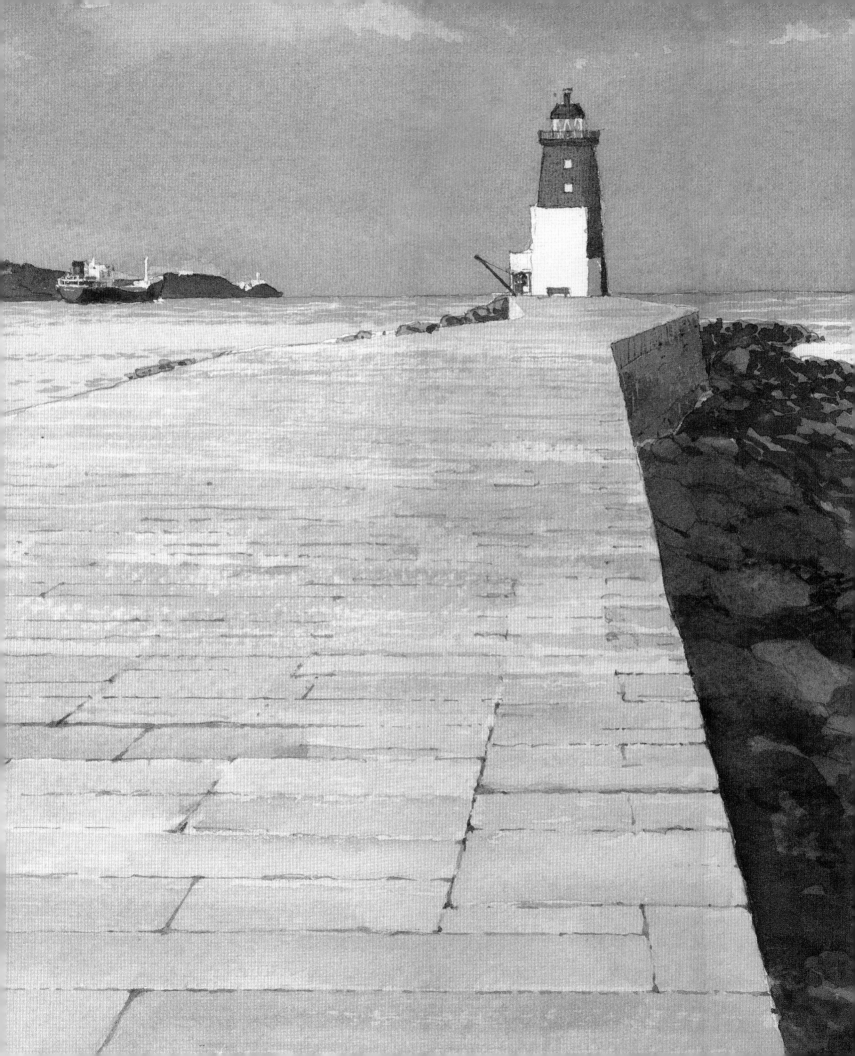

Dublin City and County

Poolbeg Lighthouse and the South Wall, Dublin.

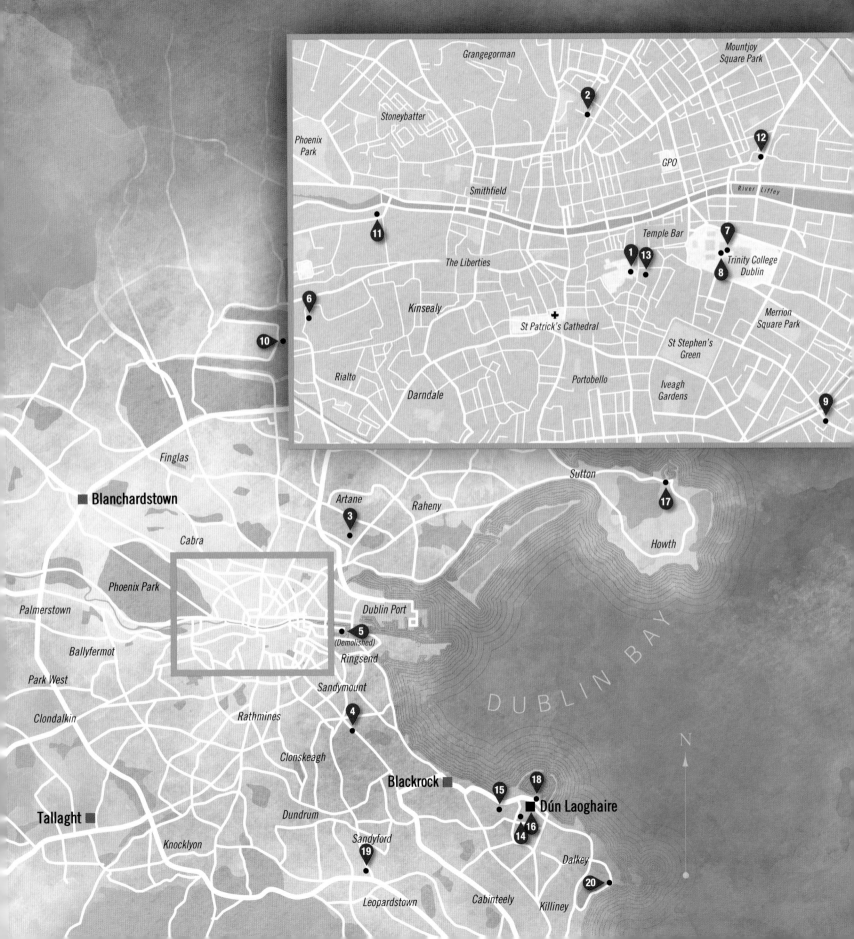

DUBLIN CITY AND COUNTY

Grangegorman

Mountjoy
Square Park

Stoneybatter

Phoenix
Park

2

12

GPO

Smithfield

River Liffey

Temple Bar

7

11

1 13

Trinity College
Dublin

The Liberties

8

6

Merrion
Square Park

Kinsealy

St Patrick's Cathedral

10

St Stephen's
Green

Rialto

Portobello

Iveagh
Gardens

9

Darndale

Finglas

Sutton

Blanchardstown

Artane

Raheny

17

Cabra

3

Howth

Phoenix Park

Palmerstown

Dublin Port

Ballyfermot

5

(Demolished)

Ringsend

Park West

Sandymount

Clondalkin

Rathmines

4

Clonskeagh

Blackrock

18

N

Tallaght

Dundrum

15

Dún Laoghaire

16

14

Knocklyon

Sandyford

DUBLIN BAY

Dalkey

19

20

Leopardstown

Cabinteely

Killiney

DUBLIN CITY AND COUNTY

Dublin Castle

Medieval Dublin occupied the high ground south of the River Liffey and was dominated by the fortress of Dublin Castle. Little now remains of the early castle, except the Record Tower, but archaeological excavations, which were carried out as the first stage of a rebuilding programme, revealed the remains of other towers and the moat which connected the, now buried, River Poddle with the Liffey.

By the middle of the 18th century the buildings surrounding the Upper Yard were completed and the resultant composition reflects the serene architecture of the Renaissance. The illustration shows the north side of the Upper Yard and presents one of the most beautiful architectural compositions in Dublin. Built in the early part of the 18th century the authorship of the design is uncertain, but the centrepiece of the composition is believed to be based on Lord Pembroke's villa in Whitehall, London, while the cupola was illustrated in William Kent's *The Designs of Inigo Jones* of 1727.

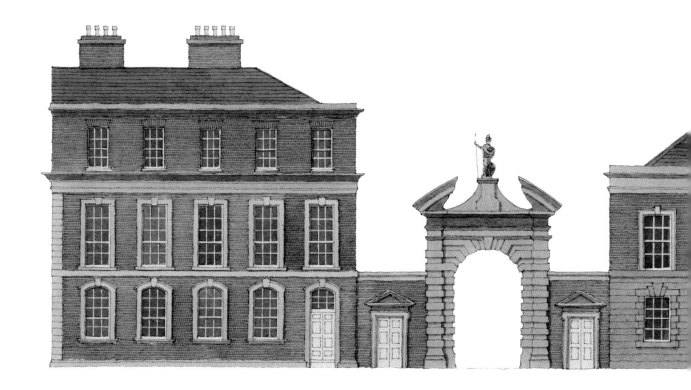

In the 19th century an attic storey was added, obscuring the hipped roof. This has now been removed, revealing the building in its original form and stressing the graceful height of the octagonal tower and cupola. The two robust Baroque gateways with broken pediments are surmounted by statues by the sculptor van Nost. These were made from lead and represent Mars and Justice.

A major restoration programme of the 18th-century Upper Yard, combined with extensive new building, was carried out from 1986 to 1989. This project was to provide for Ireland's presidency of the European Community in 1990 but also to establish a first-class international conference centre. The design and supervision were by the architects of the Office of Public Works.

Sean Rothery, 1992

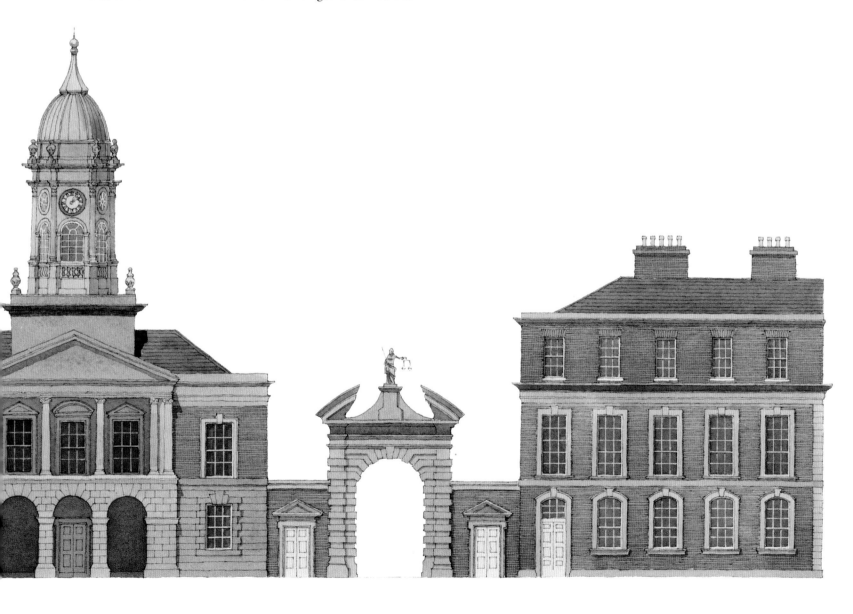

Georgian Houses, Henrietta Street, Dublin 1

Henrietta Street can in many ways be considered one of the most important urban architectural compositions of the 18th century in Ireland. We have here a cul-de-sac street, blocked at one end by the Kings Inns, a high-quality 18th-century building by a major architect, which is largely intact and almost three centuries old.

Whereas most of the other streets of buildings and squares of 18th-century Dublin have been rebuilt, altered or converted to office use, the houses in Henrietta Street are remarkably intact. Their most significant atribute is that they have survived as an early 18th-century street and, therefore, this constitutes an architectural treasure for Dublin of the utmost importance. Even for this classical city, Henrietta Street must rank as the premier architectural assemblage. The compact, relatively short length of the street, combined with the slope upwards, which is effectively closed by the powerful stone walls of Kings Inns, makes this an urban composition of exceptional charm. The taut scale of the street is achieved by the proportion of the tall houses related to the width of the street.

Henrietta Street was the creation of Luke Gardiner, a banker who, according to Maurice Craig in his book *Dublin 1660–1860*, had a larger influence on the development of the city than any other individual. The first houses in the street were built in the early 18th century and, unlike the formality of 18th-century terrace architecture of great classical

cities like Bath, the Dublin 18th-century town houses have a delightful individuality. Rooflines are varied and door cases differ: house number 9 has a rusticated stone ground-floor façade, while the rest of the houses are faced in a rich red brick.

Some of the houses were vey large, grand mansions with magnificent staircases, a few of which survive. In the early twentieth century the street was deserted by its fashionable inhabitants and the houses fell into the hands of speculators who tore out interiors and many of the splendid rich architectural features, and packed the buildings with poor families, sometimes several to a divided, formerly magnificent room. The street, however, largely survived the commercial assault and demolitions of the 18th-century Dublin in the 1960s and 1970s, and the houses, although neglected, remained intact.

Although many details are missing from exteriors and particularly interiors, this is to be expected after nearly three centuries of wear and tear and dense occupation. Preservation of this remarkable and important street is an essential and highly desirable objective.

Sean Rothery, 2001

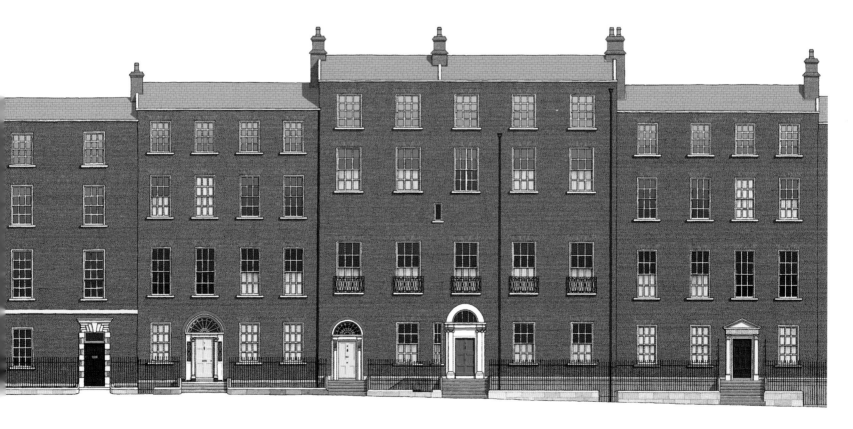

Casino Marino, Dublin 3

The country villa, known as the Marino Casino, at Marino, Dublin, is the most perfect neoclassical building in Ireland. Built in the early 1760s, the Casino was commissioned by Lord Charlemont and designed by his friend and celebrated English architect Sir William Chambers.

Lord Charlemont, an Irishman, made the fashionable Grand Tour of the continent. His great interest was architecture and when he returned to Ireland he devoted his energy to the building of his house in Rutland Square, now Parnell Square, and a country villa at Marino, Clontarf. Charlemont House, now the Hugh Lane Gallery of Modern Art, became the centrepiece for the northside of the square and was the last of the great town houses of Dublin to be lived in by its owners.

The Casino belongs to the 18th-century tradition of embellishing the landscape of parks and demesnes with pavilions and various other buildings that were mainly used for pleasure. The classical architectural language of antiquity, particularly that of Rome, was popular for such set pieces.

The plan of the Casino is a simple Greek cross with a Doric colonnade all around, with each façade expressed by a portico pushed forward. The building is raised up on a podium with a flight of steps on two sides and a classical balustrade on the other two. The sculptor of the urns and statues was English-born Simon Vierpyl, who was brought back from Rome for the work by Lord Charlemont.

Sean Rothery, 1990

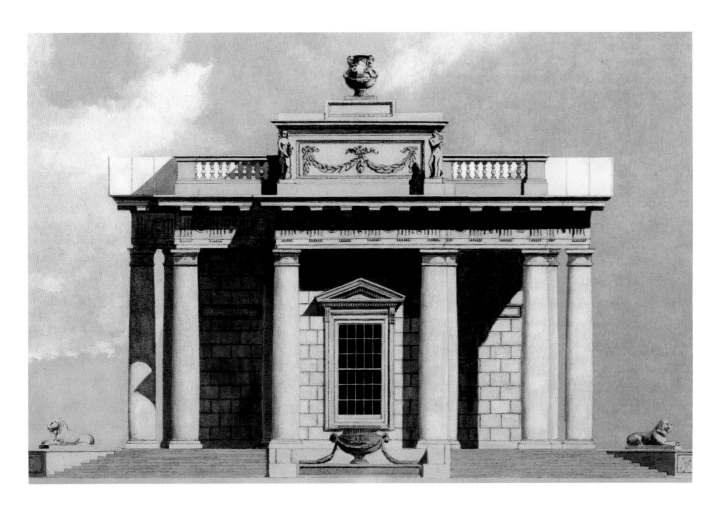

GATE LODGE, ROEBUCK, COUNTY DUBLIN

The later part of the 19th century was notable for the great wealth of new materials which were cheap and easily available. These new materials included various designs of pressed bricks, many varieties of coloured bricks and an immense selection of terracotta decorative facings. The Decorative Tradition, as it is now called by architectural historians, was enthusiastically adopted for the design of quite ordinary buildings.

The designs of gate lodges were seen by architects as unique opportunities for displays of architectural skill and individuality. The smallness of the scale tempted the designers into overemphasis of features such as chimneys and gable ends, and the decorative treatment of windows and doors, but the sureness of the use of materials is probably the most impressive feature of many of these little masterpieces.

In this magnificent example of the Gate Lodge at Roebuck, County Dublin, the main walling material is an extremely white limestone laid in a pattern with three colours of bricks, rich red for the quoins and arches and horizontal bands of white and blue in the chimney stacks. Pressed bricks were used to give bold relief patterns at the eaves level, while the gable ends were emphasised by expressing the roof trusses.

Sean Rothery, 1977

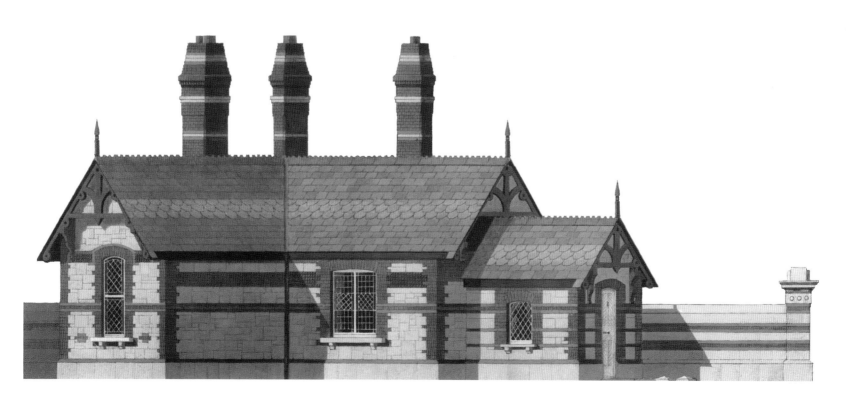

Retort House, Dublin Gasworks (*Since demolished*)

The Functional Tradition of building, where the architectural form was dictated solely by the purpose of the building, has resulted in unusual and often beautiful forms.

The Retort House of the Dublin Gas Company was one such example, a striking feature of Dublin's townscape for many years. This building was used for the gasification of coal and the manufacture of coke, and the design was completely functional. The coal was conveyed to the top of the Retort House from the quayside of Grand Canal Docks and was fed into bunkers for burning. The gas was taken off and the coke emerged at the bottom.

Designed by the Glover West Construction Company, the building was constructed in steel with thin curtain walls of single-brick thickness held in steel framing. The proportions of framing with infill panels of solid bricks, ventilated bricks and glass bricks were in the Bauhaus tradition of design, and as such this buiding is considered one of the first examples of modern architecture in Ireland.

Sean Rothery, 1978

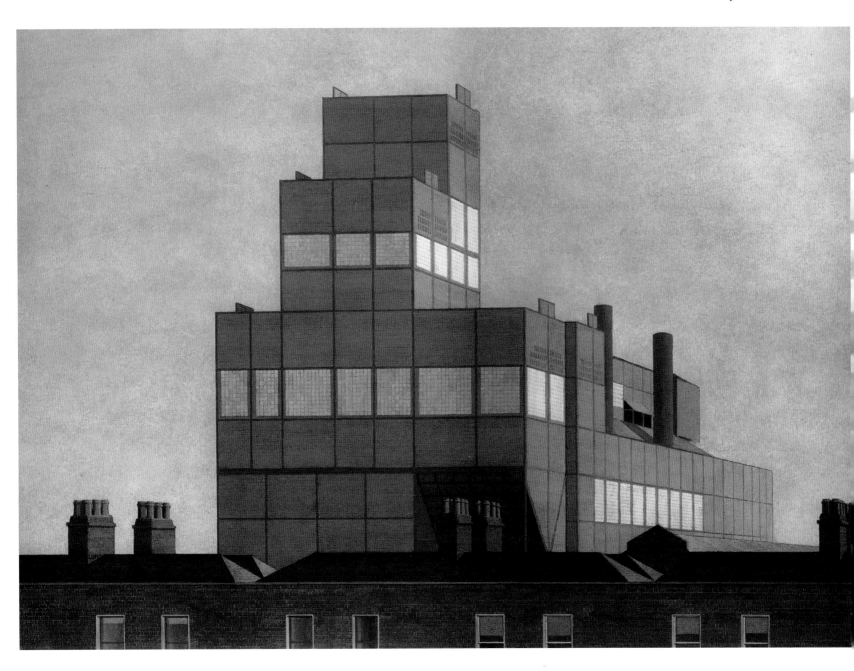

THE ROYAL HOSPITAL, KILMAINHAM, DUBLIN 8

The Royal Hospital at Kilmainham, Dublin is the oldest surviving fully classical building in Ireland. James Butler, the first Duke of Ormonde, laid the foundation stone in 1680 and the work was completed in 1684. Louis XIV built the great hospital Les Invalides for his old and sick soldiers, and this example was followed in the building of the Irish hospital. The architect was William Robinson, who had been Surveyor-General since 1670.

The great classical courtyard has arcaded walls around the central space, which is divided by four axially placed entrances. The Chapel, placed on one of the corners, has superb carved woodwork, executed by the Huguenot craftsman James Tarbarry. The Royal Hospital, a beautiful and very important part of our architecture heritage, has undergone extensive restoration through the years. All floors were replaced and innovative work carried out on the roof structure in order to retain the original oak timbers.

The work was commissioned by the Office of Public Works and the architects for the restoration were Costello, Murray and Beaumont. The building lives on as a centre for culture and the arts.

Sean Rothery, 1986

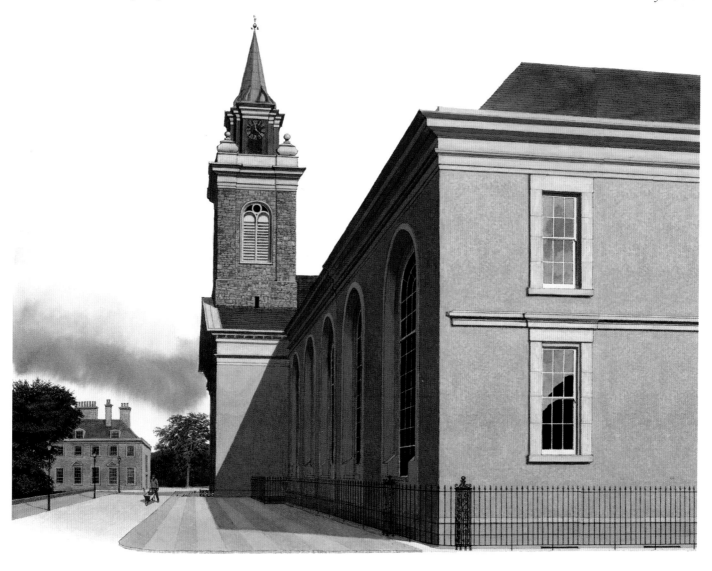

SCHOOL OF ENGINEERING, TRINITY COLLEGE DUBLIN, DUBLIN 2

The Trinity Museum, now the School of Engineering, at Trinity College Dublin was designed by Benjamin Woodward of the famous firm of Deane and Woodward. Its splendid proportions and magnificent interior staircase hall make it one of the finest Victorian buildings in Dublin.

The sculptured decorations by the O'Shea brothers from Cork are extraordinarily varied and rich in detail. The horizontal bands of deeply carved plant forms emphasise the otherwise simple façades.

The art critic John Ruskin, who influenced the design of the Oxford University Museum of Natural History was not enthusiastic about the winning design of Deane and Woodward. However, he changed his mind completely when he saw the Trinity Museum and he was largely instrumental in bringing over the Irish team of Woodward and the O'Shea brothers for the Oxford building, which sadly was never finished. The Trinity Museum along with the Kildare Street Club, also by Benjamin Woodward, are fine monuments to Irish Victorian designers and craftsmen.

Sean Rothery, 1975

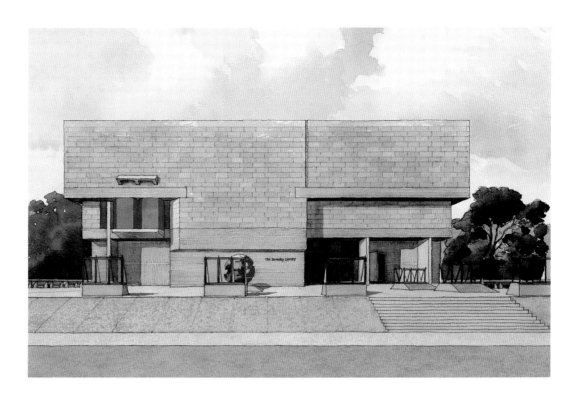

BERKELEY LIBRARY, TRINITY COLLEGE DUBLIN

An international competition was held in 1961 for the design of a new library for Trinity College Dublin. The winning design of a modern style was by Ahrends, Burton and Koralek.

The Berkeley Library was carefully positioned at right angles between two of the most splendid older buildings in Trinity College: the disciplined Classicism of the Old Library and the ornate Ruskinian Gothic of the Trinity Museum building. A raised platform links the three disparate designs to create a unified composition. This dynamic space is a reminder of the sublime public space that is the Campidoglio in Rome.

Built by G & T Crampton, the design was a groundbreaking exercise in the use of concrete as a finished element. The fair-faced concrete demonstrates the texture of the carefully chosen timber shuttering boards, and the exterior is partially clad in Wicklow granite to harmonise with the rugged stone of the older buildings.

Sean Rothery, 2003

Upper Baggot Street, Dublin 2

Towards the end of the 19th century architects were increasingly bored by the formality and conformity of endlessly revived classical styles. There was a restlessness to explore a more lively and even aggressive expression of individuality. The east side of Upper Baggot Street demonstrates this bold new initiative. The resultant streetscape is almost completely intact today.

Baggot Street Hospital, designed by architect Albert Murray (1849–1924) is the centrepiece of the composition. The street façade dates from the 1890s and the influence of the great designer Richard Norman Shaw is particularly strong. Shaw's rich modelling of the 1877 Cadogan Square buildings in Chelsea, London is an obvious source. The numerous windows show the desire in the latter half of the century to let in more light, particularly to a hospital. The Baggot Street Hospital building, as well as adjoining commercial buildings, are a cocktail mix of Dutch and Flemish gables, balconies, balustrades, cornices and highly flamboyant detailing. Exotic mixing of materials, such as different coloured red and yellow bricks, wood, and limestone shop surrounds all contribute to the brash assertiveness of the urban streetscape. The roofscapes, particularly from street

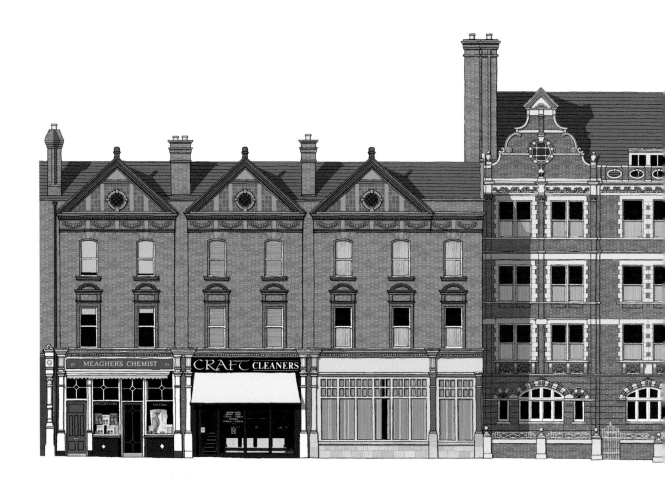

level, are an exciting feature of the assemblage, where multiple gables, copings, barges, crockets and finials stab the sky. The composition is a long way from the serene and unassuming terraces of the 18th century.

The tall narrow commercial buildings on each side of the hospital acknowledged the strongly textured set-back façade of the hospital and repeat the individualistic detailing with many striking variations on the theme. The former Drummond's seed merchants shop in Dawson Street, Dublin, now Hodges Figgis bookshop, is also by Murray and again in his extravagantly riotous Dutch style. Several other architects were also involved in Dublin's streetscape at this time, including JJ O'Callaghan, James Farrell and Robert Stirling. O'Callaghan's beautiful cut-stone detailing can be seen on the former Granary Building and the Dolphin Hotel in Temple Bar, Dublin. James Farrell, along with JJ O'Callaghan, was responsible for the design of the Olympia Theatre in Dame Street. Robert Stirling was the architect for the ornately decorated Bleeding Horse pub in Camden Street, which has miraculously survived the demolition and rebuilding all around it.

Sean Rothery, 2001

DUBLIN AIRPORT, COLLINSTOWN, COUNTY DUBLIN

The single most important new building for the infant Irish State in the 1930s was Dublin airport. The design of the new airport was entrusted to the Office of Public Works. In 1936 newly qualified architect Desmond Fitzgerald was appointed as Airport Architect and under his leadership a talented team consisting of Dermot O'Toole, Dáithi Hanly, Charles Aliaga Kelly and Kevin Barry, with the later addition of Liverpool graduate Harry Robson, designed the project.

The contract for the airport building was placed in November 1938, implying a design date of 1937. This example of the International style of modern architecture is early, and ahead of most work done in that style in Britain, for example.

The International style of the 1930s had many of the characteristics of the great ocean liners of the same period. Long horizontal forms with cantilevered balconies, open decks, metal railings and the use of large areas of gleaming white painted

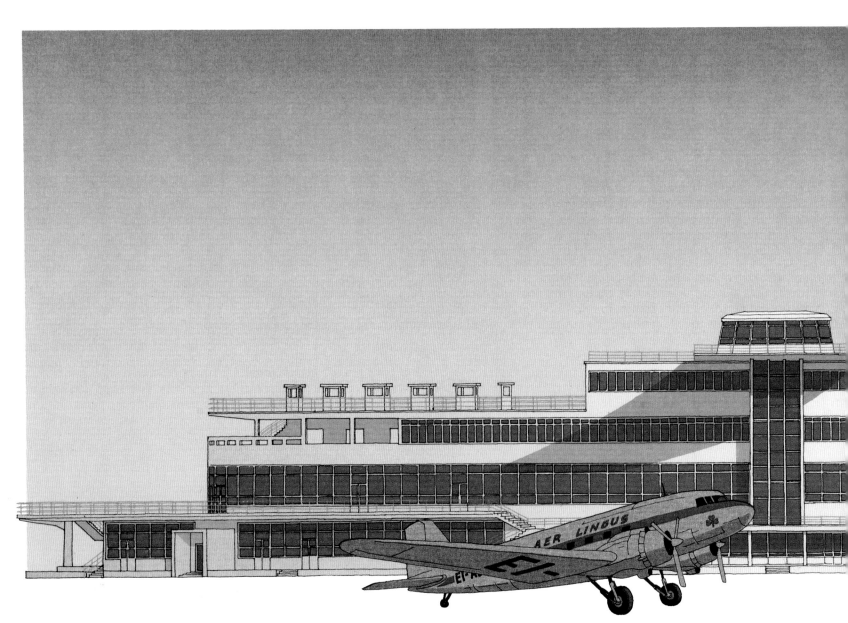

surfaces became the hallmarks of an exciting new architecture. The airport was viewed as a mature and elegant exercise in the International style. Although it is not derivative of any single European model, there are several possible sources for its forms and details. The mature modern work in Holland at the time, such as the Van Nelle factory in Rotterdam and the Sanatorium in Hilversum, were highly influential buildings and there are hints of these in the Dublin terminal.

The building work was completed before the end of 1940, but because of wartime censorship no publicity was given to a building that was a pioneer in terms of European modern architecture.

Sean Rothery, 1989

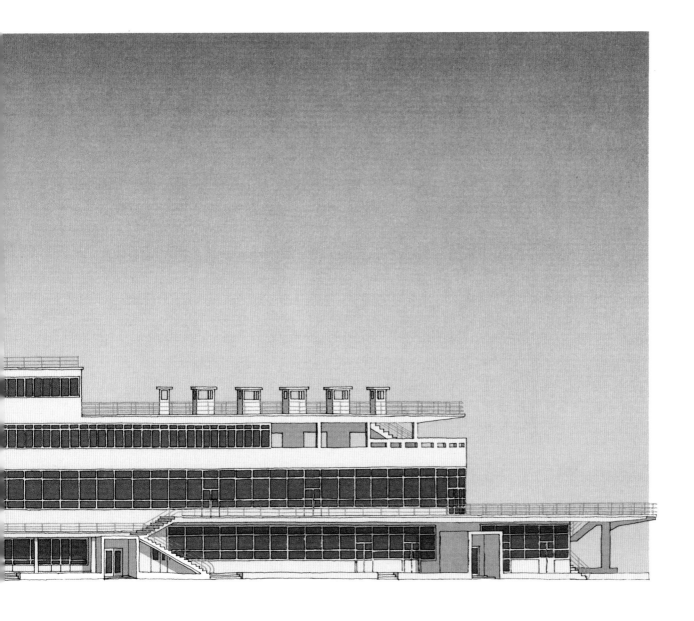

HEUSTON RAILWAY STATION, DUBLIN 8

With the great railway building period in the mid-19th century, horizons were widened, distances were reduced and new industrial enterprises flourished. In Ireland, the architectural response to this new modern age of steam and transport was to celebrate it by using the established language of historic architecture to create new building types. All over the country splendid little railway stations in Gothic or Classical dress appeared, each with matching engineering works, like bridges, engine sheds, signal boxes and other elements of the new transport.

The grand terminus, on the other hand, was usually the occasion for a greater celebration of the art of architecture. Heuston, formerly Kingsbridge, grandly announces itself as a place of both arrival and departure. The design is based on a Renaissance palazzo and would not be out of place in Florence. Kingsbridge was designed by the architect Sancton Wood for the Great Southern and Western Railway Company and dates from 1845 to 1846. The eastern front faces down the River Liffey and is a triumphant Classical composition, with a powerful central block flanked by wings complete with elaborate towers.

Classical details are employed to make a rich façade. Engaged columns divide the front into bays and the first-floor windows have alternate segmental and triangular pediments, while the bays are linked by decorative swags. By contrast, and in true Renaissance palazzo style, the ground floor of the façade is built in plain, rugged stonework in broad bands. The top of the building is an elaborate fretwork of wavy cornice, capped by a lacy balustrade to create a skyline of interest and delight.

Sean Rothery, 1989

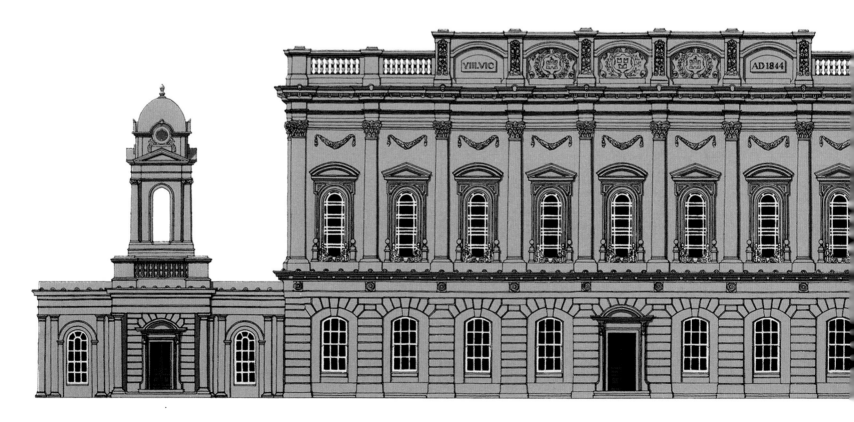

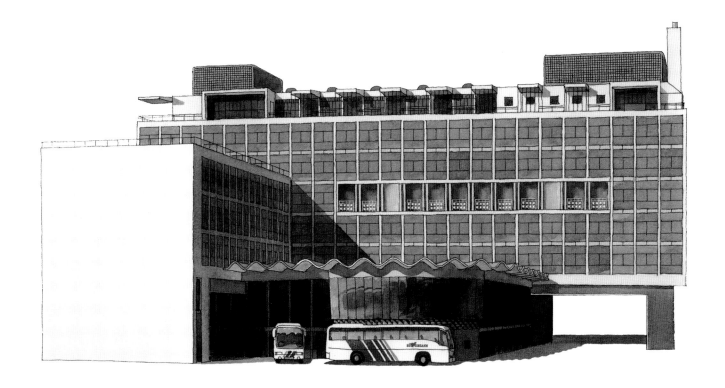

BUSÁRAS, STORE STREET, DUBLIN 1

The Dublin Central Bus Station, or Busáras as it is known, is one of the most significant twentieth-century buildings in Ireland. The design, by Michael Scott, was completed in 1953. Instead of the intended headquarters for the newly established national transport board, the main office portion of the building became the Department of Social Welfare.

Michael Scott was an important pioneer of modern architecture in Ireland. A team of architects and engineers used reinforced concrete to produce a technically advanced building. The thin wavy canopy over the bus park along with the great cantilever on the skyline were innovations that boldly announced the arrival of modern architecture to the capital.

Stylistically the building owes much to the Swiss-French architect Le Corbusier, particularly his Swiss Pavilion at the University of Paris and the Cité de Refuge of 1933. The careful detailing of the building included elegant reinforced concrete columns in the concourse, Italian glass mosaic and Portland stone facings. New for Ireland at the time was a basement cinema, later converted into a theatre, and what was heralded as a magnificent roof-top restaurant became a staff canteen.

Sean Rothery, 2003

SOUTH CITY MARKET, GEORGE'S STREET, DUBLIN 2

Victorian cities tackled, with great vitality and invention, the problems of health and hygiene, problems which became enormous with the fast growth of cities in the 19th century. The great covered market was a feature of many towns in Britain, and in 1878 a competition was held for the design of the South City Market in George's Street. The winning design was by the Bradford firm of Lockwood and Mason, under the nom-de-plume 'Northern Lights', and the building today continues to make a vital contribution to the south-city shopping area. The market is in red brick and occupies a whole block with an extension. The corners are emphasised with turrets and steep pitched roofs and the main entrance from George's Street is imposing, with its iron gateway and steep narrow roof. The central courtyard was originally roofed over and must have been a most impressive single space with the bustle and colour of the market stalls at ground level.

Sean Rothery, 1975

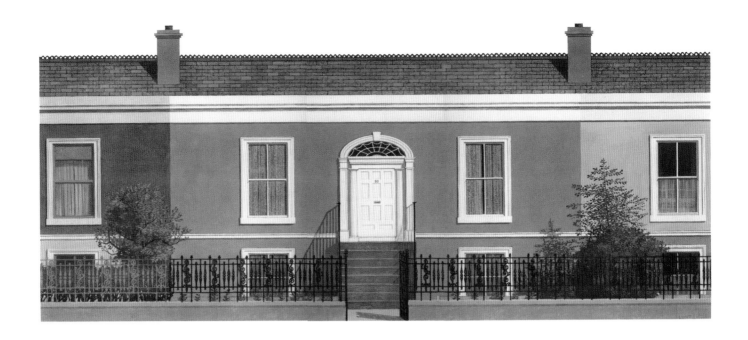

TERRACE HOUSE, DÚN LAOGHAIRE, COUNTY DUBLIN

As the 'strong farmers' house acts as a bridge between the humble cottage of the ordinary people and the mansions of the gentry in rural Ireland, the same situation can be seen in the capital city with the characteristic Dublin 'single storey over basement' terrace house, coming midway between the plain artisans' dwelling and the four-storey Georgian town house. There are many streets of these little houses in the city, the main characteristic being the entrance at the first-floor level, up a short flight of granite steps with simple iron railings.

The front doors are set in the centre with simple Georgian proportioned windows placed either side. Invariably, there is a front parapet with a blocking course, small cornice and frieze – a device to increase the apparent size of the frontage. A string course, generally of granite, articulates the first floor from the semi-basement with its smaller windows.

These houses were generally built of brick, but in Dún Laoghaire the houses often have a plastered front painted in various colours, with plaster classical details around windows and doors. The front door is an attractive feature. In this example an elliptical arch springs form simple pilasters, while the solid panelled door contrasts with the lacy and delicate tracery of the fanlight overhead.

Sean Rothery, 1977

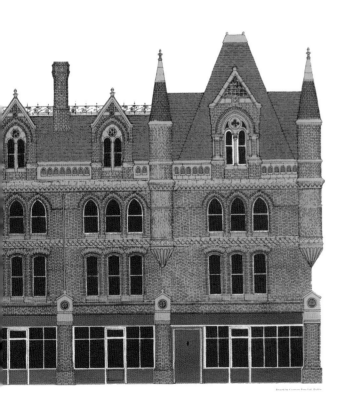

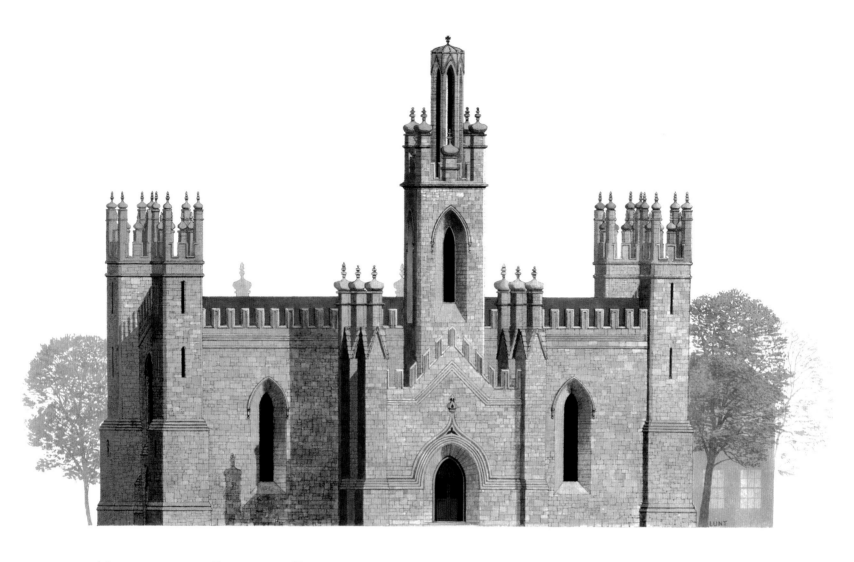

MONKSTOWN CHURCH, COUNTY DUBLIN

This splendid church at Monkstown, County Dublin is by the architect John Semple and was built about 1830. It is sited in a dominant position at the road intersection and provides a marvellous closure to the view on the long avenue from Blackrock.

John Semple was the designer of a series of interesting churches in and around Dublin, notably the Black Church on Dublin's northside, along with churches at Donnybrook, Tallaght, Kilternan and Whitechurch.

All of Semple's churches display his own individual style and interpretation of Gothic. This was usually expressed by strong and simple forms and the carefully considered use of various building stones to express a fortress-like strength and lively texture. The main building material is the warm-coloured and textured local granite. The stone is used in the wide splayed reveals to emphasise the tall lancet windows.

An individual feature of this building is the carving of the tops of the towers and pinnacles in the form of chessmen. There is the absolute minimum of decoration, only simple hoods over the windows, which are swept up to a delightfully elongated ogee over the main door.

Sean Rothery, 1978

Dún Laoghaire Town Hall, County Dublin

Some buildings appeal on first aquaintance; with others it takes time to get to know them. It was not until I came to draw the Dún Laoghaire Town Hall for the *Roadstone Calendar* that I began to appreciate its felicities. It was designed in the Venetian style first promoted by John Ruskin in the nineteeth century. The granite and limestone are set off by red and yellow sandstone detailing, and the stained-glass fanlights and the formal entrance are unified by the scale and rhythm of the repeating arches. The building exemplifies Goethe's dictum 'architecture is frozen music'.

For me, Dún Laoghaire Town Hall is one of the most beautiful buildings in Ireland.

Formally opened on 5 July 1880, the design, by architect John L Robinson, was originally to be a red-brick building with stone dressings, but on the insistance of the Board of Works the present design was completed to a very high standard by contractors Michael Meade and Sons of Great Brunswick Street – now Pearse Street, Dublin 2.

Michael Lunt, 2023

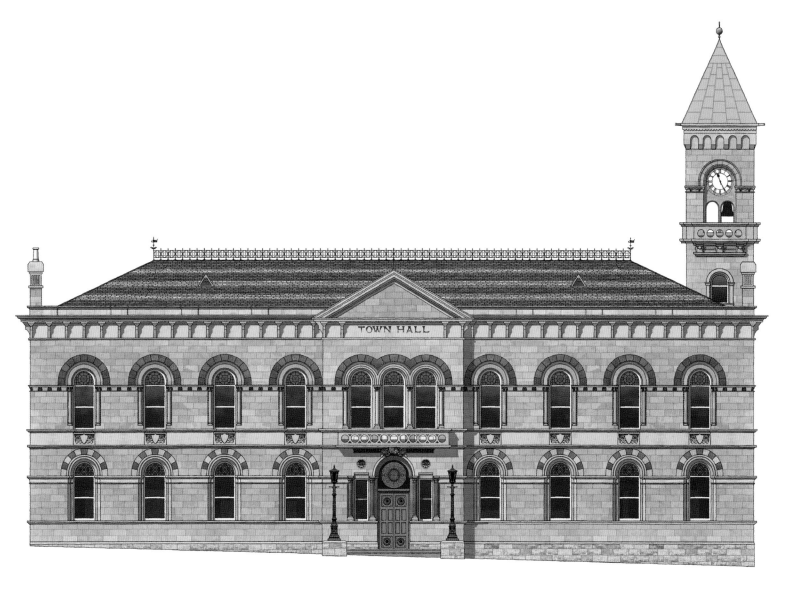

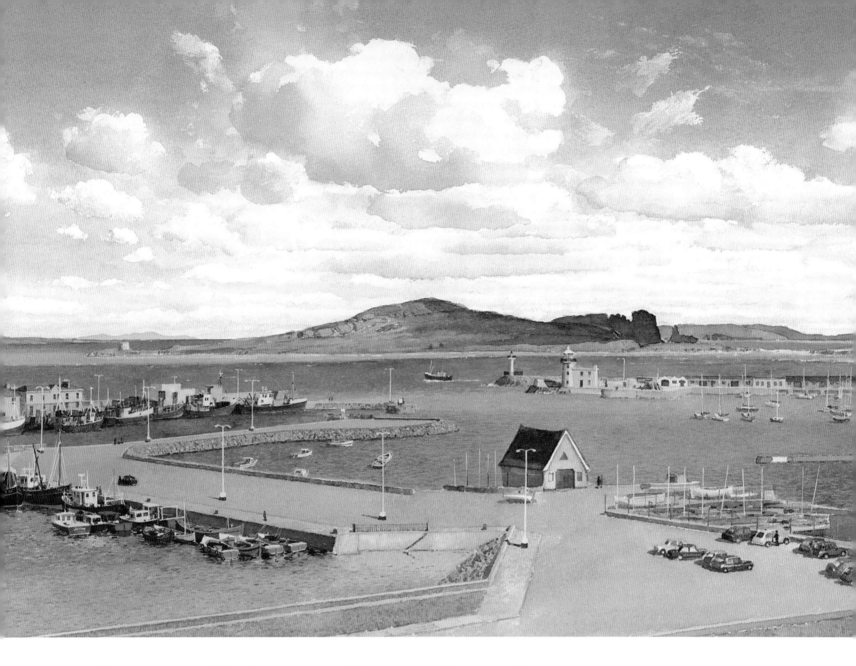

HOWTH AND DÚN LAOGHAIRE HARBOURS, COUNTY DUBLIN

Howth Harbour (above), completed in 1818, was built to serve as the designated terminal for the mail packet sailings from Britain to Ireland. In 1819 the first steam-powered paddle steamer made the crossing in seven and a half hours, half the time taken previously. As a result of silting at Howth the service was switched to a new harbour at Kingstown (now Dún Laoghaire) in 1834. Dún Laoghaire and Howth are homes to the two oldest lifeboat stations in Ireland. Howth remains a major port for both fishing and recreational sailing.

The original design for the new harbour at Dún Laoghaire (opposite) was the work of the great Scottish engineer John Rennie. The work began in 1820. The West Pier began the same year but the two piers were not to be finished for more than twenty years. There was much disagreement as to final shape and design of the pier ends. The opening to the harbour was vulnerable to winds from the north and north-east and Rennie and other engineers designed several types of breakwaters to protect the opening and suggested a narrow entrance. The final result was the rounded pier heads with

lighthouses and other buildings which exist today with a wider entrance leaving the harbour exposed to rough seas from certain directions.

Architecturally the harbour is a masterpiece. The great curving piers with their massive sloping rough breakwaters contrast with the elegant walls and walkways on the inner side. The pier heads have each a separate character. The East Pier is a beautiful piece of largely military architecture complete with gun embrasures and protective sloping parapets. Two lighthouses, also constructed with the warm and textured local granite which gives the whole harbour its unique character, strongly accentuate the pier heads. The West Pier lighthouse is splendidly surrounded by a great circular pattern of huge granite paving slabs.

John de Courcy Ireland, 1995

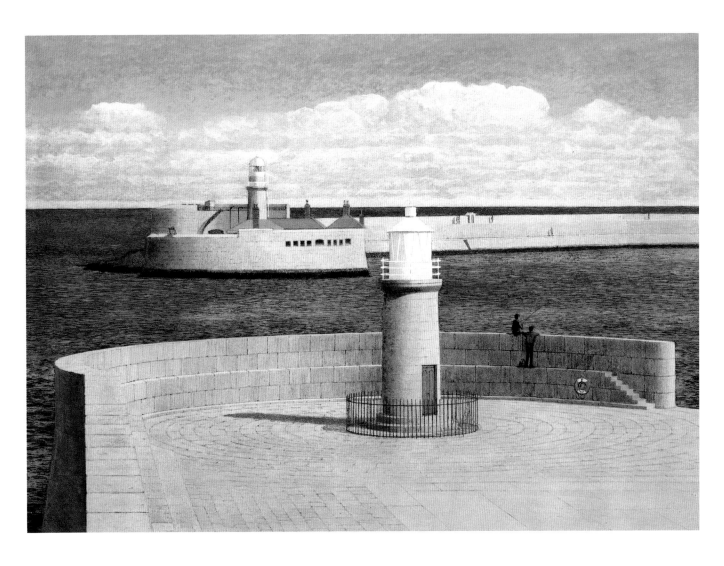

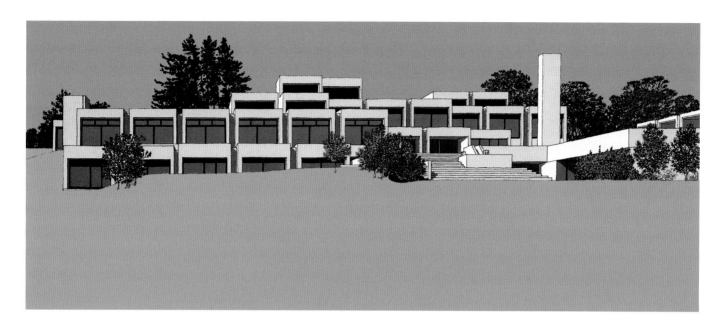

Irish Management Institute, Sandyford, County Dublin

In the postwar years modern architecture matured and moved away from the functional language of pristine cubes of concrete that characterised much of the International style of the 1930s. Experiments were made with concrete to achieve a finish which would provide a more interesting texture and would also withstand the Irish climate.

The challenge of placing large buildings in the landscape in a sensitive manner was also recognised by architects. The Irish Management Institute buildings in Sandyford, County Dublin are a fine example of the solution to many of these problems. The architects, Stephenson Gibney and Associates, had the problem of fitting a large headquarters and training centre into a mature, wooded parkland that contained a country house. The buildings needed to project an image of both a managerial and an educational nature while not dominating the landscape. This was achieved by the preservation of as much as possible of the existing landscape and the existing house. The vista was manipulated to reduce the appearance of the size of the buildings by placing them below a series of landscaped decks. The buildings visible above ground level are conceived as a series of cells, giving an intricate conglomeration of forms, which with their white finish provide an interesting profile against the trees. The work was carried out almost entirely in concrete.

The IMI building won the Gold Medal of the Royal Institute of Architects of Ireland for 1974–76.

Sean Rothery, 1989

SORRENTO TERRACE, DALKEY, COUNTY DUBLIN

One of the most enduring memories of school holidays was the train ride to Bray. Embarking at Sandymount Station we would soon be clanking past Williamstown, the sea wall festooned with towels and togs and sun-tanned bodies. Leaving the sea at Dún Laoghaire, at first through the dark confines of cuttings and tunnels, then just beyond Dalkey suddenly emerging to the resplendent panorama of Killiney Bay. To the south the line of the shore reached a perfect climax at Bray Head and the two Sugarloaf mountains. Behind and beneath us, a rockier and steeper seashore curved round towards Dalkey Island, culminating in an elegant terrace of three-storey houses perched high above the waves.

Thirty years later, in a small boat on a breathless summer morning, I was viewing the same terrace from the sea, preparing this picture for the calendar. The sea really was as motionless as the drawing suggests.

The technique used for these two pictures is one I have used several times over the years. Firstly, I do a black line drawing of the subject; then, on separate overlays, I fill in areas of single colour, the whole coming together in the final printing. In the early years, this allowed for greater control and fidelity of colour reproduction, but because there was a limit to the number of colours I could print the technique was more suited to architectural subjects than to landscape. In later years, I developed the technique using the computer to fill in the colours. This allowed a much greater variety of colours and tones. The difference can be seen by comparing the 1988 drawing of Heuston Station with the one of Dún Laoghaire Town Hall done in 2004.

Michael Lunt, 1999

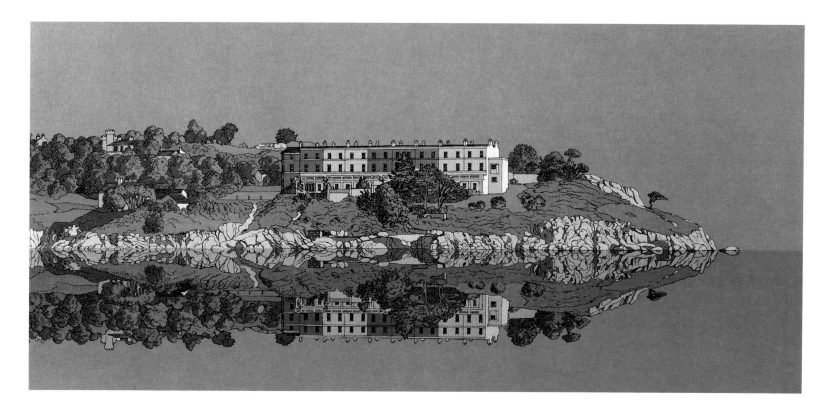

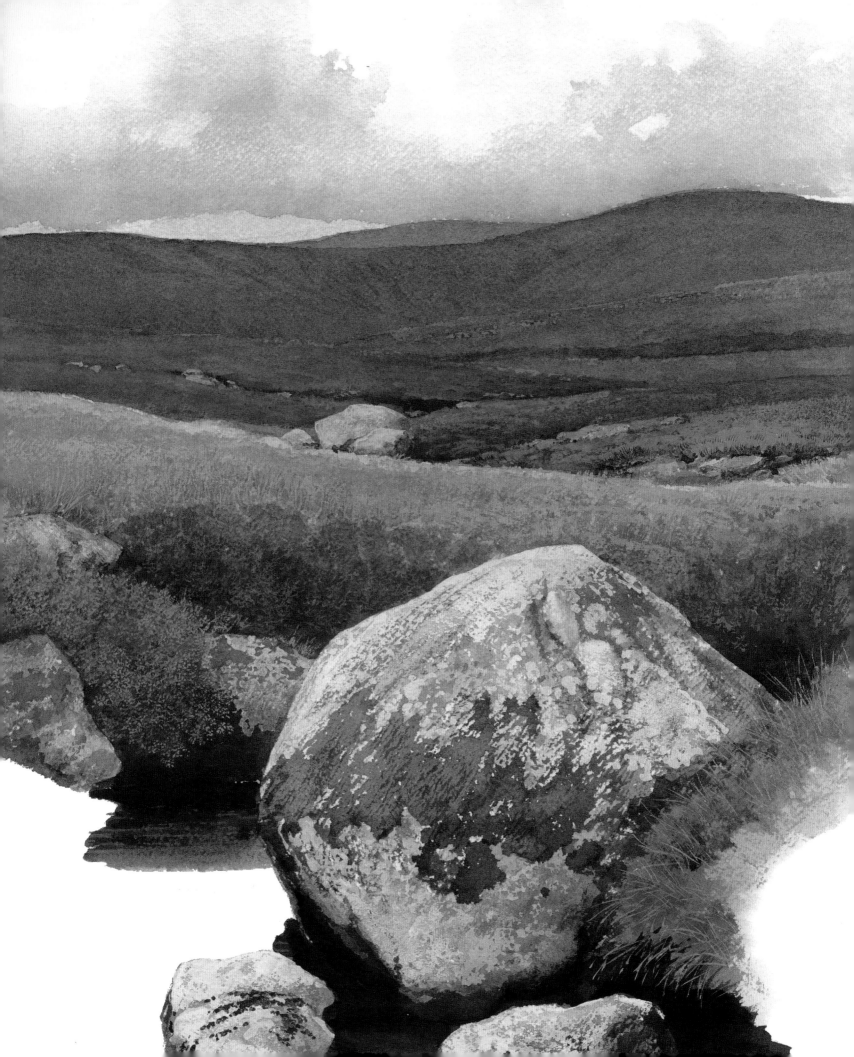

East and Southeast

EAST AND SOUTHEAST

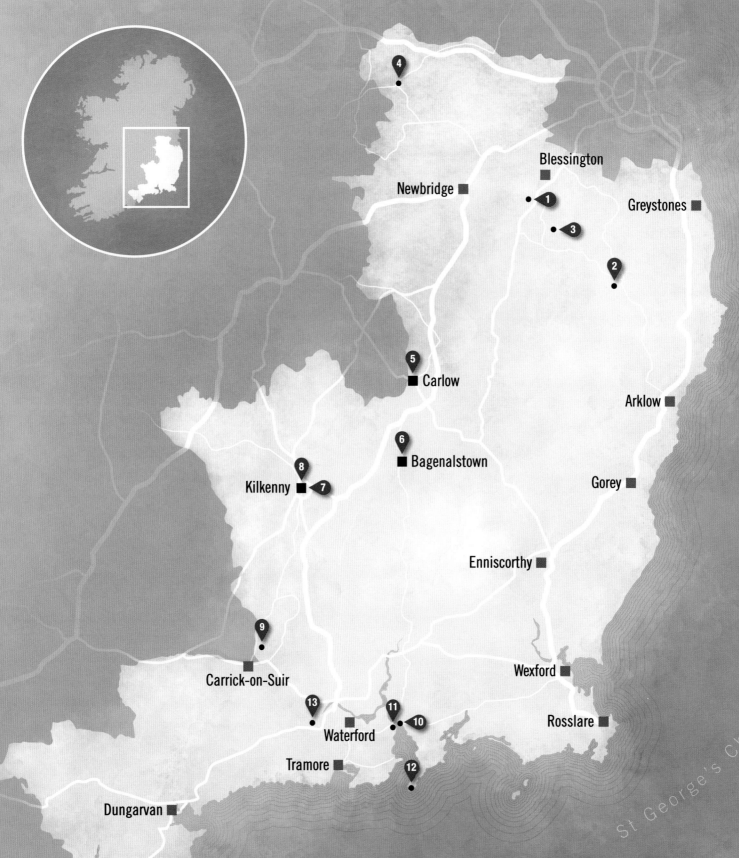

IRISH SEA

Blessington

Newbridge

Greystones

Arklow

Gorey

Carlow

Bagenalstown

Kilkenny

Enniscorthy

Carrick-on-Suir

Wexford

Waterford

Rosslare

Tramore

Dungarvan

St George's Channel

CELTIC SEA

4

1

3

2

5

6

8

7

9

13

11

10

12

N

EAST AND SOUTHEAST

RUSSBOROUGH HOUSE, COUNTY WICKLOW

Russborough House is situated near Blessington, County Wicklow. Its setting is magnificent, looking out from rising ground to the rolling Wicklow mountains. The setting is enhanced by the man-made Poulaphouca lake, separating the demesne from the hills beyond. The house was built about 1741 for Joseph Leeson, 1st Earl of Miltown and a wealthy Dublin brewer. It was one of many country houses designed by the German architect Richard Cassels. Cassels lived and worked in Ireland from 1728 until his death 1751. Along with Russborough, he designed Powerscourt House and Westport House, and Dublin's Leinster House, Tyrone House and Clanwilliam House.

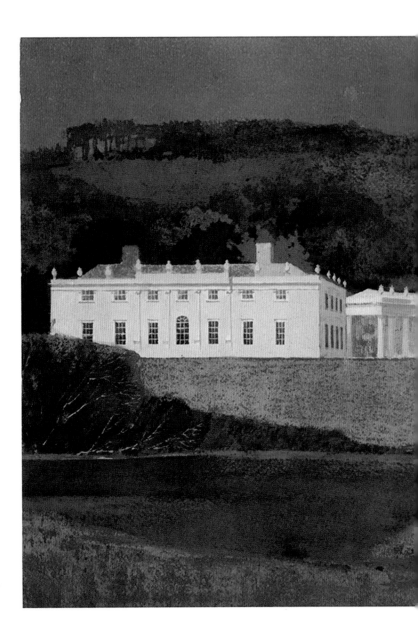

The house is built of stone from the neighbouring Golden Hill quarry. The plan, like Castletown's, is based on the Italian palace arrangement of a central block with curved colonnades of Ionic pillars connecting to wings. Like most of Richard Cassels' work, the house is massive and heavily proportioned but it is in character with the wooded site.

Some of the interiors are very fine with stucco decorations. The house was the home of Sir Alfred and Lady Beit and houses the famous Beit collection of paintings and art treasures.

Sean Rothery, 1968

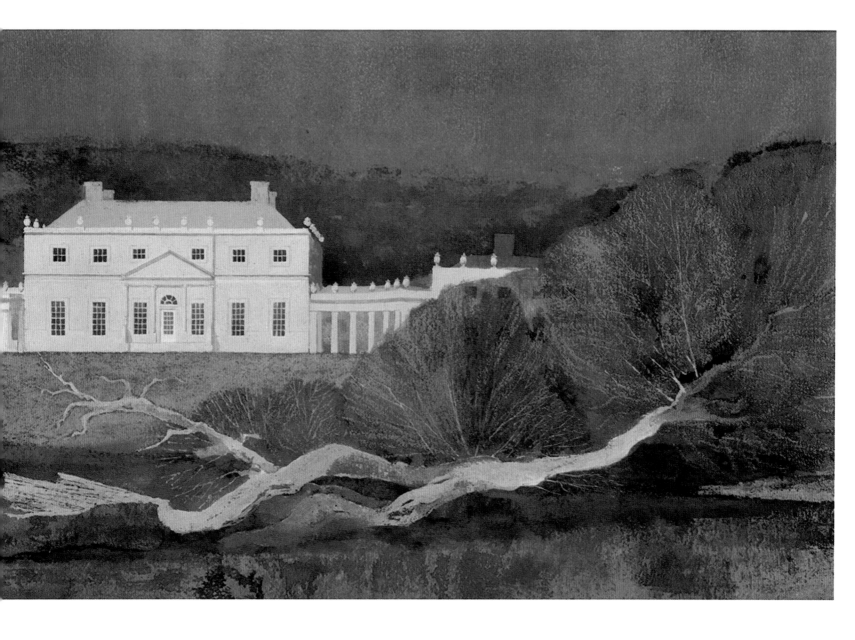

Glendalough, County Wicklow

Glendalough has played a major part in my life. The Irish Mountaineering Club bought and renovated a house in the Glendasan Valley, a short walk from the Lower Lake. Following mountaineering tradition, it was known as the IMC hut, although it was a substantial two-storey building.

Beyond the Upper Lake was Twin Buttress, a granite crag that has fostered the development of rock-climbing and mountaineering in Ireland.

On Friday and Saturday nights groups would gather round the fireplace, forging friendships. Yeats might be recited, Vivaldi appraised, and many of the world's problems solved. All this in a location that, with its monastic remains set amidst woods, lakes and cliffs, is one of the most beautiful places in Ireland, if not in Europe.

Michael Lunt

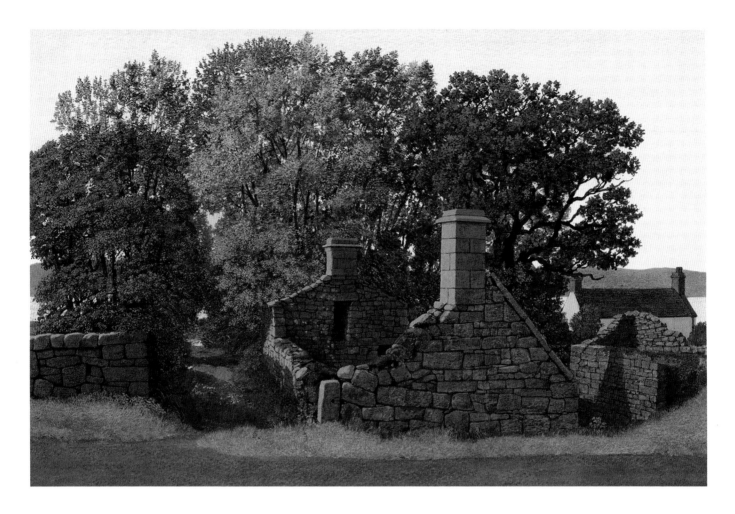

BALLYKNOCKAN VILLAGE, COUNTY WICKLOW

The village types of Ireland are many and varied. A very early form is the clachan, a small rural settlement without any formal buildings such as church or post office. They often grew up to serve a small local community at a crossroads or pass. Some of the most striking of the villages were those that were attached to a nearby estate and house. There are also villages that grew up to house the workers of a local industry and these often present a unique appearance.

The little village of Ballyknockan, just above the shores of Blessington Lake in County Wicklow, was not designed in any deliberate way, but is certainly unique in Ireland.

Ballyknockan grew up to house the stone workers and their families around the former great granite quarries. The village is a tribute to those superb craftsmen in stone. There are many examples of beautiful details in the village, including carved ornaments on gateways and superb dressed and squared chimneys. Even the dry-stone field walls are finished to a high standard.

Sadly, little of the more modern building in the village seems to have been influenced by this example of high-quality Irish craft and soon there will be little left of this wonderful fragment of our past craftsmanship.

Sean Rothery, 2001

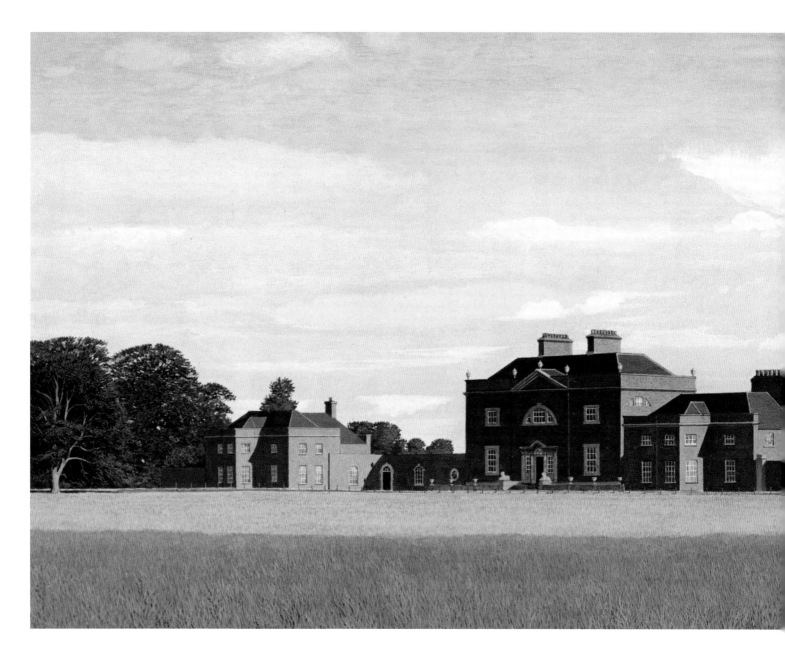

NEWBERRY HALL, CARBURY, COUNTY KILDARE

The River Boyne rises at Carbury, County Kildare, in the grounds of Newberry Hall. The Palladian style of architecture developed in Ireland in the early years of the 18th century reached its climax of design and influence with the work of Richard Cassels. Many of the great Irish country houses were in the Palladian manner and it was inevitable that the designers of the smaller houses were influenced by this pure classical style. One of the features of the style was the expression of different zones of the house in separate architectural forms. The central and important form contained the main living and ceremonial areas and this could be expressed as a simple and a strong element. The wings could contain kitchen, stables and even farm buildings, allowing composition to be unified in three dimensions.

Newberry Hall was probably designed by Nathaniel Clements (1705–77). It was built in the 1760s, and the central block is very similar in design to Colganstown, County Dublin. The house is built in red brick with stone surrounds to the windows on the front façade, which features a large Diocletian window. This was a Palladian motif and was derived from the public baths of Ancient Rome. The doorway is also characteristic of the period, being a Venetian type with sidelights flanking the actual door. The curtain walls connecting the wings contain round windows known as bull's-eye windows and the wings themselves have half-octagonal bays that are unusual in Ireland.

Sean Rothery, 1991

RAILWAY STATION, CARLOW

The first railway line in Ireland opened in 1834 and ran from Dublin to Kingstown (Dún Laoghaire). Lines began to spread throughout the country, and while the main terminus for each line was generally a monumental piece of architecture, the architects for the little country stations indulged themselves in a variety of styles.

The railway station was a whole new building type, and the architects had to devise an assembly of buildings, each with a different function. A hierarchy was usually established, with the main station buildings on one side of the track and a minor shelter on the other. A unity was achieved with both sides being connected by a footbridge, often an elegant exercise in cast-iron trusses and railings. Further additions might include cut-stone and rugged engine sheds, high water towers and signal boxes.

The railway station at Carlow was intended as the terminus of the Dublin to Carlow line and was completed in 1845. The architect was Sir John MacNeill and the building is the largest and finest of his stations. He used the style of the 17th century with many high pointed gables, sharp finials and tall chimneys.

The steam engine illustrated is Engine No. 461 and is a 2-6-0 heavy goods engine, used for the Wexford to Dublin Goods Service and restored today.

Sean Rothery, 1992

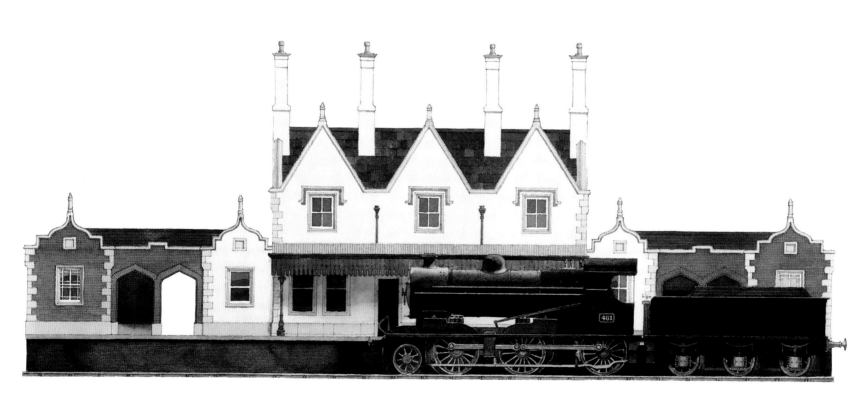

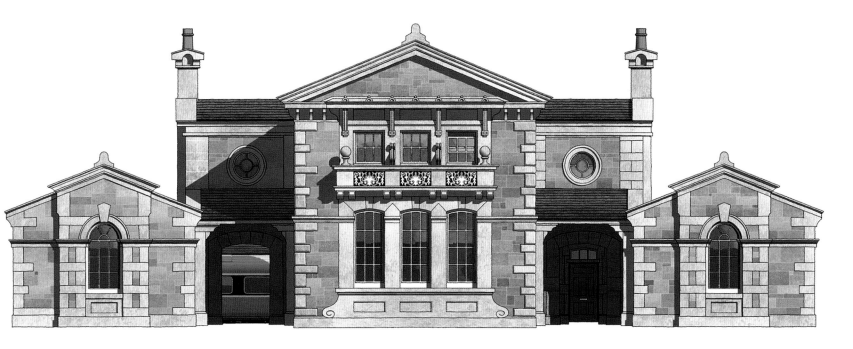

RAILWAY STATION, BAGENALSTOWN (MUINE BHEAG), COUNTY CARLOW

When the railway age arrived in Ireland in the 19th cenury not everyone was enthusiastic about the new method of transport. Many people were nervous of the fire-spitting monsters hurtling through the countryside at the dizzying speed of thirty miles (approximately fifty kilometres) an hour.

The promoters of the new iron roads sought to reassure their potential customers with the design and construction of station buildings and associated facilities. They employed distinguished architects and built on a monumental scale. An example of this was Sir John Macneill's great train shed at Knightsbridge (now Heuston) and Sancton Wood's terminal building at the same location.

The Great Southern & Western Railway was incorporated in 1844, and a main line from Dublin to Cashel, with a branch to Carlow, was authorised.

Engineered by William McCormack and William Dargan,

Ireland's Brunel, the line reached Carlow by 4 August 1846. The Irish South Eastern Railway undertook the extension southwards from Carlow to Kilkenny, reaching Bagenalstown (Muine Bheag) on 24 July 1848.

Muine Bheag echoes, on a small scale, the Classical style and has preserved its original character. From 1858, when a branch line was opened in stages to Borris, Ballywilliam and Palace East with connections to Wexford via Macmine, Bagenalstown/Muine Bheag was a junction station, with extensive sidings, a turntable and a stable of locomotives. All that was to vanish from 1963 onwards with the final closing of the branch that never carried substantial traffic (passenger services had been withdrawn as early as 1931). Muine Bheag station now stands in isolation, approached by a wide thoroughfare that shows to best advantage the building's mellow granite and limestone façade.

Bernard Share, 2005

Magdalen Court, Kilkenny

In the 1980s the problem of building sensitively in old towns and cities became a real issue for architects. The problem of infill in historic towns and cities was a particularly critical one. Instead of housing people in huge horizontal or vertical blocks, many of identical design, a movement grew which went back to study the older typologies of urban houses. The individuality of the houses of the past, the use of interesting textures and traditional materials, the traditional arrangements of terraces, closes, squares and streets were rediscovered and adopted for the homes of the 1980s.

In Ireland there have been many highly successful new inner-city housing developments. The inner-city housing in Dublin, Cork and Limerick attempts to match the profiles and textures of the earlier 19th-century work but with modern standards of construction and facilities. The traditional materials and finishes of Irish towns were often adopted for any infill or new groups of houses to be inserted into established urban areas. The result has been to reinforce the characters of each town.

An excellent example of this work is award-winning Magdalen Court in the ancient city of Kilkenny. The architects were John Thompson and Partners, who were Highly Commended for their effort in the Royal Institute of Architects of Ireland Medal for Housing 1979–81. The design of the new homes in traditional style relates to the carefully restored piece of Kilkenny's old stone architecture.

Sean Rothery, 1989

Tholsel, Kilkenny

Elements of townscape can be appreciated for their colour, texture, and forms. We are intrigued by the turning and twisting of a narrow street, opening out into a brighter, wider space, as can be experienced in Wexford. The façade of a street charms with its rhythm of windows, balconies, parapets and shop fronts. We are fascinated by buildings reflected in water and the railings, walls and steps of the quayside, like those of Cork City. The characteristic Irish town buildings, such as courthouses, castles or churches, often add to the delight of a place and give each town a sense of place and history.

Kilkenny has all of these elements in abundance. The illustration here shows the Tholsel in High Street, which was built in 1761 as an Exchange and Town Hall.

Most of the tholsels and market houses of Ireland were arcaded and open on the ground floor and Kilkenny's Tholsel retains its open arcading. The Tholsel stands forward from the street façade, with its imposing clock tower, steep pitched roof, cut stone, quoins, columns and arches. It forms a dramatic punctuation of the street at the crown of the hill. The arches invite the pedestrian in, a device common throughout Europe, where streets in the past were conceived for people to use and not just as traffic arteries.

The shop fronts illustrated are among the best examples of this great Irish tradition. The use of strong colour, the high-class lettering and the sure touch of proportions, scale and craft are qualities to be appreciated and preserved.

Sean Rothery, 1976

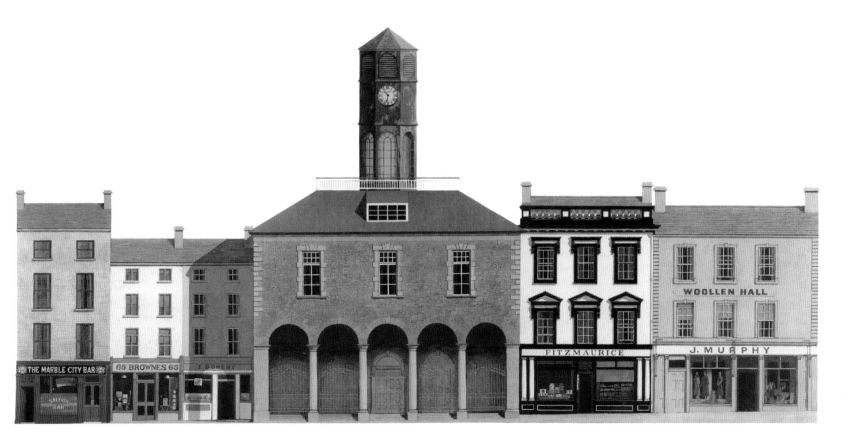

CASTLETOWN COX, COUNTY KILKENNY

Enquire in the village of Piltown as to the location of 'Castletown Cox' and you will be met with puzzlement; the place is known locally as just 'Castletown' or 'Castletown House'. The 'Cox' is used to distinguish it from its more famous namesake in County Kildare, and refers to Michael Cox, former Church of Ireland Bishop of Ossory and Archbishop of Cashel from 1755, who had the house built in the early 1770s.

Sir Richard Cox of Dunmanway, County Cork, who became Lord Chancellor of Ireland in 1703, had bought the Castletown estate from the Butler family, Earls of Ormonde. His fifth son, the archbishop, was a colourful figure. He laid out a racecourse within the demesne, and was very fond both of card-playing and of his food. On a blank tablet on his memorial intended for the customary encomium some wit has written: 'by this blank thy life is well expressed'. He had the vision, nevertheless, to commission a house which is now regarded as an outstanding example of its kind. There are many, according to the Knight of Glin, who consider it to be 'Ireland's most beautiful house'.

The architect, variously known as Daviso d'Arcourt or Davis Ducart, is a somewhat shadowy figure, apparently of Franco-Italian origin. He was also an engineer, and worked on the canal system in the north of the country. His first recorded commission in the south was the Custom House in

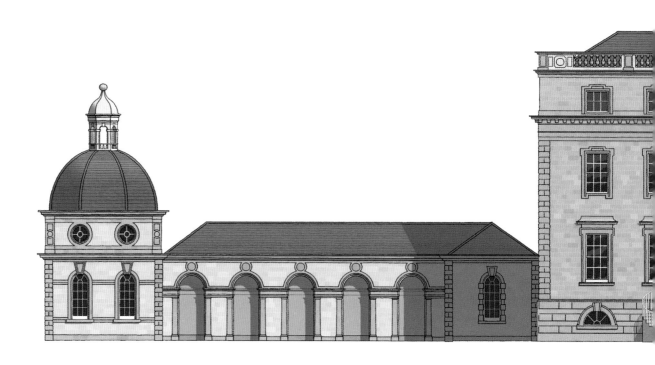

Limerick, where he also designed the stone-fronted houses on St John's Square.

The house he built for the archbishop, employing dressed sandstone and unpolished Kilkenny marble in the central block, has, in the view of the architectural historian Maurice Craig, 'a strong flavour of the Petit Trianon'. It was completed about 1774, as is confirmed by a surviving bill dated 19 August of that year presented by Patrick Osborne of Waterford, who was the craftsman responsible for the fine interior plasterwork.

Castletown Cox remained in the archbishop's family until the middle of the 19th century, when it was acquired by Lieutenant-Colonel William Villiers-Stuart, of the family seated at Dromana, County Waterford. In 1909, it passed to the Wyndham-Quins, who embellished the gardens with statuary, and on through a succession of private owners, all of whom were careful to preserve the fabric and integrity of the house even if most of the original contents were inevitably dispersed. Under the present ownership both house and gardens are being comprehensively and authentically restored by a team of highly skilled craftsmen and women.

Bernard Share, 2004

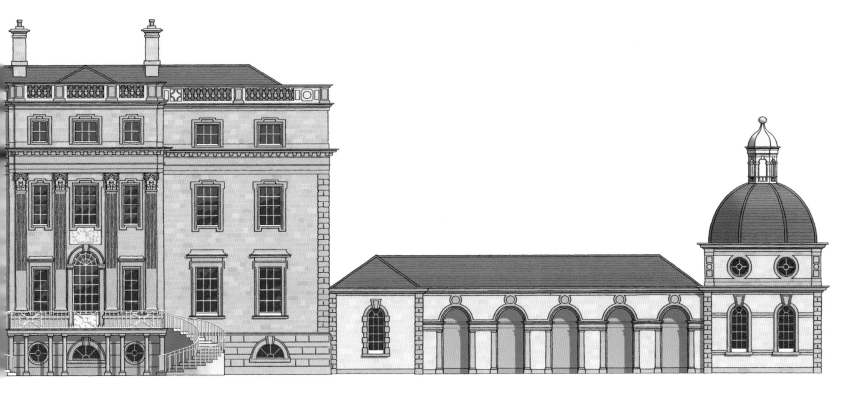

Ballyhack, County Wexford

Ballyhack sits near the mouth of the River Suir in County Wexford. On the opposite bank is Passage East in County Waterford. A ferry service has long linked the two.

The Suir estuary is depicted on the early maps as a way to navigate from the Irish Sea into the very heart of Ireland.

Norse seamen built the two seaport towns of Wexford and Waterford. In the 12th century Cistercian monks sailed up the Suir. Later in that century, the Normans arrived, turning Norse seaports, such as Waterford, into chartered boroughs.

In the Middle Ages Waterford merchants sent sons to Bordeaux to study the wine trade. Waterford and Wexford developed relations with North America, and a high percentage of Newfoundlanders speak with a southeast of Ireland accent. In the 19th century Waterford was an early builder of steamships. So many ships and seamen sailing past Ballyhack.

John de Courcy Ireland, 1995

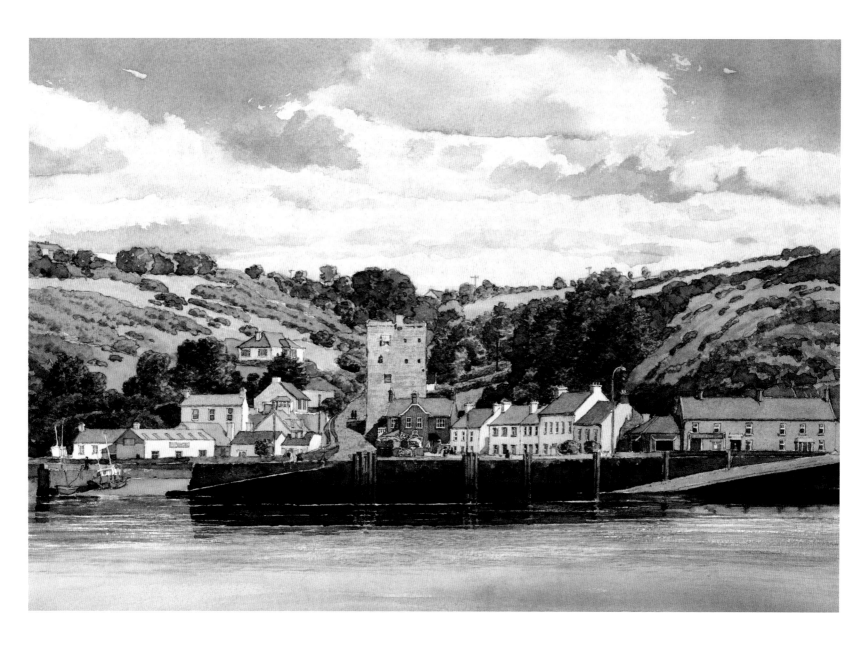

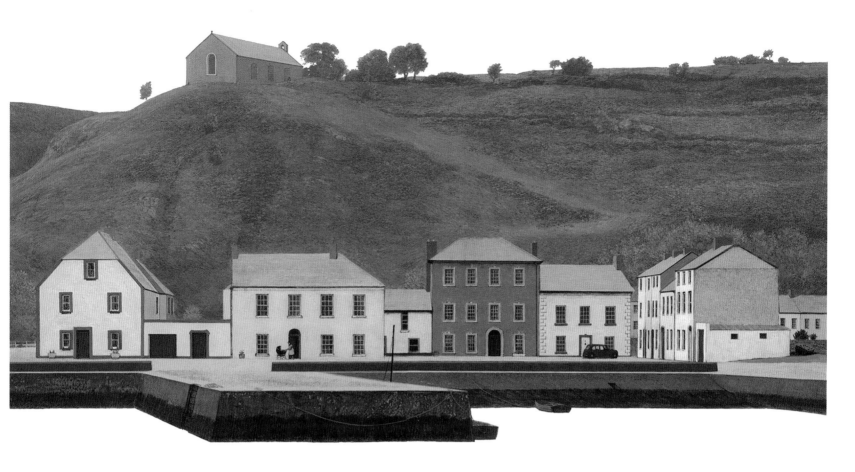

PASSAGE EAST, COUNTY WATERFORD

The tiny village of Passage East occupies an important position near the mouth of the River Suir and provides a port on the west side of Waterford Harbour. Strongbow landed here in 1170 with two hundred knights and a thousand soldiers. He was joined by Raymond le Gros with his army, and they stormed Waterford town. The next invader through Passage East was Henry II, who in 1171 brought a huge force of four thousand men and four hundred ships.

Irish villages can broadly be classified into two main types. The first is the planned village and these were mainly the product of the local large estate owner. The second category are various responses by their builders to the natural local environment. Villages were built where there was a suitable crossroads pass or waterway crossing or landing point, such as at Passage East.

Here, the little village provides a planned response to its position under the steep slope and at the water's edge providing a regular flat platform and an orderly arrangement of neatly scaled houses. The simple grammar of Irish town architecture is displayed in the rhythm of pitched roofs and the expertly placed fenestration. The human scale is achieved by the device of using simple classical proportions. The freshly painted houses and tidy streets of Passage East show that the village is appreciated and cared for by its inhabitants.

Sean Rothery, 1983

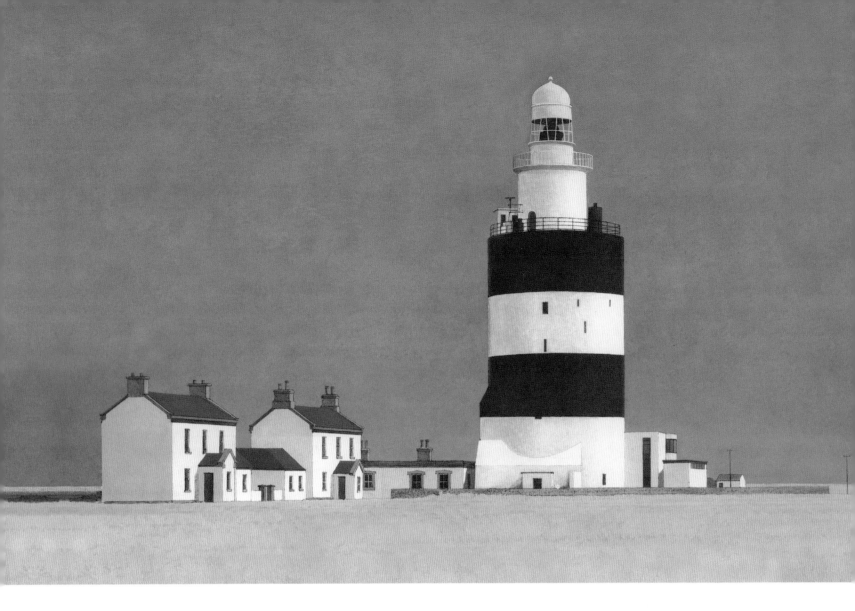

Hook Head Lighthouse, County Wexford

The Hook lighthouse signals the approach to Waterford harbour and the mouths of the Suir, Nore and Barrow rivers. The lighthouse is the oldest still in use around Ireland or Britain. The building of Hook Tower is attributed to William Marshal, Earl of Pembroke, in 1245. The earliest lighthouse had bonfires and open braziers showing a light at night and smoke by day.

The original tower at Hook was built as a defended lighthouse and is 12.20 metres in diameter and 31 metres high. In 1665 the entrepreneur Sir Robert Reading was given the job of erecting lighthouses in Ireland, maintaining the towers and keeping the lights operational. He is credited with repairing the old tower at Hook and probably added a lantern to enclose the coal fire. The glazed lantern was added in 1687 and the present turret was completed in 1863. Enclosed glazed lanterns were added to lighthouses, particularly those built on open headlands, to prevent the danger of scattering sparks and burning coals.

The Hook lighthouse had a large convex lens in the lantern in the late 18th century, but Augustin-Jean Fresnel revolutionised lighthouses optics by the introduction of his annular lens in 1822.

Sean Rothery, 1983

MOUNT CONGREVE, COUNTY WATERFORD

Mount Congreve House dates from the early 18th century. Today the beautiful gardens and demesne established there are its principle glory.

Eighteenth-century landscape architecture and gardening were mainly in the English landscape tradition, although characteristics of the beautiful Irish natural landscape were used in landscape design to give shape to the new demesnes.

In the 19th century garden designers looked to the exotic gardens of the Mediterranean and the sub-tropics.

The hundred-acre garden at Mount Congreve, the work of Ambrose Congreve, is one of the most ambitiously planted anywhere in the world. Great gardens like Mount Congreve are an important asset to Ireland's heritage.

Sean Rothery, 1983

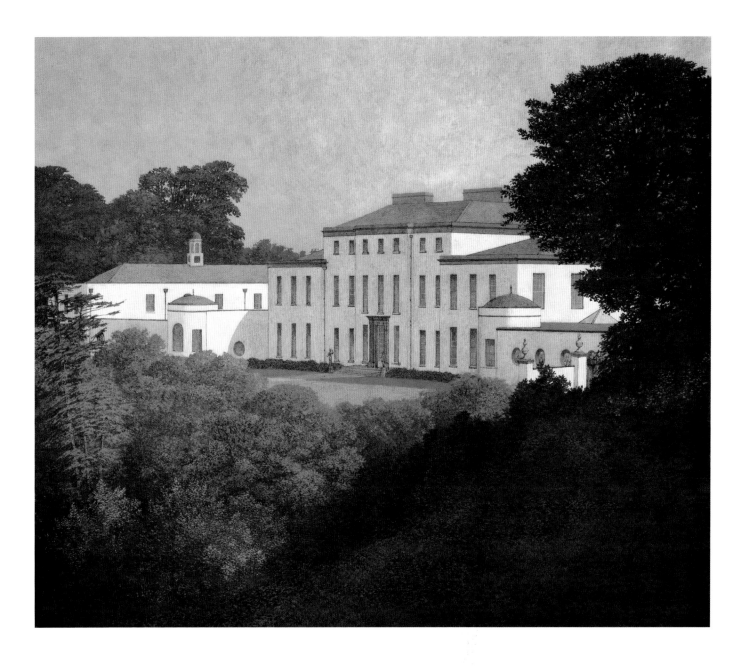

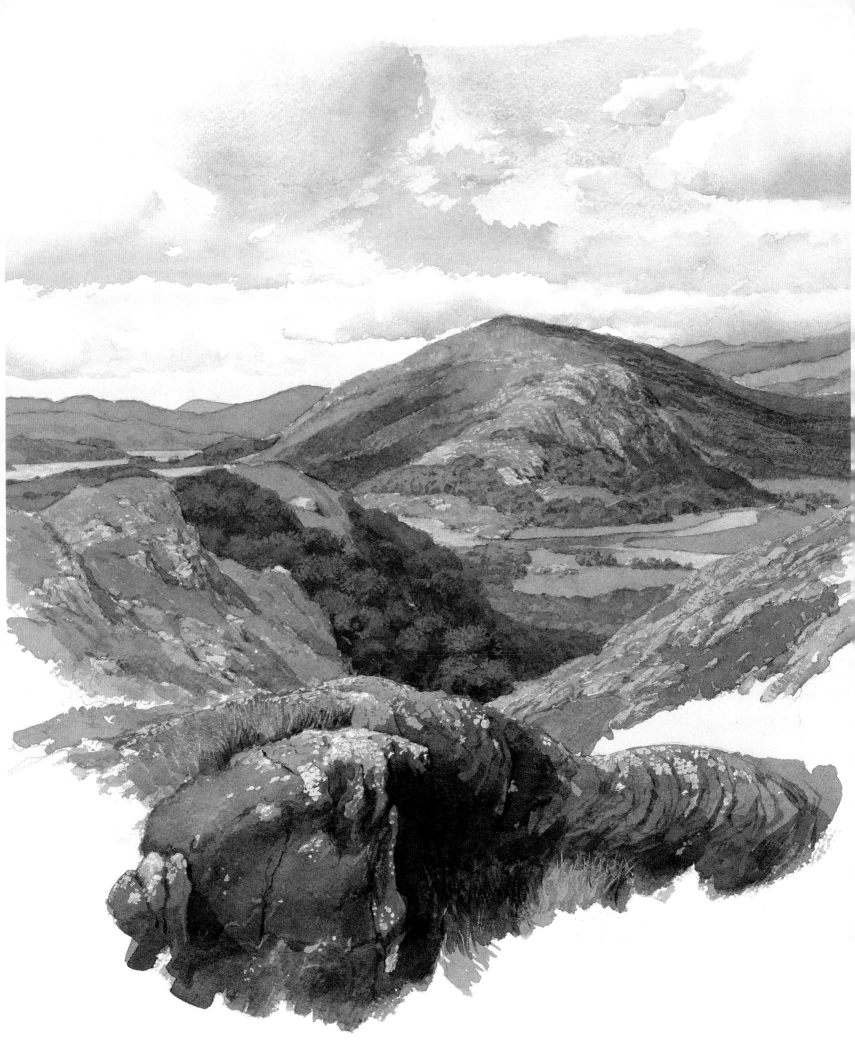

SOUTH AND SOUTHWEST

Old Red Sandstone, Eagle's Nest, Killarney, County Kerry.

SOUTH AND SOUTHWEST

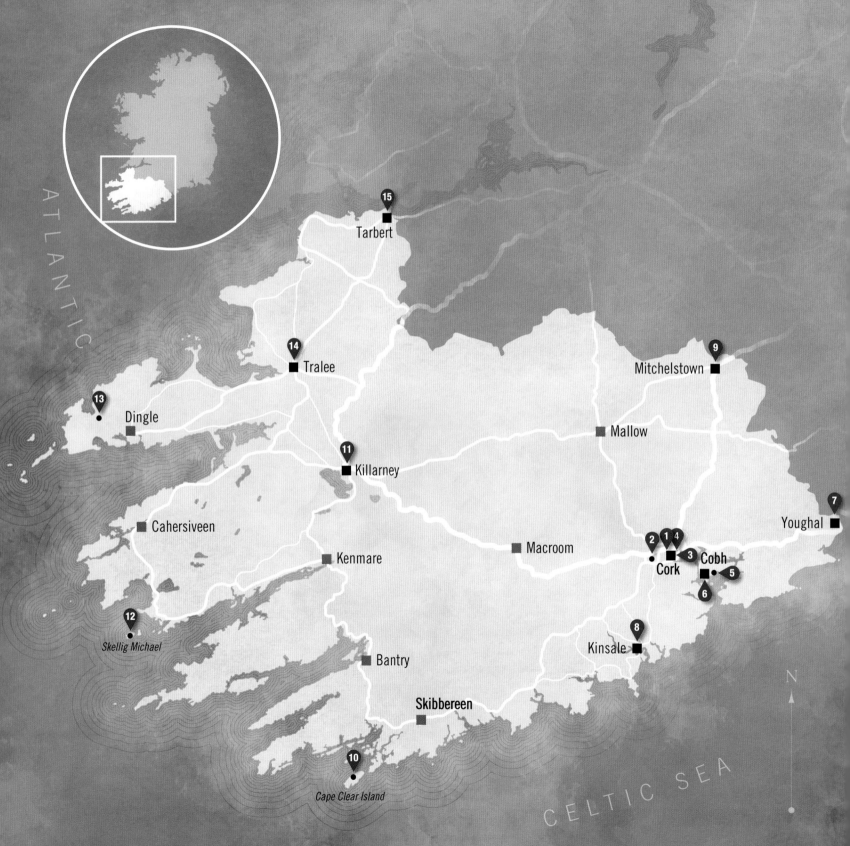

ATLANTIC

CELTIC SEA

N

15 Tarbert

14 Tralee

13 Dingle

Mitchelstown **9**

Mallow

11 Killarney

Youghal **7**

Cahersiveen

Macroom

2 **1** **4**
Cork **3** Cobh

5

6

Kenmare

12
Skellig Michael

Bantry

Kinsale **8**

Skibbereen

10
Cape Clear Island

SOUTH AND SOUTHWEST

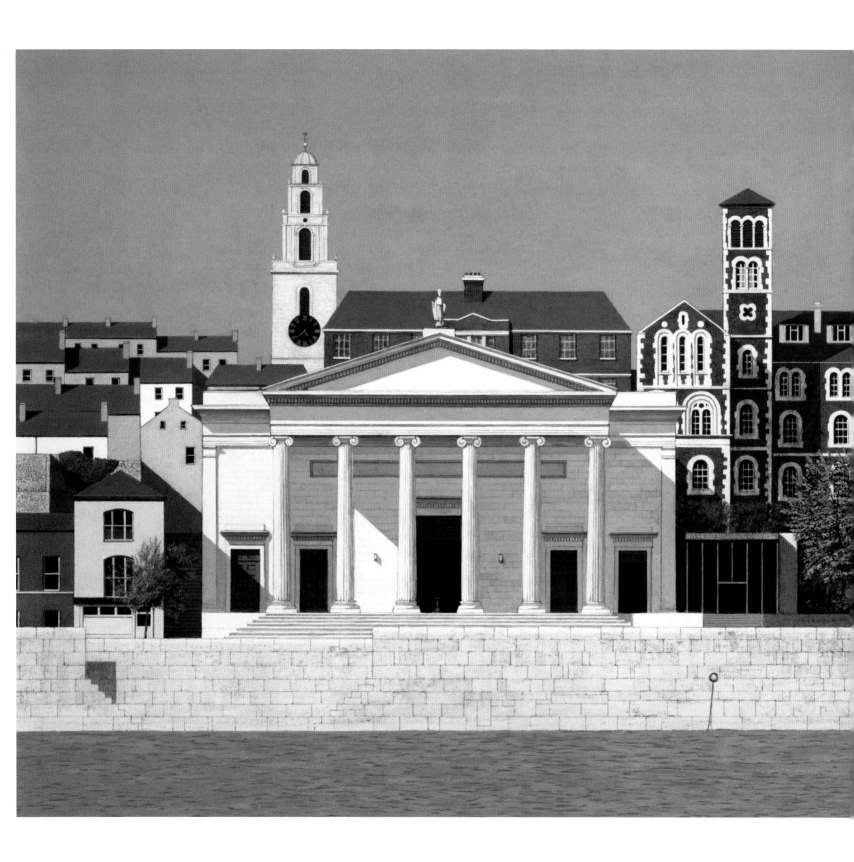

POPE'S QUAY AND SHANDON BELL TOWER, CORK

St Mary's Church on Pope's Quay was designed by Kearns Deane, a younger brother of Sir James Deane. It was commenced in 1832 and is a fine neo-classical revival style with six tall, fluted Ionic columns carrying a large and dominant pediment. The interior is particularly interesting with its elaborate and massively coffered ceilings. These were by local Cork plasterers, who carried out the work during a period when Italian plaster workers were usually employed for such large-scale works.

The priory behind the church is an unusual building. It is constructed in a rich red sandstone with dressed limestone facings to openings and quoins. The tower is Italianate and one of the gables is Dutch with a bull's-eye window.

St Anne's, Shandon, in the background, is one of the earliest buildings surviving in the city of Cork. It was probably designed by Coltsman and dates from about 1720. The tower sports a large black clock with gold letters while the crowning feature is a magnificent gold fish-shaped wind vane. Two sides of the tower are of limestone while the other two are of rough rubble sandstone. One theory for this is that the limestone faces the weather sides; another theory is that the sides face their own geological areas; but a contemporary theory is that the more expensive limestone faced the districts where the majority of the major church benefactors lived.

Sean Rothery, 1982

The Maltings, Cork

The 19th century left many Irish cities and towns with a legacy of large, sturdy and simple buildings: the mills, warehouses and grainstores of breweries, distilleries and other enterprises. Many of these buildings offer boundless opportunities for renovation and conversion into entirely new uses.

People can derive a sense of identity with their city or town by the feeling of continuity and relationship with local history given by the familiar buildings that surround them. Official conservation policies have often only recognised the idea of antiquity as having to do with scholarship or tourism – the museum concept. Real conservation can serve the people of the town in far more subtle ways – not least aesthetic – for instance, the humble deserted town warehouse can have a splendid proportion of simple windows set in

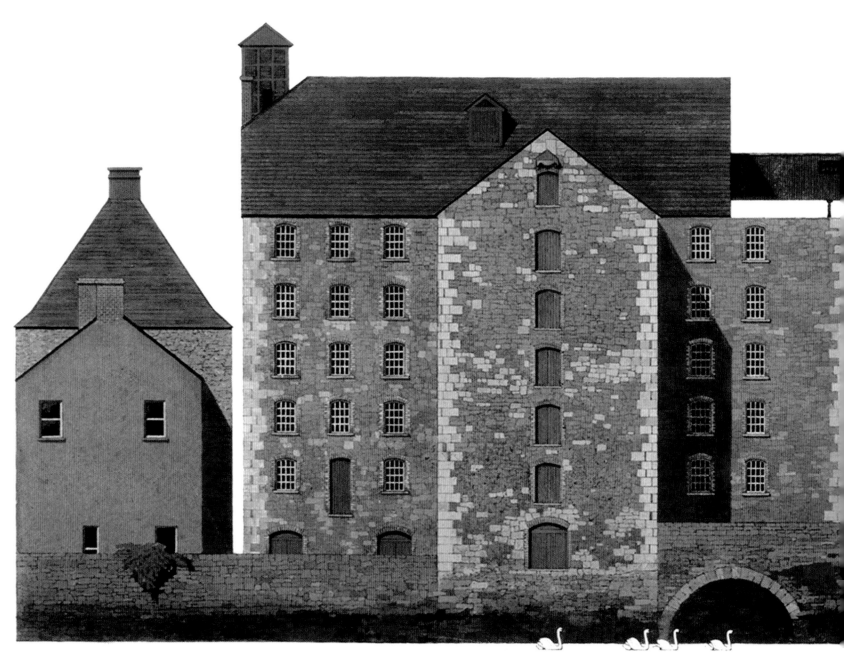

warm textured stonework and can give as much joy to a place as the ruins of a medieval church or castle.

The illustration here shows an example of one of the largest conversions of an old industrial building into a new use carried out in Ireland. The Lee Maltings in Cork was purchased in the late 1960s by University College, Cork from D Crawford, Brewers, and converted into laboratories and sports and recreation accommodation for the college. The architect for the conversion was Aidan McElhinney of EG Pettit and Co. and the builder was PJ Hegarty and Sons, Ltd.

The problem of the low floor-to-ceiling height of this typical maltings was solved by removal of alternate floors to provide high, better-lit laboratories. The lower levels contain a restaurant, showers and the locker rooms, while the kiln towers house the new sports accommodation. The exterior of the buildings with its mixture of white limestone and red sandstone remains untouched and continues to form a magnificent townscape feature.

Sean Rothery, 1976

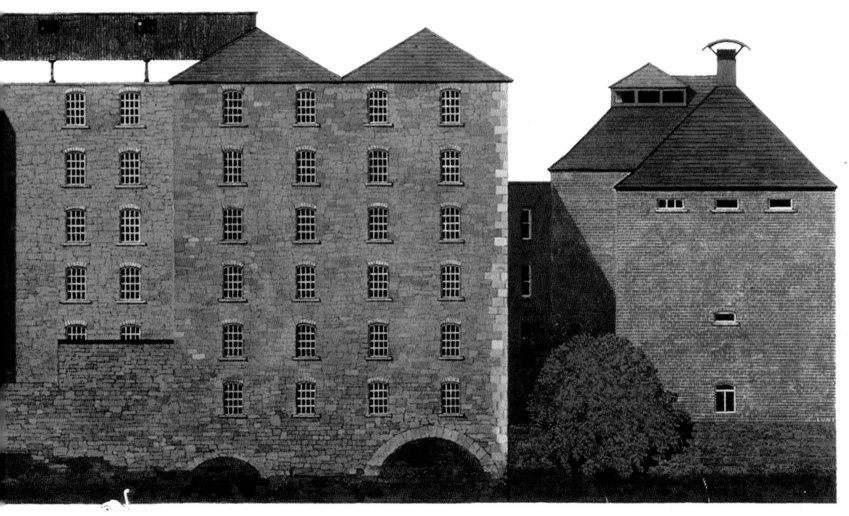

BUTTER MARKET EXCHANGE, CORK

A market for butter existed in Cork from the early 18th century and by the 19th century butter exports from Cork amounted to one-third of the total volume of butter exports from the whole country. In the 1850s the Committee of Merchants had developed a strict system of inspection of the produce. The casks that contained the butter were called firkins and over three thousand casks arrived each morning at the exchange during the height of the season.

The main building of the market was rebuilt in the early 19th century, while the heavy classical portico was built about 1850, and was used to inspect, weigh and brand the newly made casks. The exchange went on to house a craft centre from the 1980s. Current plans (2023) are in place to alter the use of the building to a technology and enterprise centre. The architects for the work were Boyd Barrett, Murphy O'Connor. The circular building, known as the firkin crane or the crane house on the early Ordnance Survey maps, has been completely restored and is the headquarters of the Dance Cork Firkin Crane organisation and dance hall.

Sean Rothery, 1985

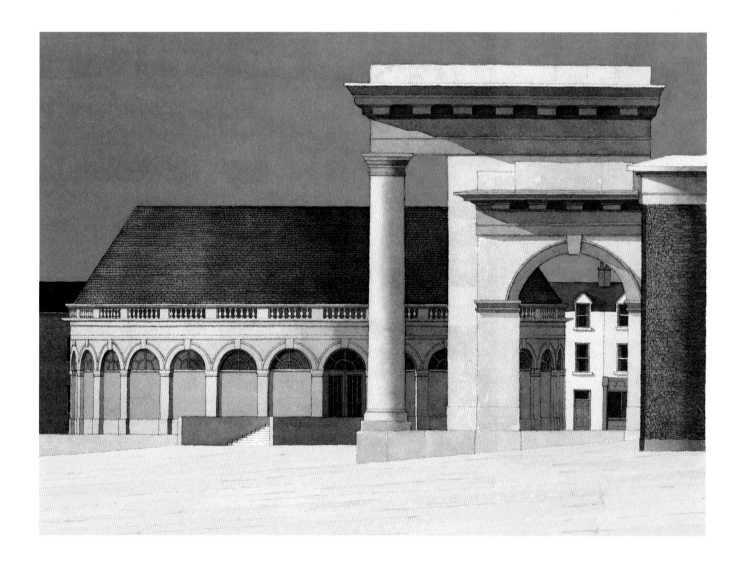

SKIDDY'S ALMSHOUSE, CORK

The almshouse was originally the house belonging to a monastery where hospitality and alms were dispensed. By the 18th century the almshouse was usually a foundation of a private charity to house the 'deserving' poor.

There are a number of almshouses in Ireland. One of the earliest is the little group at Kinsale which date from 1680. County Cork can also boast of another classically formal arrangement of almshouses at Mitchelstown which date from 1775.

The Skiddy's Almshouse in the city of Cork was built in 1718 and its plain feature and high pitched roof give the appearance of the earlier Renaissance period. It is a more urban design with two-storey living accommodation and an attic storey with very small dormer windows. The buildings were originally grouped around a small courtyard with round arched open arcades on two sides, while the third side was closed by the Greencoat school, the whole forming an architectural unit. The Greencoat school was demolished in recent years and by 1968 the Almshouse itself was threatened with demolition. A campaign by the Cork Preservation Society managed to save the building and it was completely restored, with the help of architect Frank Murphy, in 1975 and again in 2005.

Sean Rothery, 1982

QUAYSIDE SHOPS, COBH, COUNTY CORK

The medieval town was often dominated by a cathedral and particularly by the tall and elegant later Gothic buildings.

Catholic Emancipation in 1829 was followed by a spate of church building in Ireland, and the influence of the great Gothic revivalist architect Pugin was responsible for many of the impressive Gothic revival churches all over the country.

Cobh is certainly dominated by its cathedral with its immense spire. The architects were Edward Welby Pugin, a son of Augustus Welby Pugin, and George C Ashlin.

Cobh was formerly named Queenstown and its site on the south side of Great Island made it an important deep-sea port with a long and colourful naval history.

There are many interesting buildings, some with a definite maritime character. The terraces of houses with shops at street level rise up in tiers to the great arched retaining wall of the cathedral and conspire to complete the medieval impression in this largely mid-19th-century seaside town.

Sean Rothery, 1982

YACHT CLUB, COBH, COUNTY CORK

The Royal Cork Yacht Club was founded in 1720 and in 1854 their club building, by architect Anthony Salvin (1799–1881), was opened in Cobh. Salvin worked for John Nash in his early career and most of his work follows the Nash fashion for the Neo-Gothic.

For this particular maritime building, however, the architect chose the Italian Renaissance Revival style. Venetian architecture was popular, and in Ireland this style of round-headed windows and graceful rhythms became widespread.

In 1969, when the Royal Cork Yacht Club moved to Crosshaven, the clubhouse was abandoned. The building was saved when a dedicated group of enthusiasts, led by Peter Murray of the Crawford Gallery, began a massive restoration project, working with the architect Alexander White and expert local builders and craftsmen.

Sean Rothery, 1992

MAIN STREET, YOUGHAL, COUNTY CORK

This streetscape in Youghal, featuring a formal arrangement of shops with living quarters on the upper floors, is firmly of the 19th century. The town, however, is far older, having being founded in the 13th century by the Anglo-Normans. The long, narrow and sinuous Main Street is a trace of the town's medieval past and the splendid Clock Gate, once the town gaol, is an 18th-century replacement of the earlier gate in the town's walls.

One of the special architectural features of Irish streetscapes, and particularly of Youghal, is the variety and quality of the shop fronts. These were generally an integral element of the house-front façade, creating liveliness and colour at street level, while the more placid upper floors became a unifying force to the composition. The classical style was ingeniously adapted to produce a new building type: the shop front presented as a classical entablature, seemingly supported by pilasters which, in turn, framed the windows. The entablature consisted of a decorated cornice which protected the frieze below, the flat surface of which offered an ideal location for the nameboard. Elaborately carved consoles or brackets often closed the frieze and these are a real delight of Irish town streetscapes.

Specialist books on shop design appeared in the early 19th century and the influence of these can be seen in the splendid No. 17, which has been beautifully preserved, although no longer used as a shop. This symmetrical design is particularly refined and is strikingly similar to designs in earlier source books. The all-wood shop front is the most common traditional design, although plaster or stucco was also used as an alternative material. The local builder could imitate every type of classical detail in stucco, quickly and cheaply, and produce an entire shop front with an entablature and flanking pilasters and then match these, as here in Youghal, with upper-floor window hood mouldings and bracketed cornices. The wood shop fronts of Youghal were once its great glory; skilfully detailed wood shutters protected the glass windows at night, while delicate wood mullions, graceful arches and fanlights imposed classical proportions on the plate-glass windows. Many of these fronts were needlessly destroyed in a mistaken zeal for change. Their replacements were almost always inferior and devalued the whole streetscape. The original fronts are easy to maintain and worth preserving in order to retain the unique character of Youghal.

Sean Rothery, 2001

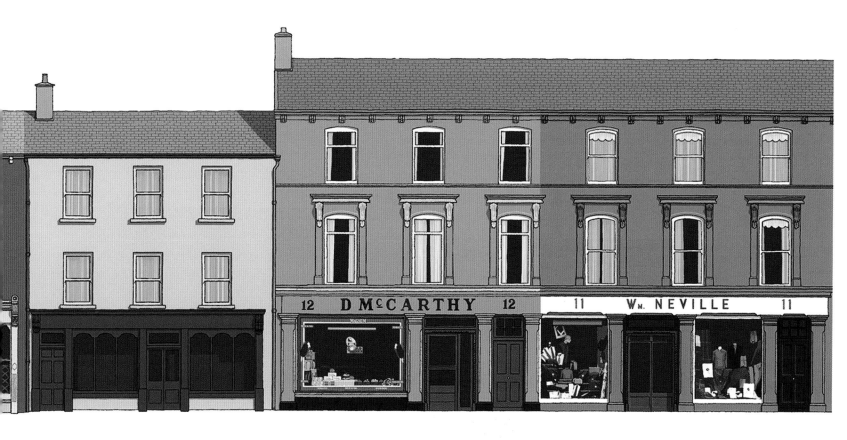

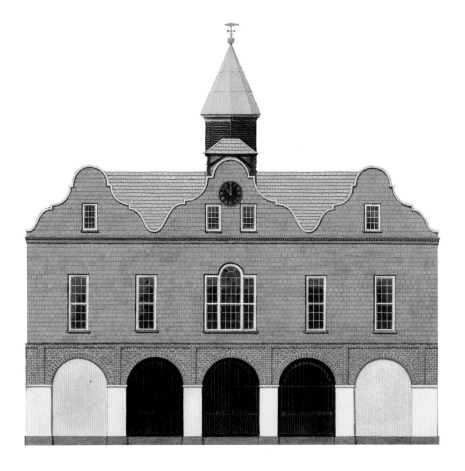

KINSALE COURTHOUSE, COUNTY CORK

In the small towns of Ireland the courthouse is a recognisable formal building, often found as the upper storey of an arcaded market house. In the planned estate towns of the 18th and 19th centuries the courthouse usually commanded a prominent position related to the town square or diamond.

Kinsale Courthouse (see above), dating from 1706, was fitted into an older informal streetscape. The three curved Dutch gables are unusual. The slate-hung façade is char-acteristic of coastal towns on the east of Ireland, where the slates formed a watertight barrier to the rain from the sea. The tall, narrow first-floor windows are typical of the early 18th century. The symmetrical façade is emphasised by the central Venetian window and the two small attic windows surmounted by a clock. The roof is crowned with an impressive bellcote, complete with a salmon-shaped weather vane.

Sean Rothery, 1984

Kingston Square, Mitchelstown, County Cork

In the 17th century the estate at Mitchelstown came into the possession of Sir John King of Boyle, County Roscommon, inherited from the former owners, the Earls of Kingston. In the late 18th and early 19th centuries, the King family set about a formal plan for Mitchelstown. The plans included a set of almshouses forming three sides of a spacious square known as Kingston College. These buildings, designed by John Morrison from Midleton, County Cork, were not an academic foundation but were built between 1771 and 1775 as 'an asylum for decayed Protestant gentlefolk'.

Formerly catering for the widows and other dependent relatives of Church of Ireland clergy, it is now administered by a trust and receives applications from prospective tenants irrespective of religious affiliation.

While externally the houses present a relatively unmodified 18th-century façade, the interiors have undergone substantial alteration. In 2001 a grant from the national heritage authority was applied to remedy the roof structure, but old buildings demand continuing expenditure to maintain the fabric.

Richard Morrison, the architect of Kingston College, is remembered as the father of Sir Richard Morrison, designer of the Grand Yard, Castle Coole and as author of the *Essay on the Convenience Strength and Beauty, which should be connected in all private and public Buildings.*

Kingston College demonstrates durability and elegance, epitomising its designer's principles.

Bernard Share, 2004

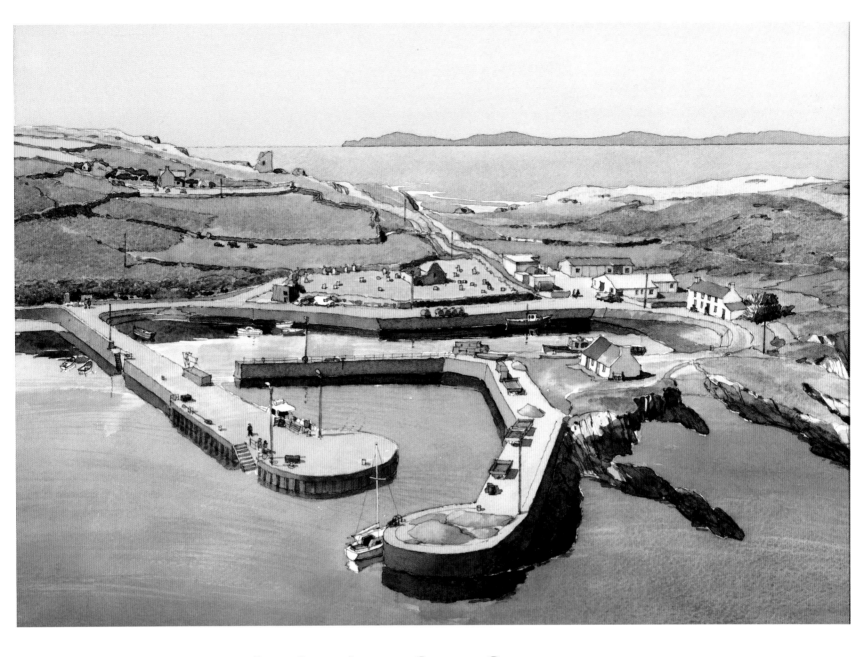

NORTH HARBOUR, CAPE CLEAR ISLAND, COUNTY CORK

Cape Clear is the southernmost portion of Irish soil. South and west of it is the broad Atlantic, northwest and northeast a rugged coast strewn with countless wrecks. To the southwest lies Ireland's final terminal point, the Fastnet, a rock without soil, where Ireland's most famous lighthouse looms.

Cape Clear Island, nearly three miles (almost five kilometres) long and one mile (one and a half kilometres) broad, boasts two small harbours. South Harbour, Ineer, is capable of sheltering only very small craft, but is often unsafe in gales. Picturesque North Harbour, Trawkieran, is more satisfactory, but also unsafe in heavy weather, save in its inner basin, which dries out. A post boat from Baltimore is a regular visitor.

For centuries Cape Clear was the Irish seamark best known to mariners, though many were vague about its whereabouts.

John de Courcy Ireland, 1995

St Mary's Cathedral, Killarney, County Kerry

To many Victorian architects the Gothic Revival was a great liberating force for designers schooled in the classical tradition. Instead of the symmetry of the classical façade, designers could rediscover the power of three-dimensional form and the wealth and variety of medieval sculptural detail.

Augustus Welby Pugin, one of the great architects of the Gothic Revival, wrote, 'There shall be no feature of a building which are not necessary for convenience, construction and propriety,' thus opening the way for the early functionalism which was to be the feature of the 20th century. Pugin is now considered to have done some of his best work in Ireland. His largest church is St Mary's Cathedral in Killarney, commenced in1843, and his other works in Ireland include St Aidan's, Enniscorthy, St Peter's Church at Summerhill, Wexford and the Gothic quadrangle at Maynooth College, County Kildare. Pugin had tremendous influence on the development of Catholic church design in Ireland and the later 19th century saw many fine Gothic Revival works from a variety of Irish architects.

Sean Rothery, 1975

Skellig Michael (Sceilg Mhichíl), County Kerry

Seven miles (eleven kilometres) west of Bolus Head in County Kerry and 700 hundred feet (213 metres) above the Atlantic is Skellig Michael (Sceilg Mhichíl) with its 8th-century monastic settlement. There are six beehive huts, two oratories and the remains of a tiny 12th-century church, all of dry stone. The huts are circular on the outside (to withstand the weather), but have square interiors. The site is enclosed and supported by dry-stone terraces. There are several ancient stairways to the settlement. Abandoned in the 12th or 13th century, the rock continued as a place of pilgrimage up to modern times.

Sean Rothery, 1984

GALLARUS ORATORY, DINGLE PENINSULA, COUNTY KERRY

The most perfectly preserved of the early stone-built oratories in Ireland is Gallarus, situated near Dingle. This up-turned boat-shaped structure is entirely constructed in stone – walls and roof – and is a direct development from the stone corbel tradition of Neolithic times.

Gallarus belongs to the Early Christian period of Irish architecture. Precise dating of the period is debatable but is generally taken as from the fifth to the eighth century. The architecture of the period can be described as primitive, a more or less straight development from prehistoric passage graves. The structural system of stone corbel was a simple and logical one given the availability of suitable local material. The actual craft of building as seen in Gallarus reached a very high order.

The structural problem posed by the building of Gallarus was that the sides and the gables all slope inwards, thus eliminating walls and making the roof the entire structure. The plan of Gallarus is rectangular and this has the potential to make the structure unstable. The skilled workmanship of building in small stones has preserved Gallarus from the fate of other similar oratories, such as the one at Kilmalkedar, which have all collapsed. The circular beehive cells built using the same corbelling technique tend to be more stable. The best known of these are the cells of Skellig Michael.

The doorway of Gallarus has a simple flat stone lintel and the only other architectural feature of this strange little building is a tiny round-headed window in the gable.

Sean Rothery, 1990

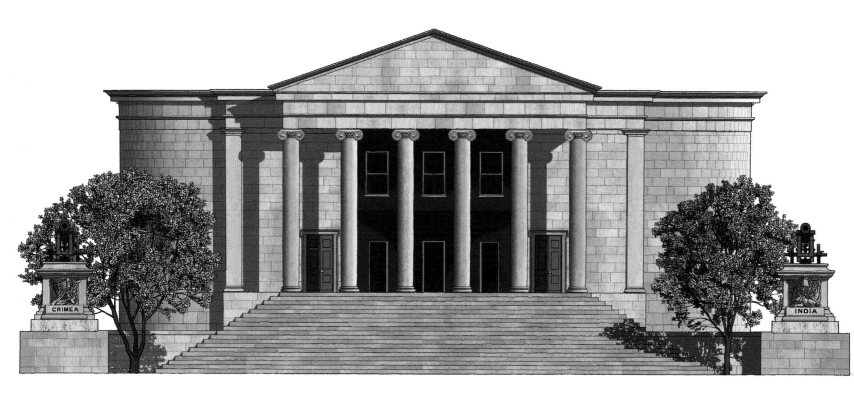

TRALEE COURTHOUSE, COUNTY KERRY

Architect William Vitruvuis Morrison, born 22 April 1794 in Clonmel, son of the distinguished architect Sir Richard Morrison, favoured Tudor and Greek revival styles, and it was the latter which influenced his 1830 design for the courthouse on Nelson Street (now Ashe Street), Tralee.

Constructed in limestone quarried from Castle Green, near Tralee, by the builders Messrs Deane and Notter, the courthouse was completed in 1835. The impressive, deep portice-fronted covered spaces were not integral with the interior, which featured two semi-circular courtrooms, each with theatre-like tiered seating and a gallery.

Unlike Morrison's other courthouse at Carlow, the Tralee building is not free-standing, its impressiveness somewhat inhibited by its position on a relatively narrow thoroughfare.

Among William Morrison's other designs were those for Glenarm Castle, County Antrim and Clontarf Castle, Dublin.

Following the Crimean War of 1854–6 and the Chinese conflict of 1858–60, monuments in the form of two captured Russian canon were erected in front of the Tralee courthouse to commemorate local men who had lost their lives serving with the British armed forces in the two campaigns.

By the middle of the 20th century Morrison's Courthouse, which in the course of its history had witnessed many notable trials including one involving Daniel O'Connell, had fallen victim to neglect and was closed in 1962. Debate as to whether to demolish or restore the building continued for the following twelve years, when the latter option was happily adopted. By then the decay of the interior had reached such a point that the building had to be entirely gutted, only the outer walls and stone features being retained by the architects, O'Sullivan Campbell, who rebuilt it without employing any structural timber. Tralee courthouse was reopened on 23 October 1981 by Dick Spring TD, then Minister of State at the Department of Justice.

Bernard Share, 2005

BRIDEWELL, TARBERT, COUNTY KERRY

Political and economic factors in 19th-century Ireland led to high levels of petty crime. Sentences were severe, e.g. for stealing one live hen and one dead hen, transportation to the penal colony of New South Wales.

The administration of the law was through a system of bridewells – small local prisons designed to house those charged with such offences pending their hearings, alongside convicted prisoners awaiting transfer to county gaols and those serving short sentences. The name derives from a London workhouse located near St Bridgid's or Bride's Well which from 1729 was used as a prison. In the early years of the 19th century, Irish prisons were grim, with no segregation of the sexes and no provision of food. Following a campaign by English Quaker reformer Elizabeth Fry a Prison Act of 1826 resulted in the closure of many of the worst of these institutions. In 1828, eight new bridewells, including

Tarbert, were built in County Kerry.

Each bridewell comprised cells for men and women, a courtroom, day rooms, exercise yards for the prisoners and apartments on the first floor for the Keeper and his family.

Tarbert bridewell was completed in 1831, by which time the growing village, with a population of 1,000, was enjoying a flourishing trade in agricultural produce with Limerick, maintained by the vessels of the Inland Steam Navigation Company. With the Famine and trade competition from the railway, Tarbert's population declined and the bridewell fell into disuse in the 1870s. In 1987, following a long period of neglect, a complete restoration began under architects Messrs O'Sullivan Campbell of Tralee. The restored structure, in its attractive setting on the Shannon, was opened as a visitors' amenity in 1993.

Sean Rothery, 2005

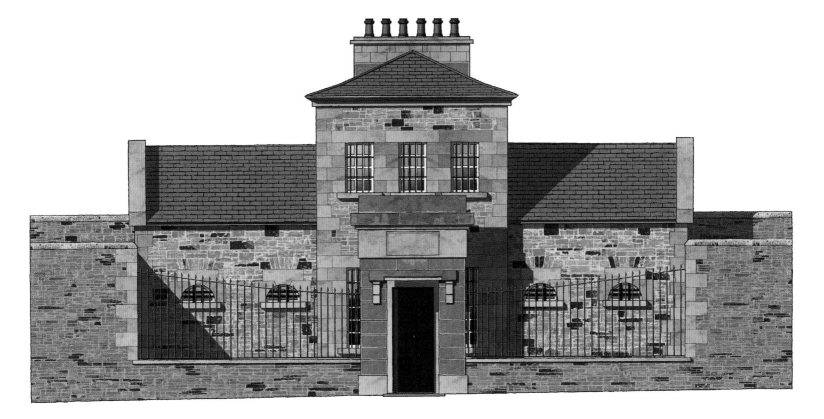

CENTRE AND MIDWEST

Burren limestone, County Clare.

CENTRE AND MIDWEST

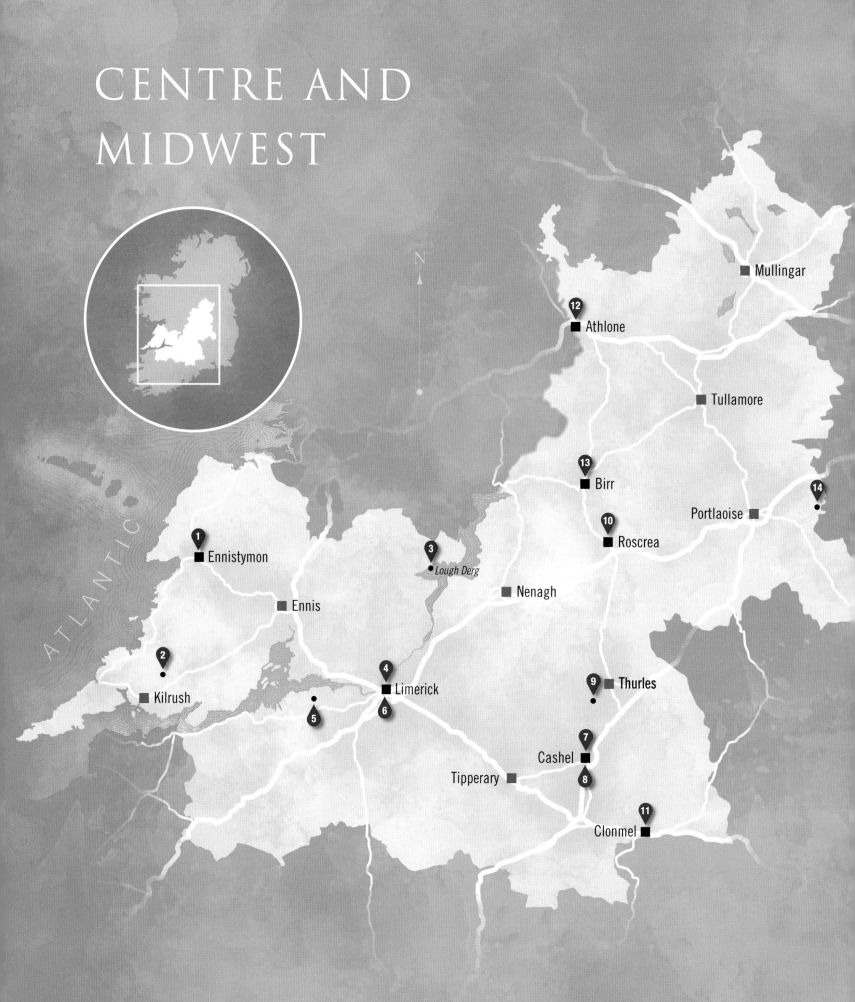

N

ATLANTIC

Mullingar

12 Athlone

Tullamore

13 Birr

Portlaoise

10 Roscrea

14

1 Ennistymon

Lough Derg

3

Nenagh

Ennis

2

Kilrush

4 Limerick

5

6

9 **Thurles**

7

Cashel

Tipperary

8

11 Clonmel

CENTRE AND MIDWEST

Shop Fronts, Ennistymon, County Clare

These buildings in Ennistymon exhibit all the characteristics of the Irish vernacular tradition in town architecture – a tradition which not alone showed an understanding of basic proportion and scale, but could effortlessly produce streets which were lively, colourful and exciting. An analysis of these simple buildings can show the qualities that they have and help us to produce better design when replacing buildings in a street or developing a growing town. The varying roof lines with the steep pitched roofs give an interesting skyline that integrates the town into the surrounding countryside.

The facias themselves are masterly in their very simplicity – a perfect balance of solid and void – window to wall. The shop windows are divided into small panes, a device which keeps the scale small and human and makes the content seem more interesting.

Traditionally, many shops had wooden shutters and wrought-iron screens for protection on Fair Day, and when these are painted they give a marvellous splash of colour to the town.

Sean Rothery, 1976

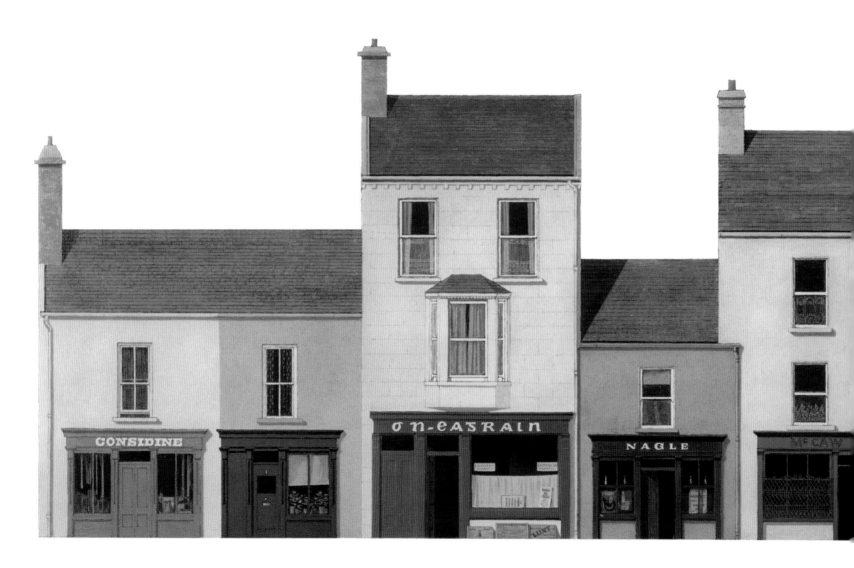

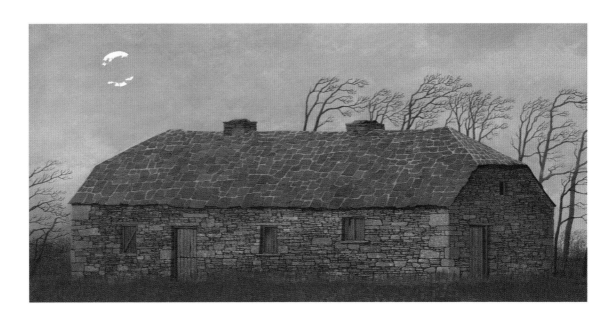

STONE-ROOFED COTTAGE, COUNTY CLARE

Traditional Irish country cottages made use of local materials. This house in County Clare is of mostly stone construction, with a roof of Namurian flagstones, split into thin slabs. The stone flags are irregular in size and roughly squared. The joints between the slabs are filled with lime mortar for weather proofing.

In other parts of southwest Clare there are examples of flagstone roofing where each tile is regular in size and laid in the slating tradition. There are also examples of very large flagstones being used for roofing. Stone roofing was chosen over thatch in areas exposed to great wind speeds. Thatched roofs in these areas are usually roped and weighted down with stones.

Sean Rothery, 1977

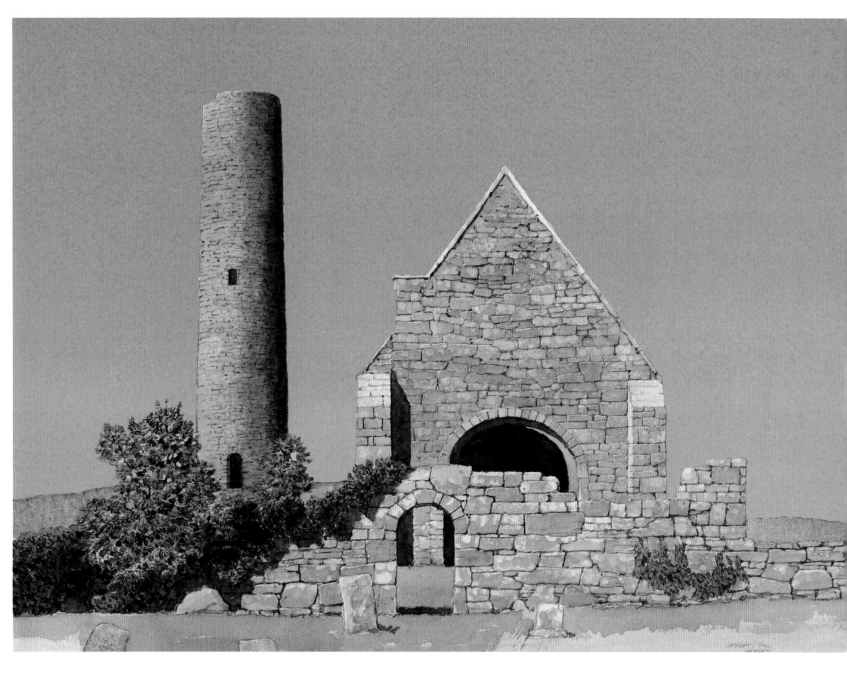

HOLY ISLAND (INIS CEALTRA), LOUGH DERG, COUNTY CLARE

Between the arrival of St Patrick and the Middle Ages, Ireland earned a name as the Island of Saints and Scholars. Monks sought out wild places, on mountains, isolated promontories and islands, where they could get nearer to God. One such place was Holy Island (Inis Cealtra) in Lough Derg.

A typical monastic community in the early Irish Church grew up when a hermit set up a cell in a remote place. When he died, he was normally buried beside his cell and a community grew at the site.

In later centuries round towers were added to preserve monastic treasures from pillagers such as Norsemen. Churches became larger, incorporating European architectural ideas, such as the Romanesque.

The saint of Holy Island was probably St MacCreiche the Anchorite from the 6th century.

There are fifteen centuries of human history in each stone of each building on this very magical island.

Dick Warner, 1997

THE GRANARY, LIMERICK

The earlier historical works on architecture rarely mentioned one large area of building which rapidly developed from the early 18th century onwards. Whereas ecclesiastical and public buildings – the cathedral, monastery or town hall – were neatly chronicled, little or no mention was made of the great stone warehouses, mills, granaries and factories which clustered in cities and towns. The architecture of these industrial buildings was often bare and simple, to the point of severity. It was probably this aspect of the older buildings that attracted the attention, in the early 20th century, of the apostles of a new modern architecture which would be free of historical styles.

The design of industrial buildings was simple for reasons of economy and also because an elaborate architecture was not considered appropriate for their function. These buildings, however, have a special kind of beauty since most are built of stone or brick or a combination of several kinds of stone, with brick used to form arches and openings.

The Granary in Limerick was built in 1787 by Philip John Roche, with local limestone, and the ground floor has impressive vaulting in brickwork. The Granary was used for storing grain, which was exported using nearby Charlotte's Quay. Later, the building was used as a bonded store, but by 1970 the store was becoming derelict.

In 1930 Shannon Development purchased the Granary and with Cooneen Ltd a restoration and redevelopment project was carried out. The Granary has now become an important focus for tourism and commerce in Limerick and houses the Trinity Rooms, the library and office space.

Sean Rothery, 1986

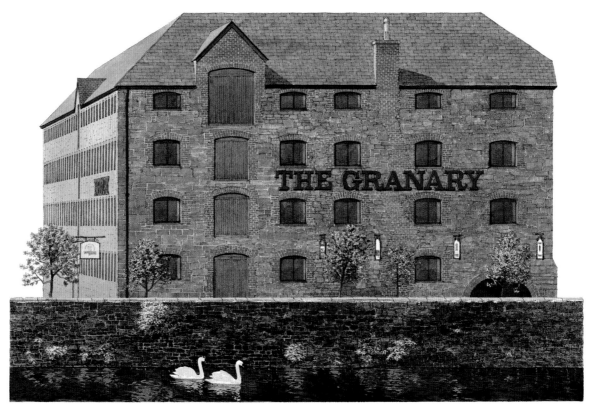

Shannon Grove, Pallaskenry, County Limerick

In September 1709 a large group of German Lutherans, fleeing religious persecution in the Rhine Palatinate, found refuge in County Limerick. These Palatines settled largely in Ballingrane, Kiliheen and Pallaskenry, and though many of them departed for America later in the century, they left a legacy not only of industrious husbandry and advanced farming methods but also of their distinctive surnames, such as Switzer and Guerin.

It was in the same year, and no great distance away on lands bordering the Shannon estuary, that John Bury commissioned the design and building of a substantial house. It is probable that Shannon Grove was the work of the mason John O'Brien. The front door bears the date 1709 and the rear 1723. The house exhibits the Dutch influence which at the time was still to be found both in towns such as Limerick as well as the countryside and, though by no means large by the standards of the day, possesses a strong presence.

The early years of the 18th century saw an increase in the use of brick, both native and imported, in house construction, and the impressive chimney-stacks of Shannon Grove are rendered in this material with, uniquely in Ireland, diaper-patterns of headers on their shafts. The flanking wings of the house were added by John Bury's son William in 1723, in the same year that he married Jane Moore, daughter of the first Lord Tullamore, and were probably the work of one of the Rothery family, many of whom were builders and craftsmen over a long period beginning with Nathaniel, a pewterer in Dublin in 1674, and extending to George, a mason there in 1756, but also including John, Isaac and James, who worked in Limerick and Clare earlier in the century. John Rothery, who died in 1736, was the architect of the celebrated Mount Ievers Court in County Clare.

John Bury died in 1722 and his monument in Adare church carries an inscription which suggests that the same member of the Rothery family was responsible for the additions to the house.

Bernard Share, 2004

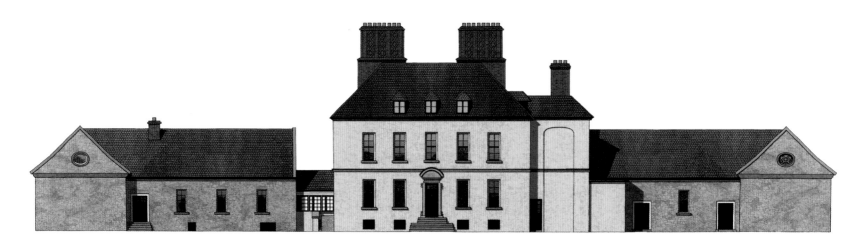

KING JOHN'S CASTLE, LIMERICK

When the first Norse pioneers reached Ireland's shores they sailed up the Shannon estuary until they met shallow rapids and could go no further. This settlement would become Limerick. It was a fording point of great strategic importance and, above the rapids, smaller craft could reach the rich midlands.

In the 12th century the Normans arrived on Irish soil. Recognising the strategic importance of Limerick, they built King John's Castle beside the river between 1200 and 1210.

The castle was a frontier fort. The Normans were more or less in control east of the Shannon, but to the west Gaelic Ireland was proving difficult to subdue.

With more peaceful times, Limerick prospered and grew. In the days before proper roads or railways, trade came in from the estuary or down the river. In the 18th century canals and improved river navigation led to commodites such as porter from St James's Gate in Dublin arriving by the barge-load. Limerick is still very much a river town, aware of the fact that it sits at the mouth of a great waterway, and dominated by the magnificient King John's Castle.

Dick Warner, 1997

ROCK OF CASHEL, COUNTY TIPPERARY

Buried in the embrace of the larger and much later cathedral on top of the Rock of Cashel is Cormac's Chapel, a fine example of early Irish Romanesque architecture, dating from 1127 to 1134.

The high pitched stone roof of the chapel had its predecessors in the ancient Irish stone corbels of Ireland's megalithic passage graves. Placing a high pitched stone roof over a simple rectangular church plan posed the problem of stability. In the chapel a stone barrel vault acts together with the roof to create a balanced triangle. The chancel of the chapel has a ribbed groin vault under its high pitched roof, which may be the first of these to be constructed in Ireland.

The Rock of Cashel with its austere interconnected forms looks as if it is carved from a single block of stone. The blind arcading and the simple carving of animal shapes and human heads have an almost barbaric look.

Sean Rothery, 1990

CASHEL PALACE HOTEL, COUNTY TIPPERARY

The 18th-century 'great house' provides one of the best challenges for conversion to new use. The high architectural character of the exterior of the building combined with the essential quality and integrity of the interior spaces makes changes to the original building difficult and potentially damaging. The conversion of the former palace of the Archbishops of Cashel into a modern hotel provides an example of a low-key and successful new use. The building was designed by Sir Edward Lovett Pearce, the architect of Parliament House, now the Bank of Ireland, in College Green, Dublin. The date of the work was 1730–32 and the client was Archbishop Theophilus Bolton.

The entrance front is Palladian in design, built of brick with stone facings, giving a dignity to the building when viewed from the main street of the town. The main entrance doorway is pigmented with banded columns and the end bays of the front elevation have Venetian windows. In true classical style the main entrance floor is raised and gives the impression of a building settled on a firm strong plinth. The front has a plain parapet with a high pitched roof containing another storey with dormer windows. The garden elevation is built in stone and the main reception rooms face out to the Rock of Cashel, providing a true 18th-century romantic view of splendid ruins.

Sean Rothery, 1985

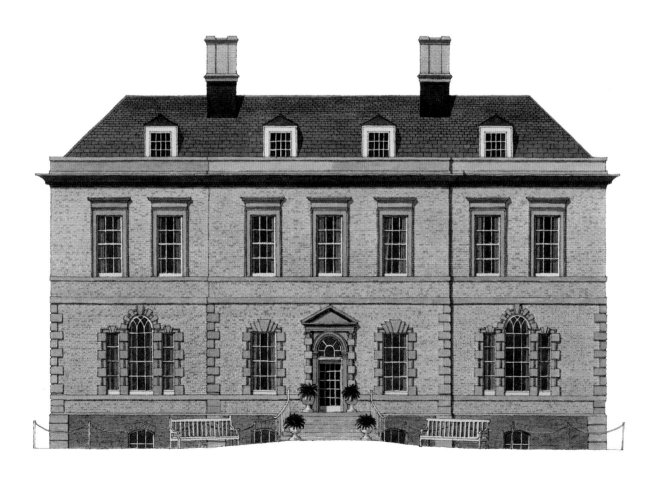

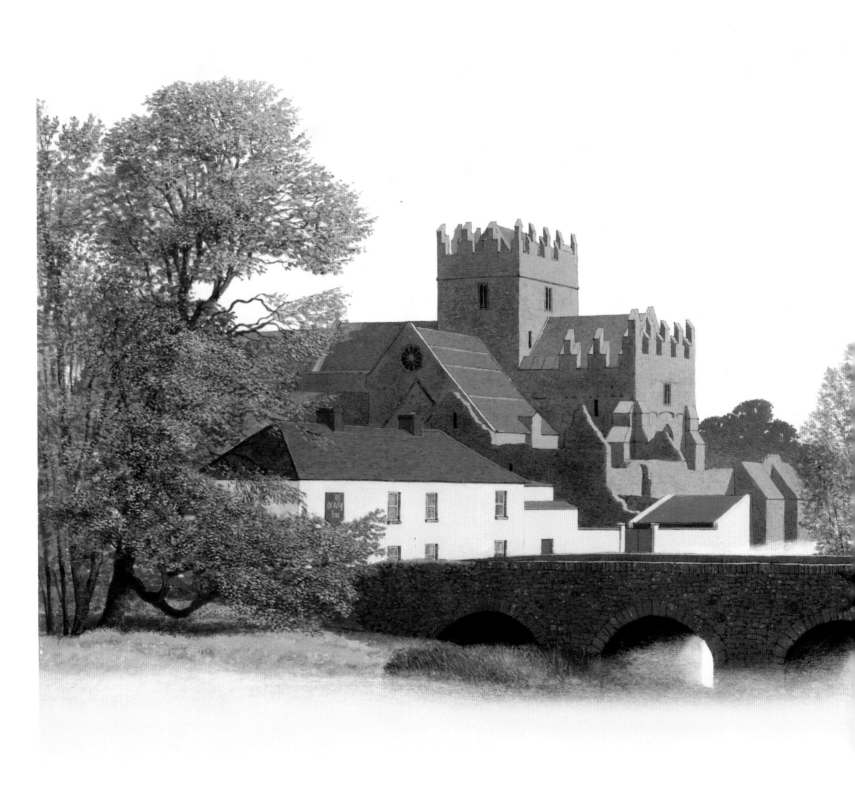

HOLY CROSS ABBEY, COUNTY TIPPERARY

The Cistercian abbey of Holy Cross was founded in 1182 by Domnall Mór Ua Briain, the King of Limerick. Most of the building dates from the 15th century when the great rebuilding of the abbey was carried out under the patronage of the Earls of Ormond.

Holy Cross was a famous place of pilgrimage and the alms of the pilgrims who came to this shrine of the True Cross enabled a great architectural project to be carried out. Unlike many English and Continental Gothic buildings, Holy Cross has a solid and low profile rising from the banks of the river, more like a defensive wall than a great church. The building contains a wealth of decorative detail and fine examples of the stonemason's craft. The interior of the church has intricate rib vaulting and delicate carvings of foliage which look as if they were intended for wood. In the north transept is one of the few surviving frescoes of Irish medieval times.

The original abbey was a complete settlement. The church was on one end of a cloister that was originally enclosed on all four sides. Now only the foundations of the refectory on the fourth side remain. The windows are particularly beautiful, showing various styles of medieval tracery and shapes. The abbey was suppressed in 1563, but the monks returned at various times during the 17th century. The church has now been totally restored with a new roof and upper works in new stone and is in use as a parish church.

Sean Rothery, 1983

ROSCREA CASTLE AND DAMER HOUSE, ROSCREA, COUNTY TIPPERARY

Roscrea has a number of buildings of historical and architectural note, including the early Round Tower, the 12th-century High Cross, the Romanesque doorway, the 13th-century castle with its 17th-century additions and the splendid early 18th-century house of Damer House.

Damer House was built, within the walls of the old Butler castle, by Joseph Damer, and the architect is unknown. The tall narrow doorway with its scrolled pediment has an early Queen Anne appearance as have the tall narrow windows.

Used as a barracks in the 19th century and then as County Council offices, by 1973 the house was in a ruinous condition and was saved from demolition by the Irish Georgian Society and the Old Roscrea Society. The building has been beautifully restored and serves as a heritage centre.

Roscrea Castle was originally constructed in the middle of the 13th century. The gate tower, which largely remains, may date from 1280 but the picturesque roof with chimneys and stepped gable is a 17th-century addition.

Sean Rothery, 1986

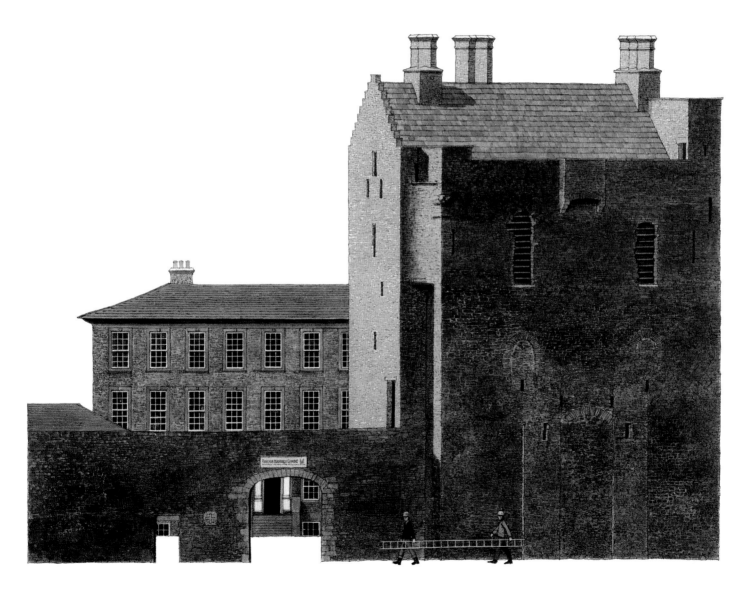

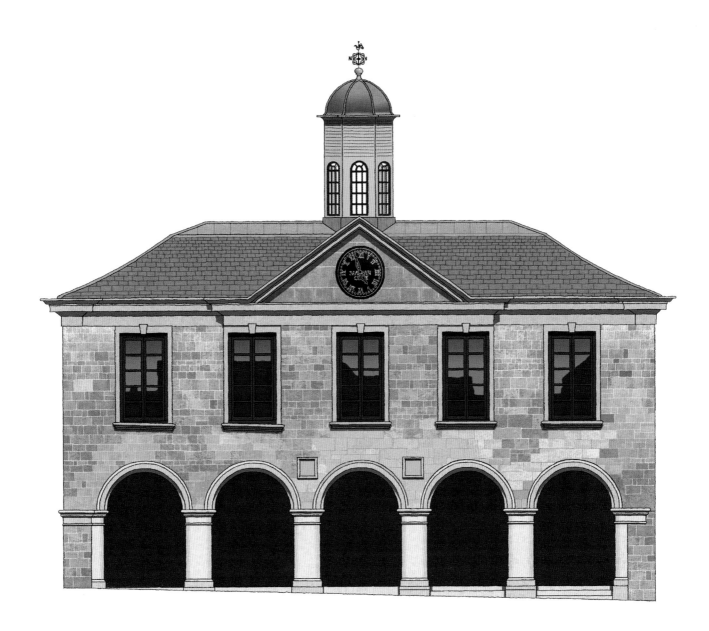

THE MAIN GUARD, CLONMEL, COUNTY TIPPERARY

In 1328 James Butler, Earl of Ormond, was granted a palatinate with its administrative centre in Clonmel.

Clonmel prospered as a trading centre and in 1608 became a free borough by royal charter. In 1650 the town withstood a three-week siege by Oliver Cromwell. In 1673 the first Duke of Ormonde (with an 'e') campaigned for a new courthouse to replace that destroyed during Cromwell's siege. The architect is unknown. The courthouse also served as a tholsel for the collection of tolls and other duties, and the Assize Courts were held there until the late 1790s, when they were transferred to a new building designed by Sir Richard Morrison. The ground floor of the old courthouse was converted to shops (later Thomas Cooney's pub) and three superior floors were added. By 1820 the building had become known as the Main Guard due to its use as a barracks.

In the 1980s the Main Guard fell into disrepair and restoration began in 1995. Clonmel-born architect Margaret Quinlan received a Royal Institute of Architects of Ireland Award for the restoration, turning the building into an attractive exhibition and event space.

Bernard Share, 2005

THE SHANNON WEIR, ATHLONE, COUNTY WESTMEATH

There are surprisingly few weirs along the Shannon. This is because it's an undrained river – which means it has a tendency to overflow its banks in winter. A tendency which discourages town planners. Athlone is an exception. Originally the river here was fast and shallow and never went into serious flood. It was also a ford: *áth Luain,* Luain's ford. And, like all the fords on the great waterway, it had considerable strategic importance.

The Vikings were here and the Normans, and in Elizabethan times it was the seat of the English provincial boundary. By the 1750s, when history had become a little calmer, a canal and lock were built to allow boats up and down.

In the 1840s the authorities decided to replace the old lateral canal. They built a new bridge and lock, both still operational, and the impressive weir. The lock and bridge were constructed using coffer dams, but when it came to the weir the engineers came up with a more ambitious idea. They dammed the entire River Shannon at a spot near the present railway bridge and turned its waters down the line of the old canal. The dam held for two months, just long enough to finish the construction of the weir. In the context of the time, this must rank as one of the greatest achievements in Irish civil engineering.

The engineers had to worry about the passage of other things apart from boats: fish, for example. Every summer thousands of salmon passed upstream through Athlone, and every winter thousands of eels went downstream. By the end of the last century rivers like the Rhine, the Thames and the Seine were already losing their fish to pollution. It is believed that the Shannon then carried the largest spawning run of Atlantic salmon in the world – an honour it held until the hydro-electric barrage at Ardnacrusha was built in the late 1920s. These fish runs had been economically important from the very earliest times. A few salmon still run the river as far as Athlone today, and the eel fisheries, which are run by the ESB, are remarkably lucrative. There remains a fish pass in the centre of the weir.

Dick Warner, 1997

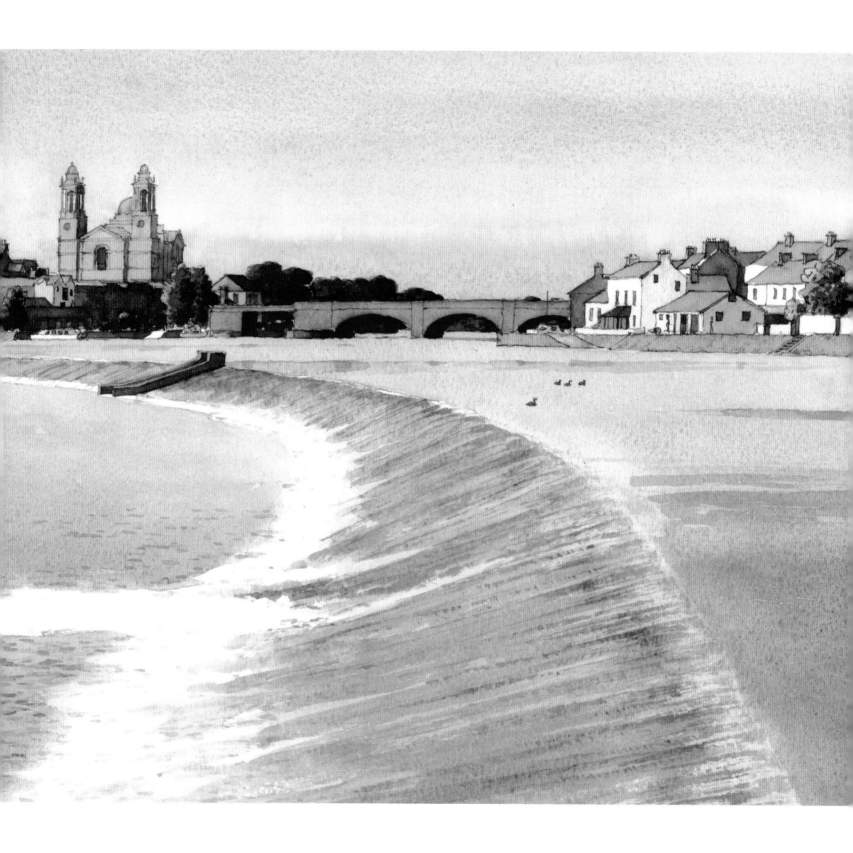

OXMANTOWN MALL, BIRR, COUNTY OFFALY

In the 17th century Birr Castle was the seat of the Earl of Rosse. In the late 18th and into the early 19th centuries the town of Birr was laid out under the earl's influence. Earlier villages and towns of Ireland were changed by the initiatives of landowners during this period. The former essentially random settlements were replaced by new planned developments. A formal layout of malls, squares and diamonds established a strong discipline to the design of the village or town.

In Birr the Oxmantown Mall has terraces of town houses where the tall three-storey blocks are complemented by the smaller two-storeyed units, forming a composition of Palladian symmetry. A restrained version of the classical style was favoured in the building of the town house. The façades were simple and unadorned and proportion was the ordering influence. A feminine frivolity was allowed for the doorways, where delicate fanlights, slim flanking classical columns and round and segmental arches softened the severity of the geometry. The three-storey terrace, as befits its importance, is faced with stone. The rendered frontages of the smaller houses reflect the general practice for the modest houses throughout Ireland during this period. Rough rubble stone was used for the structural walls, which were then finished with a coating of stucco, thus providing a flexible weatherproofing. The stucco could then be exploited creatively by being painted, mostly in white lime washes but sometimes, and increasingly in the 19th century, in brilliant colours. The practice of stripping off the old rendered finishes to expose the original stone needs to be approached with caution. The original stone may not be weatherproof and the resulting need to repoint the joints can result in a confusing pattern, negating the calm classical proportions. The rendered and painted finishes to the streetscapes of Irish towns today are an essential feature of their architecture and they complement the cut-stone façades of the important edifices, such as church, courthouse and bank.

Birr Castle is famous for its gardens and the extraordinary astronomical telescope built in the 1840s.

Sean Rothery, 2001

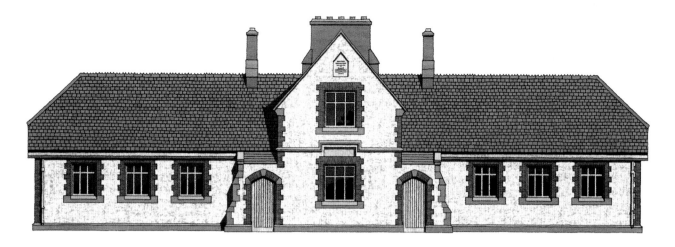

VICARSTOWN SCHOOL, COUNTY LAOIS

The Barrow branch of the Grand Canal, from Lowtown to Athy, passes over the Grattan aqueduct on its way to the little village of Vicarstown. In 1782, Henry Grattan, statesman and would-be political reformer, bought the estate of Moyanna, where he built a shooting lodge and a summer residence.

Henry Grattan (1746–1820) died in London a disappointed man. His 'Grattan's Parliament' never became truly representative of the people, confined as it was to the Protestant and landowning class, and his advocacy of the cause of Catholic emancipation in the British House of Commons also failed. He found solace and repose in his Moyanna estate. His granddaughter Pauline Grattan-Bellew inherited the estate. She was responsible for the construction of a school in 1868, to the design of Charles Geoghegan (1820–1908), on the outskirts of the village of Vicarstown for the children of her tenants.

The teachers occupied the central block, a physical and moral bulwark between the boys and one side and the girls on the other. This central block dominates the design, facilitating the two separate entrances to the twin classrooms. The door and window dressings are in red brick, contrasting with the plastered walls, with stone employed for the Gothic buttresses. Though no young voices echo here now, this graceful building is still in use as a social centre and remains evocative of a responsible and an enlightened landlord.

Bernard Share, 2004

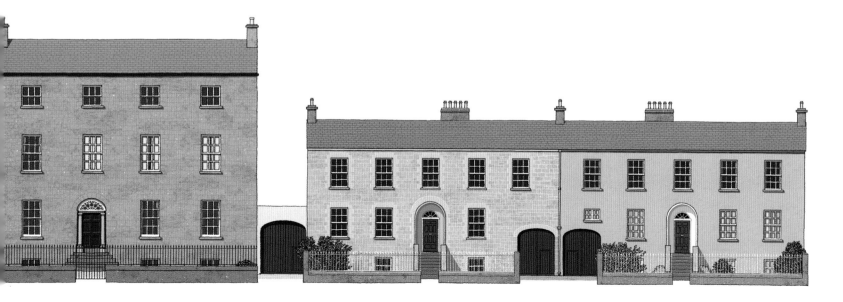

WEST AND NORTHWEST

Quartzite boulder, Errigal Mountain, County Donegal.

WEST AND NORTHWEST

ATLANTIC

N

18

19

Letterkenny

Killybegs

Donegal

Ballyshannon

16

14 15

Enniskillen

Sligo

Ballina

Charlestown

Boyle

13

Carrick-on-Shannon

11

Castlebar

9

Westport

Claremorris

10

12

8

Roscommon

7

Tuam

6

Roundstone

4

Athlone

Ballinasloe

5

3

Galway

2

Loughrea

1

WEST AND NORTHWEST

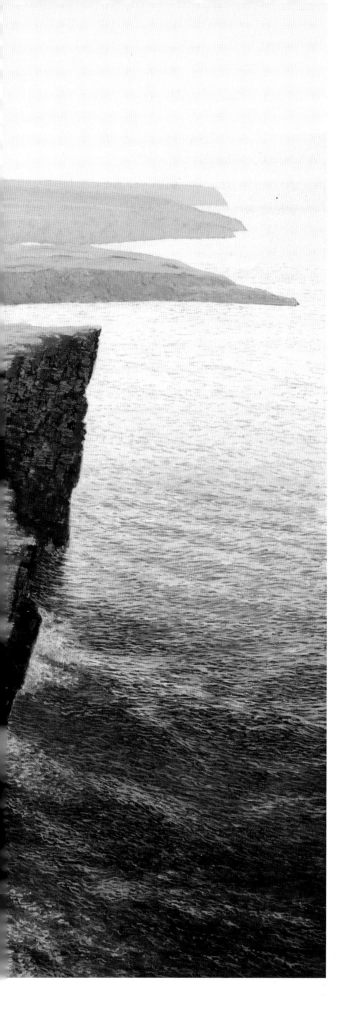

DÚN AONGHASA (DUN AENGUS), INIS MÓR (INISHMORE), ARAN ISLANDS

The stone fort of Dun Aengus on Inishmore, Aran Islands, is one of the great monuments of Europe. Its situation alone, using the nearly 300-foot (91.5 metre) high vertical cliff rising from the stormy Atlantic as its rear defence, would make it remarkable. Early forts in Ireland often used natural features as one line of defence; inland forts used cliffs or ravines, coastal forts were situated on tiny islands or used a headland with a narrow isthmus as the approach. Later developments of stone castles throughout Europe continued to site buildings where the natural topography would aid the defensive strategy.

Experts find it difficult to date Dun Aengus accurately. It probably dates from the Iron Age, which is usually accepted as lasting from about 500 BC until the early Christian period. Forts and habitation sites of all kinds in Ireland had varied and lengthy periods of occupation. The fort covers an area of eleven acres (almost 4.5 hectares) and has three rows of enclosed defences all built of massive walls of drystone masonry. A remarkable feature, one that was to feature for centuries in the language of military architecture, was the chevaux-de-frise. This is the surrounding band of jagged stones placed vertically in the ground to deter and slow down attackers.

Sean Rothery, 1984

DUNGUAIRE CASTLE, KINVARA, COUNTY GALWAY

There is a centuries-old tradition of conversion of castles since the main function of a castle, that of defence against siege, was destroyed by the invention of artillery. Irish castles, with the exception of a few great castles like Carrickfergus and Trim, were a good deal smaller than their counterparts in England and Wales. The castle at Kinvara is little more than a tower-house surrounded by a defensive wall. Built in the 16th century, this was the O'Hynes castle. The building is constructed on a rocky knoll with the tidal bay being used as a partial defence. An original fort (*dún*) on the site was built by the 6th-century king Guaire Aidhneach of Connacht.

In the 18th and 19th centuries the castle was owned by the Martyn Family of Tullira, County Galway. The most well known member of this family was Edward Martyn (1859–1923), poet and playwright and contemporary of WB Yeats. In recent years the castle was purchased by Lady Ampthill and extensively restored by architect Donal O'Neill Flanagan. The large rooms in the main tower, with their original stone fireplaces, have been converted as the principal drawing room and dining room. Shannon Heritage presents medieval banquets in this castle as well as at Bunratty and Knappogue.

Sean Rothery, 1985

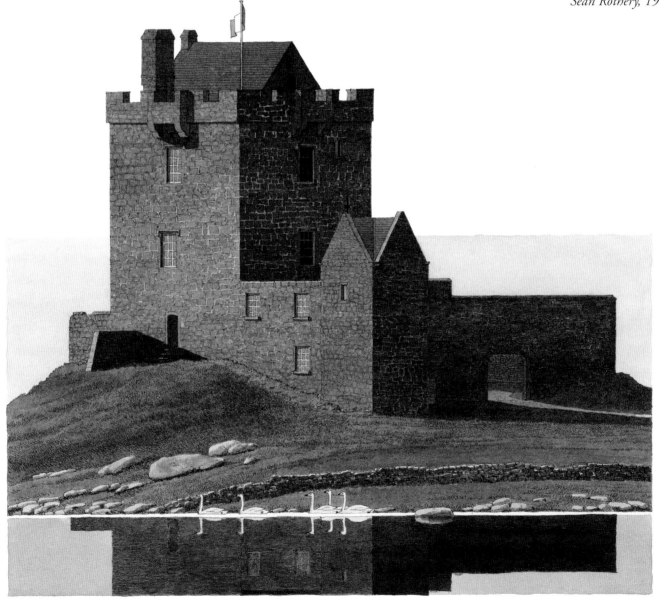

LYNCH'S CASTLE, GALWAY

Galway, which straddles the River Corrib, and Kilkenny, inland on the river Nore, are the two towns in Ireland which retain much of their medieval character. Small winding streets and alleys, paved with well-worn limestone, combine with Georgian openness to generate a unique urban atmosphere. Important limestone buildings in Galway include Lynch's Castle, an ornate fortified dwelling of a wealthy 16th-century merchant, and St Nicholas's Church, and in Kilkenny, Rothe House, the Tholsel and St Canice's Cathedral.

County Galway also produced Connemara marble which was the premier Irish decorative stone from the 18th to the early 19th centuries. It is the only true marble, in a geological sense – that is, an altered or metamorphosed limestone – to be commercially extracted at one time or another in Ireland. This marble was formed when great heat and pressure was applied to the region over 500 million years ago. The resulting attractive streaked green and white stone contains serpentine and chlorite which contribute the green coloration. The stone was worked at a number of regions in Connemara: Barnanoraun and Ballinahinch supplied pale sepia varieties, while Clifden yielded darker stone. In the 1970s quarrying was recommenced and stone extracted and worked into polished slabs for internal cladding and flooring. Unfortunately, such enterprise did not last. Today the marble is extracted at Streamstown in small quantities only and is used to produce tourist souvenirs and worry stones.

Patrick Wyse Jackson, 1998

BALLINASLOE RAILWAY STATION, SHOPS AND HOUSES, COUNTY GALWAY

The railway buildings of the mid-19th century in Ireland are fine pieces of small-scale architecture. The architects and engineers of the different railway companies vied with each other to create architecturally perfect complexes of buildings at each station.

The group of buildings at Ballinasloe consist of the station building on one side of the line with a large shed, signal box and a tiny elegant platform shelter on the other side.

The railway came to Ballinasloe about 1851 when the Midland Great Western railway was established to link Dublin and Galway. John Skipton Mulvany (1813–70) was the architect to the company in its early days and he designed the great terminus at Broadstone in Dublin as well as the station at Athlone and several smaller stations on the line. The engineer to the company was George Willoughby Hemans (1814–85) and he may have designed the complex at Ballinasloe.

The buildings are all in the picturesque manner, with medieval details, high pitched roofs and exaggerated chimneys. The walling is in square snecked limestone blocks and the windows,

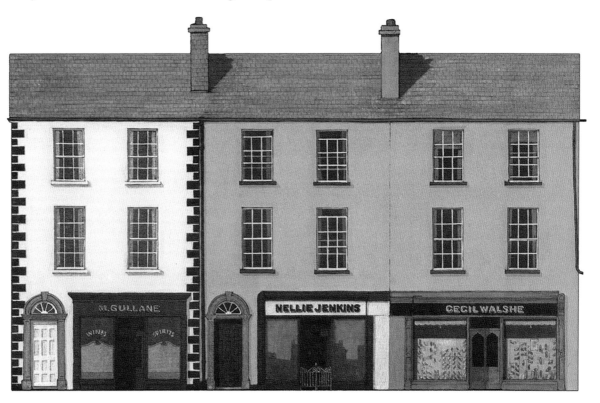

in contrast to the classical approach, are emphasised only by the careful detailing of jamb blocks, one piece lintel and one piece cills all built flush with the wall face.

The Great Ballinasloe Fair was no doubt the reason for the town's splendid station buildings and the fair reached its greatest size during the early years of the railway.

The forms used by the local builders of Irish towns and villages were simple and functional, and the designs adopted were those familiar to the craftsmen. In the early 19th century many Irish towns had rows of single-storey cottages, often mud-walled and with thatched roofs, along the main streets. This traditional building form was most unsuitable for the towns with their growing trade and animal fairs. Many contemporary engravings show scenes of poverty with insanitary cabins along congested and muddy streets.

By the mid-19th century the Irish town street was taking on the forms many still have today. The houses had narrow vertical proportions with stone or plastered fronts of simple classical design, displaying more exotically detailed painted details at street level.

The traditional Irish small shop contributes to the fabric and texture of town and village in an attractive manner. The traditional wood fronts with their hand-painted lettering are items of antique value and should be cherished and restored by their owners.

A fascinating and unique characteristic of Ballinasloe is the arrangement of windows illustrated below. The top floor has a simple Diocletian window, while under it, on the first floor, is a delightfully out-of-scale Venetian window. This motif is repeated on several of the tall stone-built houses in the principal streets and is an interesting feature of an architecturally distinguished town.

Although this illustration shows existing buildings, the shop fronts are based on original designs taken from photographs of Ballinasloe.

Sean Rothery, 1989

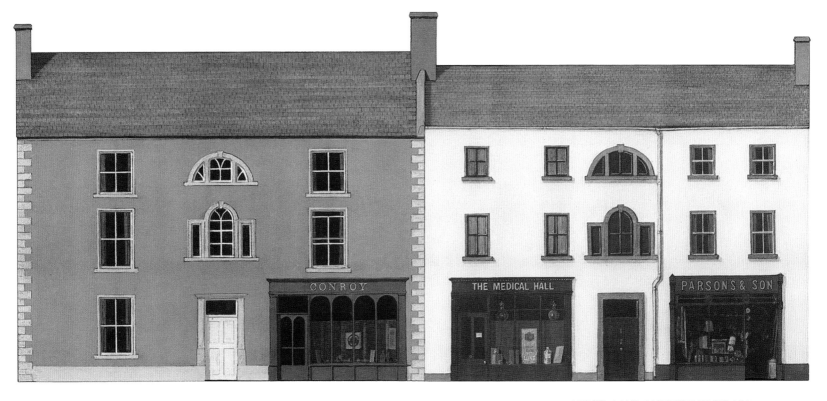

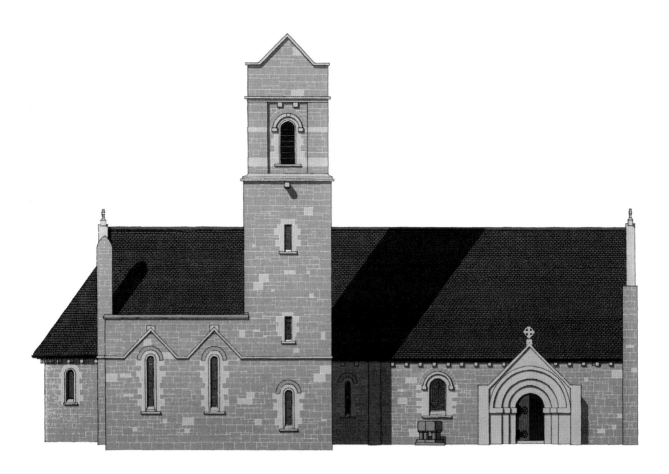

Church at Spiddal, County Galway

The architect William Anthony Scott's designs were influenced by his early years in the innovatory Architects Department of London County Council. The work of CFA Voysey, one of the early pioneers of modern movements in architecture, had a profound influence on those at LCC.

One of Scott's early buildings in Ireland was the house 'Killyhevlin' in County Fermanagh. The design, although in the prevailing Arts and Crafts tradition, has many Voysey elements. The simplicity of form and absence of ornament established this building and others following, such as the Agricultural College in Athenry, as innovatory and modern.

The little church at Spiddal, County Galway, of 1904–07, while Romanesque in spirit, has many of the characteristics being developed by Scott. The strongly expressed and simplified forms, typical of the Irish Romanesque, are here abstracted further by Scott. There is little ornament and the bare walls are simply enriched by the use of rock-faced rubble masonry in the long tradition of Irish stone architecture.

One of Scott's later works, the Diocesan College in Galway, is a further development of his ideas of abstraction and simplification. Built in 1912, with a flat reinforced concrete roof and floor, the building is highly original, exhibiting the elements of a new simplicity which were increasingly being explored internationally.

William Anthony Scott, with his small but highly competent and interesting body of work, must have a strong claim to be Ireland's first 'modern' architect.

Sean Rothery, 1989

ROUNDSTONE HARBOUR, COUNTY GALWAY

In 2024 the village of Roundstone in Connemara will celebrate its bicentenary. The village and harbour owe their existence to the vision of Alexander Nimmo. A Scotsman, Nimmo first came to Ireland in 1810. During the following twenty-two years he would become arguably the most productive civil engineer to practise in this country at that period. Skilled as a surveyor, teacher, academy rector and acknowledged scientific author, Scottish civil engineer Thomas Telford receommended him to the Irish Bogs Commissioners as one of nine engineers to be appointed to survey the Irish peatlands.

In 1813, Nimmo made an intensive survey of Connemara. His heart was set on the development of the West of Ireland. He was to build roads and harbours around its coasts. As part of his lasting legacy, he planned and began to build a new town at Roundstone, perching part of its main street along the edge of a 40-foot (12-metre) high cliff that he had quarried out to form a new harbour.

Sean de Courcy, 1996

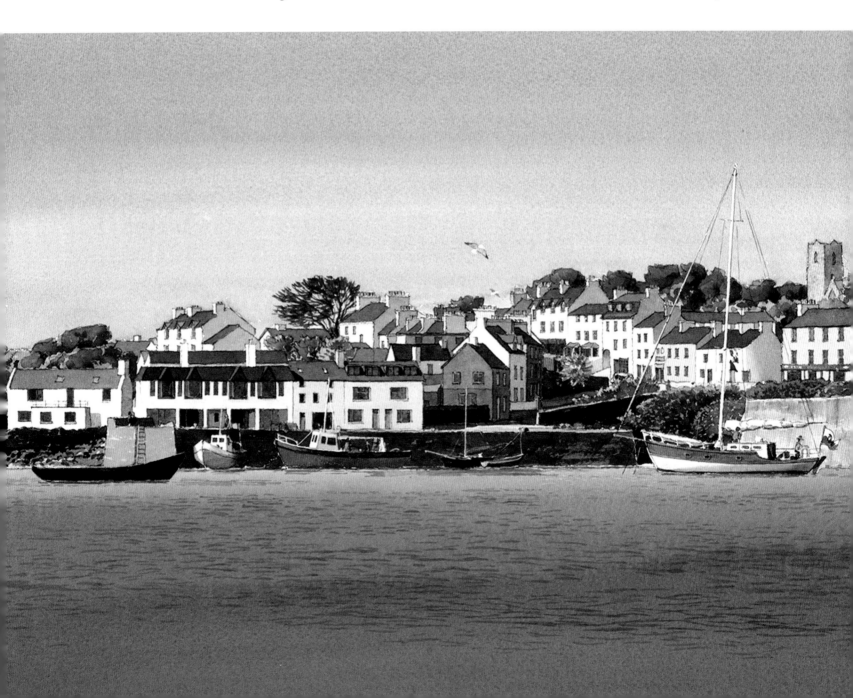

Renvyle Hotel, Renvyle Peninsula, County Galway

The hotel experience is for most of us a short-term and occasional one and the variety of hotels reflects the variety of our aspirations and needs for our holiday accommodation.

In Ireland the expansion of the railways in the Victoran period saw a great boom in travel to areas that in the past were inaccessible. The adventurous Victorians wanted to explore these wildernesses and the first hotels in these areas were relatively simple buildings to provide shelter and warmth for the long-distance traveller. The south of the country was well established as a tourist area as early as 1750, and when the railway arrived in Killarney one hundred years later tourism boomed.

The West was still relatively unknown when the Blakes decided to open their house at Renvyle to paying guests in 1883. Renvyle House was an old building then and in poor repair. The Blakes were in debt and turned to the Prime Minister, Balfour, and others for financial assistance. A 'Blake House Committee' was set up to help repair the house. A coach was used to ferry passengers from the Galway–Clifden train and the house was known as the Clifden Station Hotel.

The house was burned to the ground during the Irish Civil War and rebuilt in 1930 by Oliver St John Gogarty, the famous surgeon, author, poet and wit.

Sean Rothery, 1978

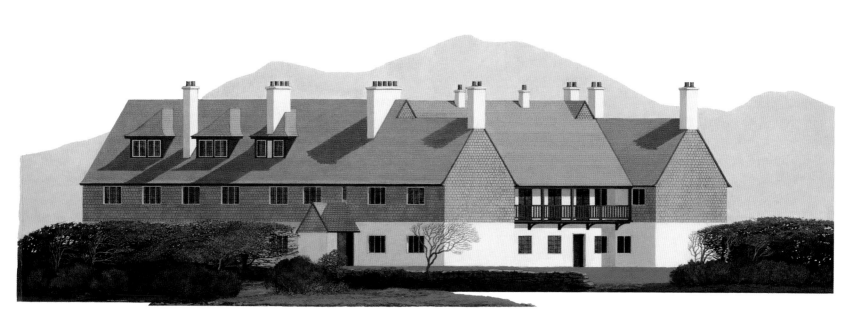

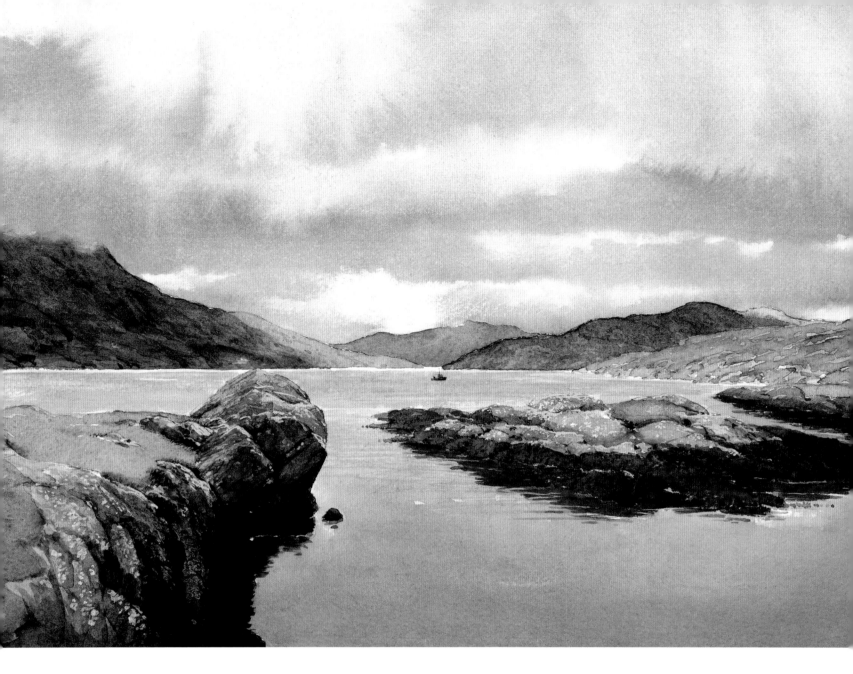

KILLARY HARBOUR, COUNTY GALWAY/MAYO

Killary is a beautiful, deep, narrow inlet bordering counties Galway and Mayo, with high mountains on either side. Picturesque islands lie off its entrance. The dominant peak in the area is Mweelrea, rising to 2,675 feet (815 metres). North of the entry to the inlet is Clare Island, rich in geology, history, flora and fauna.

Killary's beauty has been compared with the splendid Gulf of Kotor in Montenegro. Kotor, unlike Killary, did become a naval base. It paid the price by figuring bloodily in two world wars. Killary's age of misery was in the mid-19th century, when men fished in open boats for a dwindling and down-hearted population that could not afford to buy the fish. The jetties built by the Congested District Board, that provided better boats to improve their lot in the 1880s, are still visible.

John de Courcy Ireland, 1995

BRIDGE STREET, WESTPORT, COUNTY MAYO

In the 18th century it became fashionable for the wealthy owners of the estate houses to employ architects and landscape gardeners to plan the surrounding estates, embellishing the scene with picturesque cottages, farm buildings and gate lodges. The entrance to the estate now became an important issue. Many landlords competed to build new, planned villages and towns so that visitors might have an agreeable approach to the big house. While genuine philanthropy cannot be ruled out, some owners being real improving landlords, the main motivation for the planned new settlements must have been self-importance.

The powerful and dominating presence of Westport House, designed in 1731 by Richard Cassels, led to the building of Westport, a well-planned town and a satisfactory entry point to the estate. The planner was possibly James Wyatt, one of the late designers employed at Westport House, and the town dates from about 1780. The Carrowbeg River was canalised for a stretch, and formal tree-lined malls were laid out on each side with graceful, curved stone bridges connecting the banks. The buildings in the new settlement all conformed to a plain classical formula, which could include a multiplicity of shops and houses in a harmonious framework.

Although the plans of the streets, malls and octagonal place conform to the geometric rules of the classical style, the streetscapes lean more to the Irish vernacular with their irregular heights and individualistic shop fronts. They follow a standard arrangement of classical cornice, name fascia and pilasters, framing the shop window, but the variety in the detail, combined with strong contrasting colours on the painted fronts, make for a unique Irish folk-art form.

Westport has a large number of traditional Irish wood-fronted shop fronts with nameboards. The classical frieze provided the ideal space for the name and traditionally was hand painted. In many Irish towns this beautiful and native craft has been discarded for more commercial lettering. The craft of sign writing is, however, alive and well, and discerning business people are recognising the value of reviving this Irish art form.

Sean Rothery, 2001

THATCHED COTTAGE, COUNTY MAYO

The longhouse was a traditional form of building common in Ireland. The 'longhouse' was a dwelling where quarters for humans and farm animals adjoined. Longhouses have been dated as early as the 9th century in parts of Britain, and 19th-century photographs show some dwellings in Ireland which were still of the same early construction.

In the western part of the country longhouses were generally of local stone construction, with small windows and thick walls, weatherproofed with many layers of lime.

Roofing material was thatch and the material used depended on availability locally. The earliest forms of thatch were sods of grass and heather laid on furze stems, and this method can still be seen on outhouses in the west. Reeds or straw gave excellent insulation against heat loss. An interesting feature in the example illustrated from south County Mayo is the stepped stone barges on the gable ends. This was done to avoid the difficulty of cutting the stones at an angle.

Sean Rothery, 2001

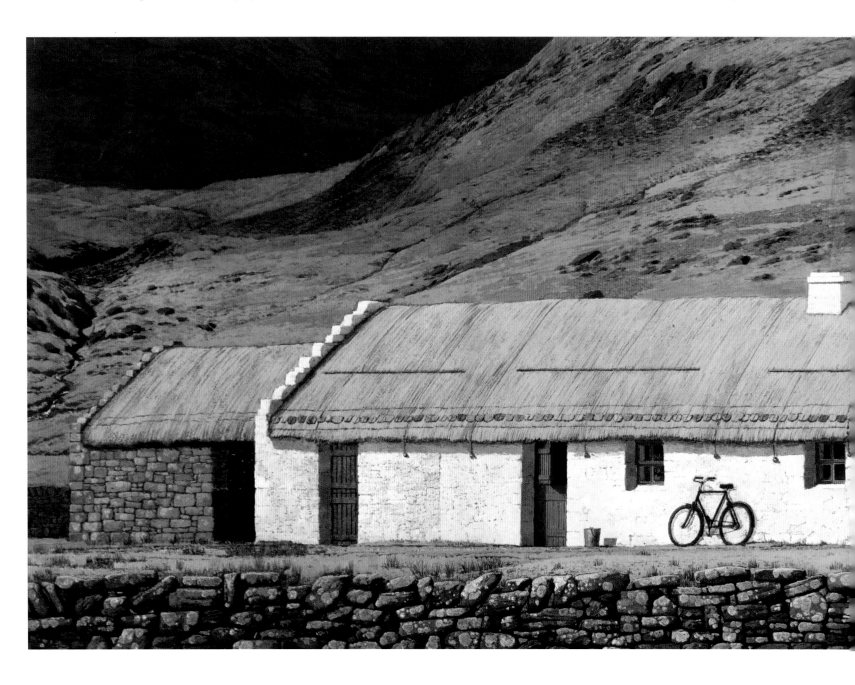

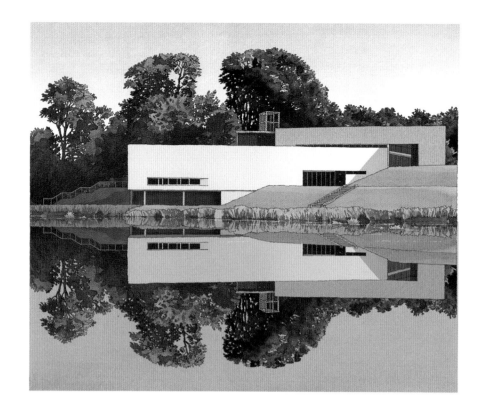

NATIONAL MUSEUM OF IRISH COUNTRY LIFE, CASTLEBAR, COUNTY MAYO

In the mid-1990s, an Irish folklife museum opened at Turlough Park House in Castlebar. The house, designed by TN Deane (1828–99) and built in 1866, is in the flamboyant Venetian Gothic style. The architectural team for the Museum of Irish Country Life was led by Des Byrne of Architectural Services, Office of Public Works. The original house was renovated to house administrative offices, while an imaginative decision was made to create new buildings in a modern style. The magnificent site – with its formal gardens, woodlands, lake, river, ruined fortified house and nearby round tower – was the unifying force.

The white horizontal concrete modern structure is set down at a low level and dramatically relates to the lake. Grass terraces mould the main exhibition areas into the landscape and the new buildings act almost as a plinth to the old house.

Roadstone, who supplied stonefill, concrete and concrete blocks from Castlebar Quarry, are proud to have played an important part in such an exciting and successful project.

Sean Rothery, 2003

Harrison Memorial Hall, Roscommon

Harrison Memorial Hall, currently a branch of the Bank of Ireland, occupies a commanding position on the square at the head of Main Street, Roscommon town.

In 1762 the Grand Jury of County Roscommon commissioned George Ensor to construct Session House and Market House on the site of an old courthouse. Ensor and his brother John were partners in a successful Dublin practice, the latter having laid out Merrion Square in Dublin, while George had designed several prominent Dublin buildings, including St John's Church, Fishamble Street.

In Roscommon, stone and timber were salvaged from the existing session house and supplemented by oak from County Laois. Other materials included slates from Killaloe, paving flags from Mountmellick and glazing from Dublin.

The building was to fulfil its planned functions until 1822 when it became redundant on the completion of the new courthouse in the town.

The Harrison family had links to Roscommon dating back to 1576, but it was John Harrison MD who was greatly esteemed for his work in the 19th century for the poor, particularly during the tragic Famine years. The hall was renamed in his honour.

Bernard Share, 2006

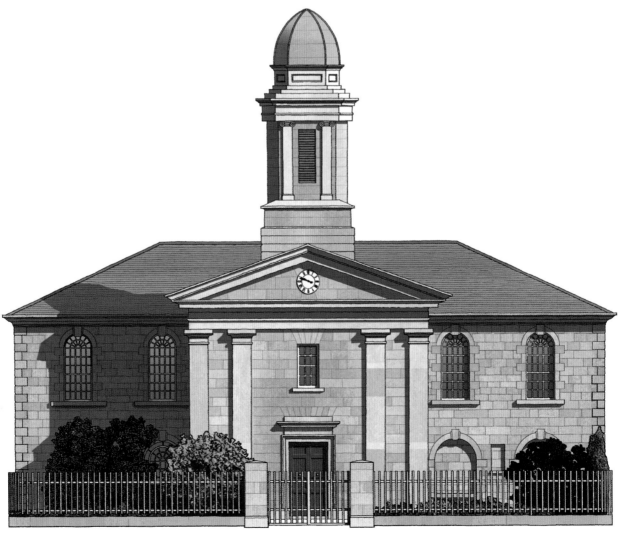

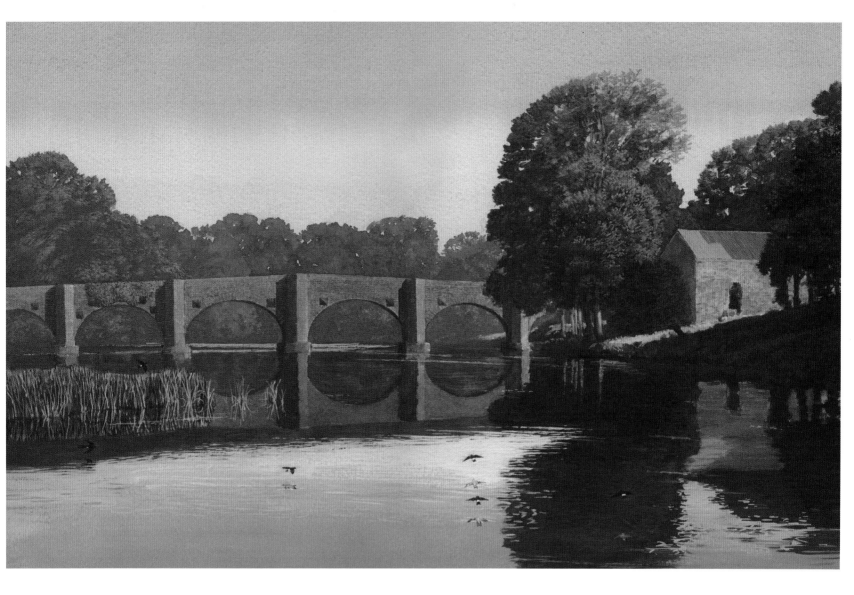

DRUMSNA BRIDGE OVER THE SHANNON, COUNTY ROSCOMMON

The bridge at Drumsna is probably the oldest on the Shannon waterway. The precise date of the bridge is uncertain.

The boats which take the shortcut from Drumsna to Jamestown miss a lot. The bypassed loop of river upstream of the old bridge is an enchanting place, an ideal spot to enjoy the rich wildlife of the waterway.

The fact that the river is undrained and floods in winter makes it so important for many forms of wildlife, including the endangered European otter and the corncrake. Hundreds of thousands of ducks, geese, swans and wading birds fly south from the Arctic and sub-Arctic to Ireland in October. Many of them stay until the following April, living and feeding in and around the flooded fields.

The fields that flood in winter and dry out in summer are called callows; their rich fertile soil is home to rare plant species such as marsh stitchwort.

Other summer birds, warblers, cuckoos, swallows and martins, fly in from the tropics to utilise our long summer days for the arduous business of gathering enough food to stuff into the hungry beaks of a nest full of young. They use the river as a safe corridor, flying up it and branching off to destinations all over the country. In just the same way as human beings have used the waterway since time before history.

Dick Warner, 1997

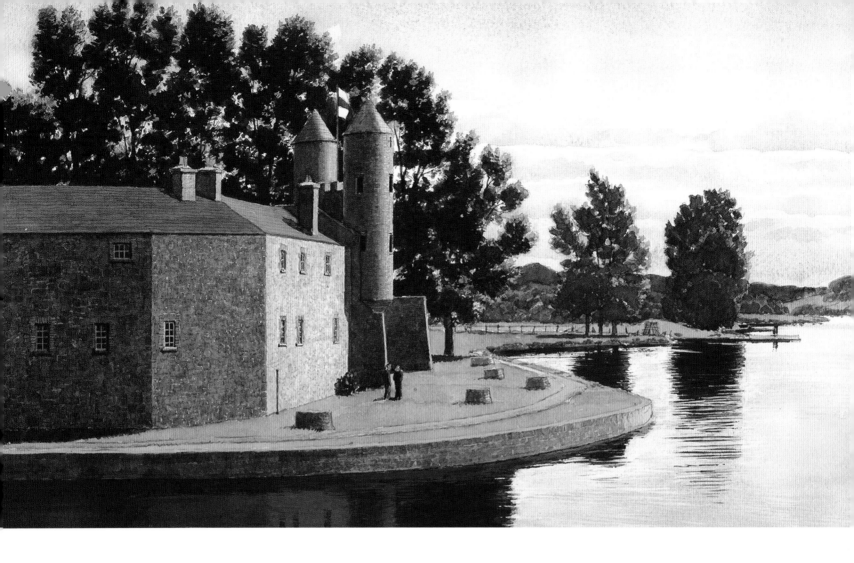

THE WATERGATE, ENNISKILLEN, COUNTY FERMANAGH

The castle by the waters of the Erne in Enniskillen tells the history of Ireland in stone. It was built in the 15th century by the Maguires, members of the so-called Gaelic Aristocracy of Ulster, whose pedigree stretches back to the Iron Age and an ancient Celtic civilisation.

The two rather attractive round turrets, which are called the Watergate, were added in the early 17th century by Captain Cole – a Protestant English settler who had been granted the Maguire estates by King James I. What happened in between was a century of bloodshed in which the Elizabethans finally conquered the last Celtic culture in the world, sent its aristocracy into exile, confiscated their lands and gave them to English and Scots settlers.

Enniskillen Castle stood at a key fording point, the site of many a battle. The castle changed hands beween the English and the Maguires on several occasions in the 15th century.

The castle went on to become a rallying point for Protestant settlers all over Ireland. It played this role both in the Rebellion of 1641 and the Williamite war of 1689. And the loyal sons of Ulster gathered to defend the British Empire in two very famous regiments – the Royal Inniskilling Dragoons and the Royal Inniskilling Fusiliers. There is a regimental museum inside the castle today.

Dick Warner, 1997

THE GRAND YARD, CASTLE COOLE, COUNTY FERMANAGH

A 1619 survey reports that a Captain Roger Atkinson 'hath one thousand acres called Coole' with 'a strong Stone House'. By the mid-century the property had passed to John Corry, freeman of Belfast and ancestor of the Earls of Belmore. His descendant Armar Lowry Corry inherited Castle Coole in 1774, and on 17 June 1790 laid the foundation of today's big house.

The Grand Yard, designed by Sir Richard Morrison (1767–1849) in 1817 for the second earl, stabled hunters and hacks. It included offices and accommodation for grooms, and formed part of an extensive complex which included a drying ground, farmyard, haggard, straw house and steward's house. The Grand Yard was in use up to World War II when it was occupied by the US army, after which it fell into disrepair, the upper floors being utilised in the 1950s for deep-litter chicken rearing. In 1989 it came under the care of the National Trust and has been painstakingly restored, while the house itself, though also open to the public, remains a family dwelling.

A tunnel, built in 1789, antedates the Grand Yard and its associated buildings. Originally used to bring materials to the construction site of the house, it subsequently connected the outbuildings with the basement of the house and contains, at the upper end, storage space for turf and wood. Six cartloads of the former were required each day to maintain the fires in 116 rooms. One can only imagine the labour involved.

Bernard Share, 2004

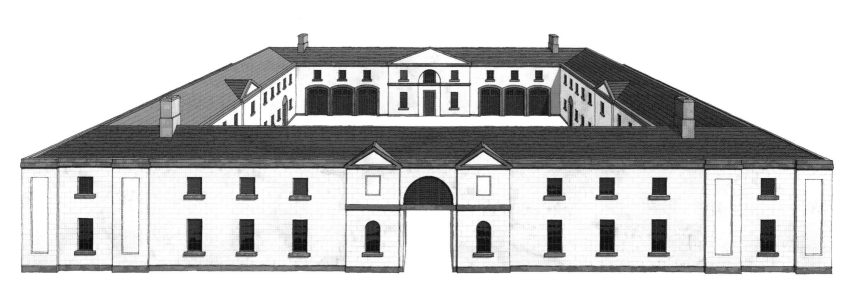

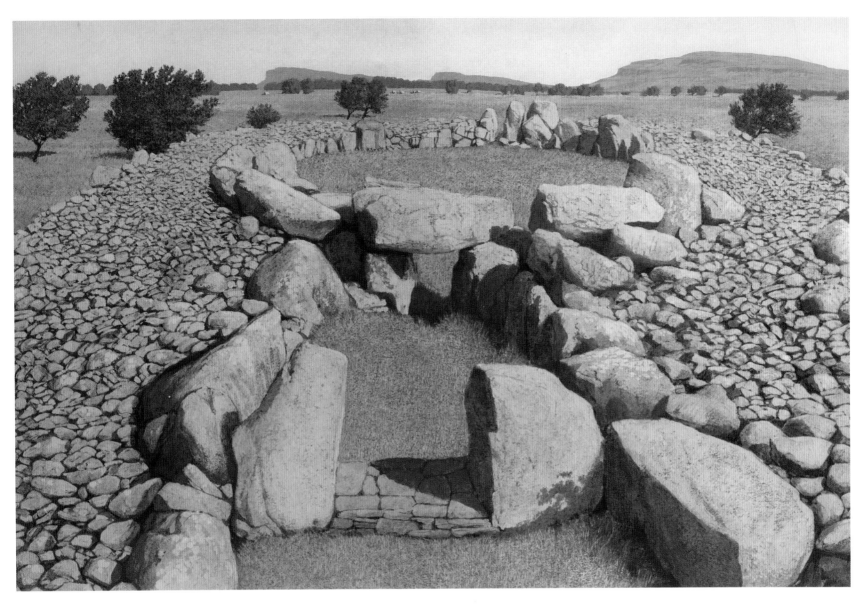

CREEVYKEEL COURT CAIRN, COUNTY SLIGO

The great monuments of the Neolithic period or Stone Age are impressive reminders of a long tradition in Ireland of building in stone. The early tombs can be roughly divided into four groups: court cairns, passage graves, gallery graves and dolmens. Often sited on hilltops, the large passage graves are the most impressive. Dolmens are probably the most architectural of the monuments in the sense that they conform more to the idea of a recognisable structure. The court cairns, on the other hand, are less obvious, but the mystery and magic evoked by encounters with them, in Ireland's ancient rural landscape, invite speculation as to their purpose

and above all to the rituals associated with their use.

According to Peter Harbison, in his *Guide to the National Monuments of Ireland*, court cairns are the earliest megalithic tombs in Ireland, possibly dating from the period 3000–2500 BC. This type of tomb usually consisted of two simple elements, a mound of earth and stones and an open enclosure of upright stones.

The court cairn at Creevykeel, County Sligo is one of the finest in the country, possibly dating to the Late Stone Age, around 2000 BC. The main burial chamber is divided into two sections, with two possible later chambers at the rear.

Sean Rothery, 1990

COASTGUARD STATION, KILLYBEGS, COUNTY DONEGAL

The coastguard was a mainly naval force which originated in the early 19th century. One of its duties was to provide a restraint on smuggling. This had flourished since the 18th century when there were very high revenue duties on goods such as tea, spirits and silks. The coastguard had other duties such as the enforcement of maritime laws and giving assistance to vessels in distress. The coastguard station provided an office for the service, living quarters and often a look-out tower.

A letter in the *Irish Builder* of 1873 asked why was there a delay in erecting the proposed coastguard station at Killybegs since the Admirality had approved the scheme. The writer then hoped 'that the new buildings would have some regard to design and have an artistic look as Killybegs is a very beautiful and picturesque town'.

The new station was sited in a commanding manner with its little matching boathouse at the waters' edge. The design was given a military flavour with symbolic machicolated windows, a device borrowed from medieval castles. The walling is built in squared local rubble stone with quoins, window surrounds and segmental arched windows trimmed with ashlar. The wide eaves give a strong shadowed effect to the roof line of the building and are supported by neat wood brackets corresponding with the rafter spacing. The architect of the Killybegs coastguard station was E Trevor Owen, who with his brother Alfred was employed by the Office of Public Works.

Sean Rothery, 1984

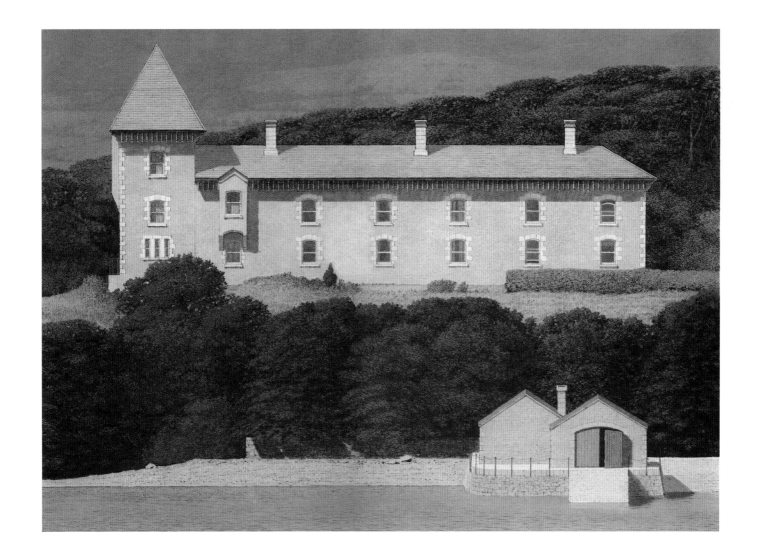

Glenveagh Castle, County Donegal

Glenveagh Castle was built between 1869 and 1873 for JG Adair in a romantic Victorian Baronial design by JT Trench (1834–1909), with square high keep, turrets, bartizans and a walled courtyard. Granite round corner towers and idealised battlements complete the illusion of a fortress defending the wild and rugged landscape round Lough Veagh.

The gardens are some of the best in these islands. A woodland garden leads to a wild garden, and a great flight of stone steps rises straight up the hillside to a view point overlooking the lake and mountains. A formal walled garden has raised beds of herbs, vegetables and fruit. To the rear of the stables is a beautiful Gothic conservatory, designed by M Phillipe Julian.

Henry McIllhenny presented the castle and gardens to the Irish nation in 1981, and today they are open to the public.

Sean Rothery, 1986

MILL COMPLEX, NEWMILLS, COUNTY DONEGAL

The remains of Ireland's early industrial past are common-place in the countryside and in towns. For many years these were little appreciated; the great gaunt mills and warehouses had become either abandoned ruins or convenient sheds. The study of industrial archaeology has now been added to the older discipline, and the surviving artefacts provide us with an understanding of our economic and industrial history.

At Newmills, three miles (approximately five kilometres) west of Letterkenny, a group of old mills were still opera-tional until 1982. Parts of these mills are as old as 300 years. The upper mill was a flax-mill, common in the northern part of the country, while the lower building was a grain mill. The complex was powered by water taken from the Swilly river along a mill-race to control the flow. Waterwheels, turned by the force of the mill-race, activated the machinery in both

mills. The lower of the mills (shown in the illustration) has one of the largest surviving waterwheels in Ireland. This great wheel was made by the Stevenson foundry in Strabane in 1867, illustrating the wealth and diversity of the industrial heritage of 19th-century Ireland.

Both of the mills served an agricultural community, but with different end products. The flax-mill processed the flax which was grown locally in the northern counties for the making of linen and the machinery that made this possible is still in place. The lower mill was for the grinding of barley and oats.

A few years after the Gallagher family finally closed their business at Newmills, the Office of Public Works beautifully restored the mills and gave the complex a new life in an age when we can enjoy a nostalgic look at our industrial past.

Sean Rothery, 1992

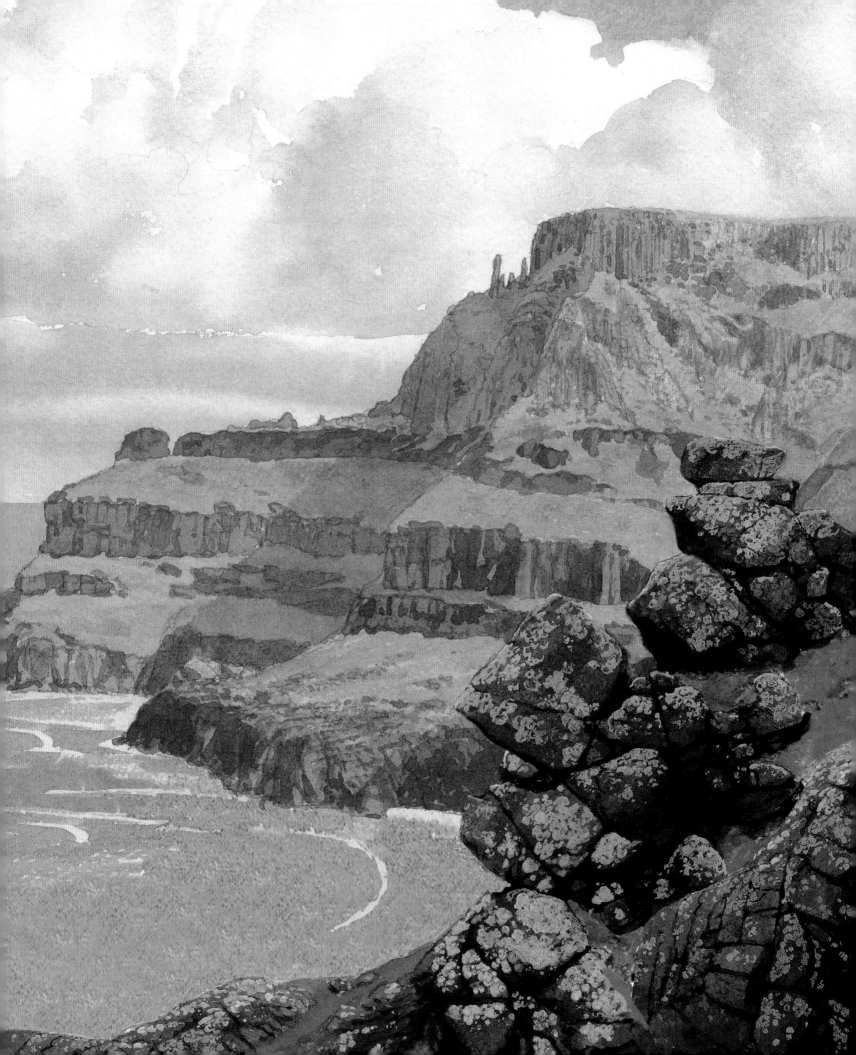

NORTH AND NORTHEAST

Basalt Cliffs, Giant's Causeway, County Antrim.

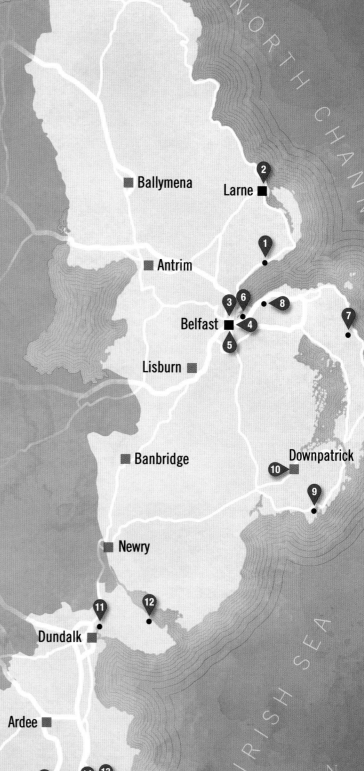

NORTH AND NORTHEAST

Ballymena ■

Larne ■ **2**

1

Antrim ■

3 **6** **8**

Belfast ■ **4**

5

Lisburn ■

7

Banbridge ■

Downpatrick ■

10

9

Newry ■

11 **12**

Dundalk ■

Ardee ■

Kells ■

16 **15** **14** **13**

Slane ■ Drogheda

Navan ■

NORTH CHANNEL

IRISH SEA

NORTH AND NORTHEAST

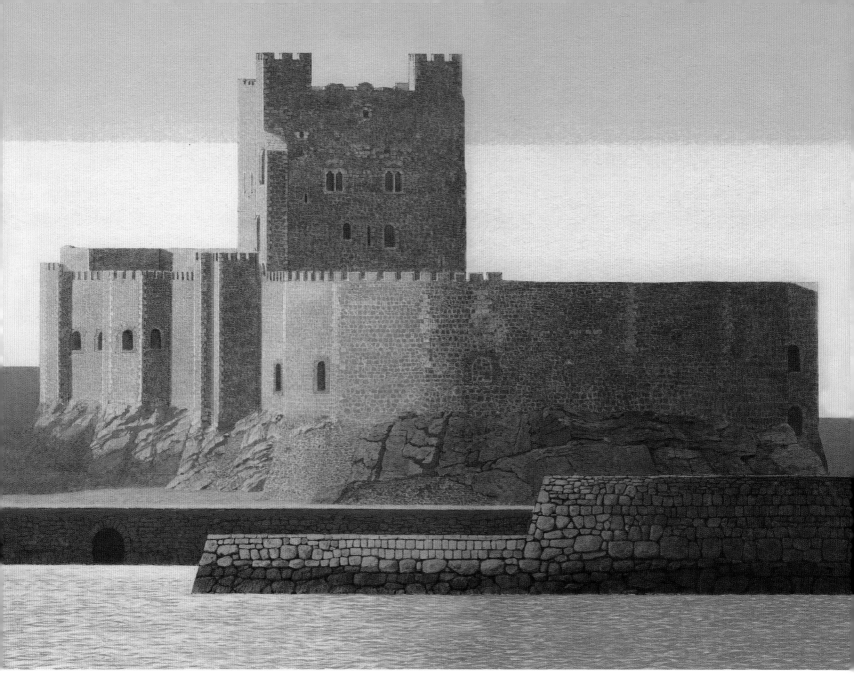

CARRICKFERGUS CASTLE, COUNTY ANTRIM

The great castle at Carrickfergus is one of the finest and largest in Ireland. Founded in 1180 by John de Courcy, it was his main stronghold until 1204 when Hugh de Lacy succeeded him as the Earl of Ulster. The great fortress is sited on a rocky peninsula, isolated at the landward end by a defensive fosse. There is a double towered entrance building leading into a courtyard, surrounded by huge curtain walls. A second smaller defensive ward or courtyard contains a massive square keep. The only entrance to the keep is one storey high over the ground. The Great Hall of the Castle is on the third floor with the private quarters of the Earl and his successors.

The castle was altered and added to over the centuries. The East tower has early arrowslits, while in the 16th century gun ports were cut through the curtain walls.

Carrickfergus Castle was besieged in 1689 and taken by the Williamite Marshal Schomberg. It was again taken by François Thurot during the French raid of 1760.

Sean Rothery, 1984

ART DECO BANK, LARNE, COUNTY ANTRIM

The former premises of the Bank of Ireland at 43–47 Main Street, Larne represent a period and style known as Art Deco, of which there are few institutional examples throughout the country. The design was the work of the bank's architect A GC Millar and was crafted by local firm Messrs. James Ferris Ltd.

The building is also unusual in that it retained its original function for a long period from 1933.

Sean Rothery, 2005

Editor's note: the building was restored in the early 2000s and reinvented as retail and office space.

Elmwood Hall, Belfast

The most obvious geological features in Northern Ireland are the basalt Antrim Plateau in the northeast and the granite Mourne Mountains in County Down.

While granite and other igneous rocks were commonly used in Belfast, so too were Irish and Scottish sedimentary sandstones. The most famous quarry was at Scrabo, near Newtownards in County Down. It produced stone, resistant to weathering, which was favoured by the Victorian architects responsible for many of Belfast's commercial and religious buildings.

One such building is Elmwood Hall, a former Presbyterian church dating from 1859, designed by the amateur architect James Carty. This unusual building has an Italianate façade and a three-tiered spire. After falling to decay, it was restored by Queen's University for use as a concert hall.

Similar stone to that from Scrabo was exploited at Dungannon, from where stone was supplied for the construction of Connolly Station in Dublin, while those at Moira provided building materials for Hillsborough.

Patrick Wyse Jackson, 1998

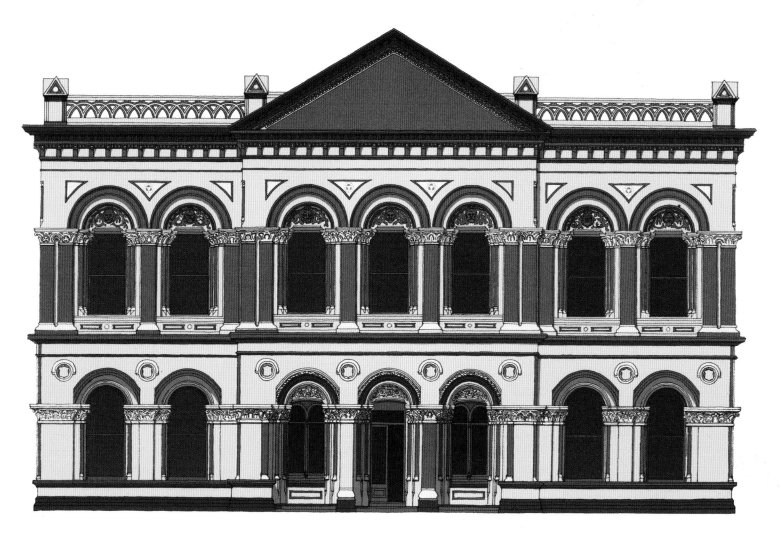

Allied Irish Bank, Castle Place, Belfast

By the mid-19th century another new building type began to appear in almost every town in Ireland. Banks had previously been housed in nondescript buildings, but the new expansion of horizons which accompanied the railway era produced an explosion in new bank buildings. In many small Irish towns the branch bank is often the finest piece of architecture.

The Allied Irish Bank on Castle Place, Belfast, formerly the Provincial, dates from 1864 to 1869 and the architect was William J Barre. Barre was an enthusiast for ornament and in the true tradition of the Victorian era could play easily with the styles. The Provincial is a delightful miniature palazzo and the main façade is ornamented in a most exuberant fashion. The pediment, however, looks remarkably bare and was originally intended to have figures carved in high relief. In 1888 when the white Cookstown sandstone used for the façade began to decay the building had to be painted.

The interior is magnificent with one of the best banking halls of any in Ireland. The style is a playful version of Gothic, applied to a largely classical geometry. A beautiful, glazed clerestory dome sits on chopped-off columns. Around the band of the dome are little carved heads and in the groin angles are odd figures representing Mechanism, Engineering, Art, War, Law, Navigation, Architecture and Industry.

Sean Rothery, 1989

DRY DOCK, BELFAST

Shipbuilding began in Belfast in 1791 and carried the name of Belfast to the ends of the earth. Harland and Wolff's yard opened in 1859 and built 1,730 ships in 135 years. Belfast's shipbuilders were some of the best in the world. The designers at Harland and Wolff's shipyard and at rivals Workman, Clark and Co. were in the very top class.

The Belfast-built ships of the Royal Mail, Pacific Steam and Blue Star lines were hailed as the best in their class, and it was the same for the vessels of the Union Castle line.

In 1912 the infamous Belfast-built White Star liner *Titanic*, then the biggest ship in the world, struck an iceberg in the Atlantic and sank with terrible loss of life. *Titantic*'s sister *Olympic* and other While Star liners safely sailed the Atlantic for many years.

Harland and Wolff also built successful naval ships of pioneer design and scores of ships for continental owners, such as the 1973 'super tanker' *Olympic Brilliance* for shipping tycoon Aristotle Onassis.

John de Courcy Ireland, 1995

CROWN BAR, BELFAST

The Victorian gin palace with its palatial interior and exotic façade became a major urban feature of the later 19th century. This new architectural form coincided with a period when new and more plentiful building materials became available, plate glass and mirrors with lavish lettering and decoration, mock marbling, cast-iron columns, glazed tiles and real marble bar-tops. All these techniques and materials made the urban pub a rich and lush place of refuge from the dismal industrial areas of the city.

The Crown Liquor Saloon in Belfast is one of gin palace design. It was designed by a Mr Flanagan, the son of the proprietor, and Italian craftsmen from Dublin, who excelled in tiling, were responsible for the high standard of workmanship. Magnificent wood-grained entrance doors lead into a richly decorated interior with painted glass panels, mirrors and tiles.

Sean Rothery, 1975

BALLYCOPELAND WINDMILL, COUNTY DOWN

Windmills, unlike waterwheels, are a comparatively modern invention. Whereas water wheels were known in the ancient world, windmills are thought to have originated in Persia in the 7th century. It was not until the end of the 13th century that windmills became established in Northern Europe. The European windmill was more efficient than the earlier Middle Eastern mills.

The wind acted continuously over the whole surface of the sails. Provision was also made for turning the sails into the wind. The earliest version of this type of mill was called the post mill; the whole structure, pivoting on a vertical post, turned with the wind. The later development became known as a tower mill, where only the top portion, carrying the sails, was turned. In the earliest versions this had to be done manually. In 1745 Edmund Lee invented the fan-tail which drove the sails into a new positon. Early mills had canvas sails but wood shutters were soon seen to be more efficient.

In the past there were over a hundred windmills in County Down, an excellent grain-growing area. The Bally-copeland Mill may date from the 1780s/1790s and was in the hands of one family, the McGiltons, from 1845 until 1935. The windmill has been restored to full working order. The Ballycopeland windmill is the only working windmill in the whole of Ireland. Situated near Millisle in County Down, it is open to the public.

Sean Rothery, 1986

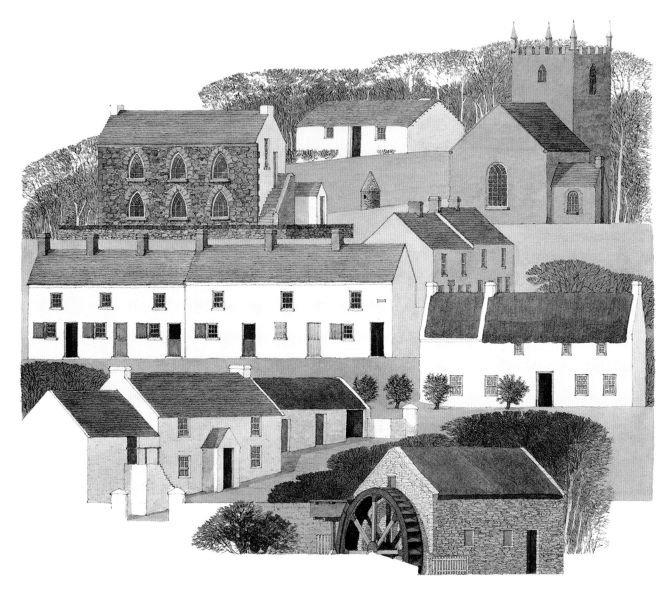

ULSTER FOLK MUSEUM, CULTRA, COUNTY DOWN

The humble everyday buildings of town and countryside are rarely given the protection which is available to the grander works of historic architecture. Increasingly, the smaller gems of our heritage are demolished or allowed to quietly crumble away. The modern idea of the outdoor folk museum is one answer for preserving complete buildings by carefully re-erecting them in a natural setting. The Ulster Folk Museum at Cultra, County Down, is an outstanding example of what can be done.

The National School of Ballyverdaugh is shown at the top left-hand side. Built in 1837, the school had two classrooms, one above the other, originally for separate classes of boys and girls. The building is faced with rough basalt and sandstone quoins and the Gothic windows were probably influenced by the clerical mangers. Kilmore Church, top right, dates from about 1790 and is an example of a simple Georgian country church. The two-storey thatched house is from the townland of Lismacloskey, County Antrim and is a very early Irish house, the date 1717 being determined by scientific dating of the oak timbers.

Sean Rothery, 1985

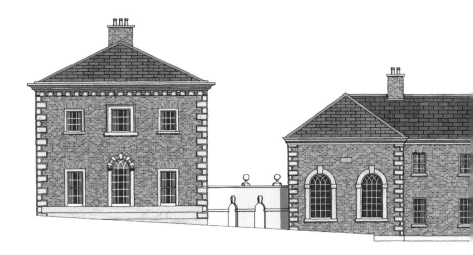

ALMSHOUSES, KILLOUGH, COUNTY DOWN

Killough is a village at Dundrum Bay in County Down. Engineer Alexander Nimmo built the harbour in 1821–29 to serve the sheltered harbour of Killough Bay. The tree-lined main street, with its simply proportioned houses, is a model for small towns or villages.

The best set-piece architectural assemblage is the Sheil's Institution, a set of almshouses (below) dating from 1868, with later 20th-century additions by architects Young and Mackenzie. The original architects were Lanyon, Lynn & Lanyon of Belfast.

In post-medieval times, ideas of charity and housing the 'deserving poor' became fashionable. Simply constructed almshouses were built in many parts of Ireland.

The muscular late 19th-century architecture of the Killough range of buildings is in strong contrast to the understated classical Irish town street façades. The sharp gables and rock-faced stonework form a lively composition, lightened by the graceful arch and the dark red contrasting horizontal bands.

The architects Sir Charles Lanyon (1813–89), his son John Lanyon (1839–1900) and WH Lynn (1829–1915) were responsible for many 19th-century buildings throughout Ireland, including Queen's University in Belfast.

Sean Rothery, 2001

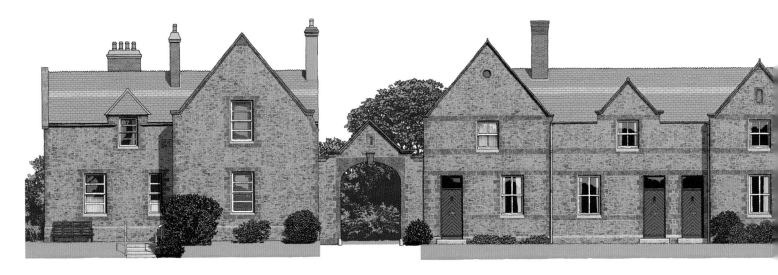

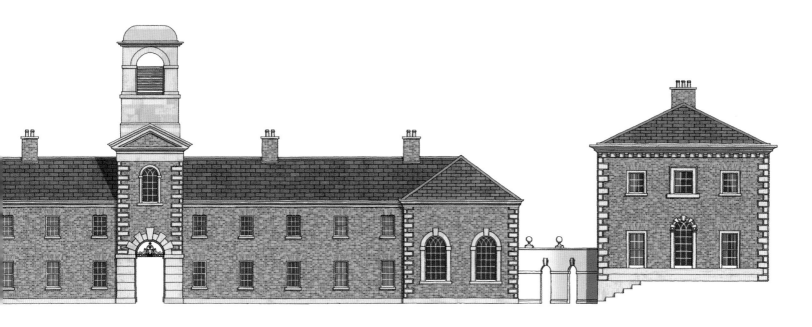

SOUTHWELL CHARITY, DOWNPATRICK, COUNTY DOWN

On the climb up to English Street in Downpatrick, there is a glimpse of the cupola – intended for a clock that never materialised – of the Southwell Charity, known as the Almshouses.

In 1703 the Right Hon. Edward Southwell, Secretary of State for Ireland, married Lady Elizabeth Cromwell, only daughter of Vere Essex, the fourth and last Earl of Ardglass, thus becoming the possessor of the town and demesne of Downpatrick. He did much to improve the town, which he found in a wretched condition – only four of its 140 houses had slated roofs – erecting a customs house, quay and store. On his death in 1730 Edward was succeeded by his son, also Edward, who established the Southwell Charity in 1733 and supported it for the rest of his life, providing for it even after his death.

The Schools, possibly the work of Sir Edward Lovett Pearce, are considered to be one of the finest examples of Early Georgian architecture in Ulster, though the prospect of the classical façade has been impaired since the street level of the Mall, on which they stand, was raised by some fifteen feet in 1790. The blue uniform of the school caused these institutions to be named 'The Blue Coat Schools'. The scholars have long departed, but the elegant building, now privately occupied, retains something of an 18th-century aura, with its meticulously maintained miniature gardens at the rear.

Bernard Share, 2004

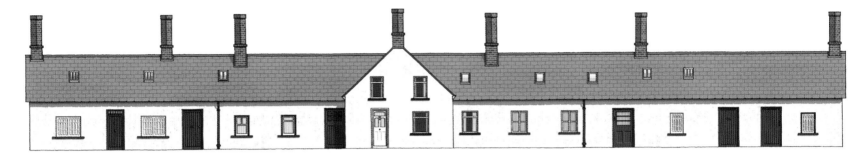

WORKERS' COTTAGES, BALLYMASCANLAN, COUNTY LOUTH

About 1688 two half-brothers, Archibald and Malcolm MacNeill, arrived in Louth from Kintyre in Scotland, with a group of Scottish settlers. The MacNeills acquired substantial property, including Mount Pleasant (Aghaboys, as it was known then) and Ballymascanlan House, built in the late 18th century but converted by the MacNeills around 1840 into a Tudor Gothic mansion with high-pitched gables, mullioned windows and hood mouldings. Contemporary with this rebuilding of the house was the construction of picturesque cottages for workers on the estate which echo, with their neo-Tudor chimney stacks and Gothic glazing, the style of the main building.

Bernard Share, 2004

CARLINGFORD PIER, COUNTY LOUTH

Carlingford has a romantic setting as fine as any in Europe. It lies on a sublimely beautiful bay, dominated on its southern bank by one of Ireland's most impressive medieval castles and backed by the formidable Slieve Foy, the highest peak in the Cooley Mountains.

Carlingford Lough's northern coast is dominated by the Mourne Mountains, of which two peaks, Eagle Mountain and Slieve Donard, are startlingly visible from vessels approaching the lough from the north.

Carlingford owes its name to the Norse. When the Normans came and saw the lough's strategic value, they built the castle in about 1200. Around it developed Carlingford town.

From the 13th to the 18th centuries the town was the most important on the lough. It was renowned for the quality of the herrings, which were exported, along with hides. Its oysters were also celebrated throughout these islands in the 18th century, and are once again much sought after today.

The 19th century saw the arrival of the steamship. First

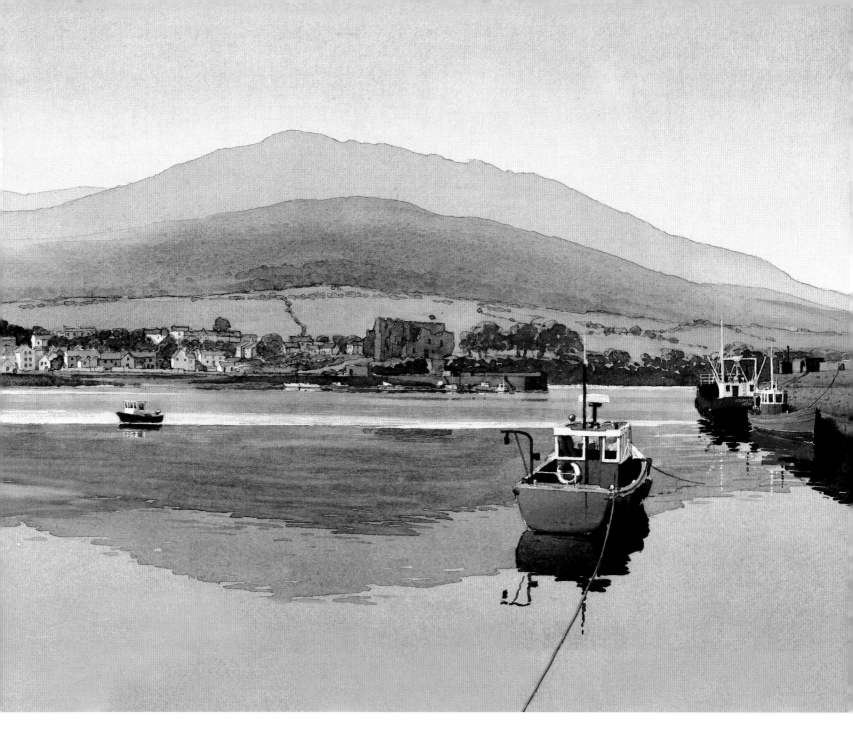

Warrenpoint, then Greenore gradually displaced Carlingford in importance. For many years Greenore operated a regular passenger service to Holyhead in Wales.

Left intact in Carlingford town is a remarkable group of buildings that bring vividly to life a picture of a stable, industrious and enterprising community.

Carlingford contributes to local folklore with the tale of the paddle-steamer *Lord Blaney of Newry*, which was wrecked with the loss of all hands in 1833 but seen again in the lough just before the *Connemara*, with passengers from Holyhead, suffered the same fate in 1916.

John de Courcy Ireland, 1995

THE BOYNE VIADUCT, DROGHEDA, COUNTY LOUTH

The crossing of rivers and deep gorges was one of the earliest problems to be solved by ancient civilisations. After the industrial revolution, Telford and Brunel pioneered the principle of suspension for long-span bridging.

The Boyne Railway Viaduct was considered one of the most structurally interesting of its day. The design was by James Barton, Engineer to the Dublin and Belfast Junction Railway, under Sir John MacNeill as Engineer in Chief. The three centre spans, originally of multi-lattice construction, were replaced in 1930 on top of the original fine limestone masonry piers. The reconstruction was the work of GB Howden and was an extremely skilful feat of engineering.

Sean Rothery, 1970

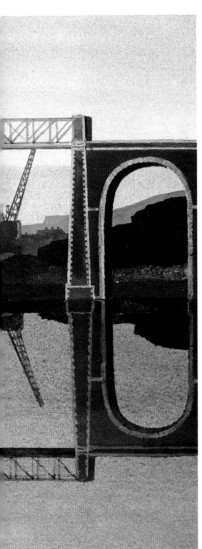

THE NEW BOYNE BRIDGE, DROGHEDA, COUNTY LOUTH

The new crossing of the River Boyne, an essential part of the M1 motorway, is celebrated by another pioneering development of the principle of suspension – a cable-stayed bridge from a single pylon. The Boyne bridge is an essential part of the new section of the M1 motorway which joins the existing southern section at Gormanstown to the existing northern section at Monasterboice. The bridge is a high-level structure spanning 1,100 feet (350 metres) supported by cables stressed from anchorages in the reinforced concrete single pylon.

The engineers for the bridge were Roughan and O'Donovan, and the whole new motorway project was carried out in three contracts; Uniform Construction, SIAC O'Rourke and SIAC Cleveland. This elegant structure is a fitting monument to the dawn of the twenty-first century and must be seen to be an exciting addition to the rich building heritage of the area, which includes the megalithic passage grave of the Brú na Bóinne Complex, Newgrange, Knowth and Dowth, the Early Christian site at Monasterboice and Francis Johnston's Townley Hall.

Roadstone supplied 50,000 cubic metres of ready-mixed concrete and over 1,000,000 tonnes of stone and bituminous materials to the project.

Sean Rothery, 2003

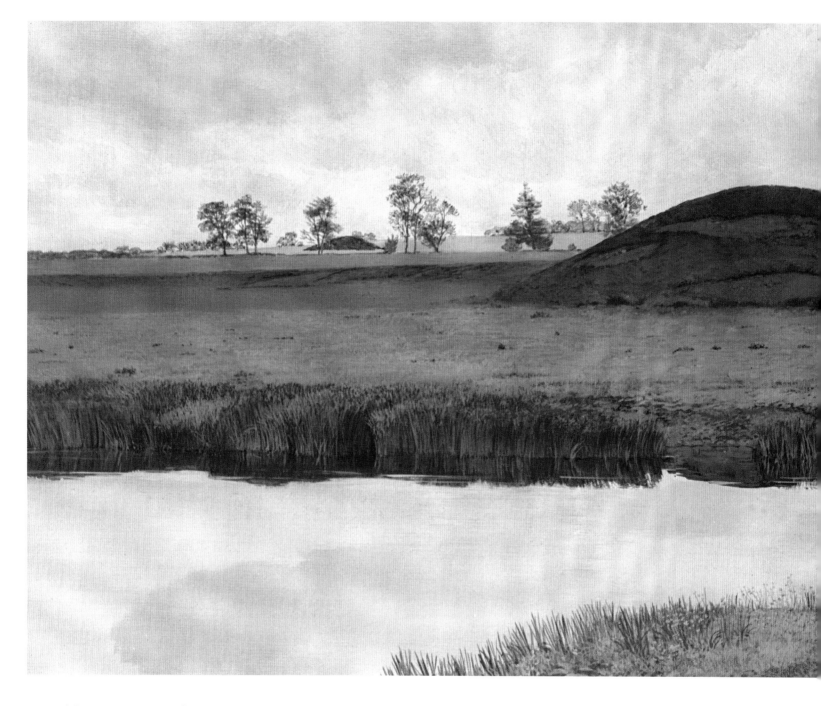

NEWGRANGE, COUNTY MEATH

The great mound at Newgrange, sited impressively above a loop of the River Boyne, is a megalithic tomb of the type known as a passage grave. The size of the tomb, 279 feet (85 metres) in diameter and 36 feet (11 metres) high gives an indication of the organisation and expertise of the society that built this monument and others in Ireland. The passage graves date from about 3000 BC (around the same

time as the pyramids in Egypt).

The passage and chambers are the most impressive features of the tomb as the building technique is ingenious. Building in dry stone, without the use of mortar, imposes technical limitations on structural aspirations. When this technique is combined with the use of relatively uncut stones, great testing is needed to select suitable stones and place them in

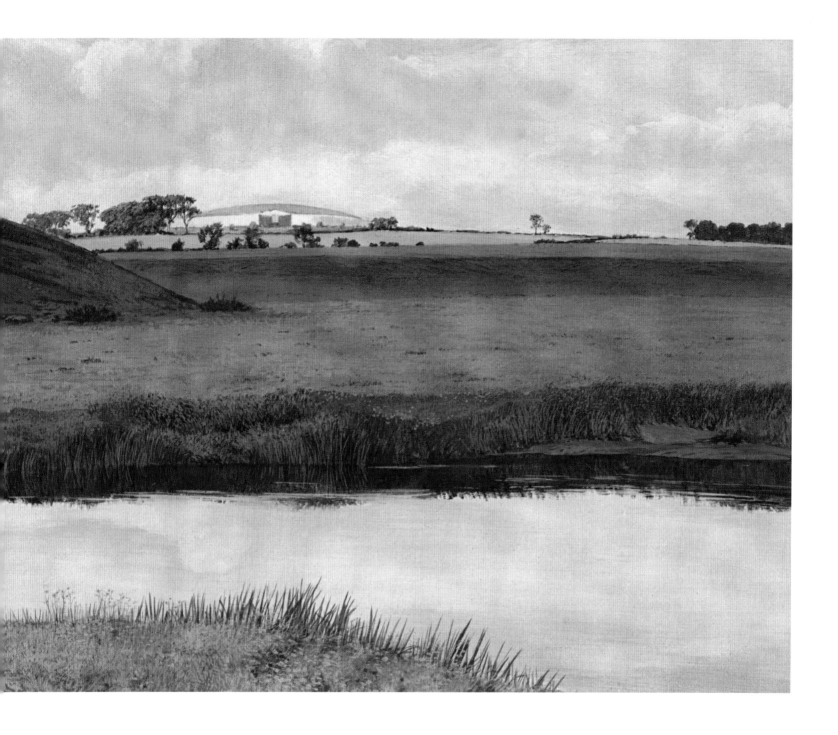

relationship with one another to achieve structural stability. The corbelling technique of Newgrange was a structural method to survive almost to the present day in vernacular building.

The great mound itself, which was probably originally higher, was made up of gravel from the Boyne layered with sods to stabilise the structure. There are several other smaller mounds in the lower terrace near the river. There is some evidence that the mound may have been covered with white quartz stones. This, combined with the size and siting of the monument, would have made it a conspicuous landmark above a notable river.

Sean Rothery, 1981

SLANE CROSS, COUNTY MEATH

The architectural set piece is a feature of many smaller Irish towns and villages, particularly those associated with great estates. It usually takes the form of a careful grouping of buildings around an open space, which was itself related to a public function like a fair green or an important public building such as the courthouse. For the vast majority of Irish towns, this architectural set piece may be the only element that the town has and it is vital that this fact is recognised and that the buildings are kept in order and the open space is given the civic dignity it deserves. Tyrell's Pass has revitalised its green and shown what a pleasant and interesting place a small Irish town can be. Too many Irish towns and villages have ignored the heritage which they have in abundance and have allowed the buildings around their square or diamond to deteriorate or to be altered insensitively. They have everything to gain by rehabilitating and proudly exhibiting the heritage of craft and design carried out by their ancestors.

The public space, instead of being a treeless waste, filled with indiscriminately parked cars or huge trailers, can become again a vital meeting place for people and a green refuge from traffic.

Slane, County Meath, is a good example of a carefully

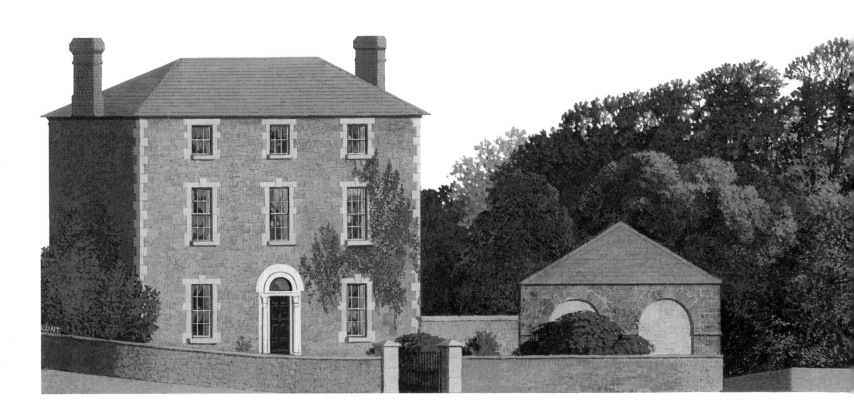

designed architectural set piece intended to give dignity to a small village. Around the crossroads, four three-storey Georgian houses were placed facing diagonally to the centre of the cross. The ends of the terraces forming the village streets are squared off to the large house and the gable ends are designed each as a pair of blind arches.

The houses are a strong and simple design in dark grey limestone with the walling in roughly coursed squared rubble and dressed quoins. The doorways are simple and each house has a different design of doorway which gives individuality to the houses. The windows have simple cut-stone jambs, slightly projecting, and a neat keystone in each lintel.

The whole layout was designed as a unit including the front gardens and iron gateways and to complete the picture the street furniture was also added in the form of lovely wrought-iron lamp standards on robust tapered stone bollards. Only four of these bollards remain.

Sean Rothery, 1976

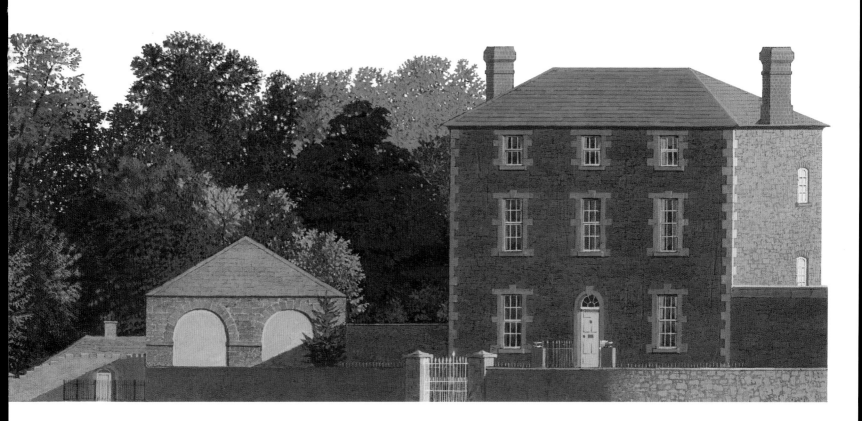

The Temple of the Winds, Mount Stewart, County Down.

A Chasm in Time

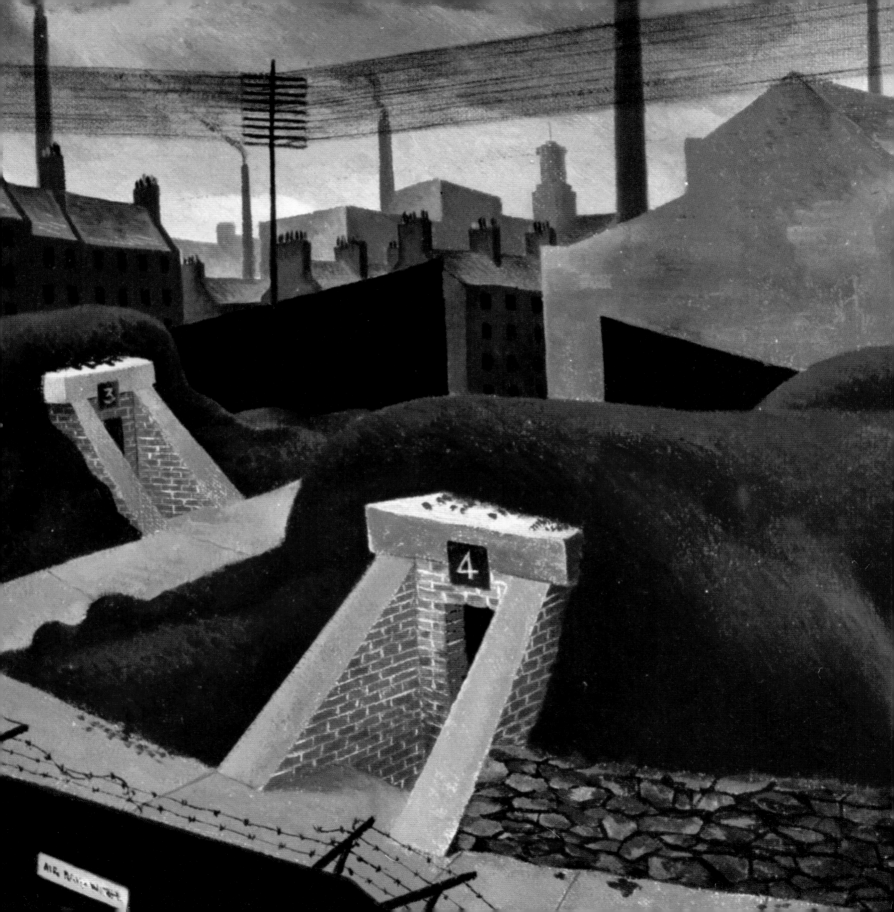

A Chasm in Time

SCOTTISH WAR ART AND ARTISTS
IN THE TWENTIETH CENTURY

Patricia R. Andrew

BIRLINN

First published in Great Britain in 2014 by

Birlinn Ltd
West Newington House
10 Newington Road
Edinburgh
EH9 1QS

www.birlinn.co.uk

ISBN: 978 1 78027 190 3

British Library Cataloguing-in-Publication Data
A catalogue record for this book is available on
request from the British Library

Designed and typeset by Mark Blackadder

The publishers acknowledge investment from
Creative Scotland towards the publication of this volume

Printed and bound in Latvia by Lavonia

DEDICATION

To two individuals who served in the major conflicts of the twentieth century, and whose contributions represent those of so many countless others

My grandfather, captain ralph farnham, lancashire fusiliers, who died of wounds on 31 october 1918 at the casualty clearing station on the ypres to poperinghe road, and who lies buried in lijssenthoek military cemetary, poperinghe, west-vlaanderen, belgium — a father whom my mother never knew

and

My mother-in-law, who, as miss irene young and as mrs l. g. cairns, served in the foreign office at bletchley park, and whose first husband, lieutenant leslie cairns, royal artillery and special air service regiment, army air corps, was posted missing in action on 18 june 1944, and who has no known grave

Contents

Acknowledgements

Publication of this book would not have been possible without the generous sponsorship of a number of trusts and individuals, to whom I am grateful for assistance in funding the costs of images and their reproduction: The Binks Trust; the Major-General J.F.J. Johnston Fund (National Library of Scotland); the David Purdie family trust; the John M. Archer Charitable Trust; the Inches Carr Trust; the A.V.B. Norman Research Trust; Lady Fiona Campbell; Will Ramsay; and a major donor who wishes to remain anonymous. Thanks are due to Douglas Connell and Gavin McEwan, of Turcan Connell, for facilitating charitable donations.

I am also indebted to Eunice Andrew, Irene Brown and the Roderick Davies Research Fund for generous assistance towards my research costs.

For advice, discussion, and information I am grateful to numerous organisations and individuals, many of whom have delved into their archives and stores for lesser-known items and provenances, and many more who have responded to queries over ownerships and copyrights.

National Galleries of Scotland: Patrick Elliott, Keith Hartley, Alice Strang, Kerry Watson (Scottish National Gallery of Modern Art); Julie Lawson, Sarah Jeffcott (Scottish National Portrait Gallery); Hannah Brocklehurst, Kerry Eldon (Scottish National Gallery); and Ryan Clee (NGS Picture Library). *National Museums of Scotland*: Dr Stuart Allan, Dr Elaine Edwards, Dr Jane Carmichael. *National Library of Scotland*: Dr Darryl Mead, Robin Smith, Alison Metcalfe and the many staff of the Reading Rooms; *The Royal Scottish Academy*: Dr Joanna Soden, Sandy Wood; *The Scottish National War Memorial*: Lieutenant-Colonel R.J. Binks; *The Scottish Parliament*, Fiona McDougall.

Aberdeen Art Gallery and Museums: Dr Jennifer Melville, Griffin Coe, Ann Steed; *Angus Museums Service*: Willie Milne; *The Barns-Graham Trust*: Geoffrey Bertram; *Biggar Museums Trust*: James Dawnay, Suzanne Rigg; *The Black Watch Museum, Perth*: Emma Halford-Forbes; *Brown University Library, Providence, Rhode Island, USA (The Anne S.K. Brown Military Collection)*: Peter Harrington;

Clackmannanshire Museums & Heritage Service: Susan Mills; *Dumfries & Galloway Council*: Siobhan Ratchford, Joanne Turner; *Dollar Academy*: Janet Carolan; *Dundee City Council (Dundee Art Galleries and Museums)*: Anna Robertson, Susan Keracher, Gareth Jackson-Hunt; *East Lothian Council Museums Service*: Dr Claire L. Pannell; *Edinburgh City Council*: Frank Little, Gillian Findlay, Paul McAuley, Ian O'Riordan, David Patterson, Helen Scott, Nico Tyack, Vicky Garrington; *Fettes College*: David McDowell; *Fife Museums & Heritage Service*: Dallas Mechan, Gavin Grant; *Glasgow Life*: Dr Mark O'Neill, Dr Joanna Meacock, Alex Robertson, Winnie Tyrrell; *Imperial War Museum*: Kathleen Palmer and the staffs of the Art Collection, Photography Archive and Department of Documents; *Perth & Kinross Council*: Maria Devaney; *The Polish Social and Educational Society, Glasgow*: Teresa Collins; *Poppyscotland*, Major Charlie Pelling, Fraser Bedwell; *The Robin Chapel*: The Revd. Thomas Coupar; *The Royal College of Physicians and Surgeons of Glasgow*: Carol Parry; *The Royal Scots Club*: Adrian Hayes; *The Royal Scots Dragoon Guards Museum*: Major Robin W.B. Maclean; *The St Andrews Preservation Trust*: Dr Peter J. Murray, Samantha Bannerman; *St Giles' Cathedral, Edinburgh*: Peter Backhouse, Veronika Kallus; *The Stirling Smith Art Gallery & Museum*: Elspeth King; *West Dunbartonshire Council, Arts & Heritage*: Andrew J. Graham.

University of Dundee: Matthew Jarron; *University of Edinburgh*: Rachel Hosker, Dr Juliette MacDonald (Edinburgh College of Art), Jacky MacBeath (University Collections); *Edinburgh Napier University*: Catherine Walker; *Glasgow School of Art*: Michelle Kaye; *University of Glasgow*: The Revd Stuart D. MacQuarrie, Lesley Richmond; *University of St Andrews*: Helen Rawson, Jessica Burdge (Museum

Collections), Rachel Hart, Catriona Foote (Special Collections).

Bourne Fine Art (now The Fine Art Society, Edinburgh): Emily Walsh; *David Cohen Fine Art, London*: David and Judith Cohen; *The Open Eye Gallery, Edinburgh*, Jilly Dobson; *The Scottish Gallery, Edinburgh*: Tommy Zyw; *Sim Fine Art, London*: Andrew Sim.

Dr Gordon Barclay, Dr Lester Borley, Alison Campbell (Kinghorn), Colonel Andrew Campbell, Joyce (Lady) Caplan, Allan Carswell, Victor Craig, Dr Elizabeth Cumming and Dr Murray Simpson, Dr Anne Galastro, Robin Gillanders and Marjory Wilson, The Earl and Countess Haig, Douglas Hall and Matilda Mitchell, Dr Nick Haynes, Dr Diana M. Henderson, Marian Hopcroft and Michael Hopcroft, George Hutcheson, Jim Hutcheson, Alison Ibbs, Andrew Kerr, John Kirkwood, The Very Revd Allan Maclean of Dochgarroch, Ray McKenzie, Leon Morrocco, Liz and John Piggott, Trevor Royle, Ann Simpson, Bill Smith, John Stansfeld, Dr Alexander Stoddart, Professor Sir Hew Strachan, Krystyna Szumelukowa, Mike Taylor, Dr Duncan Thomson, the late Margaret S. Thomson, Dr Dennis Wardleworth, Dr Norman Watson, Eric Wishart and Dr Stephen Wood.

At Birlinn, I must thank Hugh Andrew (forever labelled 'no relation'!) for having the confidence to commission this book, and the unfailingly helpful staff, especially Mairi Sutherland, Jan Rutherford and Jim Hutcheson. Particular gratitude is due to the Editorial Manager, Andrew Simmons, who has been a great support at all stages; and to Mark Blackadder for the book's elegant design.

Above all, I thank my husband, Dr Iain Gordon Brown, who has lived with this project since its

inception. It is my great good fortune to be married to a man whose wide knowledge of military history has provided numerous clarifications and has suggested illuminating connections, and whose informed interest in art has brought many items to my attention. He and I were both born at the mid-point of the century spanned by this study, and we began life in the same two countries as its first chapter – Scotland (the author) and South Africa (the spouse). He has kept me under a steady fire of constructive criticism, while giving unstinting support when I felt mired in mud or discomfited in my dug-out; he will welcome the sound of the 'all-clear'.

Abbreviations

BM	British Museum
DACS	The Design and Artists Copyright Society
IWM	Imperial War Museums
NAM	National Army Museum, London
NGS	National Galleries of Scotland
NLS	National Library of Scotland
NMS	National Museums Scotland
RAFM	Royal Air Force Museum
RCAHMS	Royal Commission on the Ancient and Historical Monuments of Scotland
RSA	Royal Scottish Academy of Art and Architecture
SAC	Scottish Arts Council
SCRAN	Scottish Cultural Resources Access Network
SNG	Scottish National Gallery, National Galleries of Scotland
SNGMA	Scottish National Gallery of Modern Art, National Galleries of Scotland
SNPG	Scottish National Portrait Gallery, National Galleries of Scotland
WAAC	War Artists Advisory Committee (Second World War)

NOTE FOR THE READER

Sizes of images are given in centimetres, height before width.

Introduction

'Is there any book on Scottish war art?' I was asked some years ago, after I had given a series of lectures to the Friends of the National Galleries of Scotland on the art of the two World Wars. A good question. I searched, but there wasn't one … so I was delighted to be asked by Birlinn to write the first such work. The quest has led me down so many interesting avenues – and into trenches and dug-outs, dockyards and anchorages, factories and forests, airfields and aircraft, homes and hospitals, to the 'front' and across the home front – and I have no doubt it will not be the last discussion of the subject.

But what precisely constitutes 'war art'? Official definitions vary, and for the purpose of this book the terms 'war art' and 'war artists' have generously wide definitions. Obviously, it includes those artists appointed to official positions, or officially commissioned to produce art of war or the war effort, or of their country at risk. But by far the largest proportion of artists featured here are those who chose to record or comment on war on their own account, sometimes in circumstances of great danger on the field of battle, sometimes from the safety of the studio. The term 'art' implies here both fine and applied art, together with memorial sculpture, and some propaganda work

and ephemera. What this study does *not* include is military art – that is, the formal and detailed record of battle scenes and events. Nor, due to lack of space, is there discussion of commemorative silver or (except in passing) uniforms, nor the video or digital work which came into use late in the century.

There is another question that any reader might ask: is the approach of Scottish artists to war, both in Scotland and further afield, different from that of other British artists? Perhaps not as much as some might wish to claim, though the influence of France and the Scottish Colourists is clearly evident in the work of many artists in the first half of the century; and, in general, there seems to be a greater awareness of the international cultural context on the part of amateur artists than was the case elsewhere. As Edward Gage noted of Scottish art in 1977, 'It would be tidy and neatly chauvinistic if we were to discover a series of powerful native traits emerging in the dawn of time and continuing to thrive over the centuries. The most we shall find, however, is a recognisable flavour … To trace the evolution of its art and architecture, is to realise just how much a part of the continent of Europe Scotland has always been.'[1]

What is all too clearly evident is that Scottish war

art lacks wider recognition. Historians of *British* war art have generally taken London as both geographical starting point and a central theme, thus minimising (often quite unintentionally) the Scottish contribution and experience; even such major events as the Clydebank Blitz are often omitted. Rather more culpably, writers furth of Scotland sometimes refer to Scottish artists as 'English', when in fact they mean British – a potential mis-attribution which some Scottish artists appear to have foreseen, and avoided, by the inclusion of visual markers of Scottishness in their work.[2]

Many Scottish artists have re-visited a wide range of war events long after they occurred, thus filling gaps in the visual record. In addition, work that was little known to the general public at the time of its creation has since been recognised as a valuable contribution to the interpretation of Scotland's experience of war, and a number of such images are reproduced here for the first time.

The definition of Scottish – as opposed to British – artists, is sometimes a difficult one to make, and it will always be a relatively subjective matter. Here, the definition is one made by the artists themselves, or by circumstances, or even by theme. But 'Scottish war art' also includes many artists working in Scotland who were visitors. Some came from other parts of Britain, some were refugees. Monographs on many of them have focused on their years of peacetime work, treating their Scottish war experiences as brief episodes in their careers, and it is interesting to see their work as a collective response to new places and events.

One of the persistent problems of any discussion of war art is that a great deal of what is described as art is good illustration, certainly, but it is work which lacks the creativity that turns an image into the category of a work of art. It is indeed difficult to determine where illustration ends and real art begins. There are numerous excellent poster designs, which

hardly changed for decades, of kilted soldiers forever standing on the esplanade of Edinburgh Castle. Then there are the celebrated illustrators such as Terence Cuneo, Peter Archer, Frank Wootton and Sir Roderick Douglas Macdonald. They can all be called artists, for they paint first-rate records of military, naval and aerial activity, often recreating retrospectively specific battles and individual acts of heroism. But the basis of their work depends on reportage and illustration, and they have already been well served by publication and commercial reproduction. It is the creative artists who have been less well recognised, amateurs as well as professionals, and who are more fully represented here.

The period 1900–2000 was selected for this book as the twentieth century encompasses an evolution in artistic approaches and social attitudes. The Second South African (or Boer) War, in progress at the beginning of the century, forced artists to consider new approaches; new forms of warfare were again having a profound effect on artists at the century's end. The war art of the twenty-first century is still evolving. Brief mention is made of work both before, and after, the twentieth century, but the narrative ends at 2000 in order to avoid the inclusion of well-publicised but possibly transient material, or the author's omission of work still to be recognised or assessed. Inevitably, the two World Wars take up the major part of both the textual and visual history.

The title of this book, *A Chasm in Time*, is derived from a letter of the poet Charles Hamilton Sorley (1895–1915). Born in Aberdeen, educated at Marlborough and enthusiastically interested in German culture, he had been arrested while studying in Germany when the First World War broke out. He chose to enlist and fight the good fight for his country, but never viewed the enemy as anything but civilised, and unlike many of his fellow-soldiers he was devoid of any illusions about war from the start,

demonstrating a very independent mind and a very un-characteristic cynicism. To his brother he wrote: 'The war is a chasm in time. I do wish that all journalists etc., who say that war is an enobling purge etc., etc., could be muzzled … All illusions about the splendour of war will, I hope, be gone after the war.'[3] He died at the Battle of Loos in October 1915. His final – and most quoted – poem was found among his kit after his death, and begins 'When you see millions of the mouthless dead / Across your dreams in pale battalions go'. His poems were published only after his death; his one formal portrait was created posthumously (see p.217).

Mention must be made of some publications which have provided a solid basis for my work; details and references are provided in the endnotes. I have used the standard histories of modern Scottish art by Duncan Macmillan, Keith Hartley and others. Specifically for art and war, my starting points have been Peter Harrington's *British Artists and War*, and his chapter in *A Military History of Scotland*, edited by Spiers, Crang and Strickland, with its further useful chapters by McFarland and Allan on, respectively, military monuments and military collections. The stimulating book by Samuel Hynes, *A War Imagined*, has given food for thought on the First World War as 'the great imaginative event' relating to 'culture and its expressions'. Brian Foss's *War Paint* contains much useful information relating to the Second World War. Various monographs, notably Kenneth McConkey's on John Lavery, have prompted me to search for further material and to make new connections. The archival resources of the National Library of Scotland, the Imperial War Museum and other collections (both public and private) have yielded a great deal of fascinating material. And through the online resources of the Public Catalogue Foundation and SCRAN, I have found several works new to me which are now included in this book.

This book is aimed at the general reader, not the academic art historian. However, as published, it represents only a small fraction of the personal research undertaken on the topic, and in-depth studies of individual artists and events will, I hope, follow.

Since I began work on this study, a flurry of new books and exhibitions has appeared on war-related topics, many of them in the business of revising and de-bunking accepted, if sometimes inaccurate, versions of written history and cultural memory relating to the First World War – for instance not one but two books on '100 objects' which serve as explanatory witnesses. Much of the new history, however, is being developed collectively on websites, and may never reach the printed page. How to refer to these is a tricky question, for websites have a habit of changing their e-names; I have therefore referred to websites by their titles, so that anyone may easily find them online. How different a world from that represented by my grandfather's War Office-issue camera, then a marvel of modern technology with which he could record the battlefield, and which now sits on my desk as I write these words.

P.R.A.
September 2014

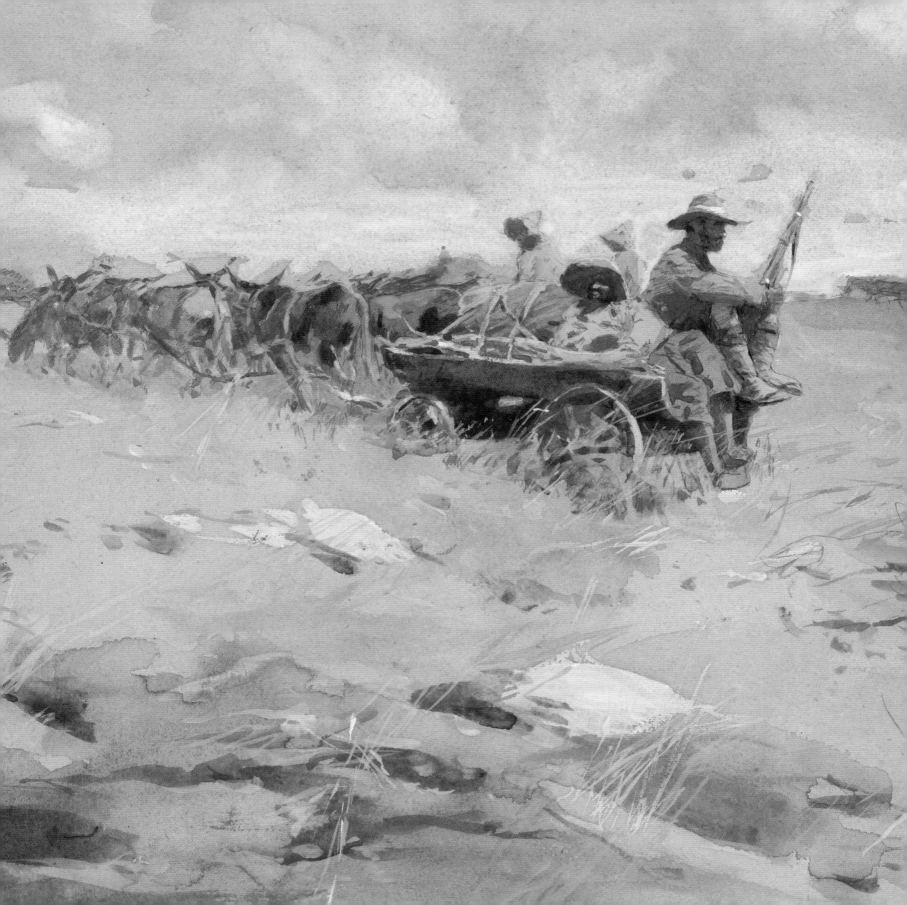

From Colour to Khaki

THE CENTURY BEGINS

In 1900 Britain was at war in South Africa, a war fought in khaki. It produced a great deal of traditional war art – heroic compositions with grand gestures – and also a new type of war art, produced by artists who had a more modern interest and intent, and who often worked from photographs. The word khaki came into the English language, and British consciousness, from India, the term first being used about 1860. It posed something of a challenge to artists, but a greater challenge was the evolving nature of war art itself, with tensions between conventional depiction and what the truthful reporter could see – concept and tradition versus reality.

War artists themselves were also changing. In the eighteenth century, the very best artists had painted war and military subjects as what were known as 'history' pictures. But by the mid-nineteenth century, artists who chose war as their subject were often second-rate in ability and conservative in attitude and style. And, all too often, they looked back to past national triumphs, particularly from the Napoleonic Wars and the Crimea, with little interest in depicting the less dramatic events of their own day,

save for the occasional glorious or glamorous incidents of the many smaller imperial campaigns of the later nineteenth-century. Artists made the most of war in Egypt and the Sudan; conveniently, Scottish regiments had always been, or seemed to have been in the minds of artists, in the thick of it. In Afghanistan and on the North West Frontier, Scottish soldiers feature prominently in the artistic record. A single episode in 1897, the storming of the Heights of Dargai by the Gordon Highlanders, was immediately the subject of monochrome images in the illustrated periodicals,

For some of the art-buying and picture-viewing public, war art simply could not *be* war art without the drama, the scarlet tunics and – for the Scots – the colourful swirl of the kilt. Yet, as the art critic Paul Konody wrote in his *Modern War Paintings* (published in 1917):

> war has lost much of its picturesqueness … everything is done to make the fighting invisible. The very colours used for active service uniform, khaki, 'field-grey,' and so forth, are chosen with this end in view. It is not without significance that in the majority of the Boer War pictures … the artist has confined himself to depicting the South African veldt, with, perhaps in the foreground some khaki-clad soldiers who at a distance are almost undistinguishable from the parched soil on which they tread …[2]

Joseph Cundall, *Crimean Heroes: William Gardner, Donald McKenzie and George Glen*, 1856. Albumen print. Scottish National Portrait Gallery

At a Royal Academy banquet in 1900, George Goschen, then First Lord of the Admiralty, lamented the loss of 'glowing colours … the varied hue of all the uniforms will be changed for one common garb …'. But there was a riposte from the *Navy and Army Illustrated*: 'A khaki uniform is no more monotonous than are successive green fields. It will lend itself to artistic treatment …'[3] In fact, although the Boer War may have lacked colour, it made up for it in the shock of modernity, stimulating artists to look at contemporary, not past, events.

then within a year, the subject of oil paintings by no less than four Scottish artists. One English painter, not artistically satisfied with the fact that the Gordons had worn khaki (as the Scottish artists had shown) actually put them back into scarlet tunics. It was English and French painters, rather more than Scots, who saw the Scottish soldier as a figure of high romance and dramatic courage.

Avant-garde artists were, by contrast, increasingly interested in everyday subjects rather than war art. But, despite this, the market for traditional war and military subjects was still generally buoyant (as it continues to be today); a military artist could make a good living, and large numbers of works were on show in public exhibitions. Incident, not mood or setting, was the key to much of their output, and during the Boer War their work was popular in illustrated magazines.[1]

THE INFLUENCE OF PHOTOGRAPHY

Photography provided a rival medium to painting in terms of record. After the Crimean War, Queen Victoria commissioned Joseph Cundall and Robert Howlett to produce a series entitled *Crimean Heroes*.

The images of The 42nd Royal Highlanders (The Black Watch) may have been taken in Dover, where the regiment was in garrison after its return from the Crimea. But they succeed in their aim of showing ordinary Scottish soldiers with their distinctive Crimea medals, their identities recorded and their faces shown in sufficient detail to display individualities of character.

Of rather more interest today on technical grounds are the earlier images made by Robert Adamson and David Octavius Hill. These show soldiers in recognisable Scottish locations, and could even capture movement by the deliberate blurring of the image, for example in their record of the *92nd Gordon Highlanders at Edinburgh Castle, 1846*.[4]

A twenty-first-century perspective can imbue earlier images with significance unintended by their makers. Fred Bremner (1863–1941) was the son of a professional photographer in Banff, who went to India in 1882 and was based there for nearly forty years. His photographs of Afghanistan were originally valued as records of traditional ethnic 'types', but they now have the added resonance of recent British involvement in the region.

Photography left traditional artists with something of a challenge. Many responded by attempting to achieve visual effects not yet possible in photography: scale, colour and a sense of movement. Huge tableaux set new standards in dramatic, theatrical representation – something that twentieth-century artists were to find difficult, and often inappropriate, to emulate. One spectacular example is Alphonse-Marie-Adolphe de Neuville's vast painting *The Storming of Tel-el-Kebir*, recording a decisive moment in the British invasion of Egypt in 1882. The artist did his preparatory work carefully, consulting Black Watch officers to ensure all details were correct, and in a battle conveniently still fought in scarlet, the uniforms comprise much of the visual excitement of the picture.

However, the battle image best known today from this period is a much smaller work, *Scotland for Ever!* by Elizabeth, Lady Butler (1846–1933). Painted in 1881, it was exhibited at the Egyptian Hall in Piccadilly, as much a glorious entertainment as an attempt at retrospective historical record. It depicts the charge of the 2nd Royal North British Dragoons (Scots Greys), part of the Union Brigade, at the Battle of Waterloo, sixty-six years earlier. Butler asserted in her autobiography of 1922 that she never painted for the glory of war, but to portray its pathos and heroism. However, she was very shrewd in creating a picture which appealed to patriotic sentiment while also providing a thrill. It certainly proved to be incredibly popular in her own lifetime, as indeed it remains today. During the First World War its composition was even adapted by the Germans for propaganda purposes (p.63).

Fred Bremner, *Afghan Warriors*, c.1895. Platinum print made by Pradip Malde from collodion glass negative. Scottish National Portrait Gallery

Alphonse-Marie-Adolphe de Neuville, *The Storming of Tel-el-Kebir*, 1883. Oil on canvas, 221 × 382.5 cm. National Museums Scotland

Elizabeth, Lady Butler, *Scotland for Ever!*, 1881. Oil on canvas, 101.6 × 194.3 cm. Leeds Art Gallery

There were other reasons for Butler's success. She featured the common soldier in many of her paintings, thus appealing to a wide audience. She also avoided any modern trends in style and was therefore – in artistic terms – reassuringly 'safe'. In fact she claimed that she was stimulated into painting *Scotland For Ever!* by the horror experienced on seeing avant-garde art at the Grosvenor Gallery, relating in her autobiography that this 'Home of the "Aesthetes" of the period' with its 'unwholesome productions', produced in her a 'point of exasperation' upon which she 'fairly fled' home to start *Scotland for Ever!* as a result. Though apocryphal, it made for a good personal anecdote.[5]

INDIVIDUALS INSIDE THE UNIFORMS

By the mid-nineteenth century, individual soldiers or sailors were increasingly featured by artists. In particular, there were a number of gallant pipers shown encouraging their regiments under fire.

William Simpson (1823–1899), born into poverty in Glasgow, became famous for his paintings made from on-the-spot sketches in the Crimea, earning him the nickname of 'Crimea Simpson'. He was sent to record the campaign by the art dealer Colnaghi in 1854, thus becoming one of the first war artists in the modern sense. His sympathy was always with the common man, and his images document the working life of an army as much as events on the battlefield. Typical of his interest is the watercolour of *Huts and Warm Clothing for the Army* showing troops bringing supplies to a winter camp under construction.

Simpson's main purpose was to document a scene accurately, describing the terrain and weather conditions in which the Army had to operate. He never shied away from the problematic or embarrassing side of what he called 'The War in the East'. One of his images of Balaklava could not be further away from theatrical cavalry charges or other military heroics, showing a supply train and gun stuck in a muddy road; it is entitled *Balaclava 1854: Commissariat Difficulties*.[6]

Like many artists, William Skeoch Cumming (1864–1929) had to work from second-hand information when depicting the British Army in the Second Afghan War. Luckily, he was able to mask his lack of acquaintance with the terrain (and what might grow on it) with a great deal of snow. But if his images lack topographical detail, his portrayal of individual soldiers is truly modern. His painting of a sentry, a

William Simpson, *Huts and Warm Clothing for the Army*, 17 January 1855. Pencil and watercolour on paper, 24.0 × 34.3 cm. Anne S. K. Brown Military Collection, Brown University Library

William Skeoch Cumming, *A Gordon Highlander
in the Afghan War*, 1881. Oil on canvas, 28 × 19 cm.
The Gordon Highlanders Museum

Gordon Highlander, blowing on his hands in the cold, is known as 'The Frozen Jock'.

Cumming did, however, go to South Africa, having volunteered with the Imperial Yeomanry in the Second Boer War. He travelled a great deal, making sketches and taking photographs (over 300 of which are now in the Imperial War Museum). He recorded everything: people, the routines of army life, transport across the veldt, and some actual fighting. Many of his photographs and sketches formed the basis of later paintings, and the compositions taken from photographs hardly attempt to hide their origins. There is a great feeling of movement in Cumming's work, and the muted tones – together with the empty horizons – really succeed in conveying a sense of wide open space, and the distances the British army 'trekked' in this war. The image reproduced on page 1, signed and inscribed 'Transvaal 1900', shows a mule-wagon trundling away from the viewer across the veldt, a kilted Scottish solder with a slouch hat seated at the rear and holding his rifle almost in a 'Wild West' style, in company with native drivers or levies.

Cumming's views of South Africa, with their new type of 'landscape with soldiers' compositions, benefited from being created before the British Government imposed any real censorship (though the written word was vetted). There is always a feeling of artists and photographers working quickly, and on the move, even if their finished productions show little of the raw stuff of the original photographs. They may not have had the dramatic punch of the contemporary woodcut illustrations which appeared in the popular magazines of the day, but there is a freedom about them, and a sense of documentary truthfulness, communicating to the viewer how this war was being experienced and fought.

By contrast, William J. Kennedy (1859–1918) had more purely artistic intentions in his series of paintings of the 3rd (Militia) Battalion, Argyll and

William J. Kennedy, *Midday Rest*, c.1892–93. Oil on canvas, 61.3 × 91.7 cm. Glasgow Museums

Sutherland Highlanders, made when the regiment was encamped near his home in Stirling for training in summertime. His interest in the daily routine of troops was unusual at the time, and led to his nickname of 'The Colonel'. He shows the heat of summer, with soldiers at rest, as well as at drill or on manoeuvres. His interest in form, colour, shadow and compositional arrangement shows the influence of contemporary artists such as James McNeill Whistler and Jules Bastien-Lepage.

MEMORIALS AND PROPAGANDA

Loss of life in South Africa was significant: as many as 8,000 Scottish soldiers died during the Second Boer War. Memorials were produced in large numbers, naturally for commemoration, but with an eye to recruitment too, and they gave considerable scope for creative and lively figurative sculpture.

No better examples can be found than the trio of sculptures made by William Birnie Rhind for central Edinburgh, funded by subscription and placed in prominent sites between the Old and New Towns. On North Bridge, the memorial to the King's Own Scottish Borderers (The Edinburgh Regiment) is placed high above the balustrade. It commemorates the Regiment's losses in various Imperial campaigns between 1878 and 1902, and was unveiled in 1906. Four large stone figures look out in different directions, all set on a rocky outcrop, probably in Afghanistan or the Tirah. They display differing emotions: the great-

W. Birnie Rhind, *Memorial to The King's Own Scottish Borderers*, 1906. North Bridge, Edinburgh

W. Birnie Rhind, *Memorial to The Royal Scots Greys, South African War*, 1906. Princes Street Gardens West, Edinburgh

OPPOSITE.
Peter Wishart, undated painting entitled *1914*. Oil on canvas, 92.1 × 123.2 cm. Royal Scottish Academy

coated officer with field glasses appears to be keeping up morale, while his men strike various poses between resolute defiance and cold despair.

The Royal Scots Greys memorial stands halfway along Princes Street, within Princes Street Gardens West. It comprises an equestrian statue of a trooper of the regiment, wearing full-dress uniform; this was also unveiled in 1906. Unlike the memorial to The King's Own Scottish Borderers, in which all the figures are clad in the uniforms they wore when they served on campaign, the Scots Grey sports a much more glamorous order of dress, avoiding any reference to the modern warfare the regiment was seeking to commemorate.

The Black Watch South African War memorial, unveiled in 1910, stands halfway up the Mound, at the sharply angled junction with Market Street. The bronze statue of a kilted soldier, dressed in review order and wearing the two Boer War medals, looks towards the Castle. He stands on a polished granite base, above a tablet showing soldiers of the regiment in action in South Africa; the reality of war thus contrasts with the romantic formality of the main figure.

The changes in artistic depictions of war were still only tentative steps towards a more dramatic shift provoked by the enormity and modernity of the First World War, which started just twelve years after the end of hostilities in South Africa. The subjects that artists chose, or were asked, to depict was also changing: technological development, and the armoured power of Royal Navy's Dreadnoughts, meant that warships had an increasingly dark, menacing and threatening appearance.[7]

LOOKING BACK FROM THE FUTURE

Viewing it in retrospect, one can only describe Peter Wishart's painting of a military summer camp at Holyrood as innocent. Wishart (1846–1932) was an Edinburgh artist whose paintings show the influence of other Scottish artists such as William McTaggart. We do not know exactly when it was painted, or which occasion is represented. It could in fact have been an imaginary scene made at the outbreak of war, or even afterwards, for this is very much an encampment scene at Holyrood (rather than the normal artistic record of a Review beside the Palace). But at some point the artist inscribed it with the title '1914'. The day is light, bright and cheerful, the clouds scudding across the sky above Holyroodhouse and Calton Hill. In the foreground, couples disport themselves on

Robert Gibb, *The Thin Red Line*, painted 1881, illustrating an event from the Crimean War in 1854. Oil on canvas, 108 × 216 cm. Collection Diageo, on loan to National Museums Scotland

the grassy slope of Arthur's Seat, while the troops marching in column from the right seem to be almost an afterthought. It was typical of such camps all over the country: a description of the 6th Argylls' summer camp in 1914 at Machrihanish reads:

> The camp was similar in most ways to the training camps which some of us had attended for almost twenty years of service. The same canvas city gleaming white in the last rays of the setting sun, the same military routine, the same cheery mess tents and the same holiday spirit and jolly comradeship of old friends![8]

But the world was about to change, and there is no better example of an artist who experienced these changes than Robert Gibb (1845–1932). Gibb was an eminent artist, also Keeper of the National Gallery of Scotland (1895–1907) and Painter and Limner to the King in Scotland (1908 until his death). Much of his reputation rests today on a single work, *The Thin Red Line*, painted in 1881 as one of a trilogy of Crimean war pictures. This example (the others are of The Black Watch at the Alma, and of the Guards at Inkerman) celebrates a famous incident at Balaklava. The 93rd Sutherland Highlanders, drawn up in line, had repulsed a Russian cavalry attack, and the correspondent of *The Times*, William H. Russell,

had described the British infantry's resolute stand as a 'thin red streak tipped with a line of steel'.[9] Russell's words became mis-quoted as the 'thin red line', this phrase continuing in the popular imagination to symbolise the steadiness of the British soldier under fire. When first exhibited, the painting was a sensation. It represented a type of warfare that had already passed, the subject more a show of character than of realistic military action.

Far less well known today is another painting Gibb produced over forty years later. It commemorates an action late in the First World War and this, too, was created after the event, though by little more than a decade. Entitled *Backs to the Wall* and painted in 1929, it takes its title from Field Marshal Sir Douglas Haig's famous 'Order of the Day' to the British Army on the Western Front issued on 11 April 1918, with its appeal for the holding of every position to the last man, 'With our backs to the wall'. Gibb's two compositions are similar in their basic design, but in the second one his kilted soldiers are clad in khaki on a battlefield of mud, their ranks thinned by the attrition of war. Gibb transports the scene from modern warfare, however, to a timeless dimension, by adding a heavenly cavalry host with wings, swords and helmets, galloping to the infantry's aid as if from a remote past.

Robert Gibb, *Backs to the Wall*, 1918, painted 1929. Oil on canvas, 162.3 × 244.0 cm. Angus Council

CHAPTER 2

'A Chasm in Time':
The First World War, 1914–18, and its Aftermath

WAR BEGINS

The Edwardian 'summer', a concept continually re-visited in later decades in the popular imagination, was evoked in numerous contemporary paintings of sunlit interiors and glorious gardens. While the 'Glasgow Boys' were taking new steps in art, much of the picture-buying public continued to prefer the more conservative styles of artists such as Patrick William Adam (1852–1929). Based in North Berwick from the 1900s, Adam painted idyllic views of the drawing rooms and gardens of affluent houses, immaculate in their elegance or prettiness. It was his own social milieu: born in Edinburgh, the son of a well-known lawyer, Adam had studied at the Royal Scottish Academy under George Paul Chalmers and William McTaggart, and travelled widely in Europe. His paintings are full of charm, and although they might lack artistic adventure and eschew any self-consciously intellectual elements, they convey with great skill and sensitivity the atmosphere of domestic quiet-ness and – in retrospect – the security of untroubled lives in what became a vanished world.

However, there is one panting that stands out in Adam's *oeuvre*: a sudden outburst of artistic anger

simply entitled *War*, dated 1915 – a war which erupts into a room still basking in sunlight. The room is clearly intended to be Belgian or French, with its Catholic crucifix on the wall above a prie-dieu, though the sash and shutters look rather more like those of Edinburgh. It appears to be the home of an art-lover, for a portfolio rack stands near the crucifix. It was Germany's invasion of Belgium that had prompted Britain's entry into the war, and the British public showed great moral as well as political support for the Belgians, regarding them as innocent victims in whose defence the country should rally.[1]

After Britain's mobilisation, and declaration of war on 4 August 1914, there was spontaneous enthu-siasm to join the forces, with queues forming outside recruiting offices. Proportionally speaking, more volunteers came forward from Scotland than from the rest of Britain during the first year of the War. Some recruits may have been prompted by patriotism, but the opportunity to leave predictable jobs and see adventure was also a great inducement. There was confidence that the conflict would be short and deci-sive, sentiments naturally reinforced by the recruit-

OPPOSITE.
Patrick William Adam, *War*, 1915.
Oil on canvas, 90.2 × 110.5 cm.
Dundee City Council (Dundee
Art Galleries and Museums)

ment campaign. In retrospect, the number of posters produced might seem extraordinarily high, but Britain's armed forces depended on voluntary enlistment until 1916; until then, the only tools at the Government's disposal were enticement and moral persuasion. During the four years of the War, over half a million Scots joined the army, most of the rest of the male population of recruitment age being employed in reserved occupations.[2]

The chromolithograph posters were simple and punchy, and often very colourful. *Your King & Country Need You*, after Lawson Wood, shows a soldier of The Black Watch (Royal Highlanders) with the caption 'A wee "Scrap O'Paper" is Britain's Bond' (the guarantee of Belgium's neutrality). The notice on the wall behind the soldier identifies the location as a Belgian street corner; the village in the background, with its crow-stepped gabled houses, appears to represent the Scotland he also defends. Appealing to the less serious young man, *Line Up, Boys! Enlist To-day* shows four kilted Argyll and Sutherland Highlanders laughing merrily as they march in step with rifles held jauntily over their shoulders, a clever design suggesting a relaxed camaraderie.

HOW TO REACT: ADAM AND CADELL

Patrick William Adam's *War* expressed forcefully his emotional shock at the outbreak of the conflict. He was too old for active service, but his fellow-artist Francis Campbell Boileau Cadell (1883–1937) promptly attempted to join up. He was initially refused on grounds of health, so gave up his pipe and made a strenuous effort to get fit, joining the Royal Scots in 1915.

Both Cadell and Adam were members of the Society of Eight, the group of Scottish artists formed in 1911, with Cadell its most brilliant member. Adam suggested that the group's 1914 exhibition should be cancelled owing to the outbreak of war, and other members initially agreed. But the extrovert and bullish Cadell did not – 'No, Mr Adam's proposal sniffs too strongly of the death chambers of the vanquished' – and he proposed they should exhibit as planned 'and by doing so show ourselves to be a victorious, joyous, prosperous society rather than a fearful, trembling, tottering collection of old wives waiting to see which way the wind blows'. The show was held.[3]

Before leaving for France, Cadell produced a series of drawings of service life, twenty of which were published in 1916 in London by Grant Richards as a book, *Jack and Tommy*, and sold in aid of the Red Cross. The books are now rare, such was the popularity of the prints, which were pasted into the book very lightly and were easy to sell later as separate images. In terms of subject-matter, their viewpoint is from the ranks – indeed, Cadell was very reluctant to take a commission.

Cadell had studied in Paris and lived in Munich, and his pre-war work shows Impressionist and other continental influences – though these images, with their flat bocks of colour, are also reminiscent of the deft dabs of paint in the compositions of Joseph

Some posters betray their English-based committee origins, a particularly glaring example being *Your Country's Call. Isn't this worth fighting for? Enlist Now*, produced in 1915. Published as Number 87 by the Parliamentary Recruiting Committee, and printed by Jowett and Sowry (Leeds), it shows a Scottish soldier gesturing proudly to an idyllic scene behind – an English one, with its thatched cottages set in rolling hills. It speaks volumes for the lack of English awareness of different identities within Britain (and, one wonders, would an English soldier ever have been depicted standing in a Highland glen?).

F. C. B. Cadell, *Jack and Tommy*, from the book *Jack and Tommy*, 1915. Ink and watercolour on card, 42.7 × 31.6 cm. Scottish National Gallery of Modern Art

F. C. B. Cadell, *Jack and Tommy: Tommy and the Flapper*, 1915. Ink and watercolour on card, 43.1 × 34.3 cm. Scottish National Gallery of Modern Art

Crawhall (1861–1913). The brisk, economic brush-and-ink technique may also have been based on illustrations made by the Dutch Fauve painter, Kees van Dongen, for journals in the early 1900s. They anticipate the development of Cadell's style in the 1920s, when his work became brighter and bolder. There is great economy in both line and colour, with a well-placed dot creating an expressive eye, or a short dash an equally expressive mouth. The image which takes its title from the book, *Jack and Tommy*, shows the back of three heads, a sailor and two soldiers. And the social comments are all very modern: the image of a solder talking to a girl is entitled *Tommy and the Flapper*, the term 'flapper' implying, at that time, a young woman rather less respectable than the word came to mean in the 1920s. The com-bination of popular theme and brilliant execution resulted in success with the critics and the general public alike.

FIGHTING FOR THE BELGIANS

The German invasion of neutral Belgium not only forced Britain into war, it also produced a huge emotional response, whipped up by stories of German atrocities (some real, some exaggerated) against Belgian civilians. The general public regarded Belgium as the plucky underdog whose morale must be supported. Recruitment posters and contemporary cartoons often showed examples of the bestial behaviour of the Hun. George Ogilvy Reid (1851–1928) encapsulated the feeling of the British public in his image of Belgian troops, dispirited, bloodied and yet defiant, entitled *1914: The Belgians on the March*.[4] Many Scottish artists had visited, or lived in, the Low Countries and they knew its cities and people well. A particular sympathy for Belgians was thus felt in the artistic community. The Dundee artist David Foggie (1878–1948), for example, had studied at Antwerp's

Academy of Fine Arts. Another Dundonian, Alec Grieve (1864–1933), had made many visits to France and Belgium, and continued to do so after the War, painting cityscapes with obvious affection as well aesthetic interest.

There was also the practical matter of coping with a sudden influx of refugees. Around 250,000 Belgians sought safety in Britain, the largest wave of refugees the country had ever received. Huge national fund-raising campaigns got underway, and all over Britain there were exhibitions, auctions, concerts and recitals to raise money. *The Daily Telegraph* started a 'Belgian Fund', and published *King Albert's Book* in conjunction with Hodder & Stoughton. In London, the Royal Academy's 1915 winter exhibition included a section of Belgian work, with proceeds to charity. On the afternoon of Saturday 23 January 1915, a *Burns' Birthday Celebration* took place at the Royal Albert Hall, a 'Grand Scotch Festival and Patriotic Concert in aid of the Belgian Relief Fund', boasting a culturally diverse line-up headed by 'Mme. Tamaki Miura, The Japanese Prima Donna', and also featuring 'Mr Alfred Fyffe, The New Scotch Tenor' and 'Band and Pipers of His Majesty's Scots Guards'.[5] There was a real awareness of the enormity of the refugee problem, and that it might continue to grow: the journalist James W. Herries wrote in 1915 that in Paris as well as London 'there are thousands of Belgian refugees whose case is often piteous'.[6]

In Scotland, Glasgow Corporation Belgian Refugee Committee was responsible for finding homes for refugees across the country, with many housed in Glasgow and the surrounding areas. Individuals also did their bit: the artist Muirhead Bone (p.20) organised collections, and many households, rich and poor, took in whole families. Lady Cynthia Asquith noted in February 1915 that the Earl of Wemyss had provided hospitality at his Cotswolds seat – 'a refugee family had been installed in the flat above the Stan-

Frank Spenlove-Spenlove, *Belgium, the Lowly Bow to Share a Nation's Woe*, 1915. Oil on canvas, 73.2 × 122.7 cm. The Stirling Smith Art Gallery and Museum

way stables and Prew [coachman to Lord Wemyss] and his wife, who had to move back to their own less convenient cottage, were not over-pleased with "them Belgians"'.[7] Patrick William Adam's painting *War* was thus typical in its sentiment. However, it packed more of a punch than many images of the subject (and interestingly, it was presented to the City of Dundee in by another, rather less destitute, refugee from war and political upheaval).[8]

The Stirling-born artist Frank Spenlove-Spenlove (1868–1933) knew Belgium well; indeed a large proportion of his output, both before 1914 and after 1918, featured Flemish towns and citizens. His painting of 1915 entitled *Belgium, the Lowly Bow to Share a Nation's Woe*, is an essay in dramatic emotionalism, as we see a lonely figure at prayer across an empty church interior, the muted palette lending a starkness

to the gloom. *The Scotsman* published it on 1 May 1915.

Greater realism is shown in the dramatic portrait by Norah Neilson Gray, *A Belgian Refugee*, which shows a dejected elderly man from Liège, whose tension and distress is palpable. It was exhibited at the Royal Scottish Academy in 1918 as *The Liégeois in exile*, and won a bronze medal when shown in Paris in 1921.

Helensburgh-born Gray (1882–1931) moved to Glasgow around 1901; she studied, and later taught, at Glasgow School of Art. During the War she worked in France as a Voluntary Aid Detachment nurse (p.55). Most artists' responses, however, were simpler and often rather sentimental. William Strang (1859–1921) produced an unusually (for him) sentimental *Belgian Peasant Girl*, purchased in 1915 by

Manchester City Art Gallery, a great contrast to the coquettish *Italian Girl* of the same year.[9] These were only a couple of the many paintings relating to Belgium which were acquired by British galleries on a wave of sympathy during the war years.

The defiance of Flanders was expressed by the sculptor James Pittendrigh Macgillivray (1856–1938) in *La Flandre* of 1914. Macgillivray was initially optimistic about the war, and *La Flandre* represents a healthy, victorious and heroic Flanders, with flowing hair and sprigs of laurel (the hair and attitude deriving in part from his *Hypnos* of 1900, showing the Greek god as female).[10]

Macgillivray also produced a volume of privately published verse in 1915 entitled *Pro Patria*, including a poem on Flanders with the line 'And there La

Flandre, proud, shall yet stand free!'. Despite the serious sentiments, Cadell organised a 'La Flandre' evening when the sculpture was completed (which – Cadell being Cadell – lasted until about 5 a.m.).[11] Also in 1914, Macgillivray made a bronze *Pietà*, influenced by Michelangelo's late Pietàs, possibly intended as a future war memorial at a time when it was still believed that the conflict would be short.[12]

Macgillivray's later wartime sculpture became increasingly tragic in tone as his disillusion grew. His sculpture *The Wife of Flanders* (1915) was inspired by a poem of that title by G. K. Chesterton, and it forms a contrast to *La Flandre*, being a ravaged and distraught image representing the ruinous result of war. The bronze exactly replicates the lumpy wax maquette, and with its truncated base and arms the

figure appears deformed.[13] In November 1917, as the war dragged on, Macgillivray condemned (in a lecture given to the Edinburgh Architectural Association) the extravagance and jingoism of those who planned war memorials before the war had ended, now that there seemed to be no end in sight.[14] In fact there were artists such as Henry John Lintott already painting memorials to the dead (p.60), and James Pryde was producing a series of haunting, if theatrical, paintings of monuments (p.228).

ATTITUDES TO ART:
PROPAGANDA AND RECORD

Some artists felt alienated from the war, or regarded it as merely an annoying interruption to their studies, work or personal lives. Many artists, and much of the specialist art press, had personal connections in Germany and were deeply saddened by its new status as an enemy; the popular press, by contrast, had no qualms about the near-demonisation of the entire German nation. Selwyn Image (1849–1930), Slade Professor of Fine Art at Oxford – and a notably pious individual – expressed the views of many educated people in a letter of 27 August 1914, in which he blamed 'Prussian Militarism' for the war rather than the German nation, saying 'I do wish now in the thick of this ghastly misery we could all bring ourselves to think, if not to speak, of the war for what essentially it is – a war not with Germany, but with that spirit of Military Caste that has crushed Germany as it longs to crush the world'.[15] Three months after the start of the War, he gave a lecture at the Ashmolean Museum, Oxford, entitled 'Art, Morals and The War'. It was a talk he had already delivered to various groups, its content better suited to a general, rather than an art-minded, audience. But in it he pleaded that the nation should not lose sight of art – 'one of the vital, perma-

nent, universal interests of the human race' – and he cited the fact that Michelangelo had created great art while being also employed on military projects, saying 'War and Art are not always enemies'.[16] Two years later Image had rather more to complain about, for the Government decided to close public museums and galleries as a cost-cutting measure, prompting him to write, 'O what fools, what fools! How the Huns will chuckle! I've fired off a letter to the Times this afternoon by way of protest.'[17] In fact there was so much public protest that museums and galleries re-opened, and no further move was made to close them.

Serious journals such as *The Burlington Magazine* continued to publish excerpts from German periodicals through most of the war. Some individuals in the art world were so aloof from current affairs, and so ignorant of current opinion, that they were unaware of the *faux-pas* they were committing. In 1916 Joseph Pennell mounted an exhibition entitled *Germany at Work* at the Leicester Galleries, expressing admiration for German industry and functional building styles; not surprisingly, he met with strong criticism from *The Connoisseur* for his pains.[18] His attitude was in marked contrast to the response of those British artists who followed current affairs more closely, and had reacted so strongly to Germany's aggression.

The first British soldier died on the Western Front on 21 August 1914. Yet the first official scheme for war artists started only in 1916, the same year that conscription was applied, and tanks were first used in the War. Initially, official art was intended mainly for propaganda purposes, the Government at last recognising the value it might have for that purpose. The scheme was managed from Wellington House, London (the scheme's organisation often being referred to simply as 'Wellington House') and run by Charles Masterman, Head of Propaganda, under the aegis of the Foreign Office. It grew into the largest and most

comprehensive national patronage of art that Britain, until then, had ever known, for it soon aimed at a much higher purpose – the creation of an artistic record, and thus a memorial to the War. Paintings were commissioned from some of the best, and the best-known, British artists, generally conventional in their artistic approach, though occasionally the more avant-garde as well. But despite its rather conservative artistic tendencies, the arrangements represented a new departure in terms of art patronage and organi-sation. Never before had the world suffered a compa-rable experience, and never before were artists of widely differing modes of expression given the oppor-tunity of meeting such a challenge.[19] It was a time when – in Britain at least – commissions for art were still mainly private rather than public, and it therefore represented a real departure in patronage.

By the time it started, there was growing pressure to send artists to the Front, for both France and Germany already had artists in the field. By 1916, too, attitudes were beginning to change towards subject-matter. No longer could artists show merely old-style dramatic heroism, or pristine uniforms in the midst of this new type of carnage, and no longer was each rank or regiment so recognisable when all were clad in khaki and fighting in a sea of mud. Those commissioning art knew that traditional heroic images were no longer possible.

Most histories of British war art have emphasised the work of English artists such as Christopher Nevinson and the brothers Paul and John Nash. The work of Scottish artists – generally rather less avant-garde – has been somewhat under-represented. What really stands out is the extent to which the war work of Scottish artists represents a departure from their personal norms of theme and style. Patrick William Adam, James Paterson and Henry Lintott are good examples, and they were working without even seeing the war first-hand. There were those who did see it

first-hand, but who never spoke of it afterwards, such as William Gillies, and for many the sense of tragedy was compounded by their previous visits to Belgium, France and Germany as well. In August 1914 Muir-head Bone wrote to Campbell Dodgson: 'How awful the war is. It makes one almost unable to work … I also have many of my best prints in Leipzig.' Like many artists he mused: 'It is very sad that all our good relations with Germany will be scrapped. How is it that individual Germans are so nice and appreciative and the Prussian military machine so beastly?'[20] Looking back in 1975, Keith Henderson remarked that 'There was no great malice in the British army. We didn't hate the Germans – we had a reasonable view of them I think.'[21]

MUIRHEAD BONE: OFFICIAL WAR ARTIST

Muirhead Bone (1876–1953) was the first official war artist to be appointed. He was a Glaswegian who trained initially as an architect. By 1914 he was one of Britain's leading draughtsmen, recognised for his production of accurate, detailed – and yet atmos-pheric – drawings of cityscapes and architecture, produced at speed and suitable for reproduction. He began printmaking in 1898, becoming well known for his etchings and drypoints. His work had energy and power, and his detailed narratives of city life demonstrated an enthusiasm for the modern world, conveyed in a tonal monochrome that was modern in style, yet which ignored much of the artistic avant-garde. His reputation extended beyond Europe to America. These considerations, together with Bone's ability to produce detailed and accurate drawing, made him a prime choice for Wellington House. His social attitudes and milieu were also in his favour, for he was well connected and appeared conservative and 'safe'. In the event, Bone showed an appreciation of

art very unlike his own, proving to be something of a 'Trojan horse', and facilitating other artists of a very different stamp in gaining employment on an official basis. But his appointment in 1916 was intended as a 'one-off', primarily for the production of propaganda images.

It was Bone's imminent call-up that seems to have prompted his appointment as an official artist, for W. P. Mayes noted in his history of the scheme that until 1916 (when conscription was introduced)

the principal raw material of the Pictorial Department was the photograph … The first official suggestion of using artists for pictorial propaganda was contained in a letter dated 12 May 1916 from A. P. Watt, literary agent and member of the Wellington House team, to Ernest Gowers, by then its chief of staff. Watt tells Gowers that Muirhead Bone's call-up is imminent and suggests that this highly esteemed draughtsman and etcher could be used to better advantage working for Wellington House than as cannon-fodder.[22]

While negotiations over Muirhead Bone proceeded, a pictorial department was set up, and in July 1916 Alfred Yockney, who had been editor of the *Art Journal*, dealt with everything relating to employment. Bone went to France on 16 August on his first six-month commission, with the expectation that he would produce drawings for both propaganda and historical record (his first drawing is dated 17 August). He was commissioned as an Honorary 2nd Lieutenant and provided with a car, enabling him to gain easy access to the action at the Front.[23] He had to sketch quickly, using pencil and pen, charcoal and chalk, with watercolour added back at his billet; he sent home about 150 drawings by the beginning of October. He found that the complete devastation of

landscapes and towns made for a lack of suitable subject-matter, though he did produce the first artwork featuring a tank (first used in action in September 1916). But he was permitted to show neither the actual killing of soldiers, nor any dead.

Bone was far from the first artist at the Front. Many artists had already made their way there, but they were either amateurs serving in the Forces, or working unofficially, taking their material home to create settings for events and actions they had not necessarily witnessed personally. The fact that Bone was working from life, rather than reconstructing events, was a significant aspect of his appointment; the emphasis throughout this scheme (and that of the Second World War) was on eye-witness accounts.

One of the photographs of Bone in France, taken

Photograph by Ernest Brooks, *Muirhead Bone Crossing a Muddy Road, Maricourt, September 1916.* Imperial War Museum

by the first official war photographer, Lieutenant Ernest Brooks, in September 1916, shows the artist cheerfully striding through a road awash with a stream of mud, the mud that came to characterise so much of the Western Front in the description of the participants and the minds of later generations.

It was very different from Brooks's other images of Bone, all too posed for the camera. One subsequently reproduced in a number of publications shows the artist drawing the shrine of the Virgin at Montauban, standing in a landscape scarred with army transport, with a group of men looking over his shoulder admiring his work. In another, he perches on a box comfortably labelled 'Bacon' alone in a grassy field, with clean boots, and no debris of war in sight.[24]

Bone returned to Britain on leave towards the end of December 1916, then made drawings of domestic industrial production for the war effort, and recorded the Grand Fleet at Rosyth on the Firth of Forth. When his six-month appointment neared its end, Masterman successfully resisted the Treasury's attempt to terminate it. However, once back in France, Bone's busy schedule started to tell as he recorded the devastated towns, and he came close to a breakdown. After recovering he went on to lecture about war art, as well as continuing to draw.

As his drawings accumulated, they were published in *The Western Front*, issued in ten monthly parts to comprise a two-volume book published at the offices of *Country Life*. Beginning in December 1916, a total of 230 images were reproduced, and they proved a huge success. The introduction was by Sir Douglas Haig, Commander-in-Chief of the British Expeditionary Force. The text was provided by C. E. Montague, an author and journalist who was now an Intelligence Officer attached to General Headquarters, who explained the drawings in detail (though Montague, like so many English writers, used the term 'England' for Britain).[25] Despite the veracity of the images, the complete absence of any visual reporting of actual killing, or evidence of death, was all too noticeable to those in the front line. The poet Wilfred Owen wrote in January 1917 that 'Those "Somme pictures" are the laughing stock of the army ...'[26] But they were highly appreciated in Germany and Austria, where Bone's work was already well-known and admired. Copies of the book, and individual reproductions of the drawings, reached continental markets within a very short time of publication.

Towards the end of 1916 Bone was commissioned, along with a number of other artists, to produce a series of prints documenting the war effort. They were published by the Ministry of Information in 1917 (and exhibited at the Fine Art Society) as lithographs entitled *The Great War: Britain's Efforts and Ideals*. Bone's own set within the series documented the Clyde shipyards. The views are wonderfully dramatic, conveying the scale of the ships under construction from often vertiginous viewpoints. Like much of his work, however, there is little interest in people – human forms are dwarfed by the objects that were his principal theme.

ART AND INDUSTRY

In 1914 Britain's industrial production had to be put on a war footing. Many factories switched to manufacturing for the war effort, and the Government took over the railways. Rosyth dockyard had been designated as a major base for the Royal Navy in 1903, with construction beginning in 1909. Booms were now constructed on the Firth of Forth and at the entries to the fleet anchorage at Scapa Flow in Orkney. The departure of men to the forces resulted in a great increase of female labour, and the image of the woman factory worker became familiar the length

and breadth of Britain, accepted as a natural – if, in most cases, temporary – aspect of life in a country at total war. In 1915 and 1916 the drive to boost manufacturing provoked industrial unrest in Glasgow, but sufficient agreements were reached for production to continue.[27]

Until this time, factories and industrial production were hardly considered fit subjects for artists. Factory owners had been reluctant to permit outsiders to see how their goods were manufactured, or to be shocked by the factory system or affronted by working conditions. But the Government considered that images showing industrial war production would both boost morale and explain the use of resources, and artists found themselves being commissioned to record these novel subjects.

Women working in the munitions factories (nicknamed 'munitionettes') earned more than they would have done in traditional areas of female employment. But they endured long hours, and were often injured in accidents or made ill by the chemical processes involved. Rebecca West's article on 'The Cordite Makers' made for grim reading, for the cordite was manufactured using nitroglycerine, nitric and sulphuric acid, and gun cotton. West was not exaggerating when she wrote that 'they face more danger every day than any soldier on home defence. The girls who take up this work sacrifice almost as much as men who enlist …'[28] The Dornock Munitions Factory (between Gretna and Annan) made the so-called 'Devil's Porridge', a term coined for this dangerous mix by Sir Arthur Conan Doyle, physician and creator of Sherlock Holmes.[29] How much the general public was aware of the dangers and difficulties facing these workers is hard to determine, but the artists who recorded their work would have been left with no illusions.

It was only later in the War that the focus of commissioned war art moved from military effort to

Muirhead Bone, *Building Ships: A Shipyard Seen from a Big Crane* (from the series *The Great War: Britain's Efforts and Ideals*). Lithograph, 46.2 × 35.5 cm. Scottish National Gallery of Modern Art

the involvement of British society as a whole. It meant that many of these subjects were dealt with by the nascent Imperial War Museum, established by the War Cabinet in 1917. Even then, the vast majority of official commissions for women artists came from its Women's Work Sub-Committee rather than the Ministry of Information, whose official art schemes employed very few women. By the time the painter Anna Airy (1882–1964) was requested to produce a series of factory paintings, munitions production was particularly crucial to the current stage of the war. Airy is little known today, but was a well-respected artist at this time, and although based in England had exhibited her work in both England and Scotland. In June 1918 she was commissioned by the Munitions Committee of the Imperial War Museum to produce four pictures, all of factories in England, though one

was eventually replaced by a view of the Singer factory in Clydebank.[30] The factory had opened in 1867 for the first overseas production of the American sewing-machine company. It had also become known for its strike in 1911, the workers' grievances encapsulated in the slogan 'An injury to one is an injury to all'. The factory was now making shells, a switch in production which could hardly have been more socially significant, a 'swords to ploughshares' transformation in reverse. (This gained added reso-

nance when the factory, once again producing war *matériel*, was destroyed by bombing in the Second World War). In Airy's painting the shells loom like giant silvery maggots, and the protection given to the women seems minimal, indeed solely for their hair. And as in so many of these factory images, the women seem merely adjuncts to a scene focusing principally on the result of their labours. The English watercolourist Arthur Knighton-Hammond produced a view of *Women Munition Workers Loading Shells*,

Airdrie, 1918, in which a group of women are painted almost as an afterthought in a long warehouse-type factory, crammed with rows of shells like so many ranks of soldiers standing to attention.[31]

The approach of John Lavery (1856–1941) was quite different. Women in the Bruce Peebles Electrical Engineering Works, near Granton Harbour in East Pilton, Edinburgh, are also shown in a factory making shells. Typically for Lavery, the scene is more colourful and cheerful than other artists might have made it. Not surprisingly, Lavery's lively, fluid paintings – filled with people, but with no reference to hardship or weariness – helped to make him a popular war artist, perhaps at the expense of other artists who rather better expressed the difficulties and dangers of wartime life. Lavery later realised this himself, admitting with a great show of self-deprecation that 'Instead of the grim harshness and horror of the scenes I had given charming colour versions, as if painting a bank holiday on Hampstead Heath.'[32]

Not only painters, but photographers, were commissioned to record work in factories. George P. Lewis (1875–1926), an English photographer who had worked in Indonesia in the 1890s, returned to Britain in 1917 and was asked to photograph home-front subjects. In 1918, the Women's Work Committee of the Imperial War Museum commissioned him to produce a set of photographs as a lasting record of women who had been working in heavy industries and transport during the War. This was intended as record rather than propaganda, and the women are documented as individuals with real character. He shows harsh and gritty realism in his photographs of Clydeside, with its social backdrop of industrial 'Red Clydeside' militancy. They were reprinted in 2004, now recognised as valuable documents of social history and portraiture.

Not all home news during the War could be positive. The Quintinshill rail disaster of 15 May 1915, a

Charles Pears, *Women Putting Anti-fouling Paint on the Bottom of a Royal Navy Motor Launch, Leith, January 1917*. Oil on canvas, 66.0 × 107.9 cm. Imperial War Museum

crash near Gretna involving five trains, killed over two hundred people and injured many more. It remains the greatest loss of life of any railway accident in the United Kingdom. Those killed were mainly Territorial soldiers of the 7th (Leith) Battalion, Royal Scots, on their way to Liverpool, bound for Gallipoli. The battalion roll was destroyed in the ensuing fire, and the precise number of dead has never been firmly established, though current estimates are 214 officers and men. Like Lewis's record of work, this too has been the subject of much later commemoration.

WORKING IN THE DOCKS

Charles Pears (1873–1958) was an English marine artist, nowadays best known as a poster designer, who had produced marine subjects for the illustrated press before the War. He was specifically commissioned to record ships and shipyards, and often used photographs in the preparation of his compositions. He travelled widely in his coverage of maritime subjects, with much of his *oeuvre* comprising dramatic episodes at sea. He also documented the

Charles Pears, *A Corner of the Dockyard, Rosyth: Winter*, 1918. Oil on canvas, 71.1 × 91.4 cm. Imperial War Museum

more mundane tasks of the dockyards, and work in winter. His misty image of Leith, the ground covered with snow, shows a line of women undertaking the gruelling job of covering the hull of a Royal Navy motor launch with anti-fouling paint, the vessel mounted on large props to permit access to the hull. The sheer oddity of the sight, and the lack of any visible background, might make it hard to work out what is going on, were it not for the dazzle-painted warship to the left and the crane to the right.

Pears produced a series of paintings of Rosyth.

As at Leith, he often chose unusual lighting conditions or perspectives. His snowy scene entitled *A Corner of the Dockyard, Rosyth: Winter*, 1918, shows the mundane, everyday business of changing shifts in sunrise or gloaming, the grey skies lit up by search-light beams. His images are very different from those of other war artists, being neither the interiors of factories, nor external scenes of any great drama, but the everyday round of human life and labour directed at the war effort.

Leaden skies also feature in his HMS *Courageous*

in Dry Dock, at Rosyth: Winter, commissioned in 1919, though here the snow forms an element of a brightly patterned composition. During most of the First World War, Rosyth was the base for the Battle Cruiser Squadron of the Royal Navy's Grand Fleet; ships like HMS *Courageous* were faster than conventional battleships.

It is a measure of the artist's skill that his documentation of the scene is totally realistic (apart from the White Ensign worn incorrectly at the jackstaff), while the long horizontal patterning of the sides of the dry dock and the surrounding buildings creates an almost futuristic design. It is clearly related in style to artists such as Edward Wadsworth, who was producing abstract images of dazzle-camouflage ships, for example his *Dazzle-ships in Drydock at Liverpool* of 1919.[33] Like Muirhead Bone, Pears contributed to the series *The Great War: Britain's Efforts and Ideals*, but his set of published images all show dramatic scenes of ships at sea. Those who illustrated land-based war had to contend with the censor's requirement to avoid depictions of serious combat or death; at sea or in the air, action could be dramatic and heroic without offence.

DRAMATIC SCENES: SEA AND AIR

Before the War, there was an expectation that any conflict involving the European powers would be waged (on Britain's part, at least) largely at sea, and the naval armaments race of the early 1900s reinforced this idea. During the War, the Firth of Forth and the strategic natural anchorage of Scapa Flow in Orkney were host to so many ships that artists and illustrators were provided with grand naval spectacles. However, such a large number of vessels – plus attendant barrage balloons and aircraft – could also pose something of a challenge for artists. John Lavery

and William Wyllie were artists who could cope well with this type of 'crowd' scene. The more focused studies of artists such as Charles Pears produced rather more atmospheric results.

Muirhead Bone made numerous studies of the Firth of Forth and its naval presence, and it has to be admitted that some of his work could be rather mundane. However, his smaller preparatory sketches could occasionally be very impressive: his monochrome sketch, HMS *Repulse, Firth of Forth, March 1917; scene at night, part of the ship illuminated in its search light*, shows a very dramatic silhouette.[34] The Forth Rail Bridge was still quite a novelty, having been opened only in 1890, and views of it appealed to the public; not surprisingly, some of John Lavery's images of the Firth of Forth make a feature of the bridge.

Lavery came from Northern Ireland, and had briefly joined the Artists' Rifles in London in 1914, but many of his war paintings were of Scotland. He was older than most official artists – sixty-one when appointed in 1917 – and best known as a portraitist (and first President of the Royal Society of Portrait Painters). But his appointment met with general approval, especially as he had already shown paintings related to the War, for example *The First Wounded in the London Hospital, August 1914* (p.58). Unlike Bone, he could sketch at speed in oil. He wanted to work on the Western Front, but was injured in a car accident just before he was due to leave, and was re-allocated to the home front with a Special Joint Naval and Military Permit (which gave him entry to many places, but excluded many others).[35] At the Forth Bridge Lavery was mistaken for a spy by the police, one of many artists to suffer this indignity, for the police and public alike were always suspicious of strangers observing and sketching during wartime. The architect Thomas Ross was arrested in 1915 for sketching Rossend Castle in Fife; the eccentric Reginald Fairlie, architect of churches

OPPOSITE.

Charles Pears, HMS *Courageous in Dry Dock, at Rosyth: Winter*, 1919. Oil on canvas, 101.9 × 127.0 cm. Imperial War Museum

RIGHT.

John Lavery, *The Forth Bridge*, 1914.
Oil on canvas, 50.0 × 76.2 cm.
Imperial War Museum

OPPOSITE.

Charles Pears, *The Lights of Rosyth
from the Forth Bridge Footpath:
Port Edgar and the Fleet*, 1914. Oil
on canvas, 71.1 × 91.4 cm. Imperial
War Museum

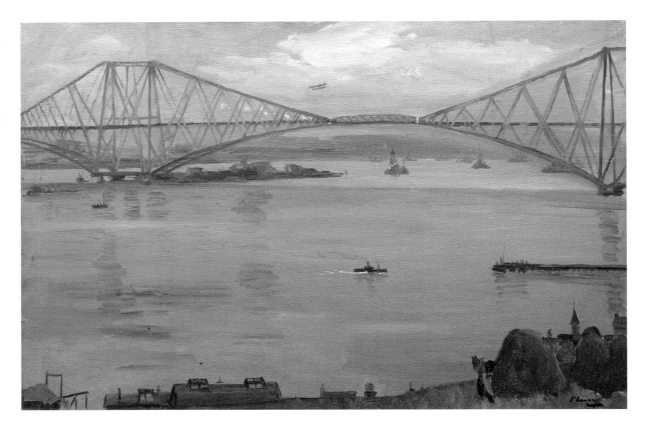

and of the National Library of Scotland, was also apprehended, though he was subsequently commissioned in the Royal Engineers and served in France. James McBey (p.74) was arrested for supposedly signalling to German submarines while sketching in Aberdeenshire (and Charles Rennie Mackintosh suffered a more serious arrest and incarceration in Suffolk – p.67). Lavery was not detained long, however, and he produced a series of works in the Edinburgh area, such as *The Forth Bridge* (1914) in which warships and an airship in the distance co-exist with the continued activity of peacetime, shown by the stooks of hay in the foreground.

Charles Pears avoided an image *of* the bridge itself, but *from* the bridge he produced a highly coloured and very individual composition entitled

The Lights of Rosyth from the Forth Bridge Footpath: Port Edgar and the Fleet of 1914, showing the lights of Rosyth twinkling in the darkness below – there was, as yet, no black-out.

By the end of the War the Firth of Forth was full of naval shipping, the Grand Fleet having been brought south from Scapa Flow. There was a very cosmopolitan presence too. The English painter and etcher William Wyllie (1851–1931) travelled extensively recording the War, as his atmospheric etching of the American battleships USS *New York* and USS *Texas*, with the Forth Bridge behind them, amply demonstrates.

In contrast to this 'water-line' image, William Walcot (1874–1943) produced aerial views of the Firth of Forth, seen from the sky above Rosyth and

William Lionel Wyllie, *The US battleships* New York *and* Texas *off Rosyth*, c.1918. Etching, touched with graphite, image 10.6 × 32.7cm. National Maritime Museum

looking south-east, down river. The version reproduced here (p.34) bears no title, which allows an element of speculation as to its exact subject: ships of the Grand Fleet at anchor; or elements of the German High Seas Fleet after surrender in1918? Barrage balloons hover in the sky above, and Walcot had no doubt sketched from such a vantage-point.

Scapa Flow, though providing less of a dramatic setting for artists, was equally busy, for it served as Britain's main Home Fleet anchorage for most of the War. In 1914 construction began on a defensive network around the entrances to the Flow and around the rest of Orkney, with anti-submarine booms and nets, minefields and naval patrols. William Wyllie often sailed with the fleet by 'special licence', working from HMS *Revenge*. In 1918 his work was published in *Sea Fights of the Great War: Naval Incidents During the First Nine Months*, which curiously lacked any reference to Scottish locations – perhaps the reason why his sequel of 1919, entitled *More Sea Fights*, included quite a number of them, such as *The Grand Fleet at Scapa Flow* illustrated here (p.34). It was the sea fights rather than the 'artistic' views that provided the best commercial possibilities, action

being preferred to mere views. Many of his quieter images are in fact very atmospheric, essays in summer sunshine and fine sunsets as much as records of war, and a contrast to the often wintry weather recorded by Lavery at Scapa Flow.[36]

Much less well-known is Lieutenant Geoffrey Stephen Allfree (1889–1918) who was both a serving naval officer and an artist. His war took him around Britain and east to Gallipoli, and he too worked in HMS *Revenge*. His painting of a seaplane station shows a rather different aspect of Orkney at war – a fine blustery day, with workers in a field in the foreground.

Much more dramatic is his *The Wreck of the 'Hampshire'*. On 5 June 1916, Lord Kitchener sailed from Scapa Flow for Russia in the cruiser HMS *Hampshire*. It struck a mine off Orkney in heavy seas; only twelve of her ship's company survived, and Kitchener's body was never found. His death shocked the public and led to various unfounded 'conspiracy theories'.[37] Alfree's powerfully imaginative image shows a drowned sailor's body lying on rocks beside one of the ship's life rings, the churning sea lit by shafts of sunlight. The artist himself was to suffer a similar fate, being drowned at the age of 29 while in command of

RIGHT.
William Walcot, *The Forth Bridge*,
c.1918. Drypoint, 14.4 × 23.3 cm.
Collection Allan Maclean of
Dochgarroch

BELOW.
William Lionel Wyllie, *The Grand
Fleet in Scapa Flow*. Watercolour,
29.5 × 47.8 cm. National Maritime
Museum

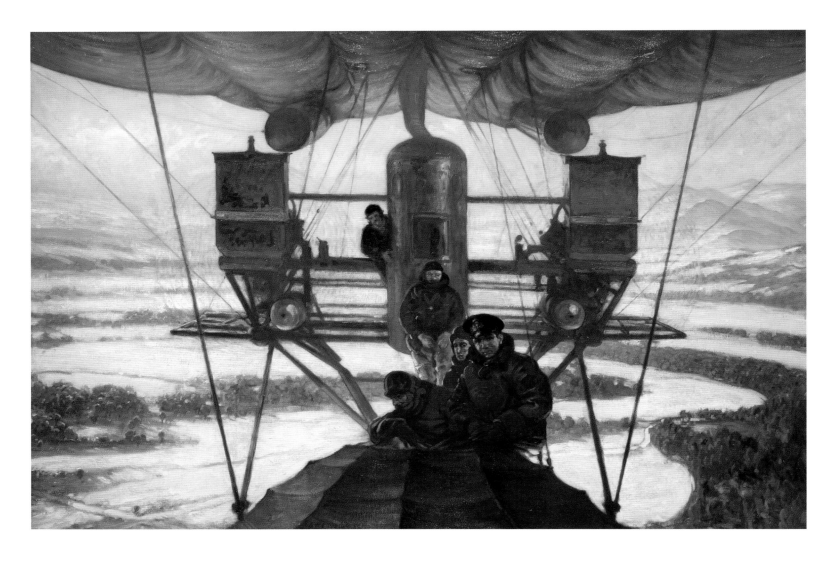

Alfred Egerton Cooper, *The First Snow, from the NS8 Airship over the Lammermuirs*, 1918. Oil on canvas, 123 × 182 cm. Royal Air Force Museum

his motor launch, just six weeks before the armistice.

The first military airfield in Scotland was opened in Montrose in 1912. Attack by sea had been expected, but not attack by air. To defend Edinburgh and Rosyth, the small naval airfield at East Fortune was upgraded in 1916 as a Royal Naval Air Station, protecting the coast against enemy airships and submarines (it now houses the Museum of Flight, National Museums Scotland).

Fortune smiled on it in artistically too, for Alfred Egerton Cooper (1883–1974) recorded much of its activity. Cooper had served in the Artists' Rifles and his sight in one eye had been damaged by chlorine gas. In his painting *The First Snow, from the NS8 Airship over the Lammermuirs* (1918) the naval aeronauts produce cheerful grins for the artist's camera (the photograph survives), despite the cold.

By contrast, Cooper's night view of the brightly lit

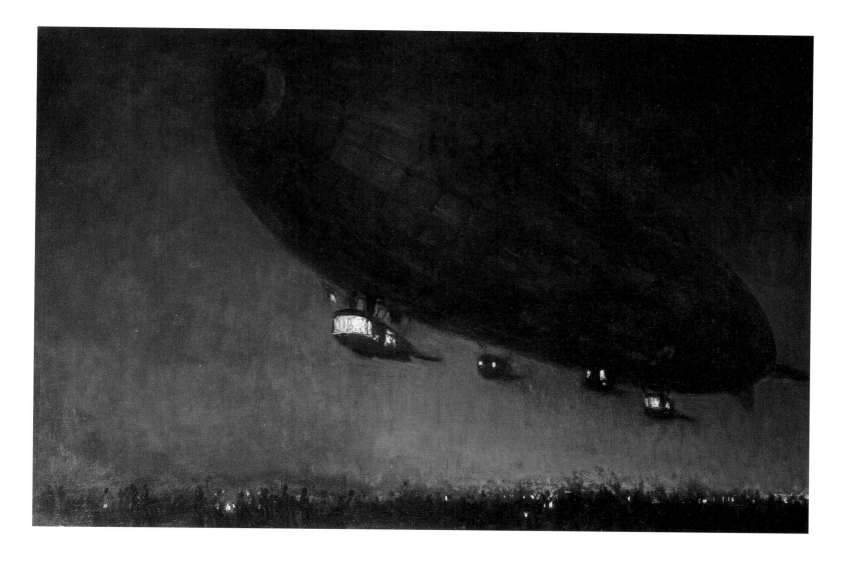

gondolas, suspended beneath the belly of the airship, makes for an eerie, luminous composition. Cooper also produced a painting of two new, gleaming airships in a hangar at East Fortune, and (apparently taken by the mystery of it all) an ethereal painting of an airship flying the White Ensign above the clouds.[38] At the end of the War, he became an official artist of the new Royal Air Force, and an expert in the art and technique of large-scale aerial camouflage, as well as

sketching and painting landscapes from the air.

Lavery also painted a view from an airship, showing a perilously poised crewman enjoying a vertiginous view of the ships below. Despite his age, Lavery appears to have shown as little fear of this situation as the crew. His later disparaging remarks about his own war work may not have been false modesty, but he was hardly faint-hearted in pursuit of his work.

Alfred Egerton Cooper, *Airship R34, East Fortune, Scotland*, 1919. Oil on canvas, 56 × 66 cm. Royal Air Force Museum

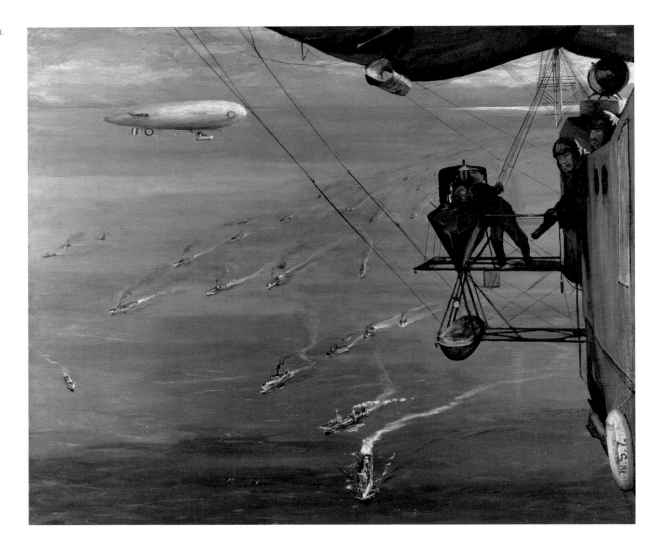

John Lavery, *A Convoy, North Sea. From NS7,* 1918. Oil on canvas, 172.7 × 198.1 cm. Imperial War Museum

CAMOUFLAGE

'Khaki' military uniform, with all its variants, is a form of camouflage, and was adopted specifically to make troops less visible in the landscape. Similarly, 'battleship grey' paint for warships was intended to make vessels less visible at sea. But a much more sophisticated science and practice of camouflage became the norm in the First World War: the 'dazzle' camouflage that was created to make it difficult for the enemy to estimate the profiles, location and movement of ships at sea. The invention is generally credited to Norman Wilkinson (1878–1971) though his work continued that of the Scottish zoologist John Graham Kerr (1869–1957), who had undertaken considerable research and trials earlier in the War, a contribution which has been rather neglected. Kerr's observations and theories were based on the biological principles

underlying camouflage – in other words, camouflage in nature – an aspect considered in greater depth in the Second World War, as James McIntosh Patrick's later lectures on camouflage demonstrate (p.134).

Dazzle camouflage was of great interest to artists and also caught on as popular design. There were dazzle parties and clothing, for it provided visual excitement at a time when so much of life seemed dull and grey. The artist John Everett, writing in the catalogue to the exhibition of *Camouflaged Ships* held at the Goupil Gallery, London, in 1918, wrote that 'The result has been to turn our Merchant Fleet from a thing of utility into a thing of beauty. Any dock about the coast seems now like the setting for some ancient pageant with its brightly-coloured ships.'

Cecil King painted a cheerful view of *Dazzled Ships at Leith*. There is also an impressive photograph of an early aircraft carrier, HMS *Argus* (a converted liner) in vivid 'dazzle' paint, with airmen and sailors cheering King George V from her deck when he visited Rosyth.[39]

Many artists serving in the War were attracted to the idea of working in camouflage, Stanley Cursiter among them, while others simply included it as part of the record. Robert Sholto Johnstone Douglas (1871–1958), known mainly as a portraitist until the First World War, was commissioned to produced a number of paintings of 'dazzle' ships (now in the Imperial War Museum). The English artist Edward Wadsworth (1899–1949), a Vorticist – and an Old

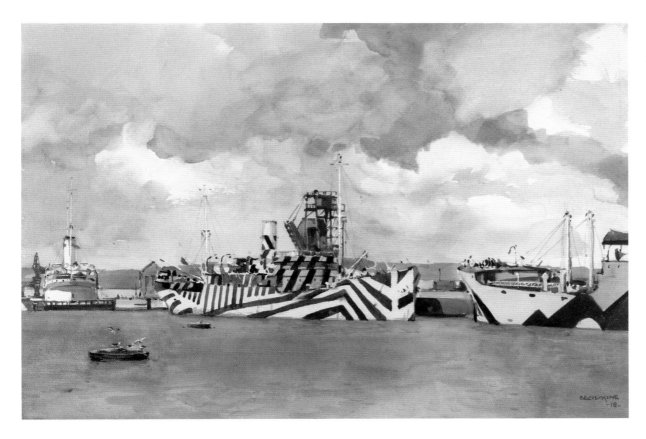

Cecil King, *Dazzled Ships at Leith*, 1918. Watercolour on paper, 38.1 × 56.2 cm. Imperial War Museum

Fettesian – oversaw much of the dazzle painting for the Royal Navy and made it a central aspect of his own art. One of Douglas Strachan's windows in the Scottish National War memorial (opened 1927) shows a troopship in dazzle camouflage. Some artists may have been unconsciously influenced by their camouflage work, such as Alick Riddell Sturrock (1885–1953), who joined the Royal Scots at the outbreak of war. He was wounded at Arras in 1917, after which he became involved in camouflage work. His later landscapes show a distinct patterning, the blocks of colours perhaps influenced by this training.[40]

NEW ART FOR NEW WAR?

While art historians have written extensively about the new type of war art exemplified by Paul Nash and Christopher Nevinson (see below), most of the work produced during the First World War was at best illustrative, with a great deal of 'Boy's Own' jingoistic derring-do, and often downright mawkish in its sentimentality. The many weekly magazines shied away from innovation, favouring the work of older artists – and thus the very artists least likely to be in sympathy with any form of novelty in the depiction of warfare.

Leith-born military artist Allan Stewart (1865–1951) was typical: not a bad painter, but not an innovative one either, producing battle scenes that are rather stagy, detailed and heroic in character, but very popular with the general public. His painting *The Charge of The Scots Greys at St Quentin* (1915, private collection) depicts an action from the year before, but one which could almost have been the regiment's much more famous charge at Waterloo a hundred years earlier. Yet in other ways Stewart was a man of the present, for despite his age he joined the Royal Engineers and went to France in December 1916 to work on projects such as camouflage and the creation of trench dummies.[41]

However, a great deal new was happening in the treatment of war as a subject. In January 1915, the Leicester Galleries in London showed war pictures by William Strang and satirical drawings by Will Dyson, and their approach was essentially allegorical. Strang's pictures included an etching entitled *War*, showing a uniformed skeleton beating a drum (adapted from fifteenth-to-sixteenth-century *Dance of Death* woodcuts), and an oil painting *Harvest*, showing a brightly coloured harvest field with, in the foreground, a man lying shot dead. These were not pictures of war, but of ideas of war – war as a concept.[42]

English-based avant-garde artists such as Christopher Nevinson (1889–1946) and Mark Gertler (1891–1939), whose work absorbed the brutalism of the Futurist and Vorticist movements, had little following in Scotland. After a few months of war, these movements were on the wane, overtaken by the harsh realities of conflict; one of its leaders, Henri Gaudier-Brzeska, was killed in 1915. But Nevinson's brilliant, energetic style continued to develop, showing soldiers as part of the devouring machine of war. Typical of his work was the *Column on the March* (a later version, painted in 1940, was acquired by Glasgow Museums the year of its creation – p.125). It was reviled by the general public and by many critics as unpatriotic and de-humanising.

But Nevinson had his champions in the art world, such as the critic P. G. Konody. In his book defending Nevinson, Konody traces the history of alarming but vital images of war down the centuries, stating that 'It is fairly obvious that the ordinary representational manner of painting is wholly inadequate for the interpretation of this tremendous conflict … A more synthetic method is needed … '[43] His frontispiece was *Column on the March*, which had been exhibited at the Leicester Galleries, London, in 1916.[44] A counter-

Christopher Nevinson, *Column on the March*, 1915. Oil on canvas, 63.8 × 76.6 cm. Birmingham Museums Trust

defence was made by Selwyn Image, in the lecture mentioned earlier, on 'Art, Morals and The War'.

Scotland did not have a Nevinson, although Stanley Cursiter (1887–1976) had experimented with Futurism and Vorticism as a style applied to rather more gentle, everyday subject-matter. Eric Harald Macbeth Robertson (1887–1941) experimented with both the style and its aggressive character. A pencil drawing, *Terror of War*, dated 18 August 1914, shows a tall, ghostly female figure, her hair composed

of smoke, stepping over the bodies of fallen soldiers, while a 'Greek chorus' of soldiers' mask-like faces watches from the left. Surrounding the figures are zig-zag and horizontal darts of light and gunfire, and the same curved wheel shapes that appear in J. D. Fergusson's work.

Robertson was to serve in France with an ambulance unit until 1919, the year he exhibited *Shellburst*. This also echoes the Vorticists, but it is too cheerful, too much of a colourful design, to be an angry war

including numerous scenes of the Champagne landscape (on leave in 1918 he sold 35 pastel sketches).[47] He also produced an oil painting of two nurses, Miss Maidie and Miss Elsie Scott, who cared for Wilfred Owen and Siegfried Sassoon at Craiglockhart Hospital (p.60).[48] Official war artists were instructed to show no dead, hence the celebrated scandal of Nevinson's painting entitled *Paths to Glory* which included bodies and barbed wire (thus earning Nevinson a great deal of publicity). Yet artist after artist who was sent to show 'work in progress' by British forces on the continent brought back images of a devastated landscape of shattered trees, ruined towns and endless mud. Some of the public actually appreciated this honesty, one being Lady Cynthia Asquith, who had complained about the lack of war pictures at the Royal Academy exhibition in London the year before, noting in her diary on 5 June 1916, 'very tiring and rather nightmarish. Just as many sheepscapes as ever.'[49]

The British establishment in general certainly had little idea of how much culture could mean to a nation, demonstrated by their proposal that national museums should close. Selwyn Image may have sent off a letter about it (p.19) but he himself then felt the brunt of changing times, for the University of Oxford suspended its Slade Professorship of Art in order to use the stipend for other purposes. Overall, there was a great sense of depression in the art world. Much of the London art trade had been dominated by German firms, many of which had now closed. Artists themselves expressed a lack of confidence in how to deal with this new type of war, so different from anything experienced before. But there were also pleas for the important place of art. James Guthrie, for example, took the offensive as the President of the Royal Scottish Academy. Addressing the Scottish Artists' Benevolent Association in 1916, he insisted that art was 'one of the essentials of life'.[50]

painting.[45] Robertson, who became a leading member of the Edinburgh Group, led a bohemian personal life which generated as much public interest as his art. The back of this painting is inscribed 'THARMAS' which, in the writings of William Blake, is one of the four Zoas, created when Albion, the primordial man, was divided fourfold; he represents sensation, and his female counterpart is Enion, who represents sexual urges; so it is both a war painting and something else as well. It has similarities with his *Cartwheels* (1920–1) one of his pictures repeating the motif of female legs, a far cry from crouching soldiers.[46]

While in France Robertson was able to continue his work, producing pencil drawings, pastels and oils,

ARTISTS AT THE FRONT

By the time Guthrie made his speech in 1916, the harsh realities of the Western Front were becoming all too well known back home, despite censorship of images and correspondence. At the outbreak of war, many Scotsmen had already served in the Territorial Force (made up from part-time volunteers), and more men had joined up as volunteers in the 'New Army', or 'Kitchener's Army'. By the end of 1915 much of the old Regular Army and the Territorials had been destroyed on the Western Front, with particularly appalling casualties sustained at Loos, a disastrous attack intended to turn the War in the Allies' favour, but one which gained a couple of miles at a cost of over 10,000 Scottish killed or wounded. Conscription was introduced in January 1916, ever extending its reach in terms of age and circumstance until the War's end. Any sense of optimism now largely evaporated.

Many professional artists produced little or no work on the Western Front; Cadell was a prime example, though he wrote home regularly, always maintaining – at least for the recipient – a good sense of humour. He gave profuse visual descriptions, caring little for any censor's potential disapproval, for example telling his sister Jean that water was so scarce he was thinking of shaving and washing 'in vin ordinaire'. His guard slipped when he wrote thanking her for a parcel, talking of 'the abomination of desolation. Like a great refuse heap – miles of country absolutely destroyed – villages levelled to the ground and the earth riddled through and through – mud everywhere and the booming of artillery night and day … Everything is filthy with mud and if cleanliness is next to Godliness our chances of heaven are few.'[51] In August 1917 he was finally persuaded to take a commission, after which he was wounded, and sent to recover near Rouen.

It was the non-professional artists who left some of the most dramatic records of the Western Front. Some had already known danger in their pre-war civilian lives. The remarkable Hiram Law Sturdy (1889–1964) from Newarthill, Lanarkshire, worked at various times as a house-painter and coal miner, and recorded his experiences in illustrated notebooks, some of which he later re-worked as the beginning of an unpublished novel. The vignettes set into his account of war from the trenches leave nothing to the imagination, yet he demonstrates humour and anger in equal measure, expressed in simple, forceful language. He was lucky to have returned with his sketches intact, for many of his images would certainly not have passed any censor.[52] They show men being blown up – 'Blowing bodies to smithereens'. And there is an unfortunate soldier who has advanced to find uncut barbed wire, now hanging dead on the obstacle, as if bowing in obeisance, with the caption 'Arras Cambria [sic] Road April 1917: "Wire uncut. He bows, 'My show is over boys You're [sic] call now." Sturdy survived, and later recorded his experiences in the Home Guard during the Second World War.

One loss in particular that struck the Scottish consciousness was that of John Lauder, the only son of the entertainer Harry Lauder. John was a Cambridge graduate and a Territorial Army officer, killed on 28 December 1916 while serving with the 8th Argyll and Sutherland Highlanders. His father received the telegram on New Year's Eve, while starring in a popular revue in London called *Three Cheers* (in which he performed his famous wartime song 'The Laddies Who Fought and Won'). In his personal writing, Lauder conjured up two very different pictures of his son, contrasts that by now were familiar to everyone:

There was a vision of him before my eyes. My bonnie Highland laddie, brave and

Hiram Sturdy, *Blowing Bodies to Smithereens*. Ink and watercolour on paper. Imperial War Museum

strong, in his kilt and the uniform of his country, going out to his death with a smile on his face. And there was another vision that came up now, unbidden. It was a vision of him lying stark and cold upon the battlefield, the mud on his uniform.[53]

Despite Harry Lauder's loss, he returned to the stage within a few days, and in 1917 travelled to France to entertain the troops on the Western Front. The personal loss suffered by this extraordinary version of a very ordinary man, combined with such heroic fortitude, came to represent the experience of the nation; he was knighted in 1919.

Francis Patrick Martin (1883–1966), who signed most of his work as 'Franc P. Martin', was a Glaswegian who recorded landscapes, buildings and people. He had already served as a very young volunteer in

Francis Martin, *Windmill, Neuf Berquin*, 1915–16. Pencil and watercolour, 25.4 × 35.5 cm. National Museums Scotland

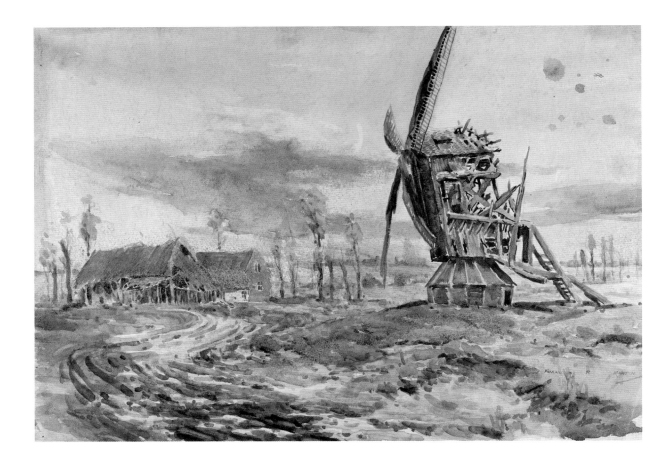

the Boer War. Now, serving on the Western Front, he produced a series of watercolour sketches showing the devastated landscape and the local people living among the ruins of their villages. Like Hiram Sturdy, he too was to serve in the Home Guard in the Second World War, though unlike Sturdy, he became a professional artist.

Martin also produced a much larger painting, *Infantry Brigade Signal Office, Flanders HQ*. It shows the comings and goings, and semi-organised confusion of war, in a theatrical tableau of army life. In the centre a young runner delivers a message, which is being read by an officer, while a harassed telephonist appears to be trying to hear above noise (field tele-

phones were notoriously unreliable). At either side of the composition two men are relaxing: one to the right smoking apparently from a cigarette holder, in an elegant and languorous pose incongruous for a helmeted and scruffy soldier; and the other, clad in kilt and Tam o' Shanter, portrayed almost as a Highland crofter as if from a genre scene by Allan or Wilkie, the empty chair in front of him giving the impression of another man just having left (will the erstwhile occupant ever return?).[54]

James McBey (1885–1959), whose record of the war in Palestine has rather eclipsed his brief period working on the Western Front, made simple sketches of both the blasted landscape and humanity making

LEFT.

Francis Martin, *Infantry Brigade Signal Office, Flanders HQ*, 1915–16. Oil on canvas, 70 × 90 cm. Government Art Collection

BELOW.

James McBey, *Figures in a Dug Out*. Pen, ink and wash on paper, 23.1 × 36.6 cm. Aberdeen Art Gallery & Museums

a sort of life in the midst of it all; he worked in black-and-white in order to facilitate future translation into etchings.

William Gillies (1898–1973), from Haddington, East Lothian, had just enrolled at Edinburgh College of Art in 1916 when he was called up for service in the Royal Engineers. His only war images are a set of tiny, postcard-sized pencil images: *An Old Factory* shows the utter devastation he wit-nessed around him, while *Our Post Behind the Wire* shows – presumably – Gillies himself and a fellow-soldier, the landscape obscured by a mesh of barbed wire, with what appears to be a wooden cross from a temporary grave in the foreground. Correspondence with his

sister gives some details of his progress. In 1918 he was wounded in March and gassed in May. He was back in Scotland, admitted to Bellahouston hospital (Glasgow) in August, and still in hospital on 23 November 1918; he was discharged as physically unfit on 25 March 1919. After the War he went back to Edinburgh College of Art, completing his studies in 1922. He then went back to France, this time to Paris, on a travelling scholarship, and subsequently joined the staff of Edinburgh College of Art, where he rose to be Principal. Apparently, he never spoke about the War, nor did he work up any war drawings into paintings, and is said to have been criticised for not producing any retrospective work. But he was one of the artists brought in to paint elements of the Scottish National War Memorial in the 1920s, and some 50 years later he noted the personal influence of the war paintings of Paul Nash and Christopher Nevinson.[55] And his experiences may well have affected the later course of his art, which shows a deep appreciation of peaceful domestic scenes and the Lothian landscape.

Adam Bruce Thomson (1885–1976) lived entirely in Edinburgh apart from his war service. He had been one of the first students to enrol at the newly formed Edinburgh College of Art, teaching there both before and after the War, and is best known today for his landscape paintings. Like Gillies, he too served in the Royal Engineers. He recorded the scene around him in a deceptively simple style that employed a *contre-jour* technique. This gave drama to his compositions, and also facilitated later printmaking from them.[56] His lithograph of the *Royal Engineers Building a Bridge near Mons* is particularly inventive in its use of ropes, hanging like fronds of creeper in a print by Piranesi.

Many writers recorded the impact of the visual image in prose. The Edinburgh journalist J. W. Herries visited the British front in February 1918:

> I remember a day, for example, when we walked six miles across duck-boards laid over the Ypres Salient, and arrived at a little concrete blockhouse within a rifle-shot of posts held by the Germans. The Salient at sunset presented a perfect picture of an abandoned world. As far as the eye could see stretched the great tortured plain, honeycombed with shell-holes, in which stagnant water had collected, with the trunks of trees shorn of their branches standing up from the chaotic earth.[57]

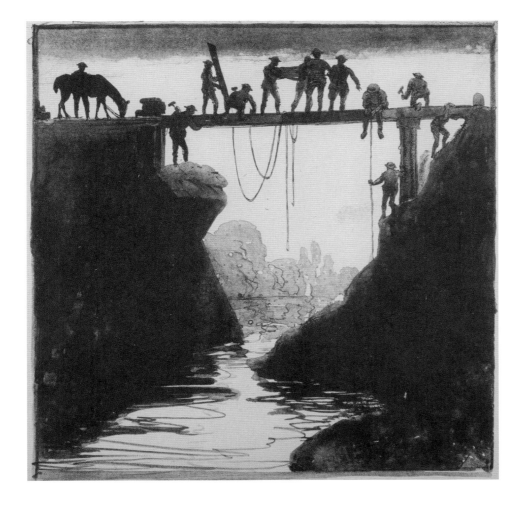

Adam Bruce Thomson, *Royal Engineers Building a Bridge near Mons*, 1918. Lithograph on paper, 21 × 21 cm. Scottish National Gallery of Modern Art

Keith Henderson (1883–1982), whose paintings of the Second World War are more notable than those from the First (p.103), served in France from 1914. He married while home on leave in 1916, and a series of letters to his wife were published in 1917 as *Letters to Helen: Impressions of an Artist on the Western Front*. The accompanying colour images are distinctly anodyne, such as *Ballieu: A peaceful place behind the battle*. But his words paint very different pictures: on 9 September 1916, for example, he writes of 'Poor dead men lying about, and dead horses too. And in the trenches this limitless porridge of mud.'[58] At the beginning of 1917, Henderson's artistic talents were re-directed to mapping, which entailed the interpretation of aerial photographs, and plotting topographical and tactical features onto maps. It was a skilled business, and on 2 January he joked that he now had to 'live with the R.F.C. [Royal Flying Corps], so as to be able to snatch their photographs the instant they come in – puzzle them out – put them quickly onto a map … '; and on 11 January: 'This job is rather in the making, and is really important stuff', appreciating that men's lives depended on the accuracy of his work.[59]

ABOVE THE FRONT

Another artist involved with mapping was Orkney-born Stanley Cursiter, who later became Director of the National Galleries of Scotland. He had moved to Edinburgh and become apprenticed as a printer, while also attending art classes, and from 1909 he worked as a designer and began to paint. His initial army service was rather uneventful, working on map production in London. He then joined the Cameronians (Scottish Rifles) and was sent to Catterick Camp where 'The months dragged on until we were marked for embarkation. I got three days leave, and Phyllis and I were married on a Saturday afternoon. A week later I was sitting in a front line trench on the Somme.'[60] He was taken out of the line owing to health problems, though not invalided out of the Army, and had hopes of camouflage work, but in the end his job was the lithographic printing of maps in France. He was in a Field Survey Battalion, and in the course of his work developed new methods of transferring information from aerial photographs, cutting production time dramatically; he also designed a portable printing press which ran from a lorry motor, and learnt to use radio (later becoming President of the Edinburgh Radio Society). Demobilized in 1919 with two mentions in dispatches, he received a military OBE.

There had been few good maps before the war, indeed the British army at first used Michelin maps of Belgium and France. But the development of trench systems from late 1914 necessitated new forms of mapping, concentrating on man-made features in the landscape instead of natural geography, and by mid-1915 a standard style had been developed. The new maps both facilitated movement on the ground and provided information about enemy lines. The work was crucial, for any errors or omissions in a map could (as Keith Henderson appreciated) have fatal consequences. The number of maps produced was enormous, and by the end of the War the British Army had printed around 32 million trench maps.[61]

Cameras were generally still cumbersome and heavy by modern standards, but lightweight versions had been introduced in the early 1900s. Not unnaturally, soldiers sometimes took their own cameras into battle, but these were considered, along with personal diaries, as a potential security risk. Several attempts were made to ban them, though enforcement varied during the course of the War.[62] Certain individuals were specifically required to carry cameras, and the press were furnished with a limited number of approved photographs. The standard issue was the No. 2 Folding Autographic Brownie Camera made by Eastman Kodak Co. Rochester, NY, USA. In early 1916 the first two official press photographers to be attached to GHQ arrived on the Western Front.

Censorship was not such an issue within Britain. One enthusiastic amateur, C. W. Burrows, was employed at Scapa Flow naval base, as Cashier of the Dockyard Section, from 1915 to 1920. He made a remarkable record of ships, of life at the base, and also of the local population. A selection of his work was published by *Country Life* in 1921, with an enthusiastic introduction by Vice-Admiral F. S. Miller; it remains a valuable record of a period of rapid change for both Scapa and Orkney.[63]

SCENES OF DESTRUCTION

From 1916 the Western Front was depicted again and again as a sea of desolation. Fred Farrell (1882–1935), a mainly self-taught painter and etcher, had studied civil engineering. He became the official war artist of Glasgow, the only city to commission its own artist in the First World War. Having been discharged from the Army on medical grounds in 1916, he

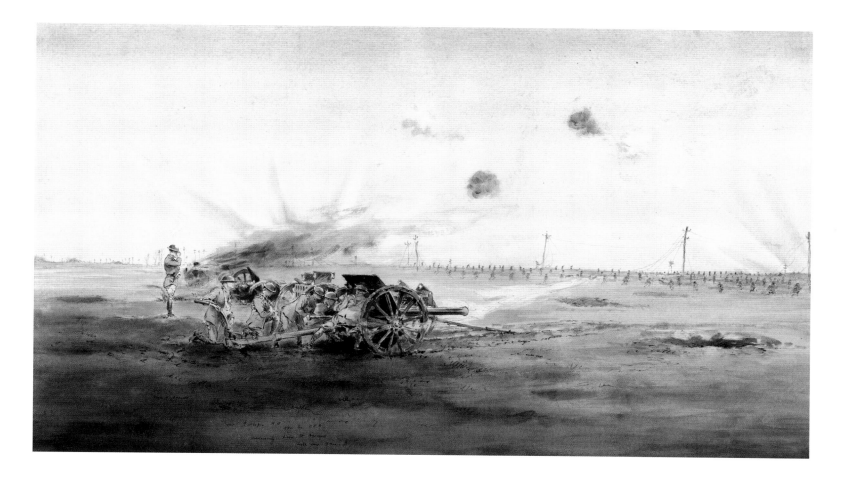

worked for Glasgow in France in 1917 and 1918. His powerful images of action and his many depictions of ruins managed to pass the censor's requirements (no scenes of dying or the dead), but they still left little to the imagination. Many were published in 1920 as *The 51st (Highland) Division War Sketches*, with an introduction by Neil Munro. Their style is both formal and naïve, a simplicity and directness of approach that conveys atmosphere as powerfully as many more sophisticated images. In fact, both as a painter and an etcher, Farrell was greatly influenced by the personal advice of Muirhead Bone (indeed one of his watercolours in the Scottish National Gallery of Modern

Art was previously attributed to Bone).[64] In some of his views, it is the sheer emptiness of the landscape that shocks, and his ability to convey utter destruction – not only of specific localities, but of the world as a civilised place. There is a strange unreality and illogicality to it all, as in his *Lieutenant J. Gillespie, M.C., 256th Brigade, R.F.A., Before Lieu St Amand*.[65]

Muirhead Bone's views of blasted landscapes do not constitute his best work. They are full of contortions and awkwardnesses, and although they convey the terrible anonymity of modern warfare, these pictures of muddy wastelands fail to convey the suffering of people, concentrating as they do on land-

Fred Farrell, *Lieutenant J. Gillespie, M.C., 256th Brigade, R.F.A., Before Lieu St Amand*, 1918. Ink and watercolour on paper, 31.1 × 50.5 cm. Glasgow Museums

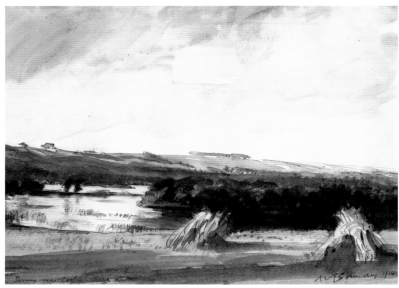

LEFT.
Muirhead Bone, *The Château, Foucaucourt*, 1916–17. Pencil and watercolour on paper, 36.0 × 53.7 cm. British Museum

RIGHT.
Muirhead Bone, *The Somme near Corbie*, 1906. Ink and watercolour on paper. 25.0 × 35.7 cm. British Museum

OPPOSITE.
Herbert James Gunn, *The Eve of the Battle of the Somme*, 1916. Oil on canvas, 83.8 × 91.4 cm. Fleming-Wyfold Art Foundation

scapes and townscapes. A typical example of a forced design is *The Château, Foucaucourt*, which was reproduced as a lithograph. The tree trunk looks – as no doubt the artist envisioned – like a withered arm, or a hangman's gibbet. Even Eric Robertson produced a very conventional and rather pedestrian, if very poignant, view of ruins at Poilly, devoid of any hint of Vorticism or violence.[66]

BEAUTY DESPITE THE BLAST

The words 'the Somme' today evoke images of a war-torn landscape and tragic slaughter, for the Battle of the Somme (1 July –18 November 1916) claimed over a million casualties, with some 60,000 British casualties (including nearly 20,000 dead) on the first day alone.

The Somme was the majestic river that ran through the region, large stretches of which were untouched by fighting. Artists often commented on its beauty and serenity, a haven from the world of

war. Keith Henderson (p.49) was one of these, revived in spirit by 'the beautiful river winding in and out of the little hills … Oh, it did look so heavenly this evening. Thank God for this glorious river.'[67] He also had a practical reason for mentioning the Somme to his wife in his correspondence, for he was not permitted to say precisely where he was.

Muirhead Bone's watercolour of *The Somme near Corbie* is even more innocent, for he made it in 1906. It was included, however, in his published *Western Front* drawings (1917), perhaps as an antidote to much of the rest of the volume. The title now has another association, for a large British military cemetery is situated at Corbie, near Amiens.

The Glaswegian Herbert James Gunn (1893–1964) had studied art in both Glasgow and Edinburgh, and had also spent some time in Paris. He was a friend and colleague of William Oliphant Hutchison (p.101), who submitted a portrait of Gunn as his Royal Scottish Academy diploma painting. Gunn himself later made his name as a portrait painter too, though his early success came with landscapes. In

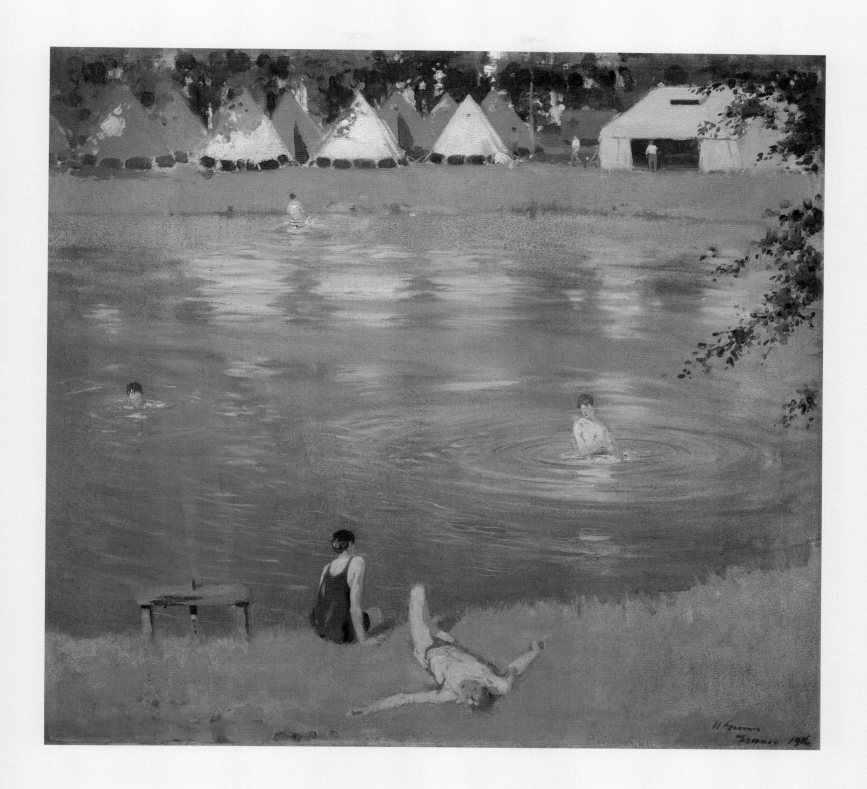

1915 he enlisted in the Artists' Rifles and by in 1916 was in northern France where he briefly managed to set up a studio in his barracks. The only finished canvas known to have survived from his service in France is *The Eve of the Battle of the Somme*, 1916, a painting with overtly Christian references, the foreground figure lying as if on a crucifix. But there is nothing ironic about this painting, produced before the great slaughter later associated with the name Somme. The stillness and serenity of the scene, the clean white tents and calm water – all have acquired a greater significance and poignancy than the artist ever expected. Two of Gunn's brothers were killed in France, and he himself was gassed.[68]

The work of sculptor William Reid Dick (1879–1961) was typical of an artist's persistence in under-taking artwork in difficult circumstances. Finding material around him in the chalk country of northern France, he set to work. The image of him at the entrance to his tent demonstrates his resourcefulness.

The term 'trench art' encompasses many small items, made from stone, wood, metal (frequently shell cases) and anything else to hand; it is now a collectors' field in its own right. One example, now in The Black Watch Museum, shows the regimental badge in chalk, and commemorates a relatively quiet two months spent in and around Gouzeaucourt from December 1917 to January 1918.[69]

Prisoners of war (POWs) in Britain also left quite a legacy of art. One example was Stobs Camp near Hawick, which served as a camp for both British soldiers and German POWs, where a considerable body of work was created.[70]

Photograph, *William Reid Dick outside his tent with a statuette.* Reid Dick Family Archive

PAINTER POET

Joseph Johnston Lee (1875–1949) was a poet, journalist, commercial illustrator and artist from Dundee, his name well known in the Scottish cultural circles of his day (his portrait was painted by David Foggie in 1911, and by Stewart Carmichael in 1913). Lee's first book of poems, *Tales o' Our Town*, was published in 1910, and he later published two books of war poetry, *Ballads of Battle* (1916) and *Work-A-Day Warriors* (1917).[71] He served in the 4th Battalion Black Watch and the King's Royal Rifle Corps.

The sketch shown here is taken from Lee's journal, kept between 14 December 1917 and 31 March 1918, when he was a prisoner of war in Karlsruhe; it is signed 'Joseph Lee / Christmas'. When in captivity he was, perhaps surprisingly, allowed to send poems and sketches home, many of which were published in the *People's Journal* and the *Dundee Advertiser*.

Joseph Lee, *Karlsruhe Christmas*, 1917. Ink on paper, 20.2 × 25.0 cm. University of Dundee Archives.

RECOVERY AND REFLECTION

Many photographs survive of the hospitals in France, especially of the Scottish Women's Hospitals, though there are few artistic images. One of the great organisers of such hospitals was the ebullient and ever-optimistic Millicent, Dowager Duchess of Sutherland, daughter of the 4th Earl of Rosslyn, who was well recorded both by the camera and in prose – Lady Randolph Churchill was particularly impressed by her exploits.[72] Duchess Millicent arrived on the continent with more aplomb than practicality, but she learnt from her false starts, and in the end ran a very successful tented hospital at Bourbourg, known as the 'Camp in the Oatfield', where the wounded were treated largely in the open air. The hospital returned to public consciousness recently when a series of ten 'Sutherland Oatfield' paintings by Victor Tardieu (1870–1937) came on the market; they have now been acquired by the Florence Nightingale Museum, London.[73] Similar images were made by other artists, including Francis Martin, in his hospital tent at Camiers. Her war work, which continued for the duration of the war, earned her the Croix de Guerre from the French government. For the First World War

Centenary, the Florence Nightingale Museum showed the paintings as illustrations of nursing in the Great War and the crucial role played by women volunteers in the battlefields of France and Belgium.

The pioneering Edinburgh doctor Elsie Inglis offered to recruit qualified women doctors and nurses for the war effort, but was famously said to have been rebuffed by the War Office with the words 'My good lady, go home and sit still.' But Inglis had already established hospitals in Edinburgh, and she proceeded to set up Scottish Women's Hospitals on the continent, her organisational skills and strength of character resulting in great success. By December 1914, her first medical unit staffed wholly by women was setting up a 200-bed hospital in the Abbaye de Royaumont, north of Paris, a semi-derelict building which had to be equipped from scratch. It was run very formally, the uniforms helping to impress those visitors who donated funds, for it was entirely supported by voluntary donations.[74]

The hospital was recorded by Norah Neilson Gray (p.57), who worked in France as a Voluntary Aid Detachment nurse. In 1918 she painted *Hôpital Auxiliaire d'Armée 301 – Abbaye de Royaumont*, 1918, a rather crowded, even chaotic scene, of soldiers arriving in the cloisters, and nurses with bandages. She offered this to the Imperial War Museum, requesting that it should be part of the general collection, not the Women's Work Section (WWS), but the budget for such acquisitions had now been spent.[75] However, the WWS were keen to have a painting which emphasised the role of women doctors, and she was commissioned the following year to produce another record of the hospital, specifically featuring Dr Frances Ivens; this is the larger, sunnier view entitled *The Scottish Women's Hospital: In the Cloister of the Abbaye at Royaumont, Dr Frances Ivens Inspects a French Patient*, of 1920. Dr Frances Ivens stops and looks at the artist

Francis Martin, *Hospital – Camiers*. Watercolour on paper, 17.7 × 25.3 cm. National Museums Scotland

(or perhaps at her camera) while an orderly holding a bowl in the foreground strikes a statuesque and quasi-religious pose; white and red dominate the left-hand side of the painting, a contrast to the *bleu horizon* of the French uniforms on the right.

In 1915, Dr Inglis went to Serbia, remaining there to tend the wounded as prisoners of war, and then served further with a Serbian Division attached to the Russian Army. By now in poor health, she was forced to return home, dying of cancer on 26 November 1917, the day after her arrival in Britain. Her body lay in state in St Giles' Cathedral; she was mourned by the nation (see p.215 for her memorials).

Living in London in 1914, John Lavery was able to sketch some of the earliest casualties brought to the London Hospital. Several oil studies resulted, with the wounded soldier in the foreground becoming a High-lander in his painting *The First Wounded*, possibly to

Norah Neilson Gray, *The Scottish Women's Hospital: In the Cloister of the Abbaye at Royaumont, Dr Frances Ivens Inspects a French Patient*, 1920. Oil on canvas, 114.3 × 139.7 cm. Imperial War Museum

boost sales of a print version of the composition; it was purchased by the City of Dundee in 1916.[76] The kilted Highlander had become something of an icon in Victorian and Edwardian society. During the First World War, the kilt was the uniform not only of the Scottish Highland Regiments, but of Canadians, New Zealanders, Australians and South Africans serving in their own regiments bearing Scottish names and with Scottish traditions. Kilted soldiers had the

honour of being nicknamed by the Germans as 'ladies from hell'.[77]

When Lavery's painting was shown at the Royal Academy, London, the reviewer for *The Studio* felt the general tone of the exhibition reflected badly on the Academicians, declaring 'Certainly there is no hint given by the show that this country is going through an experience almost without precedent in its history, and is engaged in what is actually a struggle for

OPPOSITE.
John Lavery, *The First Wounded,
The London Hospital, August, 1914.*
Oil on canvas, 175.6 × 200.7 cm.
Dundee City Council (Dundee Art
Galleries & Museums)

LEFT.
Francis Martin, *Ward 12B – Stobhill:
5 am.* Watercolour on paper,
23.3 × 30.2 cm. National
Museums Scotland

existence.' Lavery was the notable exception, his painting commended as 'the most remarkable achievement in the exhibition'.[78] It was immediately popular with the public too. Lady Cynthia Asquith noted in her diary:

> Went to the Royal Academy. Amazing to see it just the same as ever. The old sheep by lakes, historical pictures, etc. It gave an extraordinary sense of stability unaffected by cataclysm. Percentage of tropical khaki pictures surprisingly small I thought. Rather

a clever Lavery of a military hospital – very good atmosphere, it almost made one smell the antiseptics. Certainly war does not seem to incubate art. I have never seen a more vapid collection.[79]

Back in Scotland, Francis Martin was in Stobhill Hospital, north Glasgow. Stobhill had opened in 1904, and in 1914 was requisitioned by the Royal Army Medical Corps staff of the Territorial Force, with wounded men brought in hospital trains to a specially built platform inside the grounds.

TENTACLES OF ART

The Edinburgh health spa, Craiglockhart Hydropathic, had opened in 1880; it became a hospital for officers in 1916. Here those suffering from shell-shock or 'neurasthenia' on active service came to convalesce. 'Talking therapies' were developed by the pioneering psychiatrist and psychoanalyst William Rivers (1864–1922), whose aim was to get his patients well enough to go back to duty. Its most celebrated patient – in retrospect – was Wilfred Owen (1893–1918), the war poet who was to return to France to die. In recent years this temporary hospital and its patients became the subject of a novel by Pat Barker.[80] The building is now part of Napier University, which holds a War Poets collection and display.

No artist ever painted Wilfred Owen, but his views and experiences regarding art during his stay in Edinburgh are well documented in his correspondence. His first impressions of the hospital were poor: writing to his mother on 26 July 1917 from 'Craiglockhart War Hospital, Slateford, Midlothian' he said there was 'nothing very attractive about the place, it is a decayed Hydro, far too full of officers, some of whom I know.'

The patients were kept busy. Owen writes of activities with the Field Club, swimming in the public baths, theatricals, a model yacht regatta, visits to the Royal Observatory, munitions works and brass foundries; he also spends a morning beating out a plate of copper, and he tries fretwork.[81] Owen visits the Royal Scottish Academy, where he is particularly impressed by Henry Lintott's *Avatar*, 'the finest picture now in the Edinburgh Gallery', mentioning that a magazine wishes to reproduce it, even giving details of the contract. He then visits Henry Lintott: 'He seems an excellent gentleman, blessed by nature with a club foot, for he is still "of age" [to serve]', and he pays a second visit a few weeks later: 'On Friday I went to the Lintotts

again. Lintott has reason to be proud of his work, which he is not – particularly ...'[82]

Henry John Lintott (1878–1965) came from Brighton, trained in London and Paris, then moved to Edinburgh in 1902 at the age of twenty-four, joining the staff of what later became the Edinburgh College of Art. He was a slow, thoughtful painter of portraits, landscapes and ethereal allegorical subjects. *Avatar* was clearly the work by which he wished to be remembered, for it was his Diploma piece for the Royal Scottish Academy, presented in 1923 although painted in 1916. A young dead warrior is borne aloft by four spirit figures – not quite angels, for they are wingless and clad like classical spirits, the body resting on a very twentieth-century stretcher rather than on their shoulders. The black shroud, with its severely matt finish, makes the greatest impact in the composition, shown against powder-puff pink and lilac clouds. Recent conservation work on the painting has established that the medium used is oil, with added layers of various other substances, creating a chalky, matt appearance, emulating Italian fresco painting. There is also evidence of re-working, which accords with Lintott's usual laborious practice.

It was not the first work Lintott had painted to commemorate the fallen, for although his *Modo Crepuscolare* bears no visible date, this had been exhibited at the Carnegie Institute in Pittsburg in 1914, and at the RSA in 1915, where it had been greatly admired by Eric Robertson (p.41).[83] It shows the apotheosis of a dead young man, carried skyward by two female figures, one scattering flowers as they rise. The white objects on the ground appear to be human forms clad in white gowns, or ghosts or spirits; some are standing, some walking or running. The artist may have painted them to resemble doves, though they are definitely not birds. Like *Avatar*, it has a finish unlike oil. He painted other such subjects, which he referred to as his 'floaters'.

OPPOSITE.
Henry John Lintott, *Avatar*, 1916.
Oil on canvas, 101.8 × 127.7 cm.
Royal Scottish Academy

Henry John Lintott, *Modo Crepuscolare*, 1914. Oil on canvas, 110.6 × 136.6 cm. City Art Centre, Edinburgh Museums and Galleries

Lintott's work might appear eccentric, even out of place, for a teacher in an art school, but his long career influenced many artists such as William Gillies, John Maxwell and Anne Redpath, and his sensitive nature and approach were appreciated by his students.[84] Much of his work was rather more conventional, such as his portrait of the poet Lady Margaret Sackville (1881–1963), an aristocrat who turned both socialist and pacifist under the influence of Ramsay MacDonald. Both Wilfred Owen and Siegfried Sassoon knew Sackville and her anti-war

poetry, published as *The Pageant of War* in 1916. This little book, so modest in appearance, was hugely powerful in content, condemning both the War and women's support of it. The poem 'Nostra Culpa' denounces women as betrayers of their own sons for failing to speak out against it: 'We spoke not, so men died'. Sackville's own brother had already been killed before the volume was published.[85]

Both Wilfred Owen and Siegfried Sassoon arrived at Craiglockhart in the summer of 1917, and their relationship acted as a mutual catalyst for poetical

composition: Owen's 'Dulce et Decorum Est' and 'Anthem for Doomed Youth' were composed there. Owen was encouraged to edit six issues of the fortnightly hospital magazine, *The Hydra* – a clever pun on Hydro – the best-known cover of which is reproduced here. It was designed by Adrian Berrington (1887–1923), an English architect seriously wounded on active service. He died a few years later as a result of his injuries, his talent as a draughtsman acknowledged in a posthumous exhibition held at the Architectural Association in London in 1925. His cover design for *The Hydra* shows an officer wrestled to the ground by a many-headed beast, while two nurses resembling standing stones or angels (depending on one's point of view) look on. The image has proved surprisingly enduring, and original copies of the magazine are now exceedingly rare.

18 JUNE 1915:
THE CENTENARY OF WATERLOO

The Battle of Waterloo, fought on 18 June 1815, had been the climactic event of the long Napoleonic Wars, followed by almost a century free of British involvement in land war on the continent of Europe. Various organisations had planned celebrations for its centenary commemoration in 1915, but as the date neared, few had the appetite for it. The French were now allies, the Prussians were now enemies, Belgium was once again a battleground, much of the British Army was in France suffering heavy losses – and nobody liked to mention that the battlefield itself was currently under German occupation.

In her *Autobiography* of 1922, Lady Butler reproduced a 1915 spoof of her celebrated Waterloo painting, *Scotland for Ever* (p.4), which had been altered by the Germans to make 'A post-card, found on a German prisoner, with "Scotland for Ever" turned into Prussian cavalry, typifying the victorious on-rush of the German Army in the New Year, 1915.' It shows bells ringing at the top, and the date '1915' emblazoned in rays of light in the sky above – no longer a celebration of past British glory, but of hoped-for German victory in the near future.[86]

The Times announced that 'Official festivities would be out of place and likely to wound the susceptibilities of our Allies ... The annual regimental Waterloo Day dinners will not be held ...'[87] But not everyone agreed, indeed some took the view that commemoration might raise spirits, promote a sense of solidarity with the French, and remind the British of their past fighting glory. So at rather short notice, and often very locally, many celebrations did in fact take place. The Royal Regiment of Artillery explained in a commemorative publication, almost apologetically, that 'It was felt that something ought to be done in the Regiment to mark the 100th anniversary of the

Adrian Berrington, cover design for *Hydra*, Craiglockhart Hospital, 1918. English Faculty Library, University of Oxford

battle of Waterloo. Accordingly a scheme was set on foot … The scheme was only launched on 1 June …' They held events all over Britain, with visits to regimental Waterloo graves, and a commemorative lunch at Regimental Headquarters in a situation where 'our pictures are modern, and our plate has been removed for the duration of the war'.[88] An article in *The Scotsman* on 19 June was headed 'Waterloo Centenary: No Official Celebrations' but then went on to list some of the numerous local events, such as the flying of flags in Musselburgh, the laying of a wreath in Dunbar on the grave of a Major-General, and a procession in Duns with house-to-house collections for disabled soldiers; and in France, reported *The Scotsman*, 'the cordiality and loyalty of the Waterloo articles in the British newspapers were noted with great satisfaction by the Paris Press'.[89] But there were few formal commemorations. The Second Battle of Artois (9 May–18 June 1915) had been taking a heavy toll.

It was rather easier for those in more distant fields of battle such as Gallipoli, where an Old Wellingtonian, General Sir Ian Hamilton, at the Headquarters of the Mediterranean Expeditionary Force on the island of Imbros, recorded in his diary on 18 June that his thoughts had

> turned naturally towards the lives of the heroes of a hundred years ago whose monument had given us our education, and from that topic, equally naturally, to the boys of the coming generation. Then wrote out greetings to be sent by wire on my own behalf and on behalf of all Wellingtonians serving under my command here …[90]

The Royal Australian Engineers also celebrated at Gallipoli, finding it a convenient historical hook on which to hang a celebration of the completion of 'Watson's Pier', and which still continues today as an Annual Dinner.

Lady Butler had her own Waterloo Centenary Exhibition at the Leicester Galleries, with the patronage of Queen Mary. She had been preparing for the show for at least two years, and donated the proceeds to the Officers' Families Fund. The centrepiece was *Scotland for Ever* (lent by Leeds City Art Gallery) shown beside a new oil painting *On the Morning of Waterloo: The Cuirassier's Last Reveille*, along with twenty-four watercolours of Waterloo subjects. She was elated: 'The result was the best "show" I had yet had at the Leicester Galleries.'[91]

But times were changing even for Lady Butler. At the end of September 1914, having visited her soldier son at army camp and seen modern weaponry, she complained about the difficulties an artist would have in depicting modern warfare – 'The guns are made impossible to the artist of modern war by being daubed in blue and red blotches which make them absolutely formless; and, of course, no glint of light on the hidden metal is seen'; and she asked rhetorically 'Who will look at my "Waterloos" now?'[92] In 1917 she exhibited 22 watercolours in what she termed her first 'khaki' show at the Leicester Galleries, entitled *Some Glimpses of the Great War*, and in 1919 she held another exhibition there entitled *Some Records of the World War*.

'SMILE, SMILE, SMILE' – KEEPING SPIRITS UP

As Martin Hardie wrote in his book of 1920, *War Posters Issued by Belligerent and Neutral Nations 1914–1919*, 'The poster, hitherto the successful handmaid of commerce, was immediately recognised as a means of national propaganda with unlimited possibilities.'[93] But magazines were rather more influential, and used as propaganda of a different sort – for

spreading cheer and optimism, though most became rather less flippant in their humour as the war progressed, particularly those produced for (and within) the Forces, and issued free to the troops.

One Scottish example is *The Outpost. Magazine of 17th Service (Glasgow Chamber of Commerce) Battalion, Highland Light Infantry*, published by the Regimental Magazine Committee between 1915 and 1919. In Volume One (1915) the tone is distinctly jolly, but by June 1918 things have changed a great deal, with illustrations of bombed-out billets, and photographs of graves and men who had been killed in action. Another magazine, *Blighty*, did keep up humour, as cartoons showing the London Scottish in Palestine – 'the Jericho Jocks' – show all too well. But then Palestine was not the Western Front.

Some of those who recorded their life and surroundings at the Front were unfailingly cheerful. One was Lieut. Leonard J. Smith, whose cartoons document a great deal of ordinary life for officers, both on and off duty, in the line, from 1915 to 1918. One of the most delightful shows a dejected officer, in early 1918, staring into the fire thinking of his new wife, who appears as a nurse in the clouds above; it is inscribed 'Poor old Mac – The Married Man! / McEwing just returned from married leave / Leonard J. Smith / France 1918'.[94]

Many greetings cards were sent home from those serving in the forces. Some from the Western Front bore embroidered pictures and words, made locally in France or Belgium from designs supplied by British soldiers. Sometimes the troops were issued with regimental Christmas cards, such as the example shown here. Dated 1916, it bears on the front the words 'Slainte-na-Gael / In the field / Christmas 1916'. It opens out to show two printed watercolours, the left one showing two soldiers, one with a rifle and the other a trench periscope, in a snowy landscape with ruins in the distance. The borders bear motifs: a

Private J. Brooks, 2nd London Scottish, 'With the Jericho Jocks', from *Blighty*, Summer issue 1918. National Library of Scotland

Christmas card
issued to troops, 1916.
Card, folded size
18.2 × 12.0 cm.
Edinburgh Museums
and Galleries

balloon and a plane, crossed rifles, crossed pick-axe with and shovel and bag, and more. The card was probably issued for the Seaforth Highlanders; it was in the possession of John Walker, killed in action with that regiment at the battle of Arras on 15 April 1917.[95]

DREAMING OF IONA

There are numerous 'thoughts of home' pictures, most of them very sentimental. William Skeoch Cumming's composition of a soldier dreaming of Iona, dated 1917, is rather more haunting, and very different from the realism of most of his work. This painting is a curious conceit. Is the soldier – who is in The Black Watch, and who wears the ribbon of the Military Medal – supposed to be actually in Iona? Or is he in Flanders, say, and dreaming of a place which symbolises Scotland and home – albeit that he is in the wrong regiment for that recruiting area?

Skeoch Cumming was not the only artist who yearned for Iona – so did Cadell, who was by this time commissioned in the Argyll and Sutherland Highlanders, and thus of the regiment connected to that area of Scotland. He recovered from wounds in France enough to return to duty, in charge of German prisoners of war. In his letters home to his sister Jean in 1918, he often talked of his longing to be back in Iona, which he had first visited in 1912. Once he returned from France, he wanted to get to the island as soon as possible, to relax and to paint. He spent much of the summer of 1918 there, and sold fifteen Iona landscapes by Christmas that year.[96] Indeed, Iona seems to have been almost a 'heaven on earth' for many Scottish artists. Looking ahead to another war, Francis Martin mentioned in his memoirs that in June 1944, after commanding a large Home Guard area of Glasgow, the first thing he did was to go to Iona.

William Skeoch Cumming, *A Dream of Iona*, 1917. Watercolour on paper, 54.0 × 72.2 cm. Private collection

MACKINTOSH DIGGING IN

The war saw a real decline in the career of Charles Rennie Mackintosh (1818–1928). His fortunes as an architect had slumped in 1913, he was suffering from depression and drink, and his style held less appeal in wartime. He and his wife Margaret Macdonald moved south from Glasgow and he virtually gave up architecture, though he continued to create designs, particularly for fabrics.

But living in England brought its own problems. The Mackintoshes stayed in the Suffolk village of Walberswick, their principal visit lasting for about a year from July 1914. The summer passed without incident, and Mackintosh produced some of his now-celebrated flower paintings. But he started to arouse suspicion by taking solitary walks around the village and along the shore after dark. His wife's tendency to go away for extended periods also struck the locals as odd, and suspicions grew that he might be a spy. In the early summer of 1915, the authorities searched his house. They found letters from a German artist, and failing to understand Mackintosh's Glaswegian accent they mistook him for a German too, and he was arrested and held by the police. It was only when his wife returned several days later that he was

Charles Rennie Mackintosh, *Design for a Memorial Fireplace with commemorative panel, the Dug-Out, Willow Tea Rooms, Glasgow*, 1917. Pencil and watercolour on paper, 48.6 × 39.6 cm. Glasgow School of Art

released, after she managed to convince officials that he was Scottish.[97]

The Mackintoshes then moved to Chelsea, where artists were considered almost normal characters and the ambience was much more friendly. Work now appeared in form of a final commission from Mackintosh's generous patron Miss Cranston, for whom he had previously created unique designs for her celebrated Tea Rooms in Glasgow. It is possible that Miss Cranston devised the commission specifically to provide Mackintosh with work, for she chose to extend her Willow Tea Rooms in Sauchiehall Street down into the basement. It was to have a war theme, both as a celebration and a memorial, and the extension became known as the 'Dug-Out' as the space had no natural light, even from above. In design terms, it was a development of another recent, but quite separate, commission for another patron in Northampton. The new designs for Cran-ston were extremely bold: a striped ceiling, black walls, jazzy designs in vivid colours, and a great emphasis on triangular shapes. The sofa (which survives) is yellow with purple upholstery.

Mackintosh worked on the designs from late 1916. The official date of the extension is given on the memorial fireplace: 'This room was opened by Miss Cranston in the year 1917 during the Great European War between the Allied nations and the Central Powers', and construction started that year. It should have made for an exciting addition to a well-known Glasgow meeting place, but alas, the time was not right. No longer was such a cheerful approach to the War welcome. There was enormous loss of life aboard, and food shortages at home. It became the final architectural fling for Mackintosh in Glasgow, and the last of Miss Cranston's projects too, for she withdrew from business soon afterwards with the illness and death of her husband.

No photographs of the Dug-Out appear to have survived, and when Roger Billcliffe published the designs for the extension and its furniture in 1977, virtually all physical traces of the 'Dug-Out' had disappeared.[98]

FERGUSSON FINDING COLOUR

John Duncan Fergusson (1874–1961) had a very different war. He shunned anything to do with it, and avoided both volunteering and conscription. A regular visitor to Paris from the mid-1890s, he had lived in France from 1907, and the War had forced a reluctant return to Britain. He and his wife Margaret Morris resented this intrusion into their lives, an attitude not entirely unusual in artistic circles.[99] Correspondence shows that referees supported Fergusson's exemption from call-up on the grounds that he would serve his country better as an artist. However, he was summoned for a medical on 6 June 1918, and despite being only just within conscription age he passed with the top grading. But in July that year he was given permission by the Admiralty to visit Portsmouth for six weeks, to make studies for a painting relating to the war effort (not in fact an official commission, as has sometimes been inferred). He then went to London to paint – by which time the War was over.[100]

One would expect a painting by Fergusson, a Scottish Colourist, to be rather brighter in colour and more optimistic in mood than those of most artists in wartime. Even so, the flamboyant gaiety of his paintings is astonishing, especially considering when they were created, risking accusations of bad taste in a war-weary Britain. In France Fergusson had absorbed the bright, bold palette of Fauvism, and this was transposed to Portsmouth, with colour notes on his preliminary drawings.[101] The resulting paintings show the influence of both the Fauves and Vorticism, and they form a specific group of images within his

Miss Cranston's Sauchiehall Street, Glasgow
Drawing of commemorative panel over fireplace in Back Room
Scale ¼inch = 1 foot Nº 112

2 Hans Studios
73ʳᵈ Flood Place Chelsea S.W. 3

8 in × 5½
4½ × 2¾
2 × 1½
12 × 1"

Charles Rennie Mackintosh, *Design for the Dug-Out extension to the Willow Tea Rooms, Glasgow*, 1917. Pencil and watercolour, 36.4 × 54 cm. Glasgow School of Art

Entrance to Women's Lav.

Feet

Door to Private Room.

2' 8"

Red Room

2 Hans Studios
43rd Studio Place Chelsea

John Duncan Fergusson,
Dockyard, Portsmouth, 1918.
Oil on canvas, 77.0 × 68.8 cm.
Imperial War Museum

oeuvre. They could hardly have been further from the dockyard and maritime scenes of Bone, Pears and Lavery. There are people, but not at work, and some of them sport deep Mediterranean suntans. There is no hint of a war in progress, save for camouflaged ships, but even they have a fairground jollity. Functionality – indeed reality – is subsumed into a joyful celebration of summer colour and a fascination with shapes and shadows. Two paintings, both often reproduced as examples of this group, are his *Damaged Destroyer* (Glasgow Museums) which subordinates the vessel to a design of straight lines and arcs, overlooking the war damage that must have been a compelling feature; and *Portsmouth Docks* (University of Stirling), which comprises a playful geometric pattern created from cranes and gangways, funnels and ventilators, with billowing smoke and intense blue shadows, and a massive prow and anchor in the foreground.[102] Here, however, is his *Dockyard, Portsmouth*, an experiment in geometrical shapes, with the reds, deep blues and browns typical of the series. It was acquired by the Imperial War Museum only in 1975.

In his bullish and opinionated book on *Modern Scottish Painting*, published in 1943, Fergusson mentions discussions with Charles Rennie Mackintosh about the use of Army huts, roofed with glass, for exhibiting work in Hyde Park. The reference is tantalisingly vague, but shows Fergusson's enthusiasm and imagination, and his refusal to let practicalities be any hindrance to the progress of artists and their careers.[103]

DEFYING THE WAR

Conscientious objectors (the abbreviation 'conchie' or 'conchy' was in common use by 1917) have been the subject of much recent popular interest. Scotland's

connection with them, artistically speaking, is an intriguing one, as the Edinburgh prisons, Calton and then Saughton, were the destinations for many artists from England.[104]

The Brighton-born artist Percy Horton (1897–1970) was sentenced to two years' hard labour in Calton Gaol, and his drawing materials were taken from him on arrival in Edinburgh. His health deteriorated in prison and he was eventually transferred to hospital, where he made drawings of patients and nurses. While in Edinburgh his work came to the notice of the artist Edward Arthur Walton (1860–1922), who visited him, and invited him to stay while recuperating. Horton fared better with officialdom in the Second World War, when he was commissioned to produce work for the official War Artists Scheme.[105]

For the Scots, conscientious objection was a way of seeing England. William McCance (1894–1970) had completed his studies at Glasgow School of Art in 1915, then took a teacher training course, qualifying at the end of 1916. But in November 1917 he was imprisoned for refusing to go on parade with the Cameronians at Hamilton Barracks. He was moved about, his stays including spells at Wormwood Scrubs, Knutsford (Cheshire), Dartmoor and Warwick prisons. In Warwick his art training led to his being set to supervise the re-painting of buildings. It was an odd sort of incarceration, for in July 1918 he was given leave to marry Agnes Miller Parker, whom he had met at Glasgow School of Art.[106]

Not all of the 'conchies' were necessarily to be against fighting in the Second World War. One man in particular merits mention, the Glaswegian Patrick Dollan (1885–1963), who served a prison sentence for his views. But we shall encounter him again in a very different capacity in the Second World War, when he had become Lord Provost of Glasgow, a supporter of the war effort, and a patron of the arts.

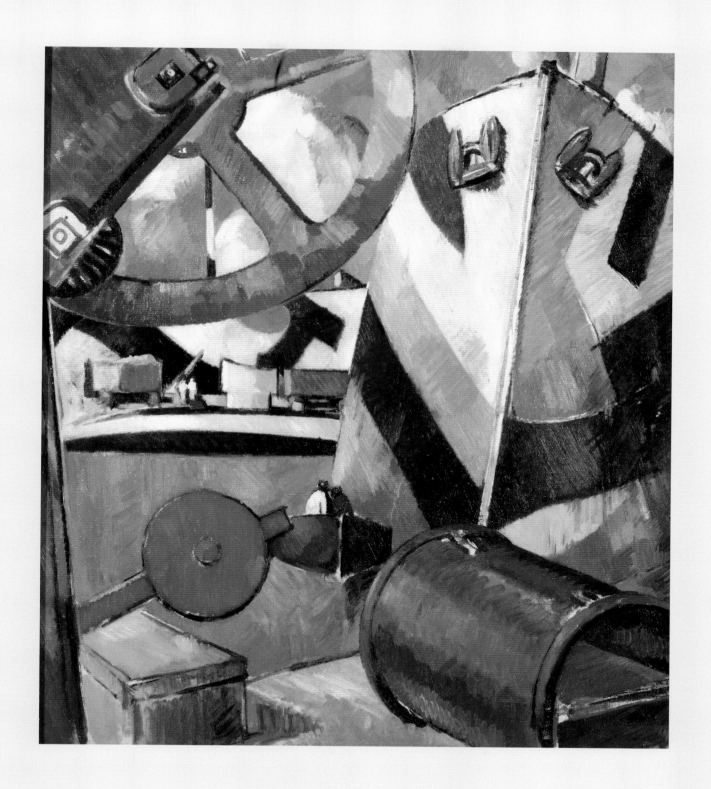

Joseph Denovan Adam, *The Covering Party*, 1918. Ink and pencil on paper, 26 × 36 cm. National Museums Scotland

FURTHER AFIELD

The 52nd (Lowland) Division was sent to the Dardanelles. The Scottish Horse, a yeomanry regiment, served during the First World War in an infantry role. The series of drawings by Joseph Denovan Adam (1879–1931) show it on active service in Salonika, fighting the Bulgarians on the Macedonian Front. Horses, however, both as cavalry mounts and transport animals, were still very important throughout the War. The artist George Denholm Armour (1864–1949) was a specialist in equestrian painting, and as a Lieutenant-Colonel commanded the remount depot in Salonika from 1917 to 1919.

While no single artist is particularly associated with the Dardanelles, Aberdeenshire-born James McBey (1883–1959) became *the* artist of the wider War against the Ottoman Empire in the Middle East. He had already left his job as a bank clerk to become an etcher, and enlisted after several rejections (due to poor eyesight!). He was subsequently commissioned in 1916 in France, serving in the Army Printing and Stationery Services. While there he sketched the Western Front battlefields and produced etchings which, when shown in London, were so successful that he was appointed an official war artist in 1917. He was attached to the British Expeditionary Force in Egypt on a six-month appointment, repeatedly renewed so that he remained in the region until 1919. A man of extraordinary physical endurance, he

advanced with the Army through Palestine and Syria to Aleppo and beyond, meeting and painting portraits of T. E. Lawrence, General Allenby and King Feisal. He made hundreds of watercolours and drawings of key moments in the campaign, as well as scenes of daily life (many of which are now in the Imperial War Museum and Aberdeen Art Gallery).

It was only after his return to Britain that McBey could produce etchings from his sketches. They were issued as three sets between 1919 and 1921, and greeted with great acclaim. The most famous etching is *Dawn – The Camel Patrol Setting Out*, made from his experience on reconnaissance with the Australian Camel Patrol in the Sinai Desert. Its nervous, energetic lines capture both the heat of the desert and the

sense of speed and urgency, the low viewpoint emphasising the distance and the lumbering gait of the camels. The frequent reproduction of this particular etching as the prime illustration of McBey's work in MIddle East has, however, rather obscured the variety of his work.

McBey made use of photographs, for example his *An Inspection of The Cameronians (Scottish Rifles) 30 October 1917*, showing men who were to participate in the attack on Gaza that night, as they were inspected by the Divisional GOC; this is a very accurate translation of a (surviving) photograph.[107]

There were other reasons for the popularity of McBey's work. The landscape and cities with biblical names struck a chord, and this war of movement –

James McBey, *Dawn – The Camel Patrol Setting Out*, 1919. Etching, 22.6 × 38.2cm. Aberdeen Art Gallery & Museums

guerrilla raids, rides across the desert with the Australian Camel Corps – was so different, and so much more exciting, than had been the stalemate of France and Flanders. The fact that McBey never saw first-hand any of Lawrence's raids, and missed the fall of Gaza, hardly mattered. He recorded the first sight of Jerusalem (and General Allenby's entry into the city), and The Black Watch guard on the Church of the Holy Sepulchre in the city.

McBey was not the only soldier–artist in the Middle East. Osborne Henry Mavor (1888–1951), the Glaswegian doctor and playwright better known by his pseudonym of James Bridie, served in the Royal Army Medical Corps. He worked first in France, then from 1917 in the Middle East and India. He made drawings of wounded soldiers (examples are in the Hunterian Museum, University of Glasgow) and he made use of his experiences in his later work. By the Second World War he was well known as a dramatist, but he nonetheless served in the Army again as a doctor.

ARRIVALS AND DEPARTURES

By the end of 1917, with families suffering losses, and food rationing and other shortages now making their impact, there was a huge war weariness. But conscription continued, and official art commissions increasingly emphasised the home effort and the common soldier.

Bernard Meninsky (1891–1950) had been born in the Ukraine, but brought up in Liverpool. He enlisted in 1914, only to be posted within England as a clerk, and suffered a breakdown in 1918 which resulted in a spell in a military hospital in Plymouth. In July that year he became a naturalised British subject, and invalided out of the Army. In September, when he was living in London, he received (at the suggestion of Walter Sickert, and with the active encouragement of Muirhead Bone), a six-month contract as an official war artist. He was now under exclusive contract to undertake no other form of work, and to make over to his employers his entire output during the contract period (in fact he took on some teaching, was found out, and had to work on his contract for an extended period). He was assigned a principal subject which would not be too arduous for him, and which suited his talents: to produce a picture or pictures at Victoria Station representing typical London scenes, during and after the arrival of a leave train from the Front.[108] The main outcome of this commission was a set of paintings now in the Imperial War Museum. They are somewhat eccentric pictures, with obvious references to Renaissance frescoes, and they repeatedly feature Scottish soldiers. In *The Arrival* (1918) a group of Scottish soldiers mingle on the platform, with nurses visible beyond.

Meninsky was making things look rather more cheerful than they were. The Scottish artist William Johnstone (1897–1981) came from Denholm, near Hawick, and worked on the family farm, a reserved occupation, until the spring of 1918, when he was conscripted. He was to discover just how desperate things had become: 'By that time the last dregs of humanity seemed to have been collected to be food for rats.' Men experienced in battle were exhausted and 'simply worn out by the effort; there was no long-long-way-to-Tipperary about it, they walked with a dreary gloom on our route marches … no more heroism, no more honour, only a desperate determination to survive, if possible, at all costs. We were sent home on draft leave … When I returned to barracks I found only ten of about four hundred men had turned up. The M.P.s had to fetch the rest from all over the country and bring them back under guard but some had reached London and were never seen again. In Perth jail they had almost a battalion imprisoned for desertion.' Johnstone was on his way to the train for the Front when he was sent off to the Agricultural Labour Corps, only to be posted back to the farm on 11 November, Armistice Day.[109]

By the time he was discharged in 1919 he had decided on an artistic career, and entered Edinburgh College of Art with an ex-service grant that year. He went on to the Royal Scottish Academy Schools, winning the Carnegie travelling scholarship in 1925. Most of his professional life was spent teaching in London; he was Principal of Camberwell School of Art from 1938 and the Central School of Art from 1947 to 1960. As well as being a highly original painter, he was an influential spokesman for art education and a friend of Hugh MacDiarmid.

Johnstone returned to Scotland on his retirement and spent the last two decades of his life painting large abstract works based on natural forms. Like William Gillies, his concentration on landscape might well have been influenced by his earlier, wartime experiences, as well as his background in a farming community.

OPPOSITE.
Bernard Meninsky, *The Arrival*, 1918.
Oil on canvas, 76.2 × 101.9 cm.
Imperial War Museum

SAILING TO SURRENDER

No artist could have failed to show the surrender of the German High Seas Fleet, in the Firth of Forth on 21 November 1918, as anything but a grand event. It was indeed grand, and it grandly humiliated Germany. The event was witnessed by numerous journalists, press photographers and artists on board British battleships.

The marine artist William Wyllie had been aboard one for a month, as the guest of Admiral Sir Charles Madden. Wyllie's group of sketchy watercolours of the surrender convey brilliantly the huge power of the battleships, the cold, foggy, hazy day, and the movement of it all; the example shown here is inscribed 'Huns in the Forth'.

The Edinburgh journalist J. W. Herries described the scene:

When I went up to the foremast turret after breakfast, the haze which had been over the sea had cleared off, and we were moving eastward in the pale light of a winter morning … Overhead there passed an airship, also scouting. A ray of sunshine caught it, and turned its upright rudders into points of golden light.[110]

John Lavery, *The End: The Fore-Cabin of HMS 'Queen Elizabeth' with Admiral Beatty Reading the Terms of the Surrender of the German Navy, Rosyth, 16 November 1918*, painted 1918. Oil on canvas, 220.9 × 276.8 cm. Imperial War Museum

And:

when I looked eastward from the fore turret of H.M.S.*Benbow* and saw on the horizon the glistening white hulls of the German Fleet come into view in the morning sunshine, on their way to surrender to the British Fleet … Here was a meeting of two of the most stupendously powerful fleets that had ever sailed on the face of the waters, the one surrendering to the other. The two fleets wheeled into position as if on the parade ground, forming a single procession of warships which moved steadily westwards – an assemblage of heavy metal on the sea such as the world had never seen and

will probably never see again. There was a magnificence about this meeting on the high seas which had its particular thrill.[111]

James Paterson (1854–1932), a Scottish artist whose work was almost exclusively concerned with peaceful landscapes and townscapes, rose to the occasion with a painting very unusual in his *oeuvre* for its power and colour. Nature dominates, with a sky almost on fire and smoke belching up from the huge ships. The gleam on the water down the centre of the picture enables the artist to show just how many vessels there are, some painted with camouflage. Above, the sky is spangled with planes and balloons. The ship's deck in the foreground provides the scale of the scene, with its tiny figures. Paterson uses nature as the unifying force of the composition, the watery sun gleaming through the haze.

Many other artists recorded the scene. Only Charles Pears competed with Paterson for the redness of the sky, in his large *The German Fleet at Anchor off Inchkeith, Firth of Forth: After the Surrender, 22 November 1918*, dated 1919 (Imperial War Museum); he was to be busy again twenty years later, in the Second World War.

The Admiralty was keen to have as many artists present as possible. Muirhead Bone had been on a four-month sketching tour of merchant marine ports with his brother David (a Merchant Navy Captain), but returned for this. Both Wyllie and Lavery were aboard the flagship HMS *Queen Elizabeth*, at Rosyth, to witness the arrival of the German delegation. Wearing the uniform of a Post-Captain, Lavery stood in a corner behind the German delegates to capture the formal surrender; 'most people would have been all ears, but I was all eyes', he later wrote.[112] The resulting painting, *The End*, seems all too tame after all the exterior drama, more like a company board meeting than a momentous and historic occasion.

THE SCAPA SCUTTLE

The surrendered German ships, manned by skeleton crews, went north to Scapa Flow and quickly became something of a tourist attraction. But without warning, on 21 June 1919, Rear Admiral Ludwig von Reuter gave the order to scuttle (sink) the fleet, fearing that the British might seize them before peace terms had been finalised. The order was carried out at noon, and nearly five hours later the last ship had sunk.[113] Marine artist Bernard Gribble was, by sheer chance, the sole artist there to witness it. The weather that day had been good, and Gribble had asked to go out in one of the patrolling naval trawlers, the *Sochosin* (itself a captured vessel) in order to sketch the German ships.[114] He recorded the scuttling at speed, preliminary studies for what would be unique oil paintings, and gave a full description of what he saw in the *Orcadian* on 3 July 1919.[115] The painting reproduced here shows boats from the German ships coming alongside Gribble's vessel, white flags flying, while the British crew – whose security had become rather lax – keep them under observation with all available weapons. C. W. Burrows made a photographic record of many of the ships immediately after the scuttling.

Bernard Gribble (1872–1962), *Sinking of the German Fleet – Scapa Flow on Saturday 21 June 1919*, painted 1919, Oil on canvas, 60.0 × 85.5 cm. National Museums Scotland

OFFICIAL ART AND EXHIBITIONS

Despite the government move to close galleries and museums, there were numerous public art exhibitions throughout the War, many in aid of charities. The National Gallery of Scotland, for example, held an exhibition of Scottish artists' work in aid of artists in Belgium in February 1915, and in aid of the Scottish Branch of the Red Cross in November 1918. Also in 1918 paintings came on loan from the Imperial War Museum Committee, to be followed by a Ministry of Information exhibition, and for two weeks in March 1919 a show from the Canadian War Records Office – and there were many more. Art magazines brought out special editions or supplements throughout the War. In 1918, a special number of *The Studio* was published entitled *The War Depicted by Distinguished British Artists*, edited by Charles Holme, including works by Bone, McBey and Keith Henderson.

By the beginning of 1918 the Department of Information had been closed, its role absorbed into the Ministry of Information headed by Lord Beaverbrook, one of Britain's most powerful press barons. When the War had started, Canadian-born Max Aitken (he became Lord Beaverbrook in 1917) had no official post, and chose to use his formidable energies on behalf of the Canadian war effort, establishing the Canadian War Record Office in London in 1916 in order to create a full documentary record of Canadians in the War. In 1917 he set up a charitable offshoot, the Canadian War Memorials Fund, which commissioned and exhibited over 800 paintings, sculptures and prints, making a considerable contribution to the 'coming-of-age' of Canada's national school of art.[116]

The project had been well received by the art world in Britain, who were kept informed on its progress by the art critic Paul Konody, employed by Beaverbrook as an adviser (Beaverbrook never pretended to be an art expert himself). Konody was a great 'Mr Fixit', who virtually advertised the scheme in his numerous articles. In August 1918 he gave notice in *Colour Magazine* that a special number would be devoted to Canada, and that 'over fifty British and Canadian artists and sculptors are engaged on works which will together provide a complete record of every phase of what Canada has done in the great war …' This special issue bemoaned the lack of art patronage during the War – 'Painters and sculptors had lit upon evil days … Art seemed dead and buried for the duration of the war, when the Canadian War memorials scheme was launched.'[117] All of which sounded wonderful, but it meant that various British artists, such as D. Y. Cameron, were getting tied up with Canadian commitments and were thus unavailable when offered other commissions later on.

In January 1919 the Canadian War Memorials Exhibition opened at the Royal Academy in London, with the Canadian Prime Minister, Sir Robert Borden, present. There was no doubt that Beaverbrook enjoyed being the impresario at this very splendid occasion. Konody had organised much of this, and he had done his work well, for the exhibition was very wide-ranging in scope; he was a man with broad artistic interests and sympathies.

In 1918 and now at the Ministry of Information, Beaverbrook wished to repeat the project for Britain, an idea not entirely concomitant with his propaganda responsibilities. And while his hands-on style had gone down well with modern-minded Canadian officials, it was not quite as acceptable to British officials. However, his forceful personality got things moving, and by March 1918 the British War Memorials Committee had been set up, based largely on the Canadian model.[118]

This resulted in another huge show at the Royal Academy in December 1918, but alas it had been upstaged by the Canadian one, and received far fewer

visitors. The art press in general reviewed it favourably, but the popular press lambasted the modernists, complaining that heroes should look heroic. There were even questions in Parliament about the 'freak' pictures. This may have had an influence on the official art of the Second World War, which was rather conservative in its style.

ART AFTER THE EVENTS

At the end of the War numerous artists summed up the War in large, commissioned paintings. But they now faced the problem of the public's over-familiarity with standard images and workaday compositions. Thus Ian Strang's *Ypres* of 1919 shows a featureless landscape with a couple of thatched cottages in which trees and hedges are just beginning to grow again, but tells us little new, especially as the landscape is very empty.[119]

David Young Cameron (1865–1945) is known principally as a painter and etcher of landscapes, though he undertook no etching between 1918 and 1922, when he was busy completing compositions for the Canadian War Memorials Fund; his war paintings include *The Battlefield of Ypres* (1919), *Bailleul* (c.1919), and *A Garment of War* (c.1926). At the outbreak of war Cameron was forty-nine, but he joined the Volunteers in Kippen. In 1917 he became one of the artists hired by Lord Beaverbrook to work with the Canadian Expeditionary Force. He agreed to produce two oil paintings, and went to France mid-October with the rank of Major to undertake preliminary studies for one of them. He went again in January 1919, by which time the War was over, though the devastation remained. He also undertook another painting as a British Government commission, for the intended national Hall of Remembrance – a project never completed, though his contribution

is held by the Imperial War Museum, a picture entitled *The Battlefield of Ypres – After*. This large-scale work lacks originality or punch, though the colouring of sky and snow relieve the visual tedium of the shattered landscape. His smaller *Bailleul* (Dundee Art Galleries & Museums) is also a snowy scene, showing the ruined town on the horizon, with three blasted trees forming a sort of Calvary. He was kept busy with war paintings from October 1917 to the end of 1920.[120]

Cameron's final large painting on a war theme, *A Garment of War*, was completed by 1926. It is his strongest image, perhaps because it was not so rushed. The shattered town can be seen as a ruin on a fine evening, or as a town actually under bombardment. Quite apart from its ambiguity, the composition has a great luminosity, and a strong presence on the wall.

The artist Joseph Gray (1890–1962) produced a group of battle paintings after the War, most of them with considerable documentary and narrative qualities, showing battles with identifiable individuals arranged in groups in the heat of action. While they provide good records, they are not in general great art. However, his painting *A Ration Party of the 4th Black Watch at the battle of Neuve Chapelle, 1915*, painted 1918–19, is both unusual and evocative in its atmosphere. Spectral, ghostly, moonlit figures, laden with supplies, move carefully through the shell-churned detritus of the battlefield.

Robert Gibb's *Backs to the Wall, 1918*, painted in 1929, has already been mentioned in Chapter 1. Gibb was born in 1845, and having made his name with *The Thin Red Line*, painted in 1881, this represents an extraordinarily late interest – in every sense – in romanticising the First World War, for he was eighty-four when it was painted. Perhaps this is what prompted the apparition of historic figures galloping to the rescue in the sky above the battlefield.

David Young Cameron, *A Garment of War*, c.1926. Oil on canvas, 121.9 × 167.0 cm. City Art Centre, Edinburgh Museums and Galleries

NEXT STEPS

Muirhead Bone had been a founding spirit of the Imperial War Museum. He was appointed a trustee in 1920, gave the museum 400 of his own drawings and watercolours, and from the proceeds of his own sales he set up a fund of £2,000 to buy works by younger artists; he received a knighthood in 1937. When the Second World War broke out, he was once again the first war artist to be appointed.

Stanley Cursiter became Keeper of the Scottish National Portrait Gallery in 1925. His interest in technical matters as well as art were highly beneficial to the collections (picture conservation, re-designing heating, humidity control, and so on), and from 1930 he was Director of the National Galleries of Scotland. His achievements in the Second World War are discussed in the next chapter.

F. C. B. Cadell continued to paint and drink (and went back to smoking). As mentioned earlier, in 1919 he exhibited a painting at the RSA entitled *Poisonous Gas*, though he painted more views of Iona than of anything else.[121] His style changed after the War, becoming harder and more angular.

Frank Spenlove-Spenlove continued to paint Belgian subjects, often very elegiac in tone, such as *The White Silence, Belgium* (1925), which shows an elderly woman in the snow outside a humble house, the loneliness and loss all too evident.[122]

William McCance, the conscientious objector (p.72), remained anti-war for the rest of his life. After release from prison he and his wife moved to London in 1920, where he produced a series of paintings on the theme of war and weapons, anxiety and hostility, including the Surrealistic *Conflict* of 1922, depicting ominous, writhing abstract forms. The alarming brightness and awkwardness of these life forms, organic and yet also mechanical (they could be brightly painted metals) appear very threatening.[123]

OPPOSITE.
Joseph Gray, *A Ration Party of the 4th Black Watch at the Battle of Neuve Chapelle*, 1915, painted 1918–19. Oil on canvas, 66 × 91.4 cm. Imperial War Museum

LEFT.
William McCance, *Conflict*, 1922. Oil on canvas, 76 × 63.5 cm. Glasgow Museums

In the 1930s McCance moved into the world of private publishing, and he wrote a considerable amount of art criticism; in an article of 1930 he declared that 'In my opinion Scotland is the great White Hope in the field of European Art,' with 'a natural gift for construction'.[124] At the beginning of the Second World War he provided gratuitous advice to those running the official scheme for war artists (p.120).

If McCance was an anxious artist, Stewart Carmichael (1867–1950) was downright depressed. A Dundonian who had travelled on the continent before the War, his *Dundee Women Reading the War News* of 1920 (University of St Andrews) is an essay in despair: three gaunt women in timeless robed clothing, who seem to be auditioning for the witches in *Macbeth*, are reading what might well be a casualty list. The subject was a common *genre* subject at the time, but the overall effect is grim rather than merely

sad. War is still very much present in this artist's mind.[125] Hiram Sturdy, who painted war in the trenches of the First World War (and in the Home Guard in the Second World War) painted a verbal picture in his unpublished piece entitled *Aftermath*, which starts:

Officially, the war finished at eleven oclock [sic], on the eleventh day of November, nineteen hundred and eighteen, unofficially it goes on in the minds of many, still groping amongst sandbags, mud and blood. When they are, where they once dreamed of, between clean sheets, in a real bed, they still crouch in terror, from the screaming shells of an artillery barrage, to wake with the same feeling of tired-

ness and misery, as in the real thing. From those dear to them, they get sympathy, but that is not enough to fill the gaps that war had made. To many, there is no sympathy, and the gap widens. Many who stayed home seem to think that their lot was as hard as the soldiers or harder … Its no use, and the ex sodger is just a lost man, bumped out, to fish for hissel in a new world where most of the best things have been snaffled up by those who never went, and his dreams of home as expected, vanish, making him feel the victim of a cruel gigantic fraud called Patriotism.[126]

Those in positions of civic authority had lent the dignity of their office to the war effort and, after the

War, to the tradition of Scottish portraiture. Sir James Taggart (1849–1929) was a successful businessman in the granite industry, who had begun as an apprentice stonemason. He was Lord Provost of Aberdeen 1914–19, but had chosen to have himself painted in the service dress of the Lord-Lieutenant rather than the robes of Lord Provost. He had been notable for his recruiting efforts, and was knighted in 1918. It was perhaps because of his relatively humble beginnings that he wished the society portraitist Ambrose McEvoy (1878–1927) to show him in such a self-deprecating manner, so very unlike a Lord-Lieutenant (either in peace or war), almost shambling into view.

Sir William Don, Lord Provost of Dundee, also chose (as did other Provosts) to lay aside his civic robe and chain, though they lie beside him as he stands, formally and self-consciously, for his portrait by George Henry (1858–1943).

James Bell Anderson, after James Guthrie, *Douglas Haig (1861–1928), 1st Earl Haig of Bemersyde*, 1928–1929. Oil on canvas, 127 × 89 cm. University of St Andrews, Museum Collections

EARL HAIG: A CHANGING PICTURE

Field Marshal Sir Douglas Haig, first Earl Haig (1861–1928), has suffered from extraordinary vicissitudes in reputation. Controversy about his leadership continues today, and the numerous images of him have perhaps fuelled some of the flames of debate. As General, later Field Marshal, Sir Douglas Haig, he was Commander-in-Chief of the British Expeditionary Force in France and Belgium, 1915–18. He was created Earl Haig in 1919. After retirement from the Army in 1921 he helped to establish the Royal British Legion and devoted a great deal of his time to it until his death in 1928. Haig's generalship became more controversial after his death, and his reputation ebbed and flowed from the middle of the twentieth century to its end.[127]

In his numerous portraits, Haig is generally shown as a handsome, benevolent-looking, patrician figure. Many portraits were painted, copied and recopied throughout Britain and its Empire. There were also mementos such as 'Haig' Toby jugs.[128] Usually, he appears serious, yet half-smiling, hinting that he might even be genial when out of uniform. The study by John Singer Sargent, which the artist made for his large group portrait of *General Officers of World War I*, also shows this typical expression.[129]

Also typical is the painting by James Bell Anderson, one of the many after the iconic image by James Guthrie (1859–1930). Here, Haig seems to be a father-figure, clothed in a great-coat as if just returned from inspecting troops in the line, and again he has that benign look.

Perhaps more telling is a rather different picture by John Christian Johansen (1876–1964), presented

LIVING WITH THE MEMORIES

The Stirling artist John Munnoch (1879–1915) studied art in Edinburgh and was on a sketching tour in the Netherlands when war broke out. He returned to Scotland, joined the Royal Scots, left for Gallipoli in March 1915, and was killed there at the end of June. His fiancée, Jessie MacGregor, had modelled for him in the picture entitled *The Chinese Coat* (Stirling Smith Art Gallery and Museum), which epitomises the arts and craft textile glamour of the pre-war world. She also sat for him in a picture known until recently as simply *Portrait of a Young Woman*, Jessie's patient demeanour prescient of her long 'widowhood', for like so many other young women of her generation, she never married.

The sculptor William Lamb (1893–1951) was born in Montrose and lived there most of his life. He trained as a monumental sculptor, joined the Queen's Own Cameron Highlanders, fought in the trenches in France and Belgium and was discharged unfit through serious injuries including the loss of use of his right hand. He learned to use his left hand, and after studying art enjoyed a successful career as a sculptor. His circle in Montrose included Hugh MacDiarmid, the poet Violet Jacob and the painter Edward Baird. Lamb's studio in Montrose is now a museum, full of the sculptures, etchings and drawings he gave to the town, and his biography was published in 2013.[130] Another man who had to learn to paint again was William Watt of Longniddry, who served in France and was wounded at the battle of Arras, losing both hands and most of one arm. But he decided to learn to paint, enrolled in classes at the Edinburgh College of Art, working with a brush strapped to his remaining forearm. In the 1930s he became known for his painting on pottery, his sense of humour shown by the signature on his work of his nickname 'Stump'.[131]

John Bulloch Souter (1890–1972) came from

to Haig by the artist in 1919. Johansen was a Danish–American portraitist, best-known today for his commissioned group portrait, *The Signing of the Treaty of Versailles* (1919, National Portrait Gallery, Smithsonian Institute, Washington). The large, bare room captures Haig's lonely responsibility of command, and the man at work.

Haig was a cavalryman, and the equestrian statue by G. E. Wade of the early 1920s stood until recently on Edinburgh Castle's esplanade. This has perhaps not benefited his image, for he was a forward-thinking man who welcomed, and used, the new technologies of the battlefield – the 'Haig' Toby jug shows him sitting on a tank – yet this depicts him as a very traditional soldier. Interestingly, it was not paid for by public subscription but (as its original metal notice reads) by an individual, a Parsee residing in England: 'Earl Haig / This statue was presented to the City of Edinburgh by Sir Dhunjibhoy Bomanji of Bombay in admiration of the services rendered to the British Empire by the Field Marshal'. In 2011 the statue was relocated to the courtyard outside the National War Museum within the Castle precincts. It is a sign of the times that its move was due to the logistical requirements of the Royal Edinburgh Military Tattoo.

LEFT.
John Munnoch, *Jessie MacGregor*, 1913. Oil on canvas, 76.5 × 64 cm. The Stirling Smith Art Gallery and Museum

RIGHT.
John Bulloch Souter, *Portrait of an Unknown Officer*, c.1925. Oil on canvas, 69 × 59 cm. National Museums Scotland

Aberdeen, where he attended Gray's School of Art, followed by study on the continent on a travelling scholarship, where his interest in the work of Chardin and Vermeer influenced his later style as a portraitist. During the War he served in the Royal Army Medical Corps, after which he moved to London. The sitter in the portrait shown here is probably a Quartermaster of The Black Watch – an officer promoted from the ranks with responsibility for accommodation and supplies. His medals show that he served through the First World War, while his age suggests that he was a pre-war regular.[132]

THE FUTURE

Alfred Leete is best known today for his 1914 recruiting poster featuring the imperiously pointing Lord Kitchener who wanted 'YOU' for the Army. He had a career as a graphic artist, much of which comprised poster design. His 1919 poster, *See the World and Get Paid for Doing It*, shows two Black Watch soldiers swaggering splendidly along in a Middle Eastern souk, in a world once again at peace and content for Britannia to go on ruling her Empire.

Despite all the art and reminiscence of the First

World War, by the late 1920s such was the ignorance of actual facts that Carey and Scott's 1928 book, *An Outline History of the Great War*, begins with a Preface which would stand as a good argument for war artists:

> To those on whom the events of the years 1914 to 1918 are branded as a living experience it is sometimes a shock to find that the youth of to-day [sic] is often ignorant of the very names of the chief battles of the War … To realise what the War *felt like* is even more important than to know its events in outline, and the false glamour which is apt to be shed on war, when viewed from a distance, finds no place in this narrative. In particular, an attempt has been made in the concluding chapter to summarise very briefly the attitude and experience of those who walked through the valley of the shadow of death.

The concluding chapter is prescient. It begins:

> If the Armistice was the end of a long night-mare, it was also the beginning of a new and vital set of problems … It is untrue to say that there is no glamour in war. There is glamour for the civilian in the mere change into uniform … But with the first sickening cry of "Stretcher-bearers!" glamour died … Modern warfare has few moments of excitement and is utterly unlike the cheerful word-picture of "Our Military Correspondent" … Mud, monotony, and deadly fatigue became the daily portion, varied only by periods of intense fear and less frequent interludes of comparative safety and comfort … not one of those who felt the scorch of the war would willingly live through all his or her experiences again. The younger generation … may be liable to forget one supreme lesson taught by the years 1914–1918 – that in the next war there will be no non-combatants.[133]

Poster by Alfred Leete, *See the World and Get Paid for Doing It*, 1919. Lithograph, 76.4 × 50.6 cm. Imperial War Museum

CHAPTER 3

After *The Long Week-end*:
The Second World War, 1939–45

NOT SUCH AN INTERLUDE

The Long Week-end was the title given by Robert Graves and Alan Hodge to their book, published in 1940, on Britain between the two World Wars.[1] The interlude was hardly a weekend away from war, even for the British, for the Spanish Civil War drew many people from Britain: a higher proportion of Scots fought as volunteers against Fascism in Spain than from any other part of Britain.

Most of the artworks depicting, or commemorating, the Spanish Civil War were created long after the event, and many of the formal memorials appeared even later (p.221). However, Wilhelmina Barns-Graham, attending the Edinburgh College of Art from 1931 to 1937, produced a painting for her Diploma exhibition entitled *Escape, Air Raid, Spain*. Its subject is the Fascist bombing in the Basque region of Spain, the composition probably adapted from a newspaper photograph. Figures in the foreground sprawl towards the viewer, while others beyond are pulled up from below. The tunnel-like setting seems to anticipate Henry Moore's series of Second World War bomb-shelter drawings made in the London Underground. Barns-Graham constantly returned to

war themes throughout her long career, much of her material coming from news reports rather than first-hand experience. However, she responded to events with perceptive and intuitive understanding, and in 1997 she commemorated the Spanish Civil War with a *Spanish Elegy*.[2]

ANOTHER WAR BEGINS

In the late 1930s, with the threat of war looming, recruitment efforts increased. The Territorial Army (TA) was doubled in size, and the many TA recruitment posters look back – not to the Great War, too fresh in the national consciousness – but to an older patriotism. A typical example by Lance Cattermole entitled *Scotland For Ever!* (1938) shows a colourful and ghostly Highlander standing protectively over three khaki-coloured Territorials. Aside from the thistles and heather, there are unfortunately mixed messages, for the Highlander is clearly a Jacobite clansman, whose enemies' lineal descendants would be the rifleman and Bren-gunners in the picture!

Wilhelmina Barns-Graham, *Escape, Air Raid, Spain*, 1936–37. Oil on canvas, 69.6 × 64.8 cm. The Barns-Graham Charitable Trust

People's War', with near-total involvement of all citizens. By September 1939 the National Service (Armed Forces) Act imposed a liability to military service on men aged 18 to 41, and by December 1941 this had been extended to 50, and women also became liable to conscription. Children were evacuated from cities *en masse*, meaning that almost all families were affected.

Britain and France declared war on Germany on 3 September 1939, less than twenty-one years after the armistice that ended the First World War. Events moved swiftly, particularly in Scotland. On 1 September the ss *Athenia* had left Glasgow for Montreal, via Liverpool, only to be sunk two days later by a U-boat, with heavy loss of life. Then on 14 October, HMS *Royal Oak*, lying at anchor in Scapa Flow, was sunk by a German U-boat. On 16 October the first German aircraft to be shot down over Britain was brought down over the Firth of Forth. As in the previous war, the yards and factories on the Clyde turned to production of warships, guns, engines and munitions (the Singer Factory at Clydebank had already been entrusted with its first war-contract by September 1938). Clydebank was to suffer terribly in the great Blitz of 1941, and Scottish cities were bombed repeatedly, albeit on a lesser scale than many of those in England.

There were many artists on hand to record both daily life in London, and the Blitz, but little was recorded in Scotland as the more dramatic events unfolded. The few on-the-spot artistic accounts have since been augmented by artists working retrospectively. Much of this corpus of material is little known outside Scotland, for the bulk of publications relating to the Second World War in Britain approach the subject from a London-centric perspective, with a resulting under-representation of the Scottish experience.

(Cattermole produced an 'English' version of the same design with the slogan 'For England and Freedom!', the soldiers in exactly the same position, though unkilted, with a figure from the period of the Armada in the sky behind.)

In the event, fewer artists than ever before were to depict men actually fighting. Not for nothing did the Second World War come to be known as 'The

WATCHING AND WAITING

In a portrait by Montrose artist Edward Baird (1904–1949), local gamekeeper James Davidson prepares to turn his shotgun on the enemy instead of poachers. He wears an armband inscribed 'LDV'. The Local Defence Volunteers came into being on 17 May 1940, the initials on their identifying armbands (worn with their civilian clothes) deprecatingly referred to as 'Look, Duck and Vanish', for many thought the organisation all too amateur. They were transformed into the Home Guard on 22 July that year.[3]

Baird was born in Montrose, the son of a local sea captain, and lived there for most of his life.[4] He studied at Glasgow School of Art, where he was influenced by the meticulous, hard-edged figurative style of James Cowie (and became a friend of fellow-student James McIntosh Patrick). He then travelled to Italy on a scholarship, and his highly personal approach shows influences of early Italian Renaissance painting, together with that of contemporary surrealists, and the English painters Paul Nash and Wadsworth. Baird was an eccentric character and painter, suffering poor health, and the detailed precision of his style, with its great attention to detail, borders on the obsessive. His sitters often have a faraway look, gazing out of the picture beyond the viewer. He worked slowly, and by the time he completed his *Still Life* of 1940, showing apples, pears and flowers, at a time when fruit was becoming hard to obtain, it had gone rotten in the studio – an extravagance, friends said, given the scarcity of it.[5] Baird produced some officially-commissioned drawings during the War, but at his death in 1949 his output had been limited, and his work has only recently received the recognition it deserves.

James McIntosh Patrick (1907–1998) was waiting for call-up when he painted *A City Garden*, an image which represented the situation of so many

citizens; it was purchased by the City of Dundee in 1940, the year of its composition and exhibition at the Royal Academy in London. It could hardly be a less dramatic subject: a view of the artist's back garden in Dundee, with tenements and factories beyond (a contrast to the view from the front of his house, looking south over the Tay Bridge). The artist himself discussed the painting many years later, saying

Edward Baird, *Local Defence Volunteer*, 1939. Oil on canvas, 91 × 69.5 cm. Aberdeen Art Gallery & Museums

'The war being on made all the little intimate things suddenly very precious and there was no knowing but that the Tay Bridge would be bombed next week.'[6] We see the everyday life of his family: his wife Janet hanging out the washing, and his daughter Ann with the basket nearby; over to the left, work is underway on the construction of an Anderson air-raid shelter. A few apples still cling to the trees, while others have fallen, symbolic of the end of a summer and even, perhaps, of the likely casualties of war. The long shadows of the low, autumn sunshine provide dramatic contrasts in light, the stark whiteness of the washing glowing against the deep browns of the garden in shadow.

William Oliphant Hutchison (1889–1970) came from Kirkcaldy, studied at Edinburgh College of Art and in Paris, and was one of the young painters who exhibited as the Edinburgh Group immediately before and after the First World War (in which he survived a serious war wound). From 1918 he worked as a portraitist in Edinburgh and London, then became Director of Glasgow School of Art in 1933 (and later President of the Royal Scottish Academy). He distinguished himself as an able administrator, especially during the war years, when he was in constant touch with students and staff at the front. But the identity of the sitter in this portrait, Walter Rankin, had been lost by the time the Scottish National Portrait Gallery acquired the painting: he was later identified as a retired newsagent of the Skelmorlie LDV unit. Rankin displays a stoic good nature and a hint of humour, the everyday objects on the table forming a domestic contrast to the military uniform (which Davidson, the keeper – in Baird's portrait – had yet to acquire), and his Canadian Ross rifle is propped against the table.[7]

The artist Robert Sivell (1888–1958) was a lively, opinionated and dynamic personality. Born in Paisley, he had first been apprenticed in a Clyde shipyard, then served in the merchant navy in the First World

OPPOSITE.
James McIntosh Patrick, *A City Garden*, 1940. Oil on canvas, 71.1 × 91.4 cm. Dundee City Council (Dundee Art Galleries and Museums)

ABOVE.
William Oliphant Hutchison, *Walter Rankin, Local Defence Volunteer [Home Guard]*, 1940. Oil on canvas, 76.0 × 55.6 cm. Scottish National Portrait Gallery

Robert Sivell, *Portrait of a Soldier* (Alistair Paterson), c.1940. Oil on plywood, 101.3 × 61.3 cm. Aberdeen Art Gallery & Museums

War. In the 1930s he lived in the artists' community in Kirkcudbright until appointed to teach at Gray's School of Art in Aberdeen in 1936, where he stayed until retirement in 1954. His *Portrait of a Soldier* (one Alistair Paterson) is hardly dramatic, however, as it conveys the quiet concentration of 'pulling through' a Lee-Enfield rifle. The young man is pictured as a diligent soldier, a far cry from the romanticised image of the Scottish soldier on posters – no muscular Highland braveheart, but a skinny workaday young man in glasses, practising the basic housekeeping of his new trade. This perception of the soldier – and what they are shown doing – was part of the artistic legacy of the First World War. Walter Rankin enjoys his mug of tea, and a young man sits down to clean a rifle – no drilling, no marching, no smartness of uniform – soldiers are now ordinary men, simply doing their jobs. War had been shorn of all visual glory, and from now on, the only positive emotion generally depicted is a sense of relief at the end of a conflict. Indeed, in a comparison with pictures painted a century earlier, many of the artists of the Second World War might appear to be pacifists.

Sivell received several commissions from the War Artists Advisory Committee, including the most unromantic picture, *Dehydration of Herrings*, now in Glasgow Museums (something of a pictorial equivalent of Lewis's photographs from the previous war).[8]

Alan Davie (1920–2014) from Grangemouth was the son of an artist, and studied at Edinburgh College of Art before serving in the Royal Artillery. His *Self-Portrait* drawing of 1939 shows an unshaven, tousled-haired art student, but a pair of small drawings of his fellow-soldiers made in 1941 and 1942 are rather more formal and considered.[9] Conventional in style, they show little influence of contemporary art movements or presage of Davie's own future style; the example shown here is inscribed 'Gunner Jimmy Armit in the Barrack Room / another Scotsman / from

Edinburgh', and dated 16 August 1941.

The saturnine *Self-Portrait* drawn in 1940 by Robert Colquhoun (1914–1962) could not be more different in character, however similar in technical approach. Colquhoun, who came from Kilmarnock, had trained at Glasgow School of Art, where he met his lifelong companion Robert MacBryde (p.140). He studied under Hugh Adam Crawford and Ian Fleming, but the foremost influence in this image is the Vorticist Wyndham Lewis, making Colquhoun's face, with its exaggerated features, appear dangerous and unpredictable, if not downright evil.[10]

TAKING TO THE AIR

Keith Henderson was one of the first two salaried Air Ministry artists, along with Paul Nash, recruited to

an appointment which, he was told, 'would be, in the first instance, for a period of 6 months only, and it is not anticipated that any artist would hold one of these posts for the whole duration of the war'. His correspondence file in the Imperial War Museum traces the progress of the appointment.[11] Arrangements did not go smoothly, as he was frustrated to find that Sir William Rothenstein had already come north on his own initiative (see p.159). In fact, Rothenstein's unexpected arrival seems to have caused some confusion among Air Force personnel as well, for they assumed him to be an officially appointed artist, which he was not. Writing from St Andrews on 27 April 1940, Henderson noted that he went 'across to the Leuchars aerodrome daily or nearly daily. It is most exciting. Subjects for pictures are all too numerous. In fact, as we say in Scotland, I'm in glory.' But in the next paragraph he writes of

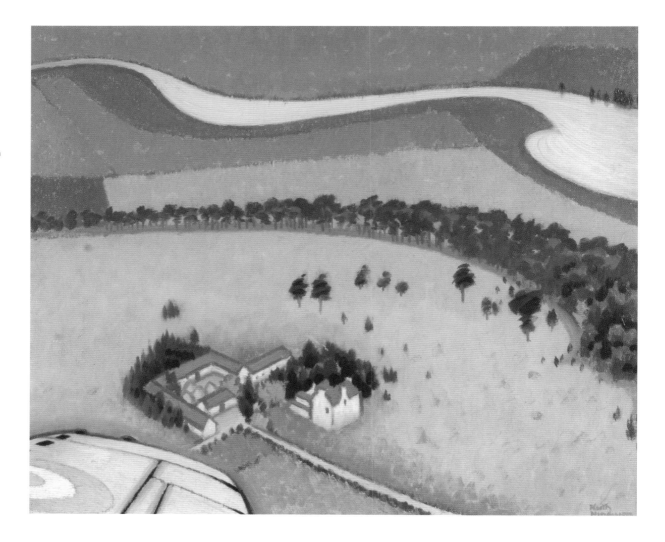

Our Good Sir William. He has forestalled me here and drawn not only the higher ranks, but the lower ranks, pilot officers and such as well. I hoped he would have left me the humbler fry! He definitely gives out that he is Official, and in consequence I am regarded with, or was at first regarded with, surprise. I am doing mostly views and hangars and so forth. You won't want two lots of drawings of the same personnel.

Henderson thus avoided portraiture, and instead embarked on some very innovative compositions of aircraft and scenes from the air. On 18 September he wrote: 'I've caught a diluvian, oceanic cold after drawing clouds at 7000 feet in an open Magister [training aircraft] with ice forming on the wings.' He also, fortunately or unfortunately, kept up an energetic correspondence (now in the Imperial War Museum) with his masters in London. It makes for sad reading, for the energy and initiative demon-

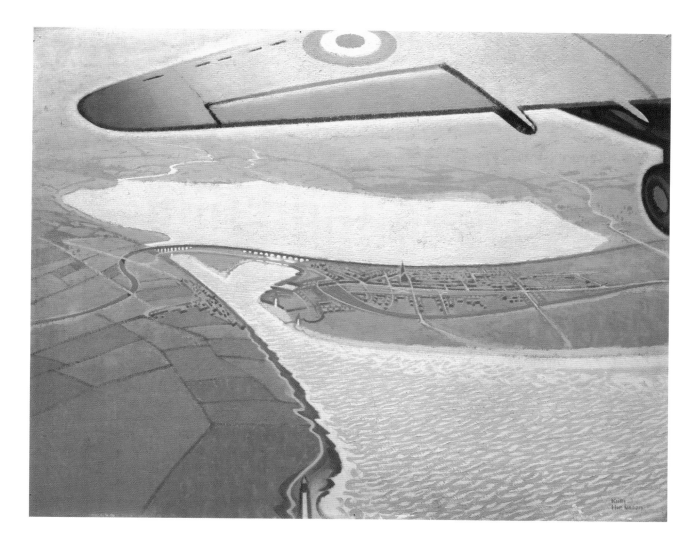

strated in Henderson's art was not reflected in the pernickety nature of his letters, particularly his repeated requests and anxiety about having his paintings photographed in case they might be lost through bombing. He also suggested that prints (of his own work and others) be made available for sale to airmen. After six months his appointment was terminated; it came as a disappointment, for he appears to have misunderstood his contract, expecting it to last a year. But he accepted it philosophically, and asked if he might go onto a 'commissioned' list.

Henderson's work is narrative and illustrative, smooth but strong on design, and his dramatic viewpoints create for tremendous images. He had studied at the Slade and in Paris, where – among various artists – he knew Edmund Dulac, whose influence can be seen in some of his compositions.[12] His *Air Gunner in Action* (p.96) is set against the dark, starry night sky, the gunner's vulnerability emphasised by his isolation in his bubble of plexiglass, like a specimen

Edward Baird, *Unidentified Aircraft (over Montrose)*, 1942. Oil on canvas, 71.1 × 91.4 cm. Glasgow Museums

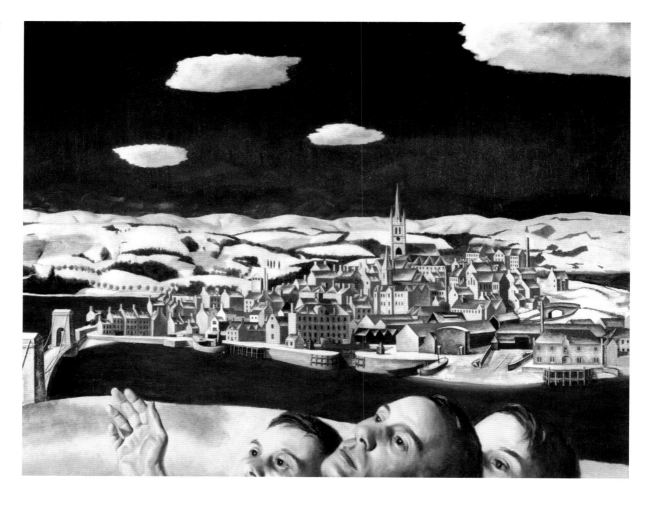

in a jar. His *Wings over Scotland* manages to show the plane with its patriotic roundel, and a Scottish landscape and farm below, all within a sweeping design of curves. The simple *An Air View of Montrose* succeeds in conveying the sense of sheer vertical height above the town, with its streets and church spire, and the viaduct at the entry to Montrose Basin.

Two of these compositions were used for wartime Christmas cards, with notes: *Wings over Scotland*, 'This picture was actually painted from the air by an artist who was at the time working for the Air Ministry,' and the *Turret* view, 'An air gunner ready to attack at a moment's notice any German aircraft which may loom up out of the darkness.'[13] Looking back on his work in 1975, Henderson mentioned the influences of illustrators Walter Crane, Edmund Dulac and Aubrey Beardsley, though his simplified synthesis of influences produced compositions particularly apt for time and purpose.[14] His work became neglected by the latter half of the twentieth century, and his best-known image today is a painting of an entirely different subject (*Women Singing at a Table*:

Wool Waulking, 1927–8, University of Edinburgh). However, the resurgence of interest in war art means that his strong designs are once again becoming appreciated.

LIFE AT GROUND LEVEL

On the ground below, one of Edward Baird's more surrealist images shows the people of Montrose looking skywards. Baird spent most of his life in the town, which featured repeatedly in his pictures. In *Unidentified Aircraft (over Montrose)* it takes on the character of an Italian town from an early Renaissance painting, forming a snowy backdrop to three very modern faces appearing awkwardly just within the bottom of the composition. They appear to be in supplication or adoration, the disembodied hand in the foreground held up as if in blessing. The townscape and clouds above repeat a motif of an earlier, smaller painting.[15]

Down to earth in every sense was the aircraft

Alexander Macpherson, *War Weapons Week: Paisley, December 1940*. Watercolour on paper, 38.4 × 56.2 cm. Imperial War Museum

Tom Gourdie, *In the Hangar at RAF Dumfries*, 1941. Watercolour on paper, 51.3 × 37.8 cm. Family collection

sketched by Alexander Macpherson (1904–1970) in his modest watercolour *War Weapons Week: Paisley, December 1940*. All over the country there were War Weapons Weeks. Paisley town hall is visible in the background, and bunting is flown as if for a fête. Townspeople examine a display of artillery, tanks and a captured German Messerschmitt 109 fighter aircraft. Macpherson made at least one other version of the picture; a variant of the composition appeared on the market recently.[16] He was also commissioned for a set of school cadet images, now in the Imperial War Museum.

Henderson recorded work on the ground with planes, as did Tom Gourdie (1913–2005) who was based at RAF Dumfries 1941–42.[17] Gourdie came from a Fife mining village, and had already studied at Edinburgh College of Art and travelled in Europe on scholarships before the War. His pictures of everyday life at an air station were rarer than he probably realised, and they now provide a valuable insight into everyday maintenance and technical work. This small watercolour is inscribed on the back 'Whitley bombers at Dumfries, Sept 1941'. Gourdie had a good sense of humour: one watercolour of 1942 is entitled *Gremlins Attacking the Simulator* (Dumfries and Galloway Aviation Museum) and shows little black elf-like creatures dancing around the mechanical works.

In October 1941, after discussion with Eric Kennington, Gourdie enquired about the possibility of work as a war artist, but this failed to materialise.[18] However, selections of Gourdie's work were published in the 'Artists in Uniform' sections of the magazine *Art & Industry*, in March 1943 and March 1944. The 1943 article noted that he was represented in an exhibition sponsored by the British Council then touring in Canada and the United States, and that he had recently been transferred to the Ministry of Aircraft Production as an artist. It was only later that his involvement in camouflage work and the production of three-dimensional maps was disclosed. He later became a celebrated calligrapher and teacher of handwriting.[19]

Ian Eadie (1913–1973), a Dundonian who served with the Gordon Highlanders, became the unofficial artist to the 51st Division.[20] His *Air Raid Shelters, Dundee* shows the influence of contemporary developments in art, with its angular shapes and bright blocks of colour emerging from the blanket of darker, softer ground above. The zig-zags of the telegraph wires at the top of the composition are matched by the barbed wire at the bottom. These mysterious, glowing numbered doorways could almost be the entrances to tombs in the Valley of the Kings at Thebes, strangely presaging Eadie's later wartime service in the Western Desert!

Much more conventional in approach, and characteristically understated, Dundee-born David Foggie (1878–1948) had moved to Edinburgh in 1919 where he taught at Edinburgh College of Art. His emphasis on meticulous draughtsmanship was very influential (if, some students complained, a little restricting), whilst his admiration for Degas lent a soft, textural quality to much of his work. He worked mainly as a portraitist, which makes his painting *The Crescent in Wartime* so unusual. It was shown at, and purchased by, the Royal Scottish Academy in 1940 (he had

previously made a pastel composition of the scene in 1939).[21] The Foggie family lived in a flat in Danube Street in Stockbridge, and part of the street is shown here, in a view taken from the north side of the double St Bernard's Crescent. We look across the gardens, with their air-raid shelter sign, the houses of Moray Place looming *contre-jour* in the distance beyond the unseen Water of Leith. Foggie went on to produce other wartime images, including two shown at the Royal Scottish Academy in 1941, *Stair in the Black-out*, and *Lieutenant Neil Foggie*.

Paintings of factories were fewer in the Second World War than in the First, reflecting a shift in both official and artistic priorities. Those that were created are very reminiscent of First World War images, such as Tom Purvis's depiction of women munitions workers at Weir's Factory, Glasgow. His painting conveys well the crowded, noisy workplace and the smoky atmosphere in which women are assembling a 25-pounder field-gun. Although Tom Purvis (1888–1959) shows a far more modern image of women than those who appeared in Great War factories, their navy-blue overalls and caps looking like some form of forces uniform, the smoky atmosphere is much the same, and the lack of protective clothing still notable.

'SOMEWHERE IN SCOTLAND …'

Artists in the forces, both in Britain and abroad, were often not permitted to let anyone know where they were. Thus many works have titles such as 'Scotland' or 'The Highlands' and not much else. We therefore do not know quite where Robert Henderson Blyth was when he painted his sketches of troops in training; one of his works exhibited at the Royal Scottish Academy in 1941 was entitled *Somewhere in Norfolk* (no. 107).

Robert Henderson Blyth (1919–1970) studied at

OPPOSITE.
Ian Eadie, *Air Raid Shelters, Dundee*,
1940. Oil on canvas, 47 × 65 cm.
National Museums Scotland

ABOVE.
David Foggie, *The Crescent in Wartime*,
1940. Oil on canvas, 63.8 × 76.8 cm.
Royal Scottish Academy

Tom Purvis, *Women Munitions Workers at Weir's Factory, Glasgow.* Oil on canvas, 116 × 141.2 cm. Glasgow Museums

Glasgow School of Art, with a post-diploma year at Hospitalfield under James Cowie, and joined the Royal Army Medical Corps in 1941. Much of his finished work is quite surrealist in style, but the water-colour sketches he made of troops training in Scotland have great immediacy and are often humorous in tone. He even worked out of doors, with a lamp adapted for painting in the dark. A group of his images, painted in a very limited palette, show 'man against the Scottish elements' with vehicles sliding off muddy roads in pelting rain, and the apparent inefficiency of recruits.

Scotland was full of solders training. Commandos trained in Scotland, and the D-Day Landings were rehearsed on various Scots shorelines including Eigg, Rhum, Loch Fyne, Kentra Bay, the Moray Firth and Arran. In 1944 a Special Air Service Brigade was based in Ayrshire, the rugged countryside being considered suitable training ground for future operations in France. One of the young officers was Leslie Cairns, who wrote to his new wife Irene Young of a night's exercise that Blyth could have illustrated: 'a constant stumble over grassy hummocks and peat-bogs. I was completely sunk to the knees and had to be pulled out with a squelch. Then I fell and banged my knee-cap on a stone' – though even the SAS kept their sense of humour and played pranks on each other and the locals.[22]

Robert Henderson Blyth, *Man and the Elements: Mountain Troops Erecting a Bell Tent*, 1943. Ink, watercolour and gouache on paper, 28.7 × 38 cm. Scottish National Gallery of Modern Art

The wartime diaries of Peter White (1921–1985) start with the author still a schoolboy in England, commenting on current events from September 1938. In February 1941 he claimed exemption from service, being a South African national, but he enquired about the possibility of working with camouflage. An art student and by nature a pacifist, he yet found himself unable to sustain his conscientious beliefs and chose to join up. He was commissioned into the Royal Artillery, transferred to the Infantry and – at his choice – was posted to the King's Own Scottish Borderers (his father coming from a Borders family). His diary records a 'battle course' in Scotland in 1944, during which he made sketches of the Highlands and lamented the exhaustion of the training. Rather more original in graphic terms are his other impressions of Scotland. In a diary entry (between 4 and 9 June) one drawing shows Berwick Law in the background, with soldiers and local boys in a perilously small rowing boat, 'taken out for a trip round the bay by two kids'. And he also recorded, on 2 August, his '[Artillery] Dome Teacher. North Berwick'.[23]

BLITZ

The Glasgow area was relatively untouched by enemy aerial attack until March 1941, in contrast to the

widespread and destructive bombing of English cities and strategic locations. This had lulled the population into a false sense of security, with some of the evacuees returning to seeming safety.[24] On the nights of 13 and 14 March 1941 the Luftwaffe bombed Clydebank and Glasgow, targeting engineering works and shipyard production. In Clydebank every street suffered casualties, and entire families were killed as tenement buildings collapsed. On the second night a parachute mine fell, destroying three tenements in Kilmun Street in Maryhill. It was the worst series of blitz attacks in Scotland. Over 500 people were killed, and many more had serious injuries; 48,000 civilians lost their homes.

The principal contemporary artist of the Clydebank Blitz was Ian Fleming (1906–1994), a Glaswegian who had been a conscientious objector but in 1941 had joined the Pioneer Corps, a combatant corps used for light engineering tasks, and had also served as a reserve policeman.

His *Rescue Party, Kilmun Street*, painted in 1942, depicts the immediate aftermath of the bombing, highlighting the individual heroism of the fire-fighting and rescue units who risked their lives. The strong diagonals of the composition give the sense of the artificial mountains of masonry over which the rescuers have to clamber, and the difficulty of balancing as they climb out of the rubble. Behind them, searches continue. In the background, the pitiful remains of domestic life are visible: at the top left, a bedstead, and a framed picture hanging on the remains of a wall; to the right, an armchair and a cupboard or wardrobe – these point to lives extinguished and people no longer present. Although this is the painting

OPPOSITE.
Ian Fleming, *Rescue Party, Kilmun Street (Maryhill, Glasgow)*, 1942. Oil on canvas, 80 × 102 cm. Scottish National Portrait Gallery

ABOVE LEFT.
Ian Fleming, *Shelters in a Tenement Lane*, 1942. Etching on paper, 21.1 × 15.0 cm. Aberdeen Art Gallery & Museums

ABOVE RIGHT.
Ian Fleming, *Blitz, Maryhill, Glasgow*, 1942. Etching on paper, 15.1 × 21.4 cm. Aberdeen Art Gallery & Museums

Hugh Adam Crawford, *Homage to Clydebank (The Stretcher Bearers)*, 1941. Oil on canvas, 107 × 210 cm. Royal College of Physicians and Surgeons of Glasgow

most associated with Fleming's record of the bombing, he produced another notable smaller study, *Bomb Crater, Knightswood*, and many etchings which are even more forceful in their evocation of events.[25]

Fleming made a number of etchings relating to air-raid shelters, an early one showing a domestic scene of a couple in night clothes hurrying into the shelter in their back garden.[26] But others are more dramatic. His *Shelters in a Tenement Lane* (1942) shows how the shelters were not built in the basements or 'back greens' of tenements – difficult to access in haste – but in the middle of the narrow streets. Clouds of smoke billow in the background, and searchlight beams fill the sky.

In his *Blitz, Maryhill, Glasgow*, those shelters are

now covered with debris, and the firestorm has reduced tenements to empty shells. It was the scene that confronted Edward Ardizzone when he visited (p.164) and was later commemorated in the paintings of Tom McKendrick. Fleming had his own share of loss during the War, as a fire in 1941 destroyed much of his work. He went on to run Hospitalfield in 1948, and in 1954 became Head of Gray's School of Art in Aberdeen.

Lanarkshire-born Hugh Adam Crawford (1898–1982) had joined the Royal Field Artillery in the First World War at the age of seventeen, after which he studied at Glasgow School of Art, and then in London. Today he is remembered as a teacher as much as an artist, both at Glasgow School of Art (where his students included Robert Colquhoun,

Robert MacBryde and Joan Eardley) and as Principal of Duncan of Jordanstone College of Art, Dundee. He considered *Homage to Clydebank (The Stretcher Bearers)* his finest painting. It depicts the grim reality of casualties and the stoic dignity of the rescuers. Its artistic influences are interesting. There are echoes of early Italian Renaissance frescoes, and artists such as Piero della Francesca, while the handling of individual elements shows influences of Cezanne and Sickert; and perhaps the influence of a painting which arrived in Glasgow's Kelvingrove Gallery the year before, Nevinson's *March of Civilisation* of 1940 (p.125), with its helmeted men moving in unison. In 1935 Crawford had himself mentioned the influences of the early Italians, and of Rembrandt and El Greco.[27] Yet this composition differs from most of his other works in oil, many of which are portraits and in 'portrait' shape, and it is also very large. He had undertaken mural work before this picture was painted, which may have influenced the size, leading him to create a work suitable for a religious or public building.

The painting was widely exhibited, shown as *Clydebank* at the Royal Glasgow Institute in 1941 (on sale for £200), at the Royal Academy, London, in 1942 as *Clydebank: a tribute*, and at the Royal Scottish Academy in 1945 as *Tribute to Clydebank*. In London it was given a prominent position in the Royal Academy, prompting the art critic of *The Observer*, Jan Gordon (who had worked as a war artist himself), to comment that this was the first time that work by 'a nobody from the provinces' had received such attention, and describing it as a scene which 'seems to move with the quiet inevitability of a Greek tragedy'. Crawford showed it in later exhibitions, and in the retrospective exhibition of his work in 1971 it was listed (erroneously) as belonging to Clydebank Burgh Council. But despite the painting's exposure to public gaze, it had to be 'rescued' by the Royal College of Physicians and Surgeons of Glasgow shortly before the artist's death; he had made several failed attempts to have it accepted in a permanent gallery (its huge size may have posed a practical problem), and is said to have threatened to burn it, but in the end he was able to present it to the College.[28] There are no details of why the College acquired it, but it might well have been the inspired action of Professor Tom Gibson (1915–1993), Honorary Curator of Art at the College from 1977 to 1983. In 1943–44 Gibson had worked in the burns unit in Glasgow Royal Infirmary, where he must have seen survivors of the bombing. He then joined the Royal Army Medical Corps as a maxillofacial surgeon, serving in northern Europe and in India, and after demobilisation in 1947 he became a Consultant Plastic Surgeon, working in Glasgow until his retirement in 1980; he was a notably warm, sociable individual, who had befriended the somewhat reclusive Crawford.

James Miller (1893–1987) was a Glaswegian artist, turned down for military service on health grounds, though he served as a fire warden; his brother had been killed in the First World War. In the 1920s and 1930s he travelled on the continent sketching the architecture and cities of France, Spain and Italy, working mainly in watercolour. He recorded the war in Spain, for example in his *Teruel after the Bombardment*, though this watercolour gives the unfortunate appearance of a picturesque town with ruins that might be of some antiquity.[29] Places rather than people were always Miller's main interest, his detailed townscapes often lacking human presence.

Miller's introduction to official war artist work was rather sudden and unusual: a letter of 'pre-invitation' from Muirhead Bone, who wrote from a hotel in Glasgow requesting an urgent meeting before a regular War Artists Advisory Committee (WAAC) meeting in London the following week.

Miller submitted eight drawings to the WAAC in September 1940, and in November he was commis-

in Glasgow and elsewhere in Scotland, for example in St Andrews, where he documented the gaping sides of ordinary homes, their wallpapers and contents poignantly visible. He was also mistaken for a spy while working – with permission – at Leith docks.[31]

Miller recorded buildings, but Robert Sivell painted people, including one of the oddest portraits painted in Scotland in the whole of the Second World War, *Mrs Marion Patterson, GM*. Even odder is the fact that it was specifcally commissioned by the War Artists Advisory Committee (WAAC) in December 1942, Sivell having been recommended for the commission by Hubert Wellington, Principal of Edinburgh College of Art. The WAAC were clearly satisfied with Sivell's work, for he was later commissioned for the Herring Factory painting.[32]

The painting shows Marion Patterson, an Aberdeen fire warden, emerging from the bombed building where she had saved trapped sailors, the deed that earned her the George Medal. She is clad in a rather flimsy-looking blouse, her skirt dirtied by the experience, with a beatific face suggesting the Madonna greeting an angel. Her pose is awkward, to say the least, and one wonders what she herself thought of it. The eccentricity of the painting matched the eccentricity of the artist, Paisley-born Robert Sivell (1888–1958), an ex-shipyard worker who could be flamboyant, but also opinionated and difficult. As noted earlier, he lived in Kirkcudbright before being appointed to a teaching post at Aberdeen (and returned after retirement in 1954). He revered Uccello, Michelangelo, Leonardo and Raphael, but despised more modern artists such as the Impressionists – and it showed. One of his major projects was a series of murals for a students' union bar in Aberdeen, initially a cooperative venture with his students – notably Alberto Morrocco – but Sivell took over and worked on it obsessively. The murals include a view of bomb damage.[33]

sioned to document air-raid damage in Scotland. A picture of Queen's Park Church, Glasgow, was purchased in April 1943, presumably one similar to that now in Glasgow Museums – in fact it may be the same one, for the Imperial War Museum's version is untraced.[30] Queen's Park Church had been designed by Alexander 'Greek' Thomson 1869, in an eclectic half-Egyptian, half-Greek style, and its destruction by enemy action in 1942 was a serious architectural loss. Miller recorded a great deal of other bomb damage

OFFICIAL ART AND ARTISTS

The London-based war-art committees of the First World War were resurrected in the Second as the War Artists Advisory Committee (WAAC), formed in 1939 by the Ministry of Information. The Committee had wide-ranging interests and very specific responsibilities, with most of the visual output of record and propaganda commissioned and vetted by its high-calibre staff, or by members of the committee. It was chaired from 1939 to 1945 by the brilliant and dynamic Sir Kenneth Clark (1903–1983). Since 1934 he had been both the Director of the National Gallery and Surveyor of the King's Pictures. The secretary was E. M. O'Rourke Dickey, who was himself an artist, but with additional experience as an Inspector of Art at the Board of Education. Clark was both a catalyst and innovator, though no great modernist in his personal artistic tastes. His aims were not just for art, but for artists: he wanted to give them employment, to keep them out of the front line, and to provide a visual record for the nation.

After their first meeting, the committee sought the recommendations of Scottish painters, writing to David Foggie at the Royal Scottish Academy, William O. Hutchison at the Glasgow School of Art and Hubert Wellington at the Edinburgh College of Art. Having received a list of names, they contacted specific artists requesting photographs of examples of their work. The Royal Scottish Academy set up a small committee (the Scottish Advisory Committee for War Records) to represent the interests of Scottish artists; it asked the Scottish Office for more specific arrangements for Scottish artists. But after some discussion the WAAC decided not to make any special provision, considering that Scottish artists were already represented under existing arrangements.[34]

The WAAC also received some gratuitous advice from the opinionated William McCance.[35] He wrote on 12 August 1940, prefacing his statement with the disclaimer that 'I am not fishing for a job. I am and want to be a free-lance.' His perception was that those 'concerned with art would like to think of this war as similar in pattern to the last one, and so they [have] based their ideas on what was done then,' although the work exhibited by 'official artists up to date has been rather dull and uninspired. It is bound to be, for I feel that it is as hopeless to tie artists to an official attitude as it would be to have poets attached to the Services.' He then offered his own thoughts: 'I shall tabulate my suggestions …' Alas, his understanding of both past and current schemes seems to have been rather poor, and his communication shows several misunderstandings, for example his view that official war artists had to adopt 'an official attitude', and a suggestion that artists were appointed through 'influence, favouritism, or from a list of known names'. It is not clear whether the recipient (Frank Pick) was aware of McCance's history as a conscientious objector. The matter was passed to Sir Kenneth Clark, who commented in an internal memorandum that 'Mr McCance's letter contains a number of doubtful statements,' and he denied the 'official attitude' slur, citing the work of Ardizzone and Ravilious, and others, in support of his assertion; the names were chosen by a committee (of three artists and one critic) on the strength of a 'wide experience of modern painting'; it was open to any artist to hand in his work for inspection; and facilities were given to men in the Services and in this way 'one or two quite good artists of a rather amateurish kind' had been discovered. He admitted that 'these facilities are not quite as good as I should like, but naturally the Services do not like to make exceptions in favour of individuals by letting them off drill, etc.'.

McCance wrote again, in response to a holding letter, attempting to clarify his views, which were that 'the artists [were] grafted onto the various Services

and Departments. The artist is a kind of indigenous plant and does not thrive as a graft, as we clearly see in Germany and Russia.' He went on to elaborate: he wanted artists who were already in the services to be given every facility to continue their artistic careers at the same time: 'If these young men painted right in the midst of their jobs as soldiers, airmen, anti-aircraft gunners or as workers, it would mean that they had real enthusiasm and felt stimulated by their environment. Any scheme which would give them encouragement to go on with it might lead to some quite new discoveries in war art. Exhibitions of work of this kind in the U.S.A. would have good propaganda value … I feel my scheme has more than a democratic flavour that would appeal to the country.' In fact, the Committee gave great freedom to its artists, though its acquisition of work by those not appointed as salaried artists was, of necessity, selective.

The Committee for the Second World War might have been new, but several artists served officially in both wars. Sir Muirhead Bone (he had been knighted in 1937) was again the first artist to be appointed, commissioned into the Royal Marines as a Major. His approach was now rather different, however, for his paintings were larger and more formal. He painted warships at Rosyth, torpedoed merchant ships in dry dock in Glasgow, and minelayers at work in stormy seas. His painting *Winter mine-laying off Iceland*, c.1942 (Imperial War Museum) is one of his most atmospheric works.[36] He resigned in 1943, after the death (through illness) of his son Gavin, and his other son Stephen continued the commission.

RECORDING BRITAIN AND RECORDING SCOTLAND

Sir Kenneth Clark devised the *Recording Britain* scheme for several reasons, the main aim being to record a Britain that might disappear, and thus remind people what they were fighting for. It also preserved and enhanced the skills required for that most English of artistic media, the watercolour – all works were to be done in this medium. It gave employment to a greater number of artists than any other war-art scheme could embrace, including artists who would not have been considered sufficiently fit for active war-art service. Funding was secured from the Pilgrim Trust, a charity founded by the Anglophile American Edward Harkness, and the artists were thus employed without cost to the public purse. The scheme also gave employment to a rather higher proportion of women than other schemes. Some very eminent artists were signed up.

Watercolour had the advantage of being cheap and easily portable. Artists could wander the highways and byways, recording hamlets, pubs and tea-shops as well as grander city views and country houses. Once framed, these watercolours provided Clark with a ready turnover of pictures for the walls of the National Gallery in London, the permanent collection having been taken into secure storage in slate quarries in North Wales. In 1949 the Pilgrim Trust gave the collection to the Victoria and Albert Museum. (For many years they were loaned out, but they were later recalled to the Museum in 1990 to form a coherent and catalogued collection.)

The scheme was very successful, but its title was a misnomer. The committee was first appointed to deal with England and Wales, but did not expand further to either Scotland or Northern Ireland. A separate project, with its own committee, was therefore set up in 1942 as *Recording Scotland*, also financed by the Pilgrim Trust. It was chaired by Sir James Colquhoun Irvine, Principal of the University of St Andrews, and after the War the resulting collection was donated to the University. Administration and regulation were rather less prescriptive than in

England and Wales. Artists were free to paint in any medium, or to make prints, and as the scheme started well into the War, the committee purchased already-existing works by artists of note, or of particular places, to make up a representative and interesting collection. Thus there is both the undated *Ceres, Fife* by the Colourist Samuel Peploe (1871–1935),[37] and *Holyrood Palace* by Aleksander Zyw, a Polish artist who arrived in Britain only in 1940.

Many of the artists were already well known for their illustrative and atmospheric recording of Scotland, or for documenting specific places. Charles Oppenheimer, whose bread-and-butter work was commercial design, had become a stalwart of the Kirkcudbright community of artists after arriving (from Manchester) in 1908; his *White Gables, Kikcudbright* shows one of his many views of a quaint small town beloved of artists. During the War this artistic community survived despite some loss of numbers. Towards the end of the War, Wilhelmina Barns-Graham, feeling somewhat isolated in St Ives (despite having become part of its artists' community) spent five days exploring Kirkcudbright with a view to moving back to Scotland: 'My purpose of visiting is to compare with St Ives for painting possibilities during war time. So much nearer Edinburgh & Glasgow, more trees, but even more out of touch with life. An asset in some ways but not for pecuniary interests.'[38] In the end she decided not to make the move.

Stewart Carmichael's often doleful view of life was typically represented by a smoky-looking print of *Dundee from the Old Steeple* of 1913.[39] But most of the images in the collection show Scotland as sunny and attractive, for example John Guthrie Spence Smith's *Skinnergate, Perth*, or Anne Spence Black's *The Tide Lamp, St Monance*.

The subjects were wide-ranging. Castles and churches inevitably made a good showing as major elements of the Scottish built heritage. There were many cityscapes and village views, and busy market places and docks. In the event, few localities suffered from enemy action, but taken together these paintings constitute an important record of Scotland before the onslaught of planned destruction in the name of progressive development later in the century, not to mention the inevitable evolution of streets and the urban environment.

The records of the scheme make for interesting, if sometimes depressing, reading.[40] A list of possible artists for the scheme was drawn up very methodically, and responses from those artists who were approached were tabulated. But the apparently overworked secretary, Miss I. M. E. Bell, was constantly having to apologise for late responses to letters, and she made frequent reference to a 'memorandum of guidance' (for some artists were not invited; they invited themselves). And some artists sent rather a large number of works for consideration: David Foggie sent 29 paintings, four of which were purchased.

Spurred on by a four-volume publication (1946–49) on the scheme in England and Wales, again misnamed as *Recording Britain*, a single volume entitled *Recording Scotland* was published in 1952.[41] This necessitated another flurry of correspondence with artists requesting permission to publish their images, indicating that it was indeed an afterthought. The quality of images is rather disappointing, but the selection wide in terms of both subject and media.

The pictures themselves were hung in various buildings in St Andrews University; some are now untraced, including two works by Keith Henderson that were reproduced in *Recording Scotland*, though they may yet come to light.

ART IN THE GALLERIES

Stanley Cursiter has already been mentioned for his work on maps and technical developments in the First World War (p.50). In 1925 he became Keeper of the Scottish National Portrait Gallery, and then Director of the National Galleries of Scotland from 1930, where he furthered his interest in technical matters, improving conservation and storage techniques. In 1938 he drew up plans for a new art centre which would have incorporated modern and contemporary art, craft and industrial design, as well as a historical collection of Scottish art – but the War put this on hold. Now, his most immediate task was to protect the national collection by dispersal. For a short time he returned to military cartography as an instructor at the Ordnance Survey, Southampton. But the national collection was deteriorating in storage, and he was permitted to return to Edinburgh. In his own words:[42]

Conditions at the Galleries became difficult; my junior assistant collapsed with a nervous breakdown; and we found that some of the evacuated pictures began to suffer through the fact that we could not control the humidity in the houses where they were stored … We were immediately involved in a search for houses on well drained sites … We started the war with six houses; we finished with four. Only two of these belonged to our original six … After some little delay we were allowed

to reopen the National Gallery; where we proceeded to arrange a series of exhibitions to illustrate the art of our Allies, in conjunction with the British Council ... These exhibitions became political occasions with long speeches at the opening ceremonies, aimed at the Press by émigré Presidents, Prime Ministers, or Army Commanders. We arranged an exhibition of Dutch Art, and Prince Bernhard of the Netherlands came to open it. The Press sat ready with notebooks open and pencils poised. Prince Bernhard rose from his seat, walked to the edge of the platform and said, 'I declare this exhibition open', and sat down! – It was an electrifying moment.

Cursiter was politically astute:

Some of our exhibitions were intended to stimulate the war effort, but others had a more definite art interest, such as the one-man shows of Peploe, Cadell, and John Duncan. We had an exhibition of 'Women's Work' showing, on one side of the Galleries, all that women did in peace time from embroideries to water-colours; on the other side of the Galleries we had women's wartime activities.

There were also exhibitions of children's art, which raised the profile of art teaching in Scotland. And he copied the London idea of concerts:

Over the years lunchtime concerts had been arranged by Miss Tertia Liebenthal, in emulation of those held in the National Gallery, London. On Saturday mornings we held classes for school children. All these activities made an appeal to a new and wider audience.

The number of visitors exceeded all expectations. It gave us a new impression of the part an art gallery might play in the life of a community.

In 1948 Cursiter resigned as director, and gave up his various committees, to return to painting.

In Glasgow, the ebullient Tom Honeyman (1891–1971), initially a doctor by profession, had become the somewhat unlikely – but brilliant – head of Art Galleries and Museums. During the First World War, he had served on the staff of the 42nd General Hospital in Salonika with Christopher Murray Grieve (Hugh MacDiarmid). Both he and Grieve applied, at the same time, for the post of Director of Glasgow's Art Galleries and Museums in 1939.

In his lively and opinionated memoirs, aptly entitled *Art and Audacity* (published in 1971), Honeyman looked back on the War with as much robust humour as he had shown at the time, admitting that

The war was a challenge ... In a sense I had two models – Sir Kenneth Clark of the National Gallery in London, and Stanley Cursiter at the National Gallery of Scotland in Edinburgh. Deprived, as with us, of their greatest treasures they succeeded in various ways in focusing public attention on escape routes from war efforts.[43]

In the event, he put on a magnificent series of exhibitions. Benno Schotz recalled in his memoirs that Honeyman (who, he said, had been appointed as the choice of Lord Provost Patrick Dollan) 'brought one exhibition after another of the Allied Artists to the Art Gallery, and this began to bring the people to Kelvingrove. He was a live wire and the Gallery became popular'.[44]

Christopher Nevinson, whose angry paintings of

Christopher Nevinson, *March of Civilisation*, 1940. Oil on canvas, 71.1 × 101.6 cm. Glasgow Museums

the First World War, imbued with the style and dynamism of Futurism and Vorticism, had both inspired and horrified artists and the general public alike, lived just long enough to see the end of the Second World War. As noted earlier, one of his First World War paintings, *Column on the March*, shows a seemingly endless procession of French troops marching to war, like automata or toy soldiers (p.41). It was a subject to which he reverted at the beginning of the Second World War with his *March of Civilisation* painted in 1940 – the same composition in reverse, though this time with more realistic figures, clearly British soldiers wearing steel helmets, and a more realistic landscape around them with trees and

searchlights. It was purchased for Glasgow Museums the following year by Tom Honeyman.

Honeyman also took the opportunity to conserve paintings, with 'a growing conviction that now was the time, when our notable pictures had to be taken from public view, to have them where necessary cleaned and restored'.[45] He did this, with some controversy about the results. Unlike Cursiter, he also went abroad during the War, giving lectures in North Africa. But his personal style and purchases were always controversial, and he was forced to leave his post in 1954 when he lost the support of his political masters.

SCOTS BUT NOT SCOTS

Life was not easy for Scots of immigrant parentage. Once Italy entered the War, Italian families felt the full fury of local people in towns and cities all over Scotland. In Edinburgh a crowd attacked Italian-owned shops and cafes, smashing windows and looting goods; the Paolozzi family shop in Leith Street was one of the targets. Italian men were interned, and families moved from coastal locations.[46]

Alberto Morrocco (1917–1998) had studied at Gray's School of Art, Aberdeen, where he was taught by James Cowie and Robert Sivell, whom he assisted on the murals for the University of Aberdeen Students' Union. He then travelled to the continent on a scholarship. When interviewed in 1993 he discussed his Scottishness, and the fact that he never learnt to speak Italian: 'I am not a real Italian and certainly not a Scot.' This in-between-ness was perhaps exacerbated by the fact that his birth certificate read 'Marrocco',

ABOVE.
Alberto Morrocco, *Self-Portrait*, c.1935. Oil on canvas, 25.4 × 20.3 cm. Artist's family collection

RIGHT.
Eduardo Paolozzi, *Soldiers Playing Cards*, 1944. Pen, ink and wash on paper-faced card, 24.7 × 28.5 cm. Imperial War Museum

but a sign-writer working on the family shop spelt it incorrectly, and the error stuck.[47] His Army service lasted from 1940 to 1946. At the outbreak of war he went for basic training, but then Italy entered the War:

> So I was sent to Edinburgh Castle and discovered that I was among a whole lot of people who were of doubtful origin – people like the Maltese, Cypriots, Viennese and people with German origins. That was it. I had to fit into this kind of régime. I was never sent overseas. I was in the Castle for three and half years; I became part of the structure of the whole headquarters company … I was employed making false wounds [for training exercises] … I was making these wounds for, by God, it must have been a couple of years. Then I went on to painting helmets, painting numbers and badges on helmets and things …'[48]

He also produced caricatures, and cartoons in the style of graphic artists such as David Low.[49] He was allowed to come and go to some extent; in fact he got married in 1941. Much of his art during the War looks back to his time in France, to the influence of Sivell's interest in the Italian Renaissance, and to James Cowie.

Eduardo Paolozzi (1924–2006) found himself in a rather more serious situation. Like many children of Italian immigrants (though unlike Morrocco) he had been staying for up to three months every summer at Fascist youth camps in Italy, in his case from the age of nine until the outbreak of war. The families who sent their children often had little interest in politics. The visits were intended to promote links with Italian society and to provide free holidays, which, for children like Paolozzi, were often welcome breaks from days at school and helping in family shops.[50]

In 1940 Paolozzi lost his father, a grandfather and an uncle on the *Arandora Star*, the ship carrying Italian internees (along with German Nationals and POWs) to prison camps in Canada, when it was torpedoed by a U-boat off the coast of Ireland. The survivors were brought back to Scotland, but not released. Paolozzi was himself briefly interned in Saughton Prison, Edinburgh. In 1943 he joined the Pioneer Corps, though he was discharged after 15 months, later claiming to have feigned madness to hasten his escape from uniform. After attending evening classes at Edinburgh School of Art, he went to the Slade, his first one-man show being held in London in 1947. His sketch of *Soldiers Playing Cards* dated 1944 is an interesting barrack-room view, the half-drawn stove oddly dissociated from the rest of the structures and people in the room.

WAR CONTINUES ON THE HOME FRONT

David Foggie showed a painting at the Royal Scottish Academy in 1943 entitled *Grandmother Knits*, showing a grey-haired lady just – well – knitting. Like so many of his portraits it is well observed and very detailed in its handling, yet conveys a real atmosphere, gentle, quiet and peaceful. It led the journalist J. W. Herries to write a verse:

> My douce auld grannie, kind and sage,
> Cares no' a docken for the blitz,
> But with the equipoise of age
> She sits and sits and knits and knits …[51]

The same spirit of home-spun, home front, stoical solidity permeates the cheerful, and often humorous, writings and drawings of Hiram Sturdy. He had

OPPOSITE.
Hiram Sturdy, *Home Guard Duty at Night*. Pen and watercolour on paper, 28.0 × 21.4 cm, National Library of Scotland

already served on the Western Front in the First World War, recording his experiences in dramatic sketches (p.45). Although an amateur, his work shows an acquaintance with Nevinson's war images, and he made sketches which were from, or at least influenced by, the work of J. D. Fergusson. He shows the formation of his Home Guard unit in Lanarkshire, the men lining up in a drill hall, and moves on to night duty and village exercises, sometimes filling complete pages of his sketchbooks with images. The 'night duty' composition comprises a multi-layered series of drawings and washes, with wedges of light containing a tank battle and an infantry attack; one particular figure seems to have been taken from his First World War drawings. It is a complex composition and gives a hint of Sturdy's latent, if undeveloped, artistic talent.[52]

Home Guard duty was made fun of at the time. The television series *Dad's Army* has made it appear even more comic, and although the programme has a south-coast location its activities were common to the Home Guard across the United Kingdom. However, the duties could be very hard, particularly for those in command. Francis Martin, born in 1883, had already served in the Boer War and the First World War (see p.46) before he embarked on Home Guard service. In the notes he made towards a potential memoir, he relates that after undertaking a period of 'secret duty' he was

seconded to raise two battalions of the LVD [Local Defence Volunteers] and [I] commanded one of them until near my retiral. Home guard soldiering was the hardest I had ever put in. 14 hours daily for 6 days and half Sunday from start to finish … I had to reconnoitre every hold and cranny and prepare my sites, communications, rations dumps etc besides emergency aid posts … It was fortu-

nate with about 70% ex regulars or service men and with the first pipe band in the city could put up a good show.

It was not until June 1944 that he 'had the first leave for five years and went first to Iona then Boat of Garten to paint lumberjacks'.[53] Like Cadell before him, and William Skeoch Cumming's soldier dreaming of home, Iona was the place he craved. As for lumberjacks, he was joining many artists in that interest too, including David M. Sutherland, a Scottish artist who, for the purposes of this book, finds himself placed in the next chapter.

In October 1941, James Cowie was commissioned by the WAAC to paint a portrait of a representative character from the world of Scottish Civil Defence. Cowie submitted a work in the spring of 1944: the Committee liked it, but as they had commissioned a painting, not a drawing, Cowie then produced a painting of the same subject.[54] There are several versions of the composition: studies in the collection of Gray's School of Art, Aberdeen, and an oil sketch – also with a further study on the back – which came up for sale in 2013.[55] This level of preparation was typical of Cowie, whose meticulous studies and compositions show influences of both classical artists like Poussin and the detailed work of the pre-Raphaelites, together with a hint of twentieth-century surrealism. In this final version the date '1941' has been added behind the sitter's head, the helmet and numbers forming a nimbus of halo and rays. It has been suggested that the police sergeant is the artist Ian Fleming, and it certainly bears a resemblance to him. Be that as it may, the portrait shows a policeman taking notes after an air raid, the results of bomb damage about him.

As mentioned earlier (p.72), Patrick Dollan had been a conscientious objector during the First World War. He and his wife Agnes were very active in the

This is a cock eyed world.

Shafts of light penetrate darkness, probing clouds, in search of insects, as a doctor
probes. Armies are chased back, in the desert, reform, and chase the chasers
back, in the desert. Great masses struggle, in the vast spaces of Europe.
Men and ships go down to the sea, and stay there. Thousands of eyes
watch and wait, in city, Town, and Newarthill road. Blank.

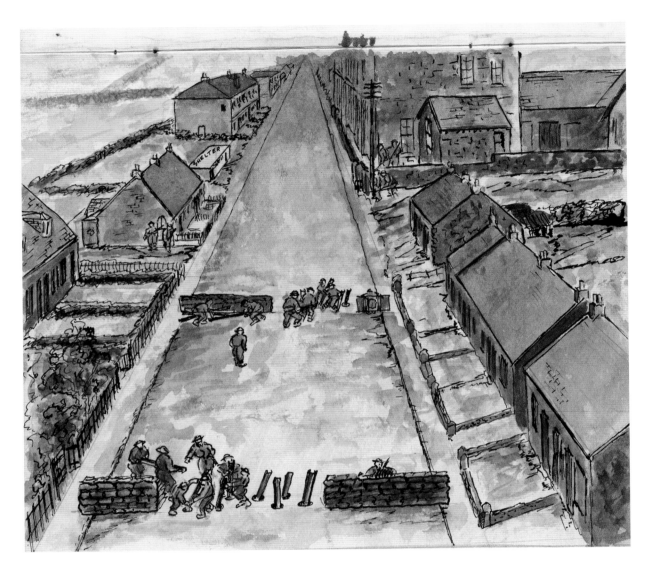

Scottish Independent Labour Party, campaigning against the Munitions of War Act (1915) which suspended trade unionists' rights for the duration of hostilities, and they also campaigned against rent rises during a period of conscription (a situation which led to the Rent Restrictions Act, 1915). In 1917 Dollan had served a prison sentence of 112 days' hard labour in London's Wormwood Scrubs (for failing to comply with a directive to leave Glasgow and seek 'work of national importance'); his resistance had been given widespread press coverage, and added to the wartime rebel image of 'Red Clydeside'. But he was an astute and influential politician, and in 1938 he became Lord Provost of Glasgow, the first from an Irish Catholic background. As Britain went to war in 1939, his attitude towards war service could not have been

more changed. He became energetic in coordinating local responses to the war effort and in urging Glaswegians to support the struggle against Nazism. By the time his term of office ended in 1941, not only had he gained respectability with the British establishment, he had earned a knighthood as well. The bullish, unsmiling, image of Dollan, painted by his friend Hugh Adam Crawford at the end of his three-year term of office, shows him in Lord-Lieutenant's service uniform – a deliberate show of support for those in the Forces, and an encouragement to others to join up. Crawford has given Dollan a physique rather heartier than he actually possessed, and has downplayed his most notable physical feature, the shock of thick silver-grey hair which is always so noticeable in photographs. Most interestingly, for this formal and official portrait, Crawford has included abstract elements in the background of the portrait, perhaps at Dollan's request; it was Dollan who had appointed the modern-minded Tom Honeyman to run Glasgow's museums. According to the Glasgow caricaturist Emilio Coia, the portrait was painted at the City Chambers between constant phone calls, and should be considered 'an eidetic representation of a volatile spirit'.[56]

Dollan was not the only person whose pacifist tendencies were overcome by the threat of Nazism. There were relatively few conscientious objectors in the Second World War, and more non-combatant forms of war-service for those who wished to support the war effort without bearing arms. However, there were still a few 'absolutists', such as the classicist Professor Douglas Young (1913–1973), who became leader of the Scottish National Party (SNP) in the early 1940s. The SNP was opposed to conscription unless issued by a Scottish government. Young refused to register either for military service or as a conscientious objector, and served two terms in prison. Dr Robert McIntyre (1913–1998), secretary of the SNP, and its first Member of Parliament in 1945, organised pipers to pass the prison on Sundays, serenading the incarcerated Young.[57]

CAMOUFLAGE

Camouflage became very sophisticated in the Second World War, and large numbers of buildings which housed essential services were covered with various types of disguise, such as the milk pasteurisation plant on Crow Road, Glasgow, shown overleaf.

Pillboxes were made to resemble various things. In country areas they masqueraded as haystacks, sheds and barns, or they were concealed with turf or bushes. A more sophisticated camouflage was invented for the pillbox in the precincts of Elgin Cathedral, where photographs show one pretending to be a ruined octagonal tower.[58] A less sophisticated disguise was the pillbox beside a railway line, painted to look like a pile of wood.[59] There were ingenious disguises for pillboxes just beyond each end of Princes Street, Edinburgh: at the corner of Waterloo Place, outside the General Post Office, one was painted to look like an architectural folly; another, outside the Rutland Hotel in Shandwick Place, was decorated, with some exuberance, as a florist's stall.[60]

Aircraft and hangars had to be camouflaged, and examples of both are shown in the watercolours of Tom Gourdie. The effectiveness of such camouflage was assessed from the air.[61] Artists were attracted to recording both the appearance, and the ingenuity, of camouflage. Stephen Bone shows the camouflaging of a pipeline near Fort William, and Eric Ravilious enjoys the patterning of funnels on a ship; in 1943 William Scott painted *Camouflage*.[62] G. W. Lennox Paterson (1915–1986, today best known for his design and book illustrations) spent much of his working life at Glasgow School of Art; he produced

OPPOSITE.
Hugh Adam Crawford, *Sir Patrick Dollan, Lord Provost of Glasgow* (1938–1941), 1941. Oil on canvas, 92.1 × 71.1 cm. Glasgow Museums

LEFT.
Photograph of a milk
pasteurisation plant on Crow
Road, Glasgow, c.1942.
The Herald Photographic Archive.

RIGHT.
Photograph by Captain Horton,
Pillbox Disguised as a Florist's Stall,
Shandwick Place, Edinburgh,
14 August 1940. Imperial War
Museum

the delightful *Carrier Park* in 1942, camouflage netting over a row of tracked Bren gun carriers in a snowy field.

Wilhelmina Barns-Graham both painted images of camouflage and worked on camouflage production, one of a large number of artists who were involved with camouflage one way or another (the surrealist artist Roland Penrose taught it at the Home Guard training centre near London, and wrote the *Home Guard Manual of Camouflage*). James McIntosh Patrick, who painted his family in their garden in Dundee at the beginning of the War, trained as a tank driver before being commissioned into the Camouflage Corps, where his knowledge of both painting and the countryside was put to good use:

We all knew how artists like Wadsworth had been involved with painting the Dazzle ships during the First World War but what I had to do was totally different. My CO had written the classic text book on animal camouflage which showed how animals not only adapted their colours to harmonise with their background but also modified their behaviour so as not to draw attention to themselves, and that's basically what military camouflage is about ... We had to build bases for mobile anti-aircraft guns and it was my job to camouflage these bases, huge plugs of concrete in the fields ... A farmer doesn't cross the middle of his fields, he sticks to the side so I had to make the drivers think like farmers. All their tracks, when seen

from the air, looked like farm vehicles, driving around the edge of the fields. That's a simple example but it shows how I was able to use my knowledge of what happened on a farm. Of course, it was all different in North Africa – there are no deserts in East Fife – but the principles are the same.[63]

Patrick's notes for the lectures he gave on camouflage, complete with illustrations, are now in the Scottish National Gallery of Modern Art, undated but probably from 1941–42, and headed 'Camouflage / Introduction'. Two pages of his illustrated notes are reproduced here. The first examines the camouflage of the natural world. Under the heading 'Dazzle' he shows an insect, and beneath it writes 'a flash which dazzles the eye whilst in flight but which is concealed before the insect drops'. In the centre of the page is an almost monochrome image of a moth against vegetation or a tree, inscribed 'Moth – Disruption / Siting' ('disruption' means the breaking up of profiles and outlines). And at the bottom, two frogs eye each other up, with the inscription 'False Display of strength to overawe an aggressor or rival'.

The second page illustrated here discusses buildings and gardens, and how to make Nissen huts look like cottages: 'Actually the average Army hut is much smaller than ordinary civilian buildings & so they are best tacked on to real buildings as "pig stys", sheds, outhouses etc.' He considers the best way of shading, and under a heading 'Disruption' he draws a pillbox, and annotates it 'Disruption with additional disruptive greens'. Other pages from the lecture notes include images of mottled birds' eggs, a Native American whose body and clothes are camouflaged for hiding in bushes, portable dummy trenches, various buildings seen from above painted in different designs, and models of heads of soldiers made of plaster.

G. W. Lennox Paterson, *Carrier Park*, 1941. Gouache on paper, 54.2 × 37.0 cm. Royal Scottish Academy

An easy way of making one hessian hut look like a cottage — alter its proportion.

Two huts linked with canvas.

texture.

When grouped together as hamlets, farms etc disguise should always be linked to ground pattern. Real gardens are best but imitation are absolutely necessary.

Actually the average army hut is much smaller than ordinary civilian buildings & so they are best tacked on to real buildings as pig styes, sheds, outhouses etc.

Counter Shading

natural

bad army counter shading.

Black

This might work.

white.

Disruption

Disruption with additional disruptive trees.

James McIntosh Patrick, *Illustrations to Camouflage Lecture Notes*, c.1941–42. Pencil and watercolour on paper, page size 33.0 × 19.5 cm. Scottish National Gallery of Modern Art

LIGHT RELIEF

Various comic characters helped Scotland win the War. 'The Broons' and 'Oor Wullie' engaged the enemy, so to speak, by belittling the Germans and Italians, and by making light of wartime austerity and hardship. The comic strips of the Broon family, drawn by Dudley D. Watkins and published by D. C. Thomson of Dundee, first appeared in *The Sunday Post* in 1936. The Broon family both endures and enjoys the full range of wartime experiences on the home front, while Oor Wullie gets into wartime scrapes and lampoons enemy personalities.

D. C. Thomson's studio was also used for work on government war maps, and one of their artists used his skills as a sign-writer on active service.[64]

The north of Scotland became very international in character (as the next chapter will demonstrate), though many of the temporary incomers were themselves Scots from elsewhere. The well-known diatribe about Orkney, ascribed to Captain Hamish Blair, RN, first appeared in the *Orkney Blast* in 1942, and began:

This bloody town's a bloody cuss –
No bloody trains, no bloody bus,
And no one cares for bloody us –
In bloody Orkney.[65]

Many amateur artists decorated the interiors of their premises. There is a cheerful frieze of a dance in progress from a canteen in Lyness, Orkney.[66] Jolly blackout panels were painted at the Women's Royal Naval Air Service Mess at Royal Naval Air Station Machrihanish, where 852 Squadron of the Royal Navy's Fleet Air Arm was based for periods in 1944.

Out of doors, graffiti abounded, much of it on official installations, such as anti-tank blocks – which rather invited additions to their austere sides. Many of these images have recently been logged and published.[67]

THINKING OF THOSE FAR AWAY

Benno Schotz (1891–1984) was an immigrant to Scotland, born in Estonia, who arrived in Glasgow in 1913 to study engineering. He worked as a draughtsman with a Clyde shipping firm, studied sculpture at Glasgow School of Art, and made his name as a portrait sculptor after a successful solo exhibition in 1926. He became Head of the Sculpture and Ceramic Departments at the School in 1938, and was later appointed Sculptor in Ordinary to the Queen in Scotland.

Schotz was a well-known figure in the Jewish community in Glasgow. His home was welcoming to artists and writers, and during the war years he gave both practical help and moral support to refugees such as Jankel Adler and Josef Herman, and organised exhibitions of Jewish art. Even before the War, he had been inspired to bring an exhibition to Glasgow in 1938, when he saw the *Exhibition of Twentieth Century German Art* at the New Burlington Galleries in London. This had been a riposte to the 'Degenerate Art' exhibition staged by the Nazis, which vilified all modern art, and the work of Jewish artists in particular. Progressive art circles in London had organised a counter-offensive: under the chairmanship of Herbert Read the show at the New Burlington Galleries exhibited the very best of modern German art. It proved so popular that it was twice extended. The Introduction in the catalogue stressed that the show had been under discussion for many years, but 'in view of the political situation the organisers have refrained from consulting the artists themselves'.[68] Schotz went to see it, as he recalled in his memoirs:

> A selected portion of it was going to be sent over to the United Sates. Milly [his wife] and I decided that this section would *have* to be brought to Glasgow for the Scottish people

Benno Schotz, *The Lament*, 1943. Wood (lignum vitae), 91.50 × 30.50 × 21.50 cm. Scottish National Gallery of Modern Art

to see before it left for the States. As a Jew, and a hater of Hitler, I did not want my name to appear as the one who brought it to Glasgow, as it would lose its impact. I therefore approached the Saltire Society of which Milly was a founder member.[69]

It was financially supported by a friend and also made a profit, enabling the organisers to send a sizeable cheque to the Refugee Artists' Fund.

Schotz generally produced his portrait sculptures very quickly, leaving rough, deliberately unfinished surfaces, a typical example being his strong, punchy portrait of James McBey.[70] But in the 1940s he made a group of sculptures in wood which were rather different. They were responses to the War, and included *The Lament*, an expression of his feelings for fellow Jews in Europe. The female figure is simplified in form, and naked, with restrained elegance of form. She shrinks in fear or horror from the viewer, holding her upcast face in her hands. Schotz wrote in his memoirs:

> I found it difficult to divide myself into two individuals; one that was living a social life with the refugees filling the house, and the other a sculptor and teacher. All the time I was searching for a symbol with which to express my feelings. This I finally found in my 'Lament' of 1943.[71]

SCOTS IN LONDON

In 1939, a major exhibition had been shown at the Royal Academy entitled *Scottish Art*. Encompassing centuries of work, it brought a great deal of Scottish art to a new audience. Stanley Cursiter, Director of the National Gallery of Scotland, wrote in the Introduction to the illustrated catalogue, 'Later Scottish painting has bowed to the cross-currents of European influences; but the native sense of colour and pattern, allied to a very real respect for the materials of the craft, continues to give to Scottish painting a local character ...'[72] In fact, the show included relatively little that was modern, but Scottish artists were migrating south, and their Scottishness as well as their art were to lend colour to the London art scene.

Robert Colquhoun and Robert MacBryde, partners both artistically and personally (and often referred to as 'the two Roberts') initially had some difficulty establishing themselves, despite being bohemian in lifestyle and customarily flamboyant in company. Colquhoun, whose self-portrait in uniform has already been discussed (p.103), had joined the Royal Army Medical Corps in Edinburgh in 1940, but his health was poor and he was invalided out in February 1941. MacBryde was exempt from military service on medical grounds from the start.[73] The two Roberts moved to London that year, where they made their presence known in both artistic and social terms, but had to contend with a wartime lack of commissions. Nevertheless Colquhoun had his first solo show in 1942, and MacBryde in 1943, and they mixed with other forward-looking artists such as Jankel Adler, who moved down from Glasgow to a studio in their building in 1943 and was a considerable influence; he held his first solo exhibition in London that year.

In October 1940 MacBryde had written to Muirhead Bone, seeking work, and Bone passed on the letter to the War Artists Advisory Committee, describing both MacBryde and Colquhoun as 'distinctly promising'. MacBryde then sent another letter directly to the Committee, with examples of his own and Colquhoun's work, and the comment: 'I cannot conceive of going through this crisis in the affairs of man without stating what I feel in my own medium about these new forms that haunt our days'; the

Committee's response was to agree to help obtain facilities for MacBryde. His *Bombed* of 1941, based on a London street, shows an abstracted, tangled heap of metal and other materials, in a style that has echoes of John Piper's work at the time.[74]

Robert Colquhoun failed in his wish to be appointed as an official war artist, though he did receive a commission in 1944 for a painting on a subject of home-front production and transport. *Weaving Army Cloth* was based on studies he had made in weaving factories; the Imperial War Museum holds a number of preparatory drawings.

The work of each Robert influenced the other, and both produced compositions of two female figures engaged in textile tasks: MacBryde's later painting of *Two Women Sewing*, c.1948, shows similarities.[75]

Wilhelmina Barns-Graham also produced paintings of textile workers. In 1941 all women between the ages of 19 and 40 had to register with the Ministry of Labour, and her official contribution to the war effort was to work in a factory making camouflage nets. She obtained permission to make drawings in the factory, resulting in an interesting series of pastel and charcoal studies.[76]

James Wallace Orr (1907–1992), a painter in the Scottish Colourist tradition, studied at the Glasgow School of Art, but moved to London where he served in the Fire Brigade before joining the RAF with Bomber Command (he was later awarded the Distinguished Flying Cross). He produced a group of images of the London Blitz in 1941, from which he made etchings in 1946.[77] The two images reproduced here show the 'organised chaos' of London under attack. The driver in the *AFS [Auxiliary Fire Service] Crew going into Action*, 1941 has a dogged and determined demeanour, though age and anxiety seem

LEFT.
Robert MacBryde, *Bombed*, 1941. Gouache on paper. 43.1 × 55.5 cm. Aberdeen Art Gallery & Museums

RIGHT.
Robert Colquhoun, *Weaving Army Cloth*, 1945. Oil on canvas, 75.5 × 101.5 cm. British Council

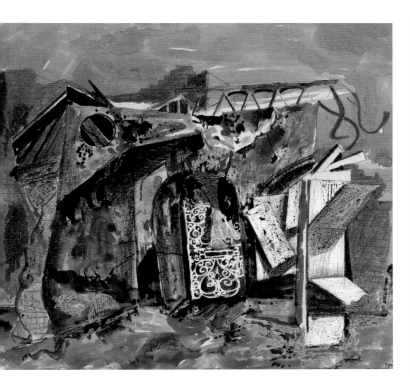

to be against both him and the man sitting beside him; their AFS steel helmets look curiously like the bowler hats appropriate to the City.

Marylebone Goods Yard, 1941 shows a surrealist looping of cables, which hang down over twisted metal, bearing similarities to some of the shipyard images of Stanley Spencer. The two firemen struggle with the powerful hosepipe, the whole image being somewhat reminiscent of the classical scultural group of *Laocoon and the Serpent*. In both images, the theatrical light source is undefined, though we must imagine it to be from the fires of bombed London.

'MY FATHER'S SON': EARL HAIG, A POW PAINTER

The 51st (Highland) Division had been forced to surrender at Saint-Valéry-en-Caux in northern France in June 1940, and at least 8,000 troops were subjected to five years of captivity in Germany. The enduring Scottish cultural legacy of this sad episode was a country dance, the Reel of the 51st Division, rather than any painting. However, men drew and painted in prison camps in Europe and the Far East – and produced magazines which had visual content.

And at home, the *Prisoner of War News*, issued by the Headquarters of the Scottish Branch of the British Red Cross Society, did its best; a typical cover of March 1943 (volume 5, no. 3) shows a prisoner peering through barbed wire.

The visual emphasis tended to be on a hearty jollity. Censorship was strict, and illustrations were often juvenile in tone. But occasionally images appeared which had more artistic ingenuity and merit. A Christmas card, the work of Major A. A. West, sent from Oflag VII-C – at Laufen Castle in Bavaria – shows a kilted Scottish officer in the courtyard, hemmed in by a border of barbed wire which is arranged decoratively to resemble Christmas holly.[78] George Waterston (1911–1980), scion of the Waterston family which ran a long-established stationery and printing firm in Edinburgh, made notes on birds, his great passion; his 'Birds Seen in Crete' journal is written in a British Government official issue notebook, but stamped by a German censor in Lübeck after his capture in Crete in 1941.[79] After the War Waterston bought the isolated Fair Isle, and co-founded the Bird Observatory there.

George Alexander Eugene Douglas Haig, 2nd Earl Haig (1918–2009), known as Dawyck Haig, was born in 1918, the son of the Great War Field Marshal. Not surprisingly, his life was overshadowed by his paternity, and he titled his autobiography *My Father's Son*.[80] His father died when he was only nine years old; he thus found himself succeeding to the Earldom and also, to some extent, his father's place at memorial events connected with his father's war. In the Second World War, Dawyck Haig served with the Royal Scots Greys in Palestine, and subsequently in the Western Desert. He was captured in 1942, and became a prisoner of war in Italy, his personal circumstances making him one of the 'Prominente', the prisoners of special importance. He wrote:

The prisoner of war's first reaction after the battle is probably one of thankfulness to be alive and of having survived. For myself I was able to shed the burden of the responsibility of living up to my father's great reputation as a soldier. Now suddenly fate had liberated me. I could slink away into the shadows of a prisoner of war camp to cultivate the resource of painting.[81]

For a time he was in a POW camp at Sulmona – best known as the birthplace of Ovid – and he recorded everyday life in a large, bare room, conveying a sense of boredom rather than any tension due to imprisonment. His only art lecture in prison camp was not a success, but he organised exhibitions, and bought watercolour paints through the Italian black market 'in pans, because tubes would have been confiscated due to the possibility of tiny maps being hidden inside them'. He painted studies of the camp and of his fellow prisoners, but it could be a messy business: 'My work was one of the reasons for the turmoil round my bed; paints and drying pages had to compete with socks and odds and ends of washing, and tins of food.'[82] He did, however, benefit from a parcel from home, with books and paints chosen by his sisters.

His *Sleeping Prisoners* is one of his records of POW incarceration. The figure in the foreground is probably Reynolds 'René' Cutforth (1909–1984), later to become well known as a broadcaster and writer. Haig also painted an oil portrait of Cutforth, later recalling that 'His lively company and his sardonic outlook were to boost my morale during the months ahead'; Cutforth became an 'admirable companion and staunch friend … listening to his well stocked mind was stimulating'.[83]

Haig was transferred from Italian to German custody, and for a short time permitted to organise weekly sketching walks (which non-sketchers soon

joined, until the walks were stopped). He was then taken to Oflag IV-C, better known today as Colditz Castle, noting that the morning after his arrival was 11 November – twenty-six years since the signing of the Armistice of 1918. He then endured what he later termed a privileged nightmare, 'living on a starvation diet, so low that the Germans themselves were anxious and weighed us all'. At least he could use oil paints at Colditz, though his privations created

a heightened mental state akin to mysticism ... During my time at Colditz I continued to paint a number of portraits of Jock McCulloch, of Michael Alexander and of Michael Riviere. I also painted a portrait of myself, which I had to paint sitting in the lavatory which contained the only mirror, working with some interruptions because of the needs of my companions. I also painted a large snow landscape of the scene from the window of our mess ... There was no shortage of paints, and to the irritation of my less artistic companions, parcels of oils and brushes and canvas boards sent by the Red Cross continued to arrive at a time when our supply of food and tobacco dried up ... [however] ... Through the exercise of my craft and through the study of people and of places around me, I was prevented from too much introversion.[84]

The *Self-Portrait, Colditz*, painted in 1945, shows a gaunt and haggard figure, old for his years.

Back in Scotland – as he later related – in August 1945 'I showed some of the POW paintings which I had brought back in the Scottish Gallery in Edinburgh in aid of Lady Haig's Poppy Factory and the Red Cross. The exhibition was visited by Her Majesty the Queen and the two Princesses.'[85] The exhibition included his *Sulmona Camp*, purchased from the

exhibition by the collector Dr Robert Lillie, who bequeathed it to the Scottish National Gallery of Modern Art.

Having by this time decided on a career as an artist, Haig studied at the School of Arts and Crafts, Camberwell. It had a very Scottish presence, notably in the form of the Principal, William Johnstone, 'a fellow Borderer'.[86] A lifetime's career as a painter followed, with the professional recognition from the public and his peers that he desired. His experiences as a POW left a lasting mark, and he devoted a great deal of his life to ex-Service charities. In his father's memory, he co-founded the Douglas Haig Fellowship, and he was a founding Trustee of The Scots at War Trust.

SCOTS IN AFRICA AND ITALY

Ian Eadie, already mentioned above, was a serving officer (from 1943) who documented so much of the progress of the re-constituted 51st (Highland) Division that he became, in effect, the divisional artist. He recorded all aspects of army life, for example a boxing match in 1942 (he had been a physical trainer).[87] He painted the Battle of the Sferro Hills in Sicily, and the destruction and desolation he saw in 1944 at Ouistreham, a village on the River Orne in Normandy. Some of this work became well known in Scotland; a selection of watercolours and drawings toured in 1944.[88]

After the War, Eadie was commissioned to paint a scene for which there were no visual records: Major-General Douglas Wimberley, GOC 51st (Highland) Division, briefing his senior divisional officers for the attack at El Alamein. Dated 1949, it is a *tour de force* of group portraiture, but suffers from the usual tendency of such paintings to be rather wooden in style; the artist has taken pains to include everybody present at the time, each face and detail clearly

The Earl Haig, *Self-Portrait, Colditz*, 1945. Oil on board, 29 × 20 cm. Coll. The Earl Haig

depicted. Eadie first had to find likenesses (from photographs) of the twenty-one officers present, and to check the complex map and names – an important aspect, for the code-names were Scottish locations such as Aberdeen and Montrose, Braemar and Forfar. The result is a narrative illustration rather than a work of art, a contrast to much of his other work. The men's stances make them look like artist's lay figures, listless and lacking in the nervous vitality which they must surely have possessed at the time. Eadie was rather more successful depicting the physical setting, the heat beating down through camouflage netting strung across the bare-walled area of the desert compound.

Edward Ardizzone's principal subject was always people, and he sketched incessantly in North Africa and Italy, showing them on duty and on leave, looting and loafing. He was irrepressibly cheerful, a tendency for which his work was sometimes criticised. In 1943 he produced a couple of charming watercolours of Scottish soldiers in the museum at Leptis Magna, the ancient Roman city in Libya. One shows two officers of the Highland Division, the other a more lively scene of an officer and three other ranks, entitled *Jocks in the Museum at Leptis Magna*.[89] The soldiers peer at the (apparently unlabelled) classical statues, the officer with a crook and the men with rifles, carried in a manner which would cause any modern museum curator to blench.

The Highland Division became known as the 'Highway Decorators' from their habit of marking their advance through North Africa during the War by painting their Divisional sign (HD within a circle) everywhere – and allegedly carving it on the posteriors of ancient statues.

James McIntosh Patrick was also in North Africa. Never an official war artist, he nonetheless sketched when close to the Fronts, latterly in Italy where he

OPPOSITE.

Ian Eadie, *The 51st (Highland) Division Plans El Alamein*, 1949. Oil on canvas, 69 × 90.5 cm. 51st (Highland) Division, Ross Bequest Trust, on loan to National Museums Scotland

ABOVE LEFT.

Edward Ardizzone, *Jocks in the Museum at Leptis Magna*, 1943. Watercolour on paper, 28.5 × 29.4 cm. Imperial War Museum

ABOVE RIGHT.

Photograph, *Highland Division Painters*: Privates James Bruce and Alec McMichael of The Black Watch, part of the 51st Highland Division, leaving their mark on the streets of Sfax, Tunisia, April 1943. The Black Watch Museum, Perth

James McIntosh Patrick, *Trefilisco, Caserta*, 1945. Watercolour on paper, 31 × 20 cm. Dundee City Council (Dundee Art Galleries and Museums)

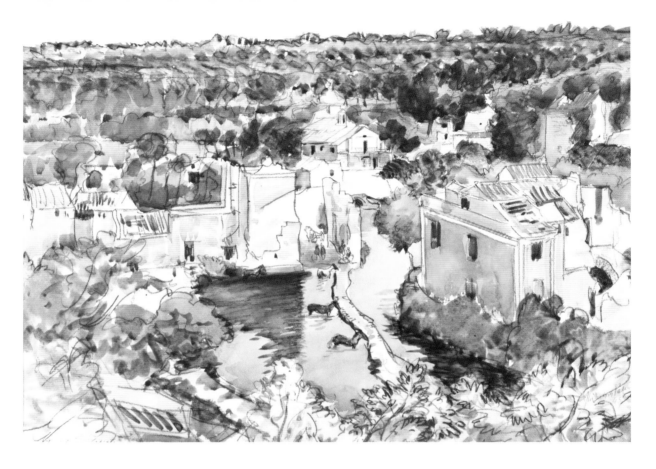

helped train Camouflage Officers, including Sir William Coldstream. By necessity, his work was in pencil and watercolour (many of these paintings were well received when exhibited in 1946, which encouraged him to work more in the medium). His *Trefilisco, Caserta* (1945) shows the lushness of the scenery, and like others in this group it has the appearance of being executed in haste, with light dabs of paint above broad washes of lighter tones.

Tom Honeyman, Director of Glasgow Museums, had a rather surprise experience of the Army in the Western Desert, later recalling that:

In December 1944 the central Advisory Council for Education in HM Forces 'sent' me by telephone and letter an invitation to spend a month in the Middle East to lecture to the troops … Cairo seemed to be full of Scots, chiefly from Glasgow. I was a bit lost until I met James Fergusson (later Sir James Fergusson of Kilkerran and Keeper of Records). He knew his way round … The reason for these tours of 'civilian lecturers' (that was the label) was to help to do something of interest the troops who were said to

be 'browned off'. The fighting in the desert was over and time hung heavy on them … My role was to inject a 'shot of culture' by way of talks on trends in Art (painting, sculpture and drama). In Cairo with good accommodation and projector it wasn't so bad … Away from the centres like Cairo, Alexandria, Benghazi and Tripoli talks on Art and Drama were out. I became a one-man Brains Trust, with the emphasis on the Trust … '[90]

Back in Scotland he received a letter of appreciation from a Major Ryan, who was unknown to him, writing from 'HQ 17th Area, MEF [Middle East Forces] on 17th February 1945':

After many years in the sandy ruts of the Middle East it is mentally refreshing to be reminded that Kelvingrove is not a distant mirage. Could you, when you get back home, tell 'them' to send out more people to talk to us – people like Bridie, Linklater, Compton Mackenzie, Grieve and some of the younger men. We would like to know what has been happening in Scotland since 1939. Like sleepers in the fairy tale we will have to wake when Peace comes, to recoup as best we can the lost years.[91]

As the Roman poet Horace said, poets and painters have always had an equal licence in daring invention. However, the poetry of the Second World War had a problem of identity – indeed it still has in the mind of the general public. The problem was summed up by Robert Graves, poet and memorialist of the First World War, who wrote in 1942 that the terms 'war poet' and 'war poetry' were 'terms first used in World War I and perhaps peculiar to it', and that this made it difficult to use the same terms in the

current conflict.[92] The poetry which has best stood the test of time was written by men who served in North Africa: Hamish Henderson, George Sutherland Fraser, Sorley MacLean, 'Robert Garioch' Sutherland and Edwin Morgan.

The Glaswegian Edwin Morgan (1920–2010) had studied English literature, French and Russian. He registered as a conscientious objector, then applied to join the Royal Army Medical Corps. In North Africa he served as a clerk and stretcher-bearer, and later in the Lebanon and Haifa, and over twenty years later, in his poem 'The Unspoken', he recalled his journey to the East. He prefaced his lengthy poem 'The New Divan' (1997) with the meaning of the word: 'Divan. *n.* (1) a state council, or its meeting-place, (2) a couch or bed, (3) a collection of poems, e.g. the *Divan* of Hafiz.' The poem explores a great deal about the Middle East, and about the writer, but a really striking aspect of this atmospheric poem is the interest in colour. In stanza 95 he paints with words:

Slowly tawny, slowly ashy, the desert and the day
suddenly gulp the plum of darkness. Rays
of indigo spill down the wadis.[93]

NORMANDY TO THE RHINE 1944–45

Fyffe Christie (1918–1979) was born in England but his father was Scottish, and he moved to Scotland in 1930, becoming apprenticed to a lithographic draughtsman before joining the Army in 1939. He attended a course at the Army School of Piping in Edinburgh Castle, and was posted to the 9th Battalion The Cameronians (Scottish Rifles). The battalion fought through the campaign in north-west Europe, from their landing in Normandy in June 1944 very soon after D-Day, until the German surrender in May

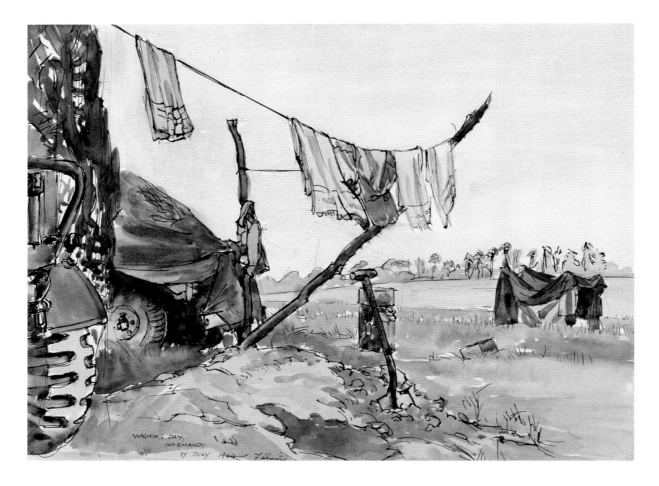

1945. Christie sketched widely, though he concentrated on the landscapes and everyday scenes around him, not the fighting. After leaving the army he went to Glasgow School of Art, and in his later career worked largely as a muralist.[94]

His *Washing Day, Normandy*, a line with washing and an improvised clothes pole, rigged up in a distinctly *ad hoc* fashion from a military vehicle, conveys well the sense of snatching a moment of domesticity while on the move. Ian Eadie's *Beachhead Library* is perhaps more surprising, for it shows a mobile library service during the Normandy campaign – even here, servicemen were given literary

diversion.[95] By this time, attitudes towards the needs of soldiers were changing, and every facility possible was provided in terms of entertainment and occupation. There had in fact been considerable national discussion about the 'soldier as citizen', for serving soldiers were at first not permitted to read the Beveridge Report of 1942 (the blueprint for a welfare state). Peter White (see p.113) commented in his unpublished diary for 3 December 1942 that the report had cased 'a great stir'.[96]

In 1942 Robert Henderson Blyth, whose sketches of training in the Highlands were shown earlier, exhibited *Cookhouse in the Wood* at the Royal

ABOVE.
Ian Fleming, *My Billet near Emmerich*, 1945. Pencil and watercolour on paper, 37.7 × 53.2 cm. Aberdeen Art Gallery & Museums

RIGHT.
Ian Eadie, *Prisoner of War Lance Corporal, 1st SS Panzer Division (Adolf Hitler Bodyguard)*, 23 July 1944. Watercolour on paper, 52.8 × 36.1 cm (frame size). National Museums Scotland

Scottish Academy (no. 319), perhaps related to the *Mobile Canteen* here, signed and dated 1944. Like many of his watercolours of the War, this shows humans enclosed within a wooded landscape. In the foreground is a burnt-out tracked vehicle, with shattered trees in a roped-off area labelled 'Mines'. Beyond, civilisation is present in the form of a 'Scottish Churches Huts' mobile canteen, clean and undamaged, providing bodily and spiritual sustenance to the troops.

The swirling lines in many of his images are neo-Romantic in style, showing considerable affinities with work being produced by artists such as Michael Ayrton, for example in his series on Chainmakers (there was possibly a personal link between the artists).[97]

As mentioned earlier, Ian Fleming had joined the Pioneer Corps, and he followed the troops in training in England and through western Europe, creating a series of fascinating watercolours. But he found little to be cheerful about. In his watercolour *Camp on*

Salisbury Plain of 1944, the viewer peers over a network of guy ropes between two sagging tents in camouflage green and ochre to bare huts beyond, and chalk spoil thrown up from trench digging. The human presence is inferred from all the temporary structures, but the scene seems desolately lonely, perhaps an expression of his own feelings at the time.[98] Once on the continent, many of Flemings's ruined buildings look very similar to images of those from the First World War, even in *My Billet near Emmerich* where a ruined car stands outside a shelled building. The limited palette gives it a cold tone, while the patterning of destruction, with the staves of wood and the undulating mud, shows similarities with the work of Robert Henderson Blyth.

Peter White did retain a sense of humour – most of the time, at least. He served as a subaltern in the King's Own Scottish Borderers, and kept (unauthorised) a journal of his battalion's advance through the Low Countries and into Germany, now a valuable document of record. His *Morning Cuppa: Platoon HQ in Afferden Woods* shows the detritus of Army meals around the troops in their individual foxholes. Propped up against a tree is a mock pub sign, sporting a pair of upturned boots and the words 'Ye Olde Header Inn / Prop: I. B. Wellunder'. Less amusing is his *Snow Hike, 23 January 1945*, showing the battalion on the march from Erdbruggerhof farm in preparation for an overnight attack on Heinsberg.[99]

A rather unusual watercolour by Ian Eadie, *Prisoner of War Lance Corporal*, shows a single prisoner of war – they are all too often shown *en masse* – and it is a magnificent essay in dejection. The man is a non-commissioned officer (NCO) with an elite Nazi unit, Leibstandarte SS Adolf Hitler, the 1st SS Panzer Division 'Adolf Hitler Bodyguard'. He was captured by the 51st (Highland) Division in 1944 (the watercolour is signed and dated 23 July 1944); it was the end of his dreams.

SCOTS IN THE FAR EAST

Stanley Gimson (1915–2003) was a Glaswegian who studied law before joining the Territorial Army in 1938, and then the regular Army in 1939. In 1941 he was commissioned as a Second Lieutenant in the 2nd Heavy Anti-Aircraft Regiment, Indian Artillery, then stationed in Singapore. He became a prisoner of war when Singapore surrendered to Japanese forces in February 1942, and worked on the notorious Burma–Siam railway, recording his often harrowing experiences in small sketches. He buried them in a camp cemetery (rolled up in a bottle) and retrieved them at the end of the War. After a period of recovery in India, Gimson returned to a legal career in Scotland, becoming an Advocate and a Sheriff Principal. He later became Chairman of the Scottish Far Eastern Prisoners of War Association.[100] Reproduced here is a 1943 sketch of Tamakan, the notorious 'Bridge over the River Kwai' on which the prisoners worked. It shows the bridge under construction, the vertical concrete pillars already in place, covered with wooden scaffolding.

Another Scot who recorded the Burma–Siam railway work was John 'Jack' Mennie (1911–1982). He trained at Gray's School of Art in his native Aberdeen, and in London. He joined the Royal Artillery in 1940 and was posted to Singapore in September 1941. His prints, made later from wartime drawings, are sparse in their detail, and simple but deep in colour. One shows the strange sight of detachments of Gordons and Argylls, Prisoners of War under armed guard, clad in the kilt, though the image selected here shows prisoners working on the railway.[101]

Several other POWs recorded these experiences, using all manner of materials for paper and colours. Dr Robert Hardie (1904–1973) had been a medical officer with the Federated Malay States Volunteer Force, a reserve force similar to the British Territorial

LEFT.
Stanley Gimson, *Tamakan*, dated 5 April 1943. Pencil on paper, 17.0 × 11.4 cm. Imperial War Museum

RIGHT.
John Mennie, *Prisoners of War Working on the Thai–Burma Railway at Kanu Camp, Thailand*, 1943. Woodcut on paper, 38.0 × 42.2 cm. Imperial War Museum

Army. Along with thousands of others, he had been captured at Singapore but kept a secret diary 1942–5 in which he made sketches and watercolours of the flora and fauna around him, as well as his record of makeshift medical care. His diary, like Gimson's, had to be buried in a camp cemetery until he could retrieve in 1945; it was finally published forty years later.[102] The brief Scottish sojourn of the young soldier and future illustrator Ronald Searle (to be discussed in the next chapter) was followed by a journey to Singapore. He too became a prisoner of war, recording the scenes around him on scraps of paper which were published in 1986.

THE ARTS BACK HOME

William Scott (1913–1989) was born in Greenock, and grew up in Northern Ireland, studying first at Belfast College of Art and then at the Royal College of Art, London. In 1942 he joined the Royal Engi-

neers, working on ordnance maps and in the process learning lithography, and producing watercolour landscapes in a neo-Romantic style. He produced a series of notable lithographs for *Soldiers' Verse*, selected by Patric Dickinson, published in 1945. One double page shows his lithograph of a couple (related in composition to an oil painting now in the Imperial War Museum) placed opposite the poem 'On a Bereaved Girl' by Alun Lewis, who was himself killed in 1944. Also on the page is John McCrae's 'In Flanders Fields', the poignant poem of the First World War.

Many publications featured the work of both official war artists and artists who had been given individual commissions. Some of these publications featured specific aspects of war work, their artistic richness unintentionally camouflaged by the most workaday titles, such as *War Pictures by British Artists (Second Series, no.4): Air Raids*, which had an Introduction by Stephen Spender (Oxford University Press, 1943). Exhibitions of war art were circulated as far as practically possible, their catalogues often

bearing verbose titles, for example *War Pictures by British Artists: Catalogue of an Exhibition of Official War Pictures Circulated by the Ministry of Information by Arrangement with the Museums Association. Second selection* (with notes by R. H. Wilenski), 1943. Yet the images were well-chosen and lived up to their stated aim: 'This exhibition gives us a cross-section of the work being done by the full-time official war artists …' The catalogue mentioned here included three of Keith Henderson's aerodrome images, and a picture by James Miller ('a Scottish artist resident in Scotland') of *Bomb Damage, East of Scotland*; the frontispiece was Ravilious's *Leaving Scapa Flow* (p.176).

Space does not permit a full account of what the many other Scottish artists did during the Second World War. Those whose work is not detailed here include William Burns (1921–1972), who served as a pilot in the RAF 1939–42, after which he went to Glasgow School of Art (Burns continued to fly in peacetime, an interest that influenced his art; he died in an air crash on a solo flight). The sculptor and painter William Turnbull (1922–2012) also served as an RAF pilot. Jack Firth (1917–2010) served in the Royal Artillery and the Royal Army Education Corps, before teaching art as a career. David McClure (1926–1998) was sent down the mines as a 'Bevin Boy', making a series of works on the theme of coal mining c.1946–49.[103] Several others served in different ways, such as Harry Keay (1914–1994), who was exempt from active service for medical reasons, but was in the Observer Corps.

LOOKING TO THE FUTURE

Agnes Mure Mackenzie considered *The Arts and the Future of Scotland* in a Saltire Society pamphlet published in 1942. As an Editorial note explained, it was the second of a series issued partly to 'deal with the question of Reconstruction, which is at present engaging the thoughts of so many'. After trying to define what art is, she wrote:

> All of this can be summed up in seven words – that art is needful to any nation's life… A nation needs art. It needs to consume it and it needs to produce it. If it fails in either it is going to lack a very important essential vitamin from its mental and its spiritual diet. Can we say that Scotland has lacked this vitamin? I fear that we must.

She discussed poets, more acceptable in Scotland than visual images owing to 'the religious terror of all but the verbal', but warned that 'We are in danger just now, in serious danger, of mixing national art and nationalism in a way that may do grave injury to them both.'[104] The Saltire Society, she pointed out, was there to assist in supporting artists of all art forms in the future.

However, Scots had a constant lament, expressed very well by Tom Honeyman when he wrote 'For a time I was the sole Scottish member of the Art Panel of the British Council', and 'The Arts Department of the British Council … did great service for Britain overseas. I should have written ENGLAND. That was, more or less, my constant grouse.'[105]

A WITNESS TO TWO WORLD WARS

Most artists who served in the two World Wars perceived, and recorded, these events as two distinct world events. But some saw less distinction, and two of Robert Henderson Blyth's paintings, both exhibited at the Royal Scottish Academy in 1946, emphasised the human links between the two Wars. Perhaps he was suggesting that war can only beget more war, and

certainly, by the time these images were painted, some of his work had become quite harrowing.

His *Self-portrait*, sub-titled *Existence Precarious*, looks very much like a scene from the trenches of the Western Front in the First World War. This was possibly its intention, and its meaning is ambiguous too: is the second soldier asleep, or dead?

Henderson's *War Baby, 1918*, painted in 1945, shows a young, rather androgynous soldier, against a barren backdrop of snow and a ruined house, the bedstead visible – perhaps a reference to the birth of the child who is now this soldier? He looks at the viewer, as if to accuse the world of creating this destruction, or to ask 'What next?' He wears an Army form on a ribbon attached to his jerkin, used to carry medical information. The packet bears the words 'Ship Label' and 'Casualty Group'.[106]

A GEAR CHANGE

But there were those with a more cheerful outlook. William Gear (1915–1997) came from a mining family in Methil, Fife, and trained at Edinburgh College of Art, where he was awarded a travelling scholarship, enabling him to study briefly under Fernand Léger in Paris. During the War, in the Royal Corps of Signals, he served in Palestine, Egypt and Italy. He also found time to paint and exhibit.

After the War he returned briefly to Edinburgh, where he volunteered to return to Germany. He was soon invited to serve (with the rank of Major) in the Monuments, Fine Arts and Archives Section (MFAA) of the Allied Control Commission 1946–47. This included overseeing the return of artworks from the Berlin Art Collections, some of which had been stored for safekeeping in the nearby Schloss Celle in which he was staying. A committed modernist, Gear seized the opportunity to promote the work of avant-garde German artists in a series of exhibitions, including work which had been labelled 'degenerate' by the Nazis. He found the work rewarding and stayed longer than originally planned, holding his own one-man exhibitions in Celle and Hamburg. Shortly before he died his contribution was belatedly recognised by the government of Lower Saxony.

Gear lived in Paris from the later 1940s until 1950, working with the COBRA group of artists, which included Otto Götz, whom Gear had befriended in Germany. The name COBRA was taken from the cities of its leading members – Copenhagen, Brussels and Amsterdam – and Gear showed work in its exhibitions in Amsterdam and Copenhagen in 1949. The group worked in an abstracted, gestural manner, but one influenced by the tradition of primitivism and European folklore as well as modern movements. Gear's own works usually have identi-fiable landscape or plant motifs, giving them an organic aspect, the colours delineated by grid-like structures reminiscent of stained glass. Gear himself stated that they were influenced by the Forth Bridge, and the pitheads of Methil, though his painting which features in Chapter 5 shows the vegetation of Africa.[107]

CHAPTER 4

Friendly Invasion:
Artist Visitors to Scotland at War

During the Second World War, Scotland was a hive of international activity. Its social scene was enlivened by the presence of the service personnel of many Allied nations, and by refugees from the conquered countries of Europe. Its national paint-pot, so to speak, was enlivened by these incomers, and by the many English artists who came north to witness events in a part of Britain new to them. Monographs on individual artists often tend to focus on the non-war periods in their lives and work, the Scottish element being considered only brief episodes in their careers. But taken together as a group, their corporate responses to a Scotland at war are very interesting.

UP FROM THE SOUTH

Quickest off the mark was the English painter Sir William Rothenstein, who had been an official war artist in the First World War. Before any artists had been appointed by the Air Ministry, he requested permission to make portraits of airmen at Scottish bases. His papers in the Imperial War Museum document the problems this caused, especially in pre-empting Keith Henderson, an official artist who was

living nearby in St Andrews, from working at RAF Leuchars (p.103).

A number of Rothenstein's drawings were acquired by the War Artists Advisory Committee (WAAC), and he produced a book, *Men of the RAF*, in 1942.[1] The book featured images only of men, though the list of his work at the end of the book includes mention of an Air Transport Auxiliary pilot First Officer, Lois Butler (shown here). Rothenstein moved on to work – at what appears to have been a frantic pace – in other parts of Britain. His high-handed keenness appears to have stemmed from an awareness that his health was failing, and he died in 1945.

As noted in the previous chapter, Sir Muirhead Bone (knighted in 1937) was once again the first official war artist. His son Stephen (1904–1958) took over his commission from 1943; Stephen is included in this chapter as he was born in London, had studied at the Slade, and was more English than Scots in terms of his lifelong base and career. He had worked at the Camouflage Unit, based in Leamington Spa, until appointed as a full-time salaried artist in 1943. He recorded a great deal of Scotland at war, including an important surrender, though much of his work in

OPPOSITE.
Anonymous artist, *A Scottish Piper and Two Polish Soldiers*, 1940. Oil on canvas, 101.6 × 101.6 cm. Glasgow Museums

Scotland is undramatic (he also covered naval craft and coastal installations in other parts of Britain, and later the Normandy landings and the War on the continent).

His experience in camouflage no doubt prompted his interest in *Camouflaging the Pipeline at the British Aluminium Company's Works at Fort William* of October 1941, looking downhill towards the factory in the middle distance, with camouflage netting being erected above a pipeline, and rails running parallel alongside it. A picture-postcard Highland landscape lies beyond. The deep blue of the sea lochs and mountains are a characteristic feature in much of Bone's Scottish work and sometimes lend a positively Mediterranean appearance to his views of Scotland.

PASSING THROUGH

Someone little interested in landscape, and consequently not seduced by Scottish scenery, was the cartoonist Ronald Searle (1920–2011). The brief record of his war experience in Scotland has been overshadowed by the frank records he made as a prisoner of war in Singapore, and then on the Burma railway, finally published in 1986. But that is to look ahead, for in April 1939, as an art student in Cambridge, Searle volunteered for the Army. He was called up in September, becoming Sapper Searle for the next seven years. After a period in East Anglia he was sent to Kirkcudbright, arriving in January 1941 unaware that it housed a very welcoming artistic community. He was befriended by Jessie M. King and her husband E. A. Taylor, and by Bill Johnston and his wife Dorothy Nesbitt, with whom he spent a great deal of his spare time, relaxing and discussing art, and enjoying domestic comforts. The Johnstons' two daughters were pupils at St Trinnean's, an Edinburgh school evacuated to the west coast for the duration

ABOVE.
William Rothenstein, *First Officer Lois Butler: Air Transport Auxillary*, 1940. Sanguine crayon on paper, 52.7 × 38.2 cm. Imperial War Museum

OPPOSITE.
Stephen Bone, *Camouflaging the Pipeline at the British Aluminium Company's Works at Fort William*, October 1941. Oil on board, 49.5 × 59.6 cm. Imperial War Museum

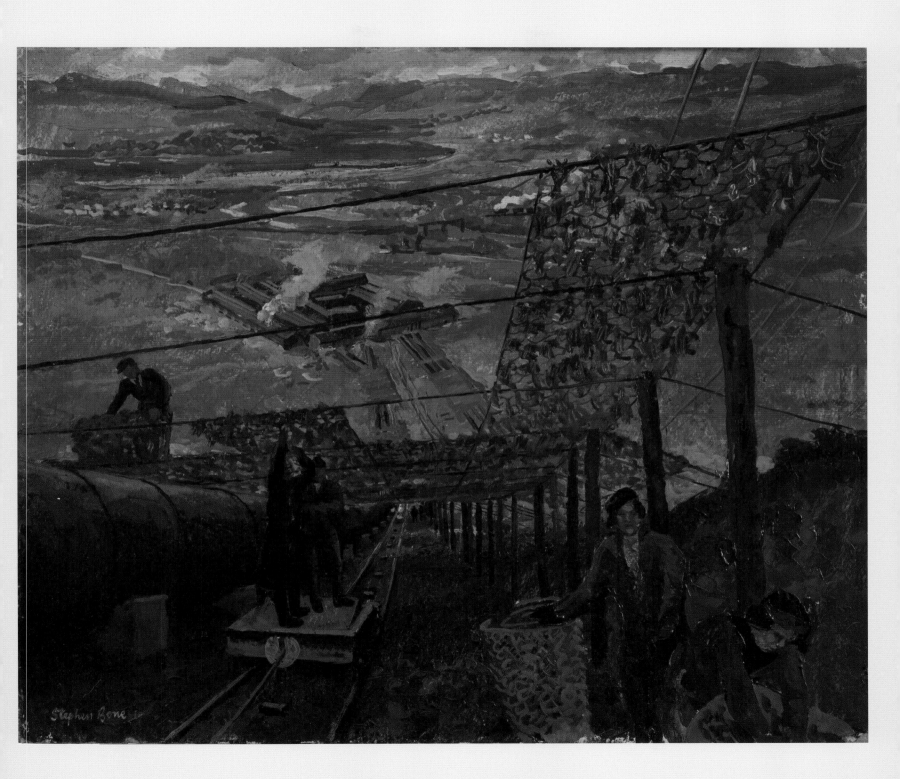

LEFT.
Ronald Searle, *River Dee, Kirkcudbright from the Barracks*, January 1941. Ink and wash on paper, 17.0 × 18.5 cm. National Museums Scotland

RIGHT.
Ronald Searle, *Night Convoy, Kirkcudbright, March 1941*. Ink and wash with touches of gouache on paper, 18.0 × 14.8 cm. Imperial War Museum

of the War. Both the appearance of the pupils in uniform, and the oddities of the school's idiosyncratic regime – such as backwards eating, pudding to soup – provided material for Searle's fictional cartoon school St Trinian's (though he may have added the Perse School for Girls and the Cambridgeshire High School for Girls to his collective inspiration). Searle's first schoolgirl cartoon was produced in 1941 but it was only after the War that St Trinian's, set in a non-specific English location, became well-known.[2]

Searle also produced a group of rather more conventional images while in Kirkcudbright, each dated 1941, with annotations added in 1992 at the request of the Scottish National War Museum, to whom they had been presented. One of these was *River Dee, Kirkcudbright from the Barracks*, exhibited at Royal Scottish Academy in 1941 (no. 564), the submission presumably made through the good offices of the Johnstons. Searle also made sketches of soldiers, both by day and on night exercises, and produced one very finished study almost in monochrome, *Night Convoy, Kirkcudbright, March 1941*. Four soldiers sit in the back of a lorry, two dozing while the others chat, a moonlit tree beyond. Searle later described it as 'The 287 Field Company R.E. on night manoeuvres "somewhere in Scotland"'.

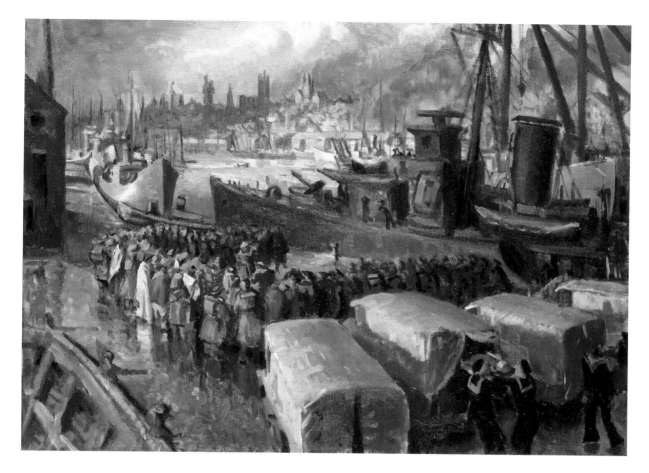

E. Christopher Perkins, *Roll-Call of the Survivors of HM Troopship* Archangel *at Aberdeen*, 1941. Oil on canvas, 71.1 × 91.4 cm. Imperial War Museum

After his stay in Kirkcudbright, Searle was sent to various locations in England and Wales, then returned to Scotland, and sailed from Gourock on 29 October 1941 with the 53rd Brigade (18th Division) in the Polish troopship *Sobieski*, destination unknown.[3] On 28 September 1945 what remained of the 18th Division was repatriated from Singapore (by sheer coincidence, in the same ship).

Many lesser-known artists produced work while serving in the Forces, one of whom was a Gunner, Christopher Perkins (1891–1968). He was an English artist who had trained in London, and after service in the First World War had spent some years in France

and New Zealand, before returning to Britain in 1934. He was given assistance by the WAAC administration, which arranged facilities for drawing at Aberdeen, and purchased several works. One of the purchases was the *Roll-Call of the Survivors of HM Troopship* Archangel *at Aberdeen*, showing the aftermath of the aerial bombing of the vessel off the coast of Aberdeenshire with the loss of 52 lives.[4] Men huddle together in the rain, while ambulances fill the foreground. A shadowed grey-blue warship lies between the rescued and the almost ethereal city beyond – it looks as if the artist has taken the opportunity to paint its portrait at the same time.

POSTED NORTH:
ARDIZZONE AND RAVILIOUS

Edward Ardizzone (1900–1979), whom we met in the last chapter, had a much-travelled life. He was born in Haiphong, French Indo-China, to a Frenchman of Italian parentage, and a British mother who had studied painting in Paris. The young Ardizzone had arrived in England in 1905, and tried twice to enlist in 1918, failing because he was a French national (he became a British subject in 1922). Based in London, he worked as a painter and graphic artist until 1939, then saw service briefly in an anti-aircraft regiment before becoming an official war artist. Much of his prolific output of war work has been published, and fully documented more recently by his grandson.[5]

Edward Ardizzone, *Bombed Out [Glasgow]*, 1941. Watercolour on paper, 20.5 × 27.3 cm. Imperial War Museum

Edward Ardizzone, *On a Fortified Island in the Firth of Forth: Barracks*, 1941. Watercolour on paper, 31.3 × 41.8 cm. Imperial War Museum

In April 1941 Ardizzone was asked to record the effects of the war in Glasgow and Edinburgh. He spent two weeks in Glasgow where he drew *Bombed Out*. There is little detail of the streets, though the sense of loss experienced by people gazing at the wreckage of their homes is expressed with great economy of line. He also drew the waterfront, showing buildings reduced to rubble, with only their facades remaining.[6]

Ardizzone was impressed by Scotland. On 27 April he wrote from Edinburgh to the WAAC Secretary, 'agreeably surprised to find a war artist exhibition here. It is very well hung and looks very well. The Scotch take it very seriously and even offer a guide to take one round … I have just been up in Perthshire. The country there is divine.'[7]

He produced a series of drawings of an island in the Firth of Forth, the largest number of works he made of any one subject (perhaps because he was, in effect, stranded there for some time). The island was Inchkeith, not far from the Forth Bridge, an identity divulged only many years later. Having been a gunner, Ardizzone knew the technical details of what he was drawing, and his simple sketches are very accurate. But people were always what interested him most, and the group of images convey an atmosphere of watching and waiting, and of isolation. Men lounge against walls by gun emplacements, as do those gazing at a soldier cultivating vegetables behind the battery. A very effective interior nocturnal view, *On a Fortified Island, the Night Watch, 1941*, shows gunners lolling asleep, either from boredom or exhaustion.[8]

Eric Ravilious (1903–1942) was born in Acton and brought up in Eastbourne, where he attended the College of Art. He specialised in wood-engraving (one of his designs was the top-hatted gentlemen on the cover of Wisden's *Cricketer's Almanac*), and in the 1930s he produced designs for Wedgwood and Stuart Crystal. However, his current, and still-growing, repu-

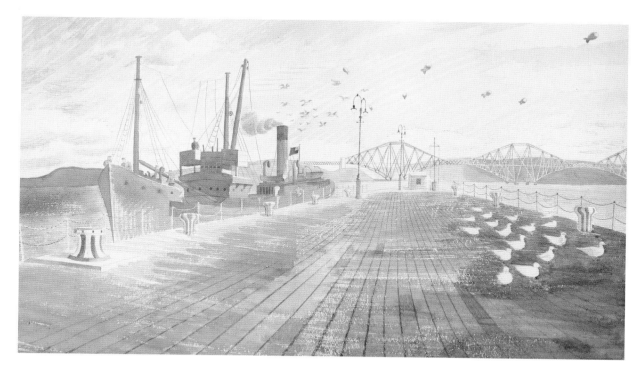

Eric Ravilious, *Channel Fisher*, 1941. Pencil and watercolour on paper, 51.0 × 55.6 cm. Ferens Art Gallery, Kingston upon Hull

tation rests chiefly on his watercolour output. He was fascinated by design, and the human side of machinery, and he 'designed' and personalised landscapes and townscapes, perceiving individuality and character in every location.

After a brief spell in the Observer Corps, Ravilious was commissioned as an official war artist in February 1940, along with John Nash, serving with the Admiralty and with the rank of Captain in the Royal Marines. He was first posted to the Admiralty's North Command, recording action at sea and coastal defences. He then saw a great deal of Scotland, free to paint as he wished; in fact no picture was a specific commission.[9]

Ravilious stayed with John Nash and his wife Christine at Crombie Point, near Dunfermline. Nash had not found his work as a war artist satisfying, transferring to active service in March 1941 with a commission as Temporary Captain (later Acting Major) in the Royal Marines, and by June he was working at Rosyth; Ravilious arrived to stay with them in the autumn of that year.[10]

Ravilious was naturally attracted by the Forth Bridge, and in his *Channel Fisher* he demonstrates his strong sense of design, making patterns from the view in front of him. The seagulls line up on a jetty with striped capstans, while numerous barrage balloons take the place of birds in the skies above. Beyond is the latticed structure of the Forth Bridge, complementing the jetty's lines of planks which draw the viewer into the composition. As often in his work, Ravilious indicates the presence of people without including them: smoke billows from the ship's funnel, and a hut sits at the end of the jetty awaiting arrivals and departures. He worked out his compositions carefully, often making detailed studies, and a less finished variant of this composition shows a similar scene from a more distant viewpoint.[11]

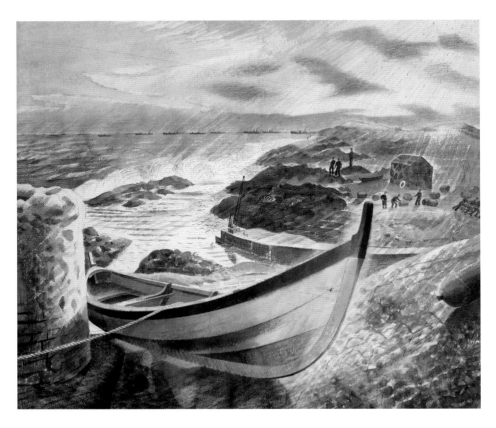

Eric Ravilious, *Storm*, 1941. Pencil and watercolour on paper, 49.5 × 54.6 cm. British Council

and an RAF launch and am now living with this small naval mess, 5 officers and few ratings … The island is rocky and rolling and wild … The wind blows and howls …

And in his next letter he enthuses:

There are such lovely things on this island, huts and lighthouses and wrecks but I hardly dare stay because they don't get my extra ration here so I can't eat or drink indefinitely … I've just been entranced with the place all day and explored all day without working …[13]

His *Storm*, set on the Isle of May, dramatic with the prow of a humble rowing boat thrust to the foreground of the picture, shows both rain and sun, and a convoy of ships on the horizon. *Storm* is one of a pair of watercolours, both of which are painted in the same delicate palette of predominately blue-grey tones; the companion image shows a group of barrels in the foreground, a farm, with the same line of ships on the horizon.[14]

Like Edward Ardizzone, Eric Ravilious found the coastal scenery interesting, and he was well placed to observe and record the convoys making dangerous journeys between Rosyth and Sheerness in Kent; one of his watercolours, *Convoy in Port*, depicts the mustering of ships with their Naval escorts.[12] In a letter to his wife Tirzah on 20 October, Ravilious related that he had been walking two miles along the coast: 'I freeze in the docks for about three or four days and then retire here to work indoors … and I've later a short trip in a destroyer and a visit to Inchkeith – the island that Dr Johnson visited.' On 25 October he visited another island:

May Island (it's off the Firth of Forth out to sea) … I've landed here by way of a destroyer

Quite different is his image of the *RNAS Sick Bay, Dundee*. The inferred presence of absent people comes over very strongly, creating a slightly eerie feeling of departure. The empty bed, its blue-and-white nautical cover so tidily spread, and the empty chair facing us – is this a memorial to someone who has recently died? Outside, a flagpole rears up by the window, with Walrus seaplanes rolling about beyond. Ravilious wrote about Walruses in a letter from Dundee, addressed to the Secretary of the WAAC: 'what I like about them is that they are comic things with a strong personality like a duck, and designed to go slow. You put your head out of the window and it is no more windy than a train.'[15]

Ravilious was keen to see Iceland, and in August 1942 he flew from Prestwick to paint the Norwegian

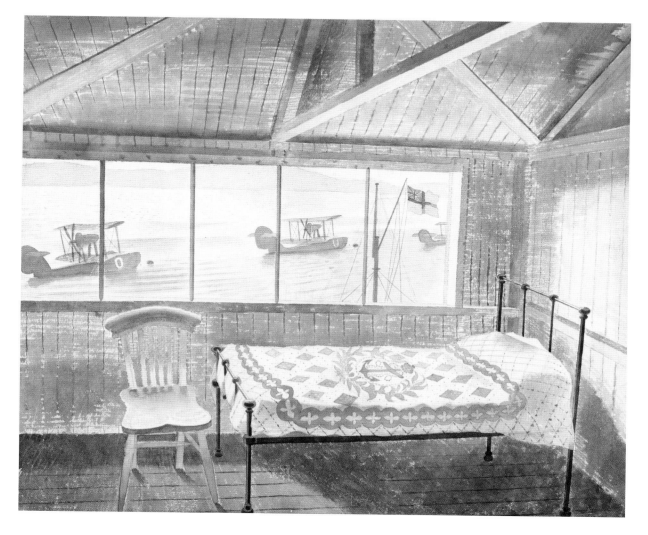

Eric Ravilious, *RNAS Sick Bay, Dundee*, 1941. Pencil and watercolour on paper, 48.8 × 54.2 cm. Imperial War Museum

squadron there (Iceland was not as remote as one might imagine: Feliks Topolski had sketched the arrival of an Entertainments National Service Association party there that summer). On 2 September Ravilious joined an air sea rescue flight as an observer, but the plane disappeared, and no trace of it has ever been found.

Thomas Barclay Hennel (1903–1945) was sent north as replacement for Ravilious. His study, *A Convoy in the Pentland Firth: Duncansby Head,* *Stroma, and Hoy in the* background, shows choppy seas.[16] Hennell was also lost while on active duty as an artist, but in the Far East.

SPENCER IN THE SHIPYARDS

Stanley Spencer (1891–1959) did Scotland proud, and he is the only English artist whose Scottish *oeuvre* has been fully studied and exhibited in Scotland.[17]

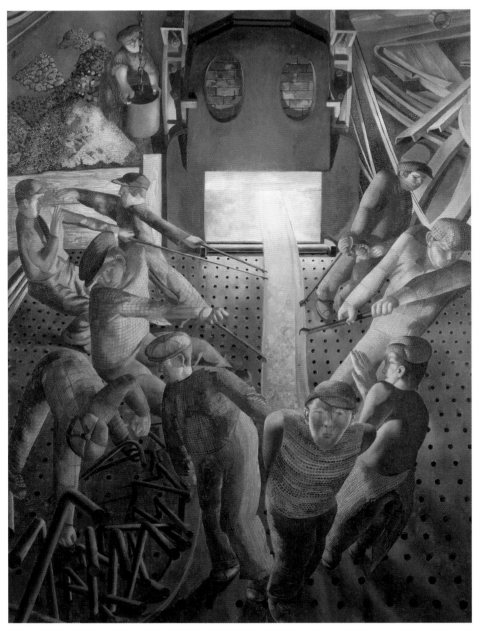

LEFT.
Stanley Spencer, *Shipbuilding on the Clyde: Furnaces*, 1946, Imperial War Museum. Oil on canvas, 156.2 × 113.6 cm. Imperial War Museum

RIGHT.
Stanley Spencer, *Study for 'Shipbuilding on the Clyde'* (Spencer sketching a female welder). Pencil on paper, 38.0 × 28.0 cm. Imperial War Museum

Spencer had served in the First World War as an orderly in a military hospital in Britain, and in Greece; he was an official artist in both Wars. When the WAAC asked him to record the war effort in the Clyde shipyards, little did they know what Spencer would produce. He really took to the shipyards, finding them fascinating places, and being hugely impressed by the camaraderie of the workforce. His eccentricity made him endearing to them; for example he put his clothes on over his pyjamas, both to save time and to keep warm. He was also keen to get very close to his human subjects, crawling after them into tight spaces.

He produced a huge amount of work, including a series of long, scroll-like canvases, showing the

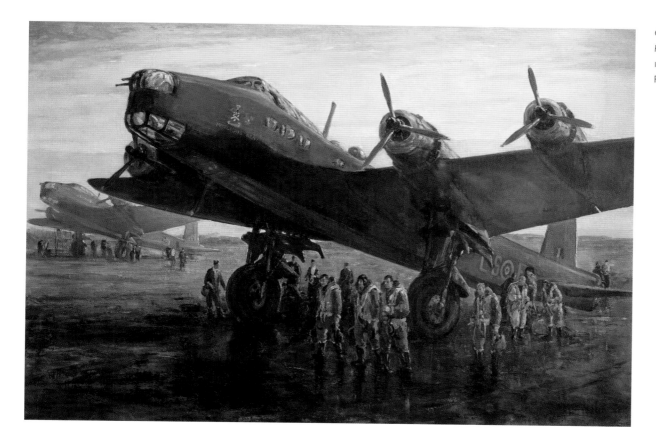

Charles Cundall, *Stirling Bombers:
Return of The MacRobert's Reply*,
1942. Oil on canvas, 87.5 × 125 cm.
Royal Air Force Museum

various processes of shipbuilding and the teams of people working on them. And 'people' they were, for many of the men's jobs had been taken over by women for the duration of the War. In the pencil study shown here, Spencer – with huge sketchpad – peers down at a female welder.

SCOTLAND PROUD AND DEFIANT

Charles Cundall (1890–1971) was an English painter, potter and stained-glass artist, whose war work fell into neglect until a revival of interest in the 1990s. He studied at Manchester School of Art and the Royal College of Art, London. During his First World War

service he was wounded in the right arm and had to learn to paint with his left before returning to the RCA in 1918, and then to the Slade and Paris, after which he travelled widely. In the 1930s he became known for his panoramic views – and known he was, being a member of various art societies and a prolific exhibitor. Much of his work is very illustrative, though his best compositions are impressive in their design.

During the Second World War Cundall worked on short-term contracts for the WAAC before being given a full-time salaried commission as an Admiralty Artist (working on Merchant Navy subjects, mainly in England), then in 1941 for the Air Ministry; in 1942 he went to Northern Ireland to paint the Amer-

Eric Kennington, *Lance Corporal Robertson of the 11th City of Edinburgh Battalion Home Guard*, 1943. Pastel on paper, 95.0 × 66.3 cm. National Museums Scotland

ican troops arriving there, and then worked in Scotland in September and October that year. His style came as something of a relief to many of the senior ranks of the Forces, who were happier with 'safe' narrative work rather than the eccentricities of artists like Spencer.

It is difficult to determine the location of many scenes in Cundall's paintings, deliberately concealed at the time and not always revealed later. But some are identifiable, such as Prestwick, Lyness, Gourock and Tobermory. His *Stirling Bomber: Take-off at Sunset* (1942) in the Imperial War Museum is almost a pair with the poignant image of *Stirling Bombers: Return of The MacRobert's Reply*, 1942.

The bomber was named 'MacRobert's Reply' by the widowed Lady MacRobert of Douneside estate at Tarland, in Aberdeenshire. She had lost the first of her three sons in a civilian flying accident in 1938. Her other two sons, both pilots, were killed in 1941 on active service with the Royal Air Force. Her response was to donate £25,000 to the RAF for a bomber named 'MacRobert's Reply', bearing the family coat of arms; the viewpoint from which Cundall has painted the aircraft permits this to be seen clearly. This gift, and the spirit in which Lady MacRobert had made it, was widely reported in the national press. At Lady MacRobert's request, its first pilot was a Scot, Flying Officer P. J. S. Boggis (1919–2010).[18] Cundall's image shows the aircraft and its crew of fifteen returning from a mission over northern France. The RAF has continued the MacRobert tradition with a succession of aircraft carrying its name; the current 'MacRobert's Reply' is a Tornado GR4.

Eric Kennington (1888–1960), draughtsman and painter, was a totally different type of artist, but like Cundall he fell out of fashion and his work has only been re-valued in recent years. He studied and exhibited successfully in his native London before serving in France 1914–15. He was invalided out of the Army

and became an official artist 1916–19; his first one-man show in 1916 created a great impression, and identified him in the public mind with images of men of action. After the First World War he went to Jordan and Syria to illustrate T. E. Lawrence's *Seven Pillars of Wisdom*, and later carved Lawrence's effigy for Wareham, Dorset.

Kennington's punchy and colourful style was ideal for book and poster illustration. His skill in characterful portraiture, together with a genuine interest in the working lives of ordinary people, led to commissions for publications on the RAF and the Home Guard. For the latter he made a series of portraits as

colour illustrations to John Brophy's text, published as *Britain's Home Guard: A Character Study* (1945). Home Guard members from around Britain were shown against backdrops reflecting national or local character. Thus Lance Corporal Robertson, an Edinburgh postman, stands with the Saltire billowing behind him, his face ruddy and resolute.

A Scot was featured on the front of the book, one of four images of Scots included. The cover image showed Sergeant Moir of the Aberdeenshire Home Guard, standing in front of a pine forest. Moir was a ghillie who had served on the Western Front in the First World War, and like Robertson, he is wearing his three Great War medal ribbons. The other Scots are Sergeant McLeod of the Aberdeenshire Home Guard, shown with a backdrop of a barn door and farmland beyond; and a very young Corporal Smith of the Argyll Home Guard, with a precipitous mountain behind him.[19] Kennington's lighting is theatrical, and his style exaggerates facial features, deliberately creating images suitable for reproduction. To twenty-first-century eyes the images can appear almost caricatures, but that is to do the artist a great injustice.

NOT ALWAYS AN EASY RELATIONSHIP

Not everyone who came up to Scotland had an easy time of it. Joan Hassall (1906–1988), artist and wood-engraver, came north to teach printing and engraving at Edinburgh College of Art from 1940 to 1946. Professionally, her stay was a success, for in addition to teaching she received several commissions for personal work, including the *Saltire Chapbooks*, 1943–51, and the *Typographic Arts*, 1944. But during her stay she experienced prejudice against her Englishness, recalling in 1950 that there had been 'a very definite hostility'.[20] Nationalism was in the air in cultural circles, and Agnes Mure Mackenzie (quoted

Joseph Lee, *Smiling Through: Whisky – 'I demand to see the Manager!' Evening News*, London, 4 February 1944

p.155) had warned against its dangers. The commission for the *Saltire Chapbooks* at least went some way to relieving Hassall's feelings.

A less political complaint in the other direction came from English whisky lovers, for in 1943 supplies of whisky were dwindling, the shortage becoming so serious that the matter was raised in the House of Commons on 8 December. (This was unconnected with the famous episode of the wreck of the SS *Politician* off Eriskay with its whisky cargo in 1941, later featured as a comic novel by Compton Mackenzie entitled *Whisky Galore* and published in 1947, followed by a celebrated film.)

The cartoonist Joseph Lee (not the Dundonian of the same name) metaphorically moved his drawing board to Scotland with a cartoon published in the London *Evening News* on 4 February 1944. It shows an irate Londoner, desperate for his dram, arriving at

McWoosh's Highland Heatherdew Distillery, shouting 'I demand to see the Manager!' In artistic and cartographical terms, the most significant aspect of this image is that it shows Britain seen from Scotland, looking south.

TIMBER!

It was forestry that brought many incomers to Scotland. There were the 'Lumber Jills' of the Women's Timber Corps, not to mention the Australians, New Zealanders, Canadians, Hondurans … For the Australians the cold was a real shock, well expressed in Colin Colahan's heartfelt *Rain and Bloody Misery* of 1942, in which eight members of the Australian Forestry Unit based in Dumfriesshire battle up a hill against the Scottish elements.

But there were good times too, and Colahan's *Scottish Idyll* could not be more different. Here, a uniformed Australian chats to a local woman in Dumfries. These are only two of a series of images made by Colahan (1897–1987), a painter and sculptor whose rather over-eventful private life was partly responsible for his move to Britain in 1935, where he became known for his portraits. In 1942 the Australian War Memorial appointed Colahan an official war artist, with a brief to cover the activities of Australia's armed services in Britain and Europe; he became the first President of the Australian Artists' Association, London, in 1952.

Sheila Hawkins (1905–1999) was an Australian who moved to London in 1931, where she wrote and illustrated children's books. In 1942 she applied for official war artist status, but was not selected. However, she was employed at the Royal Australian Air Force Headquarters in London, and later visited Scotland to record the Australian Forestry Units. Her image of Australians *Working In The Snow* shows idealised (indeed rather 'snowmen') figures, in heroic

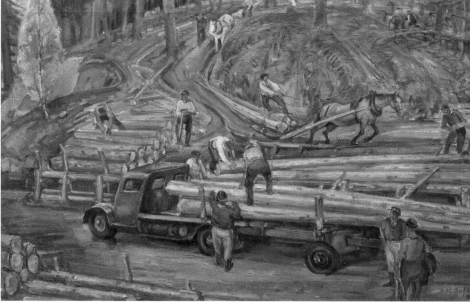

poses, their feet almost trapped between snow-covered logs.

The Scottish artist David M. Sutherland (1883–1973) appears out of sequence in this book, but is featured here recording some of the 'timber' visitors. In 1913 he had been appointed to the staff of the Edinburgh College of Art, though he left to serve in the First World War, being awarded the Military Cross. He was wounded and invalided home, and on recovering he continued to serve until demobilised in 1919. By the Second World War he was Head of Gray's School of Art in Aberdeen, and was commissioned by the WAAC to record the work of Newfoundland lumberjacks. His *War in the Forest: Newfoundland Lumberjacks at Work in Scotland, 1940* shows people working in the depths of the forest, with a horse but no motor vehicle.[21] Another scene, *The Loading – Landings*, shows the horses bringing logs down to a lorry, the long pine trunks balanced precariously on its bed.

Various other artists documented the lumberjacks. As mentioned in the previous chapter, Francis Martin went to the Highlands to paint them, exhibiting *Newfoundland Lumberjacks at Aviemore* at the Royal Glasgow Institute of Fine Arts in 1945. There were so many Canadian forestry workers that they formed their own Home Guard unit, the 3rd Inverness (Newfoundland) Battalion.

There were other nationalities too: around 800 forestry workers were brought from tropical British Honduras (now Belize) to brave the climate. They had a very hard time of it, as their treatment at the hands of both officialdom and the public alike was often suspicious, and sometimes downright hostile.[22]

Stephen Bone's small oil sketch *Highland Shepherds and Honduran Lumberjacks* shows a group of people waiting on a railway platform. A man in a cap gives a Honduran a light, while another Honduran stands beside a Scotsman in a tweed shooting suit. Behind them is a Scottish Highland landscape. Bone

LEFT.
Sheila Hawkins, *Working In The Snow, Australian Forestry Unit, Scotland*, 1942. Crayon, watercolour and gouache on paper, 56 × 76.6 cm. Australian War Memorial

LEFT.
David M. Sutherland, *The Loading – Landings, Newfoundland Lumberjacks at Work in Scottish Forest*, 1940. Oil on canvas, 61.1 × 86.5 cm. Aberdeen Art Gallery & Museums

was equipped for quick *plein air* sketching in oils, carrying with him a paint box with paints and brushes and small primed panels, and a folding stool.

The Women's Land Army (WLA) and Women's Timber Corps (WTC) – the 'Land Girls' and the 'Lumber Jills' – took on work never before expected of women; in the Highlands the Headquarters was near Brechin.[23] Edith Gabain produced a series of four lithographs of their work, one of which is reproduced here.

Gabain (1883–1950) was born in Le Harve, France (though her mother was born in Scotland). She studied at the Slade in London, and at the Central School of Arts and Crafts, where she met and married the artist John Copley. Gabain is now better known for her oil paintings than her prints, as Kenneth Guichard lamented in his book on British etchers in 1981.[24] What is really surprising is that she undertook the work while in a very fragile state of health, and coming to terms with the death of a son in 1940. Undaunted, she sometimes used photographs, and when her arthritic fingers refused to work further she strapped her brush to her wrist. Travelling to Scotland from her base in London also proved a challenge, especially as she was not a very good organiser. The lithograph shown here, *Sorting and Flinging Logs at Pityoulish*, shows women wearing dungarees and bandanas in a deadly earnest version of tossing the caber. It appears to be an endless task, given the background scene of logs receding far into the distance behind. Gabain's son Peter related:

> I was extremely worried, my mother really was not very well, but she was totally determined to bring these gallant young women to everyone's attention. She spent hours drawing in the most awful weather, talking and laughing and of course becoming completely involved with the girls.[25]

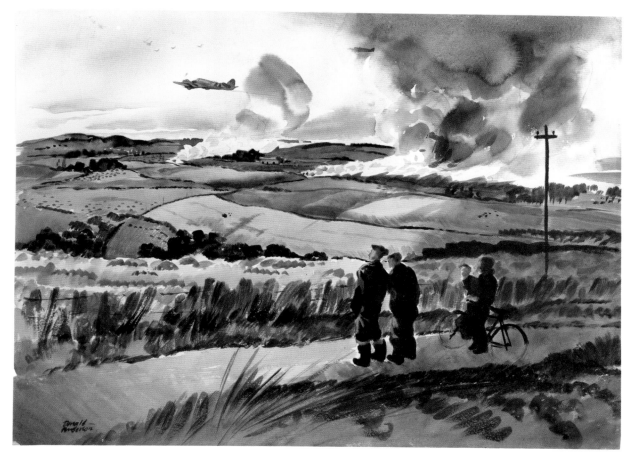

OPPOSITE TOP.
Stephen Bone, *Highland Shepherds and Honduran Lumberjacks*. Oil on card, 23.8 × 31.4 cm. Dundee City Council (Dundee Art Galleries and Museums)

OPPOSITE BOTTOM.
Ethel Gabain, *Sorting and Flinging Logs at Pityoulish*, 1941. Lithograph on paper, 35.2 × 54.2 cm. Imperial War Museum

LEFT.
Donald Kenneth Anderson, *Collision in Circuit, 2 October 1944, Banff*. Watercolour on paper, 36.8 × 49.4 cm. Canadian War Museum, Beaverbrook Collection of War Art

The location might look remote, but the area had its compensations in the form of camps for Canadians, Norwegians, Dutch and other nationalities.

HIGHLANDS AND ISLANDS

Canadians were in Scotland for purposes other than forestry. Indeed, around half a million Canadians were in Britain during the Second World War.[26] Donald Anderson (1920–2009), an official artist to the Royal Canadian Air Force, produced a series of watercolours which record the activities of the RCAF in Scotland. One of them, *Collision in Circuit, 2 October 1944, Banff* shows a crash over the Highland hills, local residents pausing on a country road to look at the unfolding disaster.

And diverting a little from the theme, there is one distinguished Canadian artist who cannot, by any stretching of definition, be included in this book – but who must nevertheless be mentioned. Charles Comfort, OC (1900–1994), born near Edinburgh, moved to Winnipeg with his family in 1912. He served as an official war artist in Italy, but never in

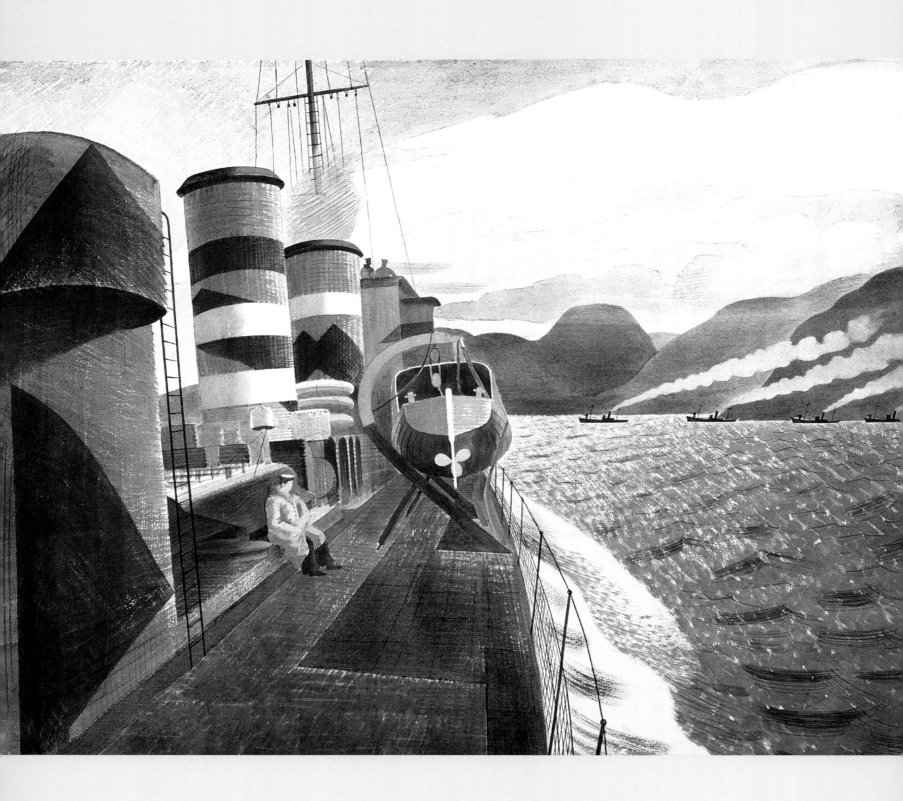

the country of his birth, producing effective and memorable work, and later became Director of the National Gallery of Canada.

As in the First World War, Scapa Flow became a base for Britain's Home Fleet, and Orkney developed into a hive of international activity, home to up to 50,000 Commonwealth troops as well as the many Allied Forces, refugees and prisoners of war from other nations, and the base for the Russian convoys.[27] Charles Pears (whose work was discussed in Chapter 2) was busy again in the Second World War, producing a set of convoy paintings, including a magnificent *Convoy to Russia* with ice floes and the northern lights.[28]

Eric Ravilious also went to Orkney, his *Leaving Scapa Flow* recording his stay. The duffle-coated naval rating in the picture gives the scale of the ship, as he sits beneath the camouflaged funnels, the vessels in the distance looking like toy boats with cotton-wool smoke coming out of their funnels. He made an unfinished sketch for this watercolour, with the sea, background ships and hills delineated in more detail, but without the principal warship.[29]

There were many POW camps in Scotland, and some have left a considerable legacy of art. For example, Dumfries and Galloway Museums hold a collection of linocuts produced at the prisoner of war camp, Carronbridge, Thornhill, which at its peak held over 1,000 men. It had a hospital, church and library. A camp newspaper was published monthly in a printing workshop which also made programmes for events, and linocuts. And Italian POWs were brought to Orkney to work on the Churchill Barriers, building their Chapel as an enduring legacy (p.223).

Various service personnel and POWs left mural decorations. Many of those that have survived – usually due to benign neglect – are now once again highly valued and often conserved.[30] Murals depicting a very un-Scottish thatched cottage, and gypsy caravans, were painted on a wall in Ness Battery, Stromness; female portraits and a farmyard scene adorn the wall of a church used as a mess at Castletown, Strangergill Bridge.[31] The decorations in the former Officers' mess at Donibristle Airfield, Fife, are particularly fine, being friezes in mock-Egyptian style with a whimsical Royal Naval theme.[32]

OPPOSITE.
Eric Ravilious, *Leaving Scapa Flow*, 1940. Pencil and watercolour on paper, 45.1 × 57.2 cm. Cartwright Hall, Bradford

ABOVE.
Frieze, former Officers' mess, Donibristle

THE NORWEGIANS

Norwegians were based in various parts of Scotland, and it was Norwegians and Poles who were responsible for much of the coastal defence of the country. Space permits discussion of only a few examples of art relating to their stay.

The bust of *Rundi Albert* was made by Tim Jeffs (1904–1975), a colourful personality in the Kirkcudbright community of artists, a curator of Dumfries Museum in the 1930s and an art teacher in the 1940s. The sitter was head of the Norwegian Women's Army in Dumfries, a friend of the Jeffs family and a frequent visitor to their home in English Street, Dumfries. The work was finished in a dark brown colour, mimicking bronze. (The Dumfries and Galloway Museums Service holds a considerable collection of Norwegian-related items.)

As a convenient date for commemoration, the book *All for Norway!* was published on King Haakon VII's seventieth birthday, 3 August 1942. It tells the story of the invasion of Norway, the resistance movement and the Armed Forces in exile, with photographs featuring Norwegian troops training in Scotland. The copy in the collection of Dumfries and Galloway Museums Service is covered in signatures dating from 1942 to 1946, including that of Rundi Albert.

Norwegians had an influence on an aspect of Scotland's applied art – knitting. Norwegian refugees who came to Shetland after the German invasion of Norway in 1940 introduced new motifs into knitting patterns, while the Norwegian forces in exile who were stationed in the islands created a large local market. Many traditional Shetland and Fair Isle patterns had been similar to those in Norway, Sweden, Faroe and the eastern Baltic region. But now the bold Norwegian star and flowers motifs, placed in vertical patterns, were introduced to Scotland, and remained important elements of design for decades. Local knitters, with a good market for their products, earned an increased return for their labours.[33]

Tim Jeffs, Rundi Albert, Head of the Norwegian Women's Army in Dumfries. Plaster, 40.0 cm high. Dumfries Museum

A 'DEGENERATE' ARTIST

Oskar Kokoschka (1886–1980), of Austrian and then Czech nationality, found that eight of his paintings were included in the exhibition of 'Degenerate Art', organised by the Nazis both to denigrate modern art and to vilify work by Jewish artists (see p.139). He defiantly altered the position of the arms in his *Self-Portrait as a Degenerate Artist* as a riposte. The background depicts the location where the painting had been begun, with a running figure to the left and a deer to the right (the deer, it has been suggested, may refer to the hunted artist).

Kokoschka had studied in Vienna, and developed

into an expressionist painter. He was wounded and invalided out of military service in the First World War, lived in Dresden, then travelled for some time and settled in Prague in 1934. But after the Munich Agreement he was forced to flee to London with Olda, his future wife. They often visited Scotland, and Kokoschka took up watercolour for the first time in many years. In 1947 he became a British citizen, though eventually settled in Switzerland.[34]

THE POLES ARRIVE

Around 25,000 Poles came to Scotland. Some had fought the invading German forces first in their homeland, and then in France, and many were to take part in later Allied campaigns in Europe. Many chose to stay in Scotland after the War, especially those whose homes lay in areas absorbed by the Soviet Union. Their presence in Scotland, and the part they played in the War, has already been the subject of study; the work of Polish artists has best been examined by Douglas Hall in his *Art in Exile: Polish Painters in Post-war Britain* (2008) which, despite its title, includes reference to pre-war years.[35]

Captain Jastrzembski of the Polish Army, stationed in Edinburgh, was interested in a potential official war artist scheme for the Poles. He contacted the authorities in London, the Royal Scottish Academy and the British Council about this. David Foggie, Secretary of the RSA, wrote to the Director General and Secretary of the Ministry of Information in May 1942:

> I have had communication from Captain Octawian Jastrzembski of the Polish Army, who has been asked by his headquarters to prepare a memorandum on the subject of war art, and official artists. He desires to

Oskar Kokoschka, *Self-Portrait as a Degenerate Artist*, 1937. Oil on canvas, 110.00 × 85.00 cm. On loan to Scottish National Gallery of Modern Art

know the machinery in operation in Britain with regard to this … Captain Jastrzembski has been in Edinburgh for some considerable time and has acted as liaison between the Academy and the Polish artists.[36]

Ten days later, Captain Jastrzembski wrote asking for details about the ranks of official artists, and their salaries. But the idea does not seem to have been taken further.

POLES IN GLASGOW

A huge number of Poles arrived in Glasgow at the beginning of the War, their harmonious assimilation assisted by the efforts of Lord Provost Dollan. Tom Honeyman, Director of Glasgow Museums, recorded that

> During the difficult early war years … [the Lord Provost] … won for himself the added title 'The King of Poland'. This reflected his energetic efforts to do everything in his power to welcome and sustain the Polish officers and men who arrived in large numbers in the West of Scotland.[37]

Their presence is commemorated by an oil painting of 1940 entitled *A Scottish Piper and Two Polish Soldiers*. A lighter side to the Glasgow connection is demonstrated in the cartoons of Marian Walen-tynowicz, which show a local girl being flattered by a Polish serviceman, and a kilted Scot giving the thumbs-up to a Pole.[38]

Among the Poles who sought refuge in Scotland, two artists of particular note arrived in Glasgow: Jankel Adler and Josef Herman, who had known each other previously. Benno Schotz (p.139), firmly part of the Glasgow artistic community, found himself welcoming many refugees:

> From 1933 onwards quite a number of Jewish doctors and other professionals began to arrive in Glasgow to escape Hitler's perse-cution in Germany. It was well known in Glasgow in non-Jewish circles that I was a Jew, and all the refugees were directed to us, and our house became like a railway station … One day I opened the door to a ring, and there stood a fairly burly man who said 'I am Yankel [sic] Adler, the artist' … A couple of months later there was another ring at the door, and before me stood a smallish man in a soldier's overcoat. He handed me a note. It was from someone I did not know, but before me stood Josef Herman. He could speak no English, but our common language was Yiddish, and we invited him to join us for our Friday evening meal … We told him, to his great surprise, that Yankel Adler was here, and directed him to his studio – which I had even found for him … [and arranged] … that both he and Adler should receive a subsidy from the Jewish Welfare Board.[39]

When the War began, Jankel Adler (1895–1949) had been living in France, where he volunteered for the Polish army; he was evacuated with it to Scotland in 1940 after the fall of France. Released from the Army in 1941, he moved to London in 1943, but his stay in Glasgow (and also Kirkcudbright) had a profound influence on local artists. Once in London, Adler influenced several other artists, notably Robert Colquhoun and Robert MacBryde. Much of his work of this period concerns war and its effects, such as *The Mutilated* in the Tate Gallery.[40] Adler's influence on the art world in Glasgow was later acknowledged

by the Scottish Arts Council's exhibition of 1968 entitled *New Painting in Glasgow 1940–46*, which featured a work by Adler on its catalogue cover.[41] His painting in Glasgow Museums, a rather more cheerful than usual *Composition* (undated), shows him working out abstracted forms from a still life.

Josef Herman (1911–2000) arrived in Glasgow from Brussels and his stay was a difficult one, for he learned of the deaths of his family in Warsaw. He was supported by Adler and others, and made numerous drawings – his 'memories' – of his lost family and their lost world.[42] Like Adler, his work had an impact on painters in Glasgow, but he too moved south in 1943. After a spell in London, he moved in 1944 to the Welsh mining town of Ystradgynlais, where he lived for eleven years, making the studies of miners with which his name is most associated today.

All through his life, he celebrated working people. The undated drawing shown here, *Man Carrying Bucket*, is typical of his energetic sketches of individuals involved in work, and may well be from his Glasgow period.

Both Adler and Herman held one-man shows in Scotland, but the appreciation given to their work by the artistic community was not always shared by the general public. Tom Honeyman later recalled:

> I know that my interest in Jankel Adler and Josef Herman, when the Poles were 'invading' Glasgow, was not regarded with favour. I was taken to task … I was told it was my duty as Director of the Gallery not to become mixed up with young painters 'who didn't know what they were talking about'.[43]

LEFT.
Jankel Adler, *Composition*. Oil on board, 63.5 × 50.8 cm. Glasgow Museums

RIGHT.
Josef Herman, *Man Carrying Bucket*. Watercolour on paper, 20.2 × 25.3 cm. Glasgow Museums

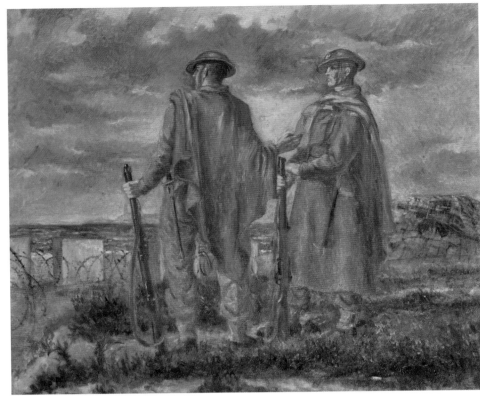

LEFT.
Witold Mars, *Polish Soldier* (self-portrait of the artist). Oil on canvas, approx. 109 × 84 cm. Biggar Museums Trust

RIGHT.
Witold Mars, *Two Polish Soldiers*, 1940–41. Oil on canvas, 74 × 86 cm. Biggar Museums Trust

POLES ON THE COAST … AND INLAND

Many Polish troops were posted to coastal defence duties, as recorded by Witold Mars (1908–1985), who painted *Two Polish Soldiers*, caped and standing behind concrete blocks and barbed wire, defending Scotland.

Mars also painted a portrait of *General Paszkiewicz*, and his own self-portrait. Photographs in the Imperial War Museum show their formal presentation to their host town of Biggar.[44] The occasion was the Polish Army celebration on 15 August 1940, the Polish National Holiday of 'The Miracle of Vistula', at which General Sikorski (Prime Minister of the Polish Government in Exile, and Commander-in-

Chief of the Polish Army in Britain) attended a Field Mass. General Paszkiewicz, on behalf of the Poles, made the presentation to the Provost. Witold Mars later worked as a book illustrator.

POLES IN FIFE

In 1943 the English artist Edward Bawden (1903–1989) visited Scotland, a brief excursion north in his career as an official war artist which has been rather overlooked, coming as it does between more exotic and war-torn locations such as North Africa and the Middle East. While in Fife, he executed an almost monochrome watercolour of a *Jumping-Tower for*

General Gustaw Paszkiewicz presenting the Self-Portrait by Witold Mars to the Provost of Biggar, 15 August 1940. Imperial War Museum

the Training of Polish Parachute Troops at Largo, Fife.[45]

There were Polish troops throughout Scotland, and they generally left some memorial of their stay, often in (or on) town halls, such as the plaque set into the Town Hall at Elie by the Polish artist Zofia Kruszelnicka in 1943. In St Andrews, home to a large number of Poles, a mosaic panel was installed on the side of the Town Hall, depicting St Andrew with the Polish eagle and bearing the wording 'Polish Soldier / to St Andrews City'. It was the work of three Polish artists and was unveiled in October 1941.[46] The University's Principal, Sir James Irvine, was presented with a Polish decoration, and an Honorary Degree of Doctor of Laws was conferred on General Sikorski.

A bust of Sikorski now stands in the ground of St Andrews Museum at Kinburn Park.[47]

A number of Polish soldiers were admitted to degree courses at the University of St Andrews and, perhaps because St Andrews was a university town, a great deal of educational activity seems to have taken place in general (though the town was not unique – there was a celebrated Polish Medical School in Edinburgh). St Andrews provided classes in drawing and printmaking run by Winifred and Alison Mackenzie and Annabel Kidston, members of the Artists Printmakers. The Committee for Adult Education supplied them with funds for equipment. There was an enthusiastic response and various exhibitions were organised in the University, culminating in a

The Polish mosaic panel on the wall of the Town Hall, St Andrews, 1941

show at the National Gallery of Scotland. Due to the careful mounting and recording of the work, a great deal of it still exists today.[48]

POLES IN EDINBURGH

Aleksander Zyw (1905–1995) had trained in Warsaw, but was based in Paris at the outbreak of the War and enlisted with Polish forces there. After the fall of France he reached Scotland via Spain and Portugal, arriving in 1940. He possessed huge energy and self-confidence, and by 1943 had organised his work into book form. The publication was entitled *Poles in Uniform: Sketches of the Polish Army, Navy and Air Force*, and to foster his reputation it was helpfully supported by three individuals known to the general public, one a Pole and two Scots: there was a foreword by Lieutenant-General Marian Kukiel, an introduction by Muirhead Bone, and an accompanying text by Edwin Muir (Zyw's thanks to 'Mr. H. Harvey Wood of the British Council' is perhaps the clue to its origin).[49]

It proved a useful book, being timely in providing artistic documentation of Polish troops in Scotland (the artist Feliks Topolski, a friend of Zyw's, also produced drawings of Poles in Britain, but worked almost entirely in England). It was thus a publication which could promote good relations between Poland and Scotland.[50] Kukiel used the opportunity to thank the Scots:

Zyw's album of drawings illustrates the history of the Polish armed forces in Britain during the period beginning in the summer of 1940 and leading up to the present day. A soldier himself, he had drawn his comrades in arms – soldiers, airmen and sailors. In his excellent sketches he has documented their

Polish Military Students in the Art Class with Miss Winifred McKenzie, St Andrews, 1943. University of St Andrews, Library Archive Collection

life ... We see in them Polish soldiers [sic] in camps in beautiful and hospitable Scotland, waiting to defend the coast against a German invasion which never materialized ... In my opinion this collection of drawings, in addition to its artistic value, will forever remain a valuable source of material for the chapter of general and military history which will bear the title of Polish-British Brotherhood-in-Arms.[51]

Muirhead Bone was delighted by the *plein air* nature of the drawings:

The public is right in its curiosity regarding artists' real done-on-the-spot sketches, for when an artist brings out his actual sketch book for our inspection it brings him very close to us indeed – we seem to be at his elbow peeping at life through another's eyes. We accompany him from spot to spot (like the inevitable small boy known to every sketcher), and this world becomes a more vivid place. Vicariously we make his experiences our own ... This is especially true of such a swift and capable artist as Mr. Zyw, and I have found much enjoyment in this book of his sketches ... The toils and endurances of the soldiers of brave Poland look at us through these pages, and we return the glance with one of admiration and respect.[52]

There are, unsurprisingly, no named places in the

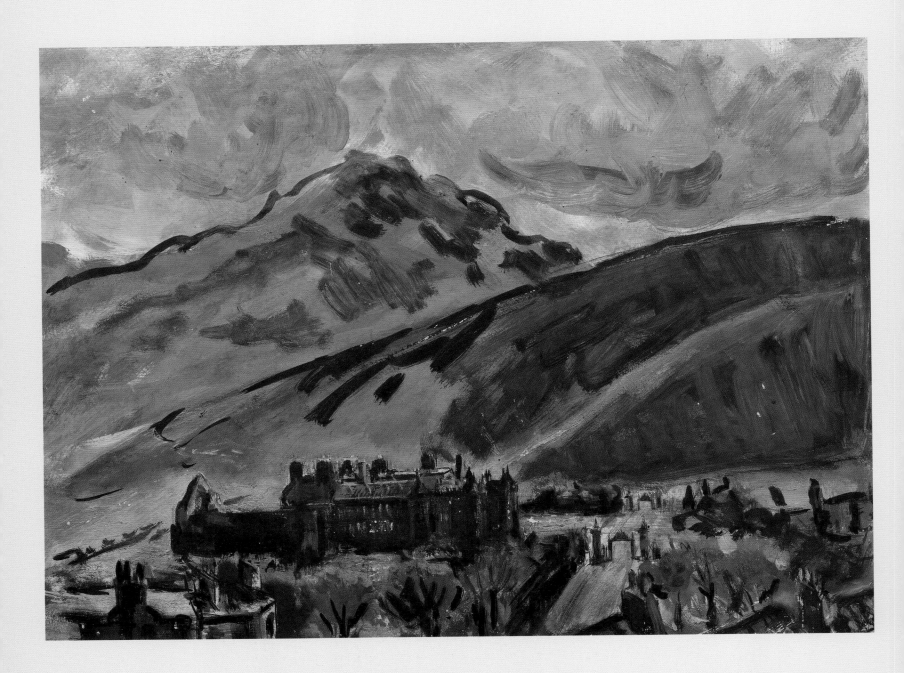

book, though Zyw's many annotations give such a sense of immediacy that this hardly seems important. He shows work on land, sea and air, the dramatic and the everyday, all drawn in apparent haste and often with a nervous, hesitant touch. He never glamorises; indeed two of his most effective drawings are very slight sketches within a series documenting bomber and fighter sorties. In such drawings as *A Young Nervously Alert Fghter Pilot Waits in Readiness* and *The Sleepless Mechanics Waiting for the Return of their Pilots*, he shows the preparation and tension, and the anxious expectation of return, a far cry from the calm and composed pilots recorded by Sir William Rothenstein at Leuchars.

Zyw was also featured, along with other artists documenting the War, in the magazine *Art & Industry*, in April 1943. He used the opportunity to advertise his book, admitting with charming immodesty that it was unusual for an artist to discuss his own work, but

> If such an artist is sensitive, honest and frank, how can he give offence, how can the reader help liking him? [sic] Let us make an agreement that we shall not call this pleasant duty self-advertisement, but simply candour. I have produced for the first time in my life a book of drawings. Most of these drawings, or rather sketches, were done without any thought of publication. They owe their existence to an irresistible urge and natural habit of noting by pencil all that goes on around me.[53]

And he is charmed by Scotland: 'And how important is the landscape! The more so that this is Scotland. The land of pastures and hilly meadows, intertwined by woods. Tall and spreading trees. The sea coast, blue and pale crimson. The little towns, stony and sad.

Day-breaks and sunsets, dramatic and colourful.'[54]

Zyw produced a group of watercolours featuring a military camp, surrounded with trees and with hills beyond; these are now in the Sikorski Polish Club, Glasgow.[55] One of his oil paintings, *Holyrood Palace*, was purchased for the *Recording Scotland* collection.

Zyw documented the invasion of France, but it was to Edinburgh, not Paris, that he returned, marrying a Scotswoman. He had also experienced Edinburgh as an international city; as the artist and temporary Royal Engineer Charles McCall had written to his wife in February 1944: 'Edinburgh just now is the most cosmopolitan town I think I've seen. It is a holiday town for the forces & every nationality is seen.'[56]

SECRET SURRENDER

Stephen Bone documented an important but secret event in May 1945: the surrender of German U-boats in Loch Eriboll, an isolated sea loch in Sutherland. At the time, local people were sworn to secrecy about it, and its full story was only published in 2010.[57] Loch Eriboll had been selected for the surrender because of its isolation and its depth.

Bone made several records of the event, showing the flotilla of U-boats arriving and the surrender of the crews.

NO RENDEZVOUS IN SCOTLAND

Immediately after the War, Muirhead Bone, always helpful in nudging artistic projects along, suggested to the Director of the National Gallery of Scotland, Stanley Cursiter, that he should request a representative group of official War Artists Advisory Committee (WAAC) pictures 'for Scotland'. So on 4 January

OPPOSITE.
Aleksander Zyw, *Holyrood Palace*, c.1940. Oil on canvas, 44.3 × 59.6 cm. University of St Andrews, Museum Collections

Stephen Bone, *A German U-boat Surrenders at
Loch Eriboll*, 1945. Pencil, ink and watercolour on
paper, 42.6 × 32.0 cm. Imperial War Museum

1946, Cursiter wrote to E. C. Gregory, Secretary of
the WAAC, asking which pictures the Committee
'might think of offering to Scotland' if, at such short
notice, it could be done – and admitting that

> My difficulty is that, in this gallery, we have
> a self-imposed regulation that we do not
> normally show works within ten years of the
> artist's death and, at the Portrait Gallery,
> within ten years of the subject's death; but I
> have no doubt that there would be ways of
> getting round this regulation …[58]

Cursiter got as far as discussing transport and insur-
ance (in October 1946) and copyright matters (in
June 1947). But alas, this most astute of men failed
to persuade his Trustees. On 21 October 1947 he
wrote an embarrassed letter to Ernest Blaikley, Keeper
of Pictures at the Imperial War Museum, revoking his
request:

> My Board of Trustees met yesterday and had
> a somewhat lengthy discussion over the
> proposed gift of pictures from the War
> Artists' Advisory Committee … My Trustees
> felt that it would be not only a breach of the
> rule which they had hitherto observed, but
> also … we would have no facilities for their
> proper exhibition at the moment.

The pictures were already in Edinburgh, such had
Cursiter's confidence been about their future welcome
into the national collections, and he now had to make
arrangements for their return. On 27 October 1947
Blaikley responded, assuaging Cursiter's embarrass-
ment, 'I imagine that the decision is as disappointing
and surprising to you as it is to me.' Cursiter wrote
back on 30 October: 'I, too, regret the decision made
by my board.' The list of eighteen pictures included

U Boat surrenders in Loch Eriboll

Stephen Bone

English painter Roland Pitchforth's *Rendezvous in Scotland* of 1944, showing an unnamed Highland location, which remains today in the Imperial War Museum.

Cursiter was an Orkney man. In 1948 he painted a view of Scapa Flow.[59] It shows a calm, gentle, and serenely peaceful scene, devoid of ships or anything that could indicate the activity of war. It is as if he was celebrating the fact that everyone had now gone home, and the Orcadians could have their landscape back.

Roland Vivian Pitchforth,
Rendezvous in Scotland, 1944.
Watercolour on paper,
50.1 × 67.6 cm. Imperial
War Museum

CHAPTER 5
New Conflicts and New Questions

From the early 1950s the word 'war' starts to disappear from the official vocabulary: terms such as 'conflict', 'peace-keeping', 'dispute' and other such euphemisms tend to be used instead. British Forces increasingly served as part of multi-national organisations, the UN or NATO. Korea was one such war (1950–53), the largest involvement for Britain in the second half of the twentieth century until the Gulf War of 1991. It made for a profound change in attitudes. The 'end of Empire' conflicts such as the Malayan Emergency (1948–60) were, by comparison, entirely British and Commonwealth, and the Kenyan conflict of the early 1950s against the Mau Mau was not a war but a Colonial guerrilla uprising, the legacy of which is still being debated. In the 1950s much of the public discussion about war centred around issues such as nuclear armaments and deterrents, rather than any specific location or conflict. And the Northern Ireland 'Troubles' from 1969 onwards were, to the British Government, emphatically not a war, for the Government refused the IRA's request that their members, when convicted, be treated as prisoners of war. Artists were now rarely 'war artists' in the traditional sense, but commentators.

By 1945 Britain might have been out of immedi-ate danger, but there was still a great deal of armed commitment. Conscription ended, and National Service began (itself ending in 1963). Rationing was still in full force, but in general things looked brighter, and the first Edinburgh Festival of 1947 provided an opportunity for nationalities to meet in peacetime, and for the city to celebrate the arts with gusto. It was not only the Scots who thought it a success, as a report from the *Manchester Evening News* report demonstrates:

> Embarrassed looking tram-cars are bouncing round Edinburgh today with small Union Jacks trailing from their electric arms – for all the world like circus elephants with their tails in curl papers.
>
> This is typical of the spirit of carnival which has descended almost overnight on this usually prim and proper Scottish capital. It's all in honour of the first International Festival of Music and Drama now being held in the city.

There were baskets of geraniums hanging from lamp-posts along Princes Street, the policemen had been

OPPOSITE.
John Kirkwood, *The Belgrano, 2 and 3 May*, painted 1990. Oil and mixed media on panel, 182.8 × 182.8 cm. Imperial War Museum

William Gear, *Mau Mau*, 1953.
Oil on canvas, 185 × 112 cm.
Birmingham Museums Trust

issued with new white gloves, and a Hungarian woman was quoted as saying it was like 'a mixture of Rome and Manchester, seasoned with a drop of Paris and a dash of Budapest'.[1]

THE 1950s

William Gear, mentioned at the end of Chapter 3, generally worked with abstracted forms based on nature, often with a framework of dark lines, creating a stained-glass effect. His *Mau Mau* of 1953 is thus typical, though the presence of people, and interest in a political topic, is unusual. It drew criticism when selected for the 50th anniversary exhibition at Cartwright Hall, Bradford. Gear wrote a letter in its defence to the *Yorkshire Observer*, which included the following: 'Without recourse to artistic mumbo-jumbo let me ask your readers and visitors to the exhibition to look at the picture with the eyes of the rather nervous, somewhat terrified young National Service-man in the Kenyan jungle. Trees and boulders take on the menacing form of the hidden terror, imagination plays tricks with the eyes. I have tried in my painting, and I think successfully, to capture this mood.'[2]

NO TO NUCLEAR

Ideas are what William McCance's work is about. He has already been mentioned earlier as both a consci-entious objector in the First World War, and a critic of Britain's official war artists scheme in the Second World War. After this War he was concerned about the atomic bombing of Japan. He also visited the caves in Lascaux, France, with their Palaeolithic paintings, and the two experiences seem to be fused in his *Hiroshima*. The large, lumpen charred figure in the foreground appears to be a body burnt to cinders

William McCance, *Hiroshima (or Atom Horizon)*, 1947. Oil on hardboard, 44.0 × 61.0 cm. Scottish National Gallery of Modern Art

(in fact one of his own fireclay sculptures), and the egg, a symbolic feature of birth, occurs in several of his paintings. Another outlined 'prehistoric' figure hides in shadow at the top left. The city beyond is in flames, while the hooped metal objects are perhaps bomb shelters (futuristic equivalents of Nissen huts?). As in most of McCance's work, the meanings are not entirely clear; hints are given, and the viewer must puzzle out what the various elements may mean.

Poets as well as artists were worried about the nuclear threat: Edwin Muir deals with it in his undated poem 'The Horses', in which he pictures a nuclear war. His setting is a seven-day period, clearly based on the Book of Genesis. But although nuclear war destroys modern technological development, humanity survives and re-discovers more basic, trustworthy aspects of life, symbolised by the re-discovery of horses in the service of mankind instead of machinery:

On the second day
The radios failed; we turned the knobs;
 no answer.
On the third day a warship passed us,
 heading north,
Dead bodies piled on the deck.
 On the sixth day
A plane plunged over us into the sea. Thereafter
Nothing.[3]

Thomas Whalen, *Clown with Atom Bomb*, c.1965. Portsoy marble, 40.0 × 30.0 × 15.0 cm. Royal Scottish Academy

Leith-born sculptor Thomas Whalen (1903–1975) worked as shipwright during the First World War, and made use of spare pieces of wood for his own carving. He later attended Edinburgh College of Art and exhibited frequently from 1930. Whalen used a variety of materials, including plastics, but his *Clown with Atom Bomb* is made of marble, a remarkably durable material for an image which looks as if it could be blown up – in both senses.

Eduardo Paolozzi also pictured the atomic bomb as a terrifying plaything in the hands of humans too immature to understand the gravity of what they were dealing with. His portfolio entitled *Cloud Atomic Laboratory: Science and Fantasy on the Technological World* depicts real events with fantastic images, and with very black humour.[4] His *War Games Revised*, from the Suite *Universal Electronic Vacuum*, refers rather more to the technology used in Vietnam; there are images of warships and rockets, tanks and soldiers, and instructions for war games.

A WAR THAT WASN'T OURS, AND 'TROUBLES' THAT WEREN'T WAR

Vietnam may not have been Britain's war, but it raised British debate and protest. The work of Elgin-born Neil Dallas Brown (1938–2003) has a superficially smooth appearance, his work influenced by American artists and Abstract Expressionism. But the images are angry. His *Visitor, Vietnam* (1968) shows a young man who has been 'drafted' to find himself among the group of helmeted soldiers, the dun-coloured surroundings with their vertical strokes suggestive of both fields of growing crops, and of mud; the plume of explosive smoke, ringed by barbed wire, could be grains of rice. The artist has stated that colour in his work contributed to the symbolic content, the colour brown being the Egypt-

Neil Dallas Brown, *Visitor, Vietnam*, 1968. Oil on board, 160 × 160 cm. University of Dundee Fine Art collections

ian dream colour symbol for sadness and imminent danger, and green for serenity.[5]

The 'Troubles' in Northern Ireland involved the British Army in the longest continuous deployment (Operation Banner, over 38 years) in British military history. It was not, as noted above, ever a war, but it is included in this study because so much of the post-1945 art deals with conflicts that are not officially war. Neil Dallas Brown painted a series of works about Northern Ireland, his surrealist atmosphere

Neil Dallas Brown, *Ulster Wall*,
1979–80. Oil on board,
161.5 × 214 cm. Scottish National
Gallery of Modern Art

conveying brooding tension and threats of violence. In *Ulster Wall* (1979–80) the dog stands in front of a wall with the slogan 'Brits Out', which we apparently view through the sights of a rifle. As in many of his paintings, the colours are muted, the man-made structures are the colour of earth, and the empty, almost polished surfaces seem slick and sinister. Dogs often appear in Brown's paintings, looking both fearful and frightening.

In his notes on the Ulster series, Brown stated that he wished to show a desolate environment and an

alien and disturbing atmosphere: 'They are to me political paintings, like Goya's in that they are on the side of the dead, the losers on both sides … The paintings, I hope, pose questions. They are certainly meant to.'[6]

Conrad Atkinson (born 1940) is an English artist who became well known in the 1980s and 1990s for his work featuring sectarianism in Northern Ireland. He has satirised many other political situations as well, and made a series of twenty-four paintings for an exhibition at the Talbot Rice Art Gallery (Univer-

sity of Edinburgh) following his residency there. The series mimicked temporary hand-written headlines made for pavement news-boards of Scottish newspapers. The images dealt with politics, culture and heritage, and one bore *The Scotsman* masthead with an apparently hand-written notice which reads 'Robert Burns calls for tougher sanctions against South Africa'.[7]

THE SOUTH ATLANTIC, 1982

There had been female war artists since the First World War, but in a very small proportion to men, and never serving at the front. Linda Kitson (born 1945) was the first officially commissioned woman war artist to accompany troops into battle when she went to the South Atlantic in 1982. She produced over 400 drawings showing all aspects of the campaign except hand-to-hand fighting. The works which best convey the atmosphere of the conflict are those recording the often difficult conditions of daily life for the troops.[8] The British Task Force included 2nd Battalion Scots Guards, and she shows them in the makeshift shelter of a sheep shed; both her handling of the drawing, and the notes on it, convey the hurried execution – '17th June The Sheep Sheds FITZROY Tumbledown heroes=Scots Gdsmen 43'.[9]

John Kirkwood's *The Belgrano* (p.190) is a large collage conveying a dramatic scene of tragedy and violence. A large red door-bell apparently breaks through the top of the canvas (perhaps representing a torpedo striking), while thickly applied red paint splashes down onto the group of men below, several of whom are shown with blood dripping from their own wounds. The sailors are very much individuals (one is the artist). Beyond, the sea is calm, the horizon cheerful. There are influences of Goya and of surrealists, and the effect is very powerful.[10]

NUCLEAR SAILS: MACH AND FINLAY

David Mach was born at Methil, Fife, in 1956, of a Polish father and Scottish mother. As a child he lived within sight of the construction of oil rigs, the size and physical form of which he has cited as an influence on his art, along with his employment in factories and a brick works. He studied art in Dundee and London, and is best known for his sculptures made out of unusual materials, such as coat hangers, tyres, or piles of magazines. His *Polaris* of 1983, around 55 metres in length and created from six thousand tyres, was exhibited at the Hayward Gallery, London, in the exhibition *British Sculpture 83*. Interestingly, although one of the exhibition's sponsors was a company involved with nuclear weaponry, Mach stated that he intended no political statement in his sculpture, a scaled-down version of a Polaris submarine. For him it was more a question of producing a very large object (in fact, under a third of the size of the actual object). The idea grew out of an earlier work, *Silent Running* (1982), showing a submarine surfacing. He had first considered building it from telephone directories, but changed to tyres, feeling these were more suitable in terms of colour and size, physical attributes and connotations.[11] The sculpture was already generating some controversy when it was set alight by a member of the public, thus causing even more controversy.

Ian Hamilton Finlay (1925–2006) dealt with themes of war throughout his career, often using both visual and verbal metaphor together in his work. Many of his sculptures have classical references, such as the *Et in Arcadia Ego*, showing a sculptured relief after Poussin of an ideal landscape, but including a tank.[12] His so-called 'Battle of Little Sparta' was a long-running feud with the Strathclyde Regional Council, to which he refused to pay rates for his temple of the arts – his home and garden in the Pentland Hills which developed into a composite set of

artworks.[13] Eventually goods were seized by Sheriff Officers for the total amount owing, an act which itself caused further controversy.

One of the outstanding characteristics of all Finlay's works relating to war is that they are exquisitely crafted (by skilled craftspeople working to Finlay's designs), and aesthetically very beautiful. The serene *Nuclear Sail*, sculpted by John Andrew and set beside the Lochan at Little Sparta, is a polished black slate monolith. Ships and sails often appear in Finlay's work, but this also has something of the prehistoric standing stone about it as well. There is also a pun: the conning tower of a submarine is called a 'sail', yet this sail is out of water.

Finlay's work has been highly influential. Charles Jencks (born 1939), an American settled in Scotland whose gardens at Portrack and elsewhere carry on much of Finlay's ethos and creative spirit, has said:

'As my friend the Scottish gardener Ian Hamilton Finlay put it, "A garden is not just a retreat, but an attack."'[14] The gateposts designed by Andrew Townsend are topped by hand grenades instead of traditional pineapples.

BACK TO BERLIN

A remarkable number of artists in the second half of the twentieth century have found their inspiration in Berlin, and in other parts of Eastern Europe.

Ken Currie (born 1960) studied at Glasgow School of Art, and featured industrial aspects of the city in much of his early work. But people, and political upheavals, became an increasing interest in the 1980s. His painting simply entitled *War* (1983)[15] shows anger, perhaps verging on madness, and uncon-

Ian Hamilton Finlay and John
Andrew, *Nuclear Sail*, Little Sparta,
1974.

the lively art scene as well as by the city's circumstances and history. Three female artists concerned about women's place in the history and contemporary society are Gwen Hardie and Margaret Hunter, both of whom have studied with Georg Baselitz; and Lys Hansen, whose several stays included working in an atelier overlooking the Wall.[16]

Jock McFadyen (born 1950) is very much an artist of cities, often recording their underbellies and seamier aspects, his style showing the influence of artists such as George Grosz and Otto Dix in Germany, and the American Edward Hopper. There is some caricature, some humour, and searing essays on the general nature of the human condition. McFadyen worked in Northern Ireland on subjects associated with the Troubles, proposing an exhibition at the Imperial War Museum which failed to materialise because Ulster was not technically a war zone. But in 1990 he was commissioned by the Museum's Artistic Records Committee to document the aftermath of the end of the Berlin Wall.[17] His *Kurfürstendamm* shows a man with an amputated leg, dressed in scruffy clothes and playing the accordion; the Kurfürstendamm had been a very affluent avenue of elegant shops and cafes, though its status has waned with re-unification.[18]

THE BALKANS

Peter Howson (born 1958) served briefly in the Army and studied at Glasgow School of Art. He became known for his paintings showing the city's often violent underclass with both understanding and sympathy. He was appointed the official British war artist for Bosnia in 1993, and some of the resulting paintings were disturbingly graphic.[19]

Howson's *Cleansed* of 1994 is a large painting, its size adding to the impact of the composition. A

trollable crowds. In his etchings of the 1990s he depicted ghoulish crowds in Eastern European cities, dehumanised people produced by dehumanising conditions, often emerging from dark backgrounds.

His large painting *The Troubled City* (1991) is one of a trilogy depicting urban unrest. This appears to be Berlin, for there are background glimpses of the Brandenburg Gate and the Reichstag on fire, but it may stand for rather more than that – the unravelling of the political arrangements of Eastern Europe as a long-term consequence of the Second World War. There are echoes of Breughel and Bosch in the general confusion of the scene, and specifically in the hooded man in the left-centre of the painting, and in the figure with the megaphone to the right. Books are being burnt, a reference to Nazism.

A number of Scottish artists have lived and worked in Berlin since the 1980s, attracted there by

OPPOSITE.
Ken Currie, *The Troubled City*, 1991.
Oil on canvas, 275.0 × 335.5 cm.
Scottish National Gallery of
Modern Art

LEFT.
Peter Howson, *Cleansed*, 1994.
Oil on canvas, 182.8 × 243.6 cm.
Imperial War Museum

group of Muslim refugees is shown sitting by the side of a road with their scant possessions outside a village patrolled by blue-helmeted UN peace-keepers. The refugees are not depicted as innocents, however desperate their plight might be. But Howson's anger is directed mainly towards the UN rather than the Croatians who have driven these people from their homes. The refugees were a real group he had come across: they had sought refuge in a UN camp, but had been refused entry and instructed to travel to a safer district, and were now in great danger as they waited.[20] Howson is quoted as saying of his Bosnian work: 'I'm not aiming to be controversial. But I wanted to cut out all the reportage. It's not my job to

do that. My job is to do the things you don't see, that the army doesn't even get to see, not be an illustrator, not to tell stories, but to produce strong images of things.'[21]

Other artists have commented on the wars and tensions of the 1990s. Wilhelmina Barns-Graham made a series of 'Bosnia' paintings; Stuart Duffin (born 1959) commented on the Middle East; and Ken Currie made allusions to the Gulf War. Stephen Barclay (born 1961) has looked back to the past, but also to the present, with deserted watch towers and shelters, showing nature scarred by humanity but continuing to grow, with an ever-present theme of conflict.[22]

INTO THE TWENTY-FIRST CENTURY

The scope of this book is, officially, the twentieth century. But it would be perverse not to mention that war art, like war itself, continues.

Wilhelmina Barns-Graham had her finger on the political pulse all through the twentieth century. Despite the fact that she never ventured into any war zone, her artistic perceptions and comments have been extraordinarily prescient. There had been chaos and conflict in Afghanistan (including the Russian occupation) for years before she painted her simple, sweeping *Afghanistan* in 2000. This was made at a time when the country's political future was again uncertain – and only a year before the United Kingdom began its involvement there at the start of the 'war on terror'.

Many of the more recent war artists, both official and unofficial, have used photography and other newer media. Robert Wilson is a professional photographer whose work in Afghanistan was published as a book, and his work with 52 Infantry Brigade (with Headquarters in Edinburgh) was shown to the public as an exhibition at the Scottish National War Museum.[23] Many other artists have been commissioned by the Imperial War Museum, or by other organisations connected with the Armed Forces. For example, in 2004 Mungo McCosh spent a month in Basra, Iraq, as an 'embedded' artist. In 2010 James Hart Dyke went to Helmand Province, Afghanistan, with The Black Watch, 3rd Battalion Royal Regiment of Scotland (3 SCOTS), which was deployed there. Mark Neville was also commissioned to work in Helmand (and he has revisited Stanley Spencer's shipyards).

The Imperial War Museum addressed the question of new media in an exhibition in 2013–14, *Catalyst: Contemporary Art and War*, the first major show of the Museum's collection of contemporary art produced since the First Gulf War. It posed the question: 'How do artists contribute to our perceptions of war and conflict in an age where our understanding is shaped by the media and the internet?'

Quite apart from any official commissions, artists continue to question and relate back to war. In 2003 Nathan Coley appointed himself as the artist to the Lockerbie trial at Camp Zeist in the Netherlands. In the past, artists were appointed to cover trials (Dame Laura Knight at the Nuremberg trials in 1946, for example) but this was a personal decision; Coley's presence at the Lockerbie trial was as much a conceptual artwork as the material work that it produced. The main exhibit resulting from the project was a facsimile of the witness box used during the trial, focusing minds on evidence.[24]

Glaswegian Toby Paterson works in an abstracted form, his paintings, reliefs and constructions dealing with place and identity. His *Hamburg Relief* (2005) in the Scottish National Gallery of Modern Art is one of a group of works centering on three cities badly damaged in the Second World War – Coventry, Rotterdam and Hamburg.[25]

Art has long been recognised as an effective therapy for stress and post-combat recovery. Earl Haig, a prisoner in the Second World War, noted in his autobiography that 'In 1948 I had written an article in *The Times* to stress the need for … art therapy'.[26] The current organisation Combat Stress (formerly the Ex-servicemen's Welfare Society, founded 1919) recognises the need for such activity and therapy. And the Army Arts Society was established by Linda Kitson after the Falklands War in 1982, for all ranks in the army. One of its key aims was art as therapy, and it includes artists and craftspeople whether serving, retired or dependent. There are regular exhibitions, and work is shown on the organisation's website.[27] Operational art packs are now available to serving soldiers on request.

OPPOSITE.

Wilhelmina Barns-Graham, *Afghanistan*, 2000. Acrylic on canvas, 121.6 × 91.4 cm. The Barns-Graham Charitable Trust

CHAPTER 6
Memorials and Meditations

The memorials made at the beginning of the twentieth century, to the dead of the South African War and other Imperial campaigns, have already been discussed in Chapter 1. The change in approach to the planning and making of these memorials – the genesis of which lay in the nineteenth century – and those which came after the First World War, could not have been greater.

It is difficult now to imagine the situation faced by the various authorities, and artists, who were to commemorate so many dead – the sheer number, and the fact the almost every family had suffered a loss; and the proportion of 'the missing' whose bodies were never found. There was a great need to do a great deal: memories to be transformed into stone and bronze, grief to be assuaged through art and epigraphy, dates and events to be recorded and ordered for future generations.

Before the First World War there had been no organised system of burial or memorial. Regiments buried their dead where they fell, and monuments were erected after a battle on a completely unregulated basis; many of these monuments were to individual (or groups of) officers. Relatives and regimental colleagues would erect memorial plaques in

cathedrals and churches. Repatriation of bodies was rare.

This all now changed. There had been a ban on the repatriation of British war dead from the continent since 1915. The work of Fabian Ware, who started to organise a formal system of record and burial, resulted in the establishment of the Imperial War Graves Commission in 1917.[1] It was decided, after some debate, that all the war dead of the Empire (other than those who were 'missing', these being commemorated on vast memorials such as Thiepval on the Somme, the Menin Gate at Ypres, or Bayeux in Normandy) would be buried individually, with uniform grave markers. The plain pattern chosen for the headstone was suitable for all religions. Religious motifs, regimental badges and individual inscriptions were to be incorporated within the form of the stone, the shape of which weathered well.

Names were occasionally added to already-existing regimental memorials, for example to the Royal Scots Greys in Princes Street, where plaques on its plinth commemorate those who fell in both the World Wars. But most memorials after the First World War were new, and they form the most common memorial type in Scotland (and indeed, all over Europe). Most

OPPOSITE.
Patrick William Adam, *Poppy Fields*, *Flanders*. Pastel on paper, 61 × 43 cm. East Lothian Museums Service

LEFT.

Henry Price, *Maxwelltown Memorial*, unveiled 1921. The Herald Photographic Archive.

RIGHT.

Philip Lindsey Clark, *Cameronians (Scottish Rifles) War Memorial*, Kelvingrove Park, Glasgow, unveiled 1924. The Herald Photographic Archive

of them also bear the names of those who fell in the Second World War, and some record those killed in subsequent conflicts too. In 1918 the Royal Scottish Academy established an Advisory Committee of the Scottish War Memorials Committee. Indeed, there were a vast number of committees organising memorials, for although there were national and regimental memorials, it was left to each village, parish, district, town and city to commemorate its dead. Few regulations applied, and the resulting memorials were very diverse.

LOCAL MEMORIALS

Most of the local memorials were erected before the national ones, and sculptors were busy in 'a hurricane season of memorials', to quote the 5th Earl of Rosebery.[2] It gave sculpture a boost; indeed several sculptors made their names through their memorial work. What is truly astonishing is just how very informal some of the monuments were.

The memorial at Maxwelltown, near Dumfries, was made in 1921 by Henry Price, a Welsh sculptor (who also created the memorial for Annan the same year). It comprises a bronze figure of a young soldier set high on a stone pedestal. He is in uniform but carries no weapons, and he raises his hands skywards. This gesture can be read as the soldier's prayer for the slaughter to stop, or the soldier surrendering himself to a higher authority.[3] Rather unusually, the memorial bears no names from the Second World War, for between the wars Maxwelltown had become part of the Burgh of Dumfries, and its later war dead are

commemorated on the Dumfries memorial.

The Cameronians (Scottish Rifles) memorial in Kelvingrove Park, Glasgow, by Philip Lindsey Clark and unveiled 1924, could not be more different. This is an angry sculpture in bronze, showing a fallen man and others going into the attack – and in its depiction of soldiers actually fighting, a very unusual one. The central figure, an advancing sergeant, was taken to symbolise Victory, the fallen officer beside him is Sacrifice, the Lewis gunner the spirit of dogged Determination.[4]

One of the most prolific sculptors in Scotland was Alexander Carrick (1882–1966) from Musselburgh. He had trained as a stone carver with Birnie Rhind, and served as a gunner on the Western Front, being invalided out with the rank of sergeant. He thus had some fellow-feeling with those he commemorated. Today, he is known almost solely for his memorials, though he was head of sculpture at Edinburgh College of Art, and a leading Academician of the RSA, and he worked on many architectural projects; his influence was wide-ranging and long-lasting. Carrick was already working on military and memorial themes during the War, producing a maquette of *The Gunner* in Belgium in 1916, a simple but dramatic design of an artilleryman lifting a shell. Shown at the Royal Scottish Academy that year, the figure was much praised. His memorial for Oban, unveiled in 1923, is unusual in that it features two men carrying a wounded comrade.

Carrick's memorial figure for Killin, Perthshire, bears some resemblance to Michelangelo's *David*, though the soldier holds the sling of a rifle rather than a catapult. The photograph of its unveiling shows an aspect particularly common to memorials in Scotland: they were often placed above rivers or near the coast, where the backdrop made even the simplest Celtic cross or cairn appear dramatic by its setting.

PRACTICAL MEMORIALS

Memorials took many practical forms, such as ex-servicemen's homes, public gardens – or to house the arts. Kirkcaldy's civic war memorial, for example, comprised a museum and art gallery set in the War Memorial Gardens, within which were erected the actual memorial plaques; the town's library was added in 1928. The memorial complex was donated by the linoleum manufacturer John Nairn in memory of his son. In Aberdeen, the war memorial and Cowdray Hall form part of a complex with the city's art gallery: the cost of the war memorial was met by public subscription, that of the Cowdray Hall by Lord and Lady Cowdray for the encouragement of art and music in the city.

The Royal Scots Club in Edinburgh has the

The unveiling ceremony of the war memorial by Alexander Carrick, at Killin, Perthshire, 29 October 1920

Robert Tait Mackenzie, *The Call*,
Scottish–American Memorial,
West Princes Street Gardens,
Edinburgh, unveiled 1927

distinction of being both a memorial and a Club for all ranks of the regiment and its affiliates (the Club's letterbox reads 'The Royal Scots War Memorial'). It was the brainchild of Colonel Lord Henry Scott, younger son of the 6th Duke of Buccleuch and an officer in The Royal Scots. A public appeal raised the funds for the Club, at first housed temporarily in redundant American Army leave huts in St Andrew Square. It was dedicated in 1922 in its current premises in Abercromby Place.[5]

NATIONAL MEMORIALS

There were regimental and national memorials, and international ones too, such as the Scottish–American War memorial in West Princes Street Gardens, Edinburgh. Paid for by Scottish Americans and unveiled in 1927, the setting was designed by the architect Reginald Fairlie, and the sculpture by Robert Tait Mackenzie (of Philadelphia). The bronze was cast at the Roman Bronze Works at Brooklyn, the stone quarried from Craigleith quarry, Edinburgh. Entitled *The Call*, a single bronze figure sits in front of a long bas-relief. It includes a quotation from a poem by Ewart Alan Mackintosh, MC (1893–1917), an officer in the Seaforth Highlanders, entitled 'A Creed', which he wrote at Vimy Ridge, and which was published in a collection of his poetry, *A Highland Regiment*, in 1917.

The soldier has a very determined expression, a change from the maquette (private collection) which shows a more cheerful and more innocent youth, with a hopeful half-smile.

THE SCOTTISH NATIONAL WAR MEMORIAL

The Scottish National War Memorial was opened in 1927. It was such a major project, and so influential, that it has already been described and discussed in numerous publications, from the major illustrated works that appeared soon after its opening to a new well-illustrated history of 2014.[6] A summary here must suffice.

The Memorial was a decade in the making. A committee had been set up in 1917 to create a memorial to be paid for by public subscription. The poster by local designer Tom Curr (1887–1966) is an eloquent essay in dignified pathos. Curr was probably influenced by a painting by William Orpen, *A High-*

lander Passing a Grave, 1917.[7] Orpen's work is the more dramatic in colour, with the artist's characteristically deep blue sky, an ironic cheerfulness which often accompanied his most harrowing scenes of death – though in this composition the bleached earth seems to be almost hallowed ground.

Curr was probably the designer of the penny stamps sold to raise funds for the War Memorial. He was an Edinburgh man (1887–1966) who spent all his working life – apart from war service – working for the Leith-based printers McLagan & Cumming (to which Stanley Cursiter had been apprenticed). His designs included army recruitment posters and cartoons. Later on in life he became better known as an artist, exhibiting at the Royal Scottish Academy, and publishing books of caricatures.[8]

There was controversy over the preferred location for the National War Memorial, Edinburgh Castle, due to concerns that the memorial might alter the Castle's profile, and thus the city's skyline. Sir Robert Lorimer was appointed as advising architect in April 1919, and he proved a brilliant choice. He was a distinguished and versatile architect (who had designed the Chapel of the Order of the Thistle, appended to St Giles' Cathedral) and was sensitive to the Castle's architecture. He gathered together a large team of artists, and the resulting Memorial, opened in 1927, combines architecture, sculpture, glass, metalwork, and natural elements (the 'living' Castle rock very effectively coming through the floor of the Shrine) – all mingled with military history, Scottish tradition and controlled but intense emotion.

Despite its simplicity, the design is quite theatrical, with shafts of light shining through stained glass. On entering, the visitor is immediately aware of the heart of the building, the Shrine, straight ahead beyond a wrought-iron screen by Thomas Hadden, with the pendant figure of St Michael illuminated by a window high above.

The friezes encircling the Shrine – the processions a kind of Parthenon frieze – were based on drawings by Morris Meredith Williams, who had served in the War,[9] and modelled by his wife Alice Meredith Williams, who was also responsible for the figure of St Michael. The friezes set out to include representatives of every rank and unit of every service that had fought, or been involved, in the War, and in every theatre. They are incredibly detailed, each figure an individual character.

Tom Curr, *Poster to promote fundraising for the Scottish National War Memorial*. National Museums Scotland

Much of the stone carving was by Charles D'Orville Pilkington Jackson (1887–1973), and it is clear and unfussy. The very popular animal vignettes were by Phyllis Bone (1894–1972), whose work as a student at Edinburgh College of Art had attracted Lorimer's attention; her *Camel* is reproduced in Chapter 2.

The light for the Memorial shines through a series of stained-glass windows by Douglas Strachan (1875–1950) and transforms the secular, non-denominational space into a quasi-religious one in character. An Aberdonian, Strachan had studied art in Aberdeen and Edinburgh, trained as a lithographer, and worked as a commercial graphic artist, before travelling on the continent.[10] After this very eclectic training he chose to concentrate on glass, and his seven large windows for the Memorial are soaring triumphs. It is on these, and on the set he made for the Memorial Chapel of Glasgow University, that his fame tends to rest today, though he produced some

LEFT.
Douglas Strachan, *Grenade Thrower*, 1927, window panel in the Scottish National War Memorial, East Bay, above Artillery Memorial

RIGHT.
Douglas Strachan, *Munitions Worker*, 1927, window panel in the Scottish National War Memorial, South Wall

340 windows in all, both in Britain and abroad. Reproduced here are vignettes which until recent re-photographing were difficult to appreciate in detail.

The *Grenade Thrower* – he would have been called a 'bomber' – is shown with an explosion in the distance behind him, his grenade the German 'potato masher' type, so in fact possibly captured stock being thrown back at the enemy. The female *Munitions Worker* reminds the viewer of the source of the ordnance – and by the time this window was made, the chemical dangers of munitions factories had become well known.

The total ensemble produces a superb effect, historicist and contemporary, austere yet highly emotional, with bejewelled light shining upon the nation's memories of pride and grief evoked in heraldry and military iconography. It has little of the heavy symbolism of the memorials erected two decades earlier to the dead of the South African War,

yet also makes little reference to current movements in modern art, thus rendering it timeless, approachable, unthreatening and indeed welcoming.

MORE MEMORIALS

Many chapels and other memorial buildings were constructed to commemorate those who died all too soon after leaving their schools and universities. A notable example is the Memorial Chapel of the University of Glasgow, originally planned as the Chapel for the University, the designers J.J. Burnet and Son producing a scheme in the spring of 1914. Work was set to start in August, but the outbreak of the War halted progress on the project. By 1919 it was decided that the Chapel would now be a memorial to the fallen of the University, and it was finally dedicated and opened in 1929.[11] It comprises a fusion of old and new

FAR LEFT.
Carving of Chapel Stalls, University of Glasgow Memorial Chapel, completed 1929

LEFT.
George Henry Paulin, *War Memorial at Dollar Academy, Clackmannanshire,* bronze figure, 1920

BELOW.
W. Birnie Rhind, *War Memorial at Fettes College, Edinburgh,* bronze figure, 1921

styles, with an oak hammerbeam roof, numerous small carvings in stone and wood, and tall lancet windows with splendid glass by Douglas Strachan.

The memorial at Dollar Academy was made by George Henry Paulin, educated at the Academy and Edinburgh School of Art, after which he studied in Paris (sharing a flat with artist James Gunn in Florence and Rome). His experience of the war service was, quite by chance, extraordinarily varied. He served in the Lothians and Border Horse in France in 1916, from which he invalided out after an accident. He then joined the Royal Flying Corps, rising to Captain, apparently serving in Italy (he had excellent Italian). In 1918 he transferred to the Royal Naval Air Service, and on the merger of the two later that year, the Royal Air Force.[12]

Paulin undertook work on many war memorials, both in Scotland and in France (notably the Beaumont-Hamel Newfoundland Memorial). The Dollar

Academy memorial, on which the name of his own brother is inscribed, shows a single life-size figure in bronze, clad in a robe with outstretched arms, as if in supplication.

During the Second World War Paulin initially undertook munitions manufacture at Weir's (see

p.112), though from January 1941 he worked elsewhere, possibly in camouflage or intelligence – even his letters to his family do not reveal exactly what he was doing. Sadly, his London studio was destroyed in the Blitz, but after the War he submitted a design for the Commando memorial at Spean Bridge. It was not accepted, but another design, which he made for the Royal Armoured Corps, was finally realised in 2000 (p.224).

William Birnie Rhind was commissioned to undertake the Fettes College memorial, having already made memorials to the Scots Greys, King's Own Scottish Borderers and Black Watch after the South African War. His dramatic single figure of a fallen officer is based on an amalgam of two classical sculptures in the Capitoline Museums in Rome (the Wounded Warrior and the Dying Gaul), yet the very contemporary words 'Carry On' are inscribed below; it was unveiled on 15 October 1921.[13]

Fettes had a connection with the Scottish

National War Memorial through its art master, Morris Meredith Williams, one of the contributors the Memorial (p.209), who had served on the Western Front and had also worked in camouflage with the artist Edward Wadsworth, an Old Fettesian.[14] The College also produced a number of poets, including Christopher Salvesen (born 1935), who wrote 'A War memorial: In Memoriam G.A.S.' which concludes:

> Of those who died each day I used to see
> The figure raised, in Edinburgh's east wind,
> A fallen soldier on the block of names,
> The young lieutenant, rallying his men,
> His slogan, Carry On, for all to read,
> Unheard, however terrible, the pun.[15]

William Reid Dick (1879–1961) has already been mentioned as an artist who managed to produce sculpture while on active service in France (p.54). For him, memorials were the path to public recognition, though he went on to produce a wider range of both public and private sculpture. From humble beginnings he rose in the establishment art world, being knighted in 1935, and becoming Sculptor in Ordinary for Scotland from 1938 until his death.

Dick's winged figure for the RAF Memorial of 1923, sited on a pedestal of Portland stone by Sir Reginald Blomfield, quickly became a London landmark on the Victoria Embankment beside the Thames. The eagle, and the globe on which its stands, are in bronze (the eagle gilded, the globe a duller patination). At the time of the sculpture's creation, the RAF was still a new service, formed in April 1918 from a merger of the Royal Flying Corps and the Royal Naval Air Service.[16]

Elsie Inglis, mentioned previously for her hospital work during the First World War, has been commemorated in many places and in various forms: hospital,

nursing home and nursery. A fountain was built in her honour in Mladenovic, Serbia, during her lifetime (recently re-dedicated) and there are plaques in most of the places in which she set up medical services. Croatian-born Ivan Meštrovic (1883–1962) never actually met Inglis, but he sculpted a bust the year after she died; it was presented to Scotland by the Serbian Government.[17]

Inglis died on 26 November 1917, the day after she arrived back in Britain. As a contrast to the often misogynist opposition to her work during her life-time, she was fully honoured in death. Her body lay in state in St Giles' Cathedral before her funeral there, while her memorial service at Westminster Abbey was attended by ministers and diplomats. A plaque was erected in St Giles' Cathedral, Edinburgh – she had been a member of the congregation – designed by Sir Frank C. Mears (architect) and executed by Charles D'O. Pilkington Jackson (sculptor). The pale pink stone on a slate background shows three elongated figures of angels, inspired by medieval sculpture, bearing an anchor (hope), a cross (faith) and a heart (charity), with the words 'Mors Janua Vitae' ('Death is the gate of life') below. It was unveiled in 1922 by Dr Mary Scharlieb, another pioneering woman doctor who had known Dr Inglis personally.[18] A collection of Inglis's personal items is held by the Imperial War Museum, including her Windsor & Newton paint box and brushes.

POSTHUMOUS PORTRAITS

In September 1914, a month after declaration of war, Elizabeth, Lady Butler, painter of the rousing image *Scotland for Ever!*, visited her son Patrick at Army camp, and wrote afterwards: 'Patrick and I were photographed together by M. E. These little snap-shots will be precious.'[19] Indeed, they often were,

being the only likeness of a lost son, and many artists were employed to translate them into paintings. Posthumous portraits were not an entirely new phenomenon, but they now enjoyed a poignant popularity. As the military painter Allan Stewart commented in his memoirs, 'One thing seemed certain to me, art was finished for some time to come except the rather lugubrious job of painting men killed at the front, from photographs, for relatives.'[20]

A typical example is that of Captain Talbert Stevenson of The Black Watch, the son of the proprietor of the Dundee dye works Francis Stevenson & Sons. He was killed by sniper fire in 1917, aged 22, and is included in Joseph Gray's painting *After Neuve Chapelle.* Like many posthumous paintings, his portrait was displayed in a public exhibition (in Dundee in 1920). The artist Anton Abraham van Anrooy (1870–1949) was a Dutch portraitist and illustrator who had settled in London in 1896, becoming a naturalised British citizen. His work is characterised by simple blocks of colour and a smooth finish, appropriate to his work as a poster designer, and much in evidence in this posthumous portrait.

One particularly striking posthumous portrait is by David Alison (1882–1955): *2nd Lieutenant J. P. C. Mitchell*, killed in action at the age of nineteen. Mitchell had served as an officer in the 4th Battalion Highland Light Infantry, and volunteered in 1916 to train as a pilot with the Royal Flying Corps. His squadron carried out reconnaissance and artillery observation above the trenches of the Western Front, and he is shown dressed for his final mission. The portrait was lent by his family for exhibition at the Royal Scottish Academy.

The only portrait of the poet Charles Hamilton Sorley (1895–1915) was made from a photograph. His poetry also appeared only posthumously, but earned him a long-lasting reputation (Robert Graves considered him to be one of the three greatest poets of the War). A quotation from one of his letters forms the title of this book (see Introduction). The coloured drawing that Cecil Jameson produced hardly seems to do justice to Sorley's lively mind, making him seem positively dull or even grumpy. It was, however, true to both the photograph and to the actual appearance of the sitter, for Sorley's mother wrote (to her future son-in-law): 'the portrait at once appealed to us. It *is* a fine portrait of Charlie himself ... I am amazed that the artist should have been able to give such a living presentment of someone he never saw.' The surviving photograph confirms the verisimilitude of Jameson's portrait.[21] Taken together, these visual glimpses hint at the maturity and complexity of the man, despite the youthfulness of his face.

Posthumous portraits were also made for those who fell in the Second World War, though by this time the genre was less common. A particularly fine example is that of Lieutenant The Hon. Alistair Robert Hervey Erskine, MC, Scots Guards (1923–1945), brother of John, 13th Earl of Mar and 15th Earl of Kellie.

A very different type of posthumous portrait was

Anonymous artist [initials A. W.],
*Lieutenant The Hon. Alistair
Erskine, MC.* Oil on canvas,
40 × 30 cm. On loan to the
National Trust for Scotland

OPPOSITE.
Sydney Kendrick, *Lieutenant-
Colonel Geoffrey Keyes, Royal
Scots Greys and No. 11 Commando,*
1942. Oil on canvas, 129 × 93 cm
(framed), On loan to National
Museums Scotland

and informal, while the muted colouring emphasises the desert location. Keyes is forever standing 'at ease', his posthumous VC included at the bottom right-hand corner of the composition. Kendrick produced three versions of the picture.

THE POPPY: A NEW EMBLEM OF MOURNING

Patrick William Adam expressed his alarm at the start of the First World War in his painting *War* (p.12). His undated pastel *Poppy Fields, Flanders* expresses the mourning felt in its aftermath (p.204). It shows a field with a crucifix, of the sort used as temporary grave markers on the battlefield, surrounded by a meadow with poppies, daisies and other wild flowers, trees and blue sky above. The artist worked in strong strokes to show the long grass, emphasising the lushness of nature hiding death beneath the ground. It is signed `PW Adam', and inscribed `Poppy Fields, Flanders`. Adam lived in North Berwick, and the pastel was commissioned by Mrs Isabella Lyon of the town's Tantallon Lodge to commemorate the deaths of three sons during the First World War (another memorial to them was erected by their sole surviving brother, the Reverend William Lyon, at his church, Christ Church, in Lanark).[23]

commissioned of Lieutenant-Colonel Geoffrey Keyes, Royal Scots Greys and No. 11 Commando. Born in Aberdour in Fife (son of Admiral of the Fleet Lord Keyes), he was awarded a posthumous Victoria Cross for the failed raid on enemy headquarters near the coast of Libya in November 1941 known as the 'Rommel Raid'. Aged only 24, he was buried with full military honours by Rommel's chaplain.[22] The artist, Sydney Percy Kendrick (1874–1955), was a London-based painter who generally produced solid Edwardian portraits together with some livelier examples of theatrical personalities, though he did change style to produce some wartime portraits rather in the manner of Eric Kennington (p.170). This understated portrait of a rather reserved-looking Keyes is one of the artist's best works: the pose is a compromise of the formal

Poppies were to become the new symbol of mourning, though they might not yet have become an adopted symbol when Adam produced this (undated) image. Until the 1920s the forget-me-not had sometimes been used to remember the dead, though official commemorations often displayed white flowers and wreaths (as shown in the photograph of the unveiling of the Killin War Memorial). The forget-me-not continued to be used until 1949 in Newfoundland, when it became the tenth province of Canada (until then it had been a separate British Dominion). Forget-me-nots are still worn there on 1st July to mark the

old Newfoundland Day of Remembrance, the day when its regiment was all but destroyed on the first day of the Battle of the Somme.

On 8 December 1915 *Punch* magazine published a poem by Canadian medical officer John McCrae (who had died in France nine months earlier). Now so well known, it begins 'In Flanders fields the poppies blow / Between the crosses, row on row'. It was reprinted in an American magazine: a secretary at the New York YMCA was struck by it, wore a poppy to remember the dead, and the idea was picked up by a visiting representative of the French YMCA – and it was in France that artificial poppies were first made. In 1921 the British Legion bought nine million poppies from France; on 28 October that year, Field Marshal Earl Haig wrote to British newspapers suggesting that members of the public night wear them. In 1922 the British Legion set up a poppy-making factory in England employing disabled ex-servicemen. In 1926 Countess Haig established a Scottish poppy factory, and a distinctive Scottish poppy was designed bearing four petals, with no green leaf.[24]

AFTER THE SECOND WORLD WAR

There were few new memorials after the Second World War. Names were added to those from the previous War, many of them barely twenty years old. Those that were created tended to be for regiments or institutions, or for new services such as the Commandos.

The Royal Scots Memorial, in Princes Street Gardens West, stands out as a very original design commemorating the whole history of the regiment – though it hardly stands out in the cityscape, being tucked away at the east end of the Gardens, at the side of the Mound. Unveiled in 1952, it comprises a series of stone slabs carved in very low relief, set in a

semi-circle with bronze medallions of monarchs
between, one large stone being inscribed with battle
honours. It was designed by Sir Frank Mears and
carved by Charles D'O Pilkington Jackson, and has
similarities with the work Jackson undertook for the
Scottish National War Memorial. Instead of stained
glass, however, it is here the sun alone that lights the
slabs, laid out like a sundial or prehistoric henge
monument, for each stone is illuminated at 40-minute
intervals. The Second World War slab (which actually
covers the inter-war period as well) shows a Bren gun
carrier surreally hovering over three pairs of soldiers
in the dress of different campaigns.

The Commando Memorial above Spean Bridge
in the Highlands, by Scott Sutherland, was also
unveiled in 1952. It commemorates a new service in
a very traditional way, and unlike the Royal Scots
memorial it has become very well known. Its setting
in the Highlands, with spectacular views (including
Ben Nevis) has ensured its inclusion in tourist

brochures, and made it attractive for publications
aimed at the Scottish diaspora.

The three figures, clothed and equipped for an
exercise, stand on a stone pedestal inscribed 'This was
their training ground'. The sculptor, Scott Sutherland,
was at the time Head of Sculpture at Duncan of
Jordanstone College of Art, Dundee.[25]

There were few memorial chapels built for the
dead of the Second World War. One of these was,
however, a particular interesting example of memorial
architecture and art: the Robin Chapel, in Niddrie,
Edinburgh. It was created by Sir Francis and Lady
Tudsbery in memory of their only son Robin, a lieu-
tenant in the Royal Horse Guards (The Blues), the last
allied officer to be killed in Europe. The architect of
the Chapel was John Fraser Matthew (partner and
successor to Sir Robert Lorimer), and it was
completed and dedicated in 1953. It was sited at the
heart of the Thistle Foundation housing complex for
disabled ex-servicemen and their families, designed by

Matthew's son Stuart Russell Matthew.

Stylistically, it looks back to the arts and crafts movement, though it also looks forward with a simplicity of form and decoration characteristic of so many interiors of post-war public buildings. The bell-tower with its crow-steeped gable is almost domestic in scale, and the façade is pierced by a window in the form of a cross. There are numerous references to nature, a particular interest of Robin Tudsberry, and the narrative theme is that of *The Pilgrim's Progress*. Every aspect of the Chapel was individually commissioned as a work of art, also individually sourced: the altar made of Botticino and San Stephano marble resting on a base of dark green slate; the oak panelling from Binning Woods on the estate of the Earl of Haddington; and the carving on the panels and stalls by Thomas Good of Ramsay Lane (who was responsible for much of the carving in St Magnus Cathedral, Kirkwall and other works in London and New York) and who claimed that the oak was the most beautiful he had ever worked. The wrought-iron work in the Chapel is by J Finnigan of Edinburgh, and the ceramic altar vases by Lydia Garth of Glasgow School of Art. Most striking of all is the stained glass by Sadie McLellan (1912–2007), including a series of nine windows depicting episodes from The Pilgrim's Progress.[26]

RETROSPECTIVE MEMORIALS

Formal memorials relating to the Spanish Civil War were generally erected long after the event – but there are many of them, now listed by the International Brigade Memorial Trust.[27] A number take the form of plaques; the memorial in Princes Street Gardens, Edinburgh, comprises a large boulder bearing one. But in Glasgow, Arthur Dooley's *La Pasionaria* stands proud – almost flies – on Custom House Quay.[28]

Sadie McLellan, *Stained glass from the Robin Chapel, Edinburgh*, 1953

REJOICE NOT AGAINST ME O MINE ENEMY ✦ ✦ ✦ WHEN I FALL I SHALL ARISE ✦ ✦ ✦

Arthur Dooley, *La Pasionaria*,
Custom House Quay, Glasgow,
1979 (since restored)

The statue shows Dolores Ibárruri (1895–1989), known as La Pasionaria – meaning the passion flower – a heroine of the Republican cause. The figure reaches upwards with a rousing gesture, and on the plinth are her words, translated into English: 'Better to die on your feet than live forever on your knees'. Viewed from the side, the figure leans forwards and has real momentum. It was commissioned in 1974 by the International Brigade Association of Scotland, and funded by trades unionists and members of the Labour movement in Scotland. The artist was the

Liverpool-based sculptor Arthur Dooley (1929–1994). The statue was controversial from the start, its erection opposed by the Conservative Councillors of the city. It also suffered numerous setbacks through funding and construction problems. The original intention of casting the figure in bronze had to be abandoned due to cost, and it was made of fibreglass. In the end it was put up without any public ceremony; it was restored and re-dedicated in 2010.

The photographer Sean Hudson (1935–1997) made a series of photographs for a book and exhibition in 1987 entitled *Voices from the Spanish Civil War* (a set of his prints are now in the Scottish National Portrait Gallery). Scots who had taken part related their individual histories of the War, and were photographed in their own homes. Hudson had worked in films, and had been active in the Workers' Revolutionary Party. He moved to Edinburgh in the 1980s and became the official photographer to the International Festival, while continuing to work on themes to which he was personally committed.[29]

Less of a commemoration of sacrifice, and rather more a gift of thanks, is the huge Norwegian boulder which stands in Princes Street Gardens West, presented by the Norwegian Army in 1978. It bears an inscription including the sentiment that in Scotland 'we found hospitality, friendship and hope during dark years of exile'.

EARLIER CREATIONS LIVE ON

The Italian Chapel on the small island of Lamb Holm, Orkney, has already been the subject of detailed study, so only a brief summary is given here.[30] Italian prisoners of war, brought to Orkney to work on the Churchill Barriers, were permitted the use of two Nissen huts as a chapel. Many of the prisoners of war were skilled craftsmen. The huts were joined end-to-

end, concrete was donated (by Balfour Beatty), the interior was covered with plasterboard and painted, and scrap metal and other available materials were incorporated for decoration.

The 'Gothic' façade is of white plaster, surmounted by a belfry and with pinnacles at each end of the gable. Inside is false brickwork, and a vault painted with the four evangelists with a white dove in the centre. The principal artist of the interior was Domenico Chiocchetti, who took his painting of the Madonna and Child altarpiece from a picture he carried on his person, and when the prisoners were due to depart he was allowed to stay to finish the work. He returned in later years, and the Italian Chapel is now a conserved, permanent memorial to the prisoners of war, and a celebrated landmark.

Another chapel, much less well known, is the Ukrainian Chapel at Hallmuir near Lockerbie. This has been little publicised, though it has been featured with enthusiasm in a book about Scotland's more hidden delights.[31] Unlike the Orkney Chapel, it lacks any external aesthetic appeal, still clearly a Nissen hut from the outside. Internally, it is quite different, with its bright decorations often made of salvaged material – a chandelier composed of tinsel and wire, candlesticks made from shell cases, and banners from tent material.

This Orthodox Chapel was not, in fact, created by Ukrainians. The camp had previously been occupied by German and Italian prisoners of war, and the Italians had used it as a chapel. The Ukrainians arrived in Scotland only in 1947, having previously been imprisoned in Italy (had they been sent home they might have faced death). The landowner, Sir John Buchanan-Jardine, gave them this hut. It is now run by a descendant of one of the original Ukrainians and his wife, with services in Ukrainian still held several times a year.

Both the Italian and Ukrainian Chapels now

The Italian Chapel, Lamb Holm, Orkney, 1942–4 (since restored)

enjoy 'listed' heritage status, as does one of the most unusual memorials from the Second World War, the Great Polish Map of Scotland. This is a three-dimensional concrete view of Scotland constructed in the grounds of Barony Castle Hotel, Eddleston Village, in the Borders. It was built by a group of Polish nationals in 1974, thanking Scotland for its hospitality to the Poles in the Second World War, and commemorating the contribution made by their countrymen. The original idea probably came from Jan Tomasik, proprietor of the Barony Hotel from 1969

ABOVE.

Hallmuir Ukrainian Chapel, near Lockerbie, begun 1947

OPPOSITE.

The Great Polish Map of Scotland, seen from above. Eddleston Village, Borders, 1974 (since restored)

Kirk of The Black Watch, Albuhera Barracks in Werl, West Germany, in 1981, and remained *in situ* until the barracks became redundant after the fall of the Berlin Wall in 1989. Set in a wooden frame, it depicts the figure of St Andrew holding a cross, flanked by two soldiers, one in No.1 dress and the other in combat fatigues, with the badges of the Church of Scotland and the Regiment at the foot. It is inscribed 'O. Peters / Paderborn / 1981', a well-known German glassmaking company. Other 'Kirk of The Black Watch' windows have been installed at Nairobi, Jerusalem, and Ballykinler, Northern Ireland.

Sometimes memorials can have a long gestation, but few quite as long as the one designed in the 1950s by George Henry Paulin for The Royal Armoured Corps. He made a maquette of the memorial at the time, but the project got no further. Then in 1997, the 80th anniversary of the first massed use of tanks at Cambrai in 1917, the Royal Tank Regiment requested that the maquette be cast into several bronzes; they then commissioned a full-size version as a Regimental memorial. This was worked up from Paulin's original design by Vivien Mallock (b.1945), and sited at the junction of Whitehall Place and Whitehall Court in London. It comprises the 5-man crew of a Comet tank, in use in North-West Europe from 1944. The memorial was unveiled by HM The Queen, Colonel-in-Chief of the Royal Tank Regiment, on 30 June 2000. This was the centenary of the date of the alleged memorandum – and it is only 'alleged' – written by the engineer and inventor Colonel R. E. B. Crompton during the Second Boer War, in which he proposed that the time had come when modern firepower demanded the development of 'some kind of armoured land-ship' for possible future wars. The vehicle that had so dominated the 20th century battlefield was thus – just possibly – conceived during the conflict with which this book began.

to 1977, together with his former commander, General Stanislav Mazcek, who had also settled in Scotland after the war.[32]

A rather different 'memorial' is a stained glass window in The Black Watch Museum, which the regiment brought home with them from their barracks in Germany. It had been installed and dedicated at the

USA, the Lockerbie Cairn was built out of 270 blocks of red sandstone, a gift from Scotland, financed through private donations; the stone came from Corsehill Quarry, Annan, in the flight path of the aircraft. (The quarry has other connections with the United States, for its stone was used in many US buildings, including – it is thought – the base of the Statue of Liberty.)

The Glasgow-based glass artist John K. Clark (born 1957) produced a window for Lockerbie Town Hall, which shows the flags of all the nations which lost citizens, a dazzling array of colour. They are shown above each other, each flown from a separate flagpole, united in mourning.

NEW NATIONAL MEMORIALS

Concepts in memorials have been evolving, and the Gardens of Remembrance have now developed into arboreta and larger parklands. In 1995 the area around Ben Lomond was designated as a war memorial named the Ben Lomond National Memorial Park. It is dedicated to all those who gave their lives in the First and Second World Wars, and was created out of the former Rowardennan Estate with the support of the National Heritage Memorial Fund (itself in origin a war-memorial fund, the National Land Fund) and opened officially on Armistice Day 1997. The formal monument for the Park is a granite sculpture by Scottish artist Doug Cocker (born 1945). Since the Park was officially designated, the Loch Lomond and The Trossachs National Park, the first national park in Scotland, has been created and now includes the Memorial Park.

The Korean War Memorial, near Torphichen in West Lothian, is a United Kingdom rather than solely Scottish memorial. The central focus is a wooden pagoda, surrounded by Korean pine trees, with birch

MEMORIALS STILL NEEDED

John K. Clark, *The Lockerbie Memorial Window*, 1991. Lockerbie Town Hall

On 21 December 1988, Pan Am Flight 103, *en route* from London to New York, exploded over Lockerbie. All 259 people on board, and 11 local people, were killed, the citizens of 21 countries. At Dryfesdale Cemetery near Lockerbie a Garden of Remembrance was created. In Arlington National Cemetery in the

trees along a pathway called the United Nation Avenue. The number of trees is proportional to the numbers of Britons lost in the War (civilians included). Beyond these are further trees, each representing the nations involved. Opened in 2000, to mark the 50th anniversary of the start of the conflict, it was designed by West Lothian Council's architect Raphael Dunbar

in consultation with the Memorial Trust, which manages the site. There are other memorials in Scotland relating to Korea, for example the memorial garden in Perth, dedicated in 2013 by the The British Korean Veterans Association, No.1 Branch Perth. It is an interesting example of an amateur mural and small garden within an enclosed urban setting.

The Scottish Korean War Memorial, Witchcraig, West Lothian 2000, re-dedicated 2013

ARTISTS REMEMBERING AND QUESTIONING

LEFT.
James Pryde, *The Monument*, c.1916–17. Oil on canvas, 151.5 × 138.50 cm. Government Art Collection

RIGHT.
Robin Philipson, *Stone the Crows*, 1964. Tissue paper and canvas, oil & vinyl toluene on canvas (with paper strips), 152.3 × 152.3 cm. Royal Scottish Academy

James Pryde (1866–1941) produced a series of paintings of monuments. He began them in 1911 – before the start of the First World War – but as the series progressed his images dwelt increasingly on ruin, decay and death, notable one entitled simply *The Monument* (c.1916–17).

It is typical of Pryde's work in that its meaning is almost wilfully obscure. It features a statue of a Roman soldier on a stone plinth with arms and one leg missing, the torso crimson as if smeared with blood. A thunderous sky and bewildered figures create a sinister atmosphere of doom.[33] Pryde was

from Edinburgh, and some of his architectural and sculptural form was influenced by the city's inheritance in stone, though this painting also borrows the darkness of Spanish artists such as Velasquez, and from his own day, low life and slums. During the War he became a Special Constable, but whether this had any influence on his art is hard to tell.

The next artist shown here as a (rather truer) commemorative painter of the First World War, Robin Philipson (1916–1992), was working around 50 years later. His celebrated *Stone the Crows* of 1964 looks back beyond the War in which he himself served (for six years, in India and Burma with the King's Own Scottish Borderers) to the tragedies of the

War in progress when he was born. The device of a reel of film compresses the soldiers, linking scenes of claustrophobic trench warfare.

His less well known *Nevermind II*, painted ten years later, addresses the same theme. The two paintings could not be more different in their colouring, however: the first dun-coloured and dark, the other bright to the point of gaudiness – but both attempt to deal with the loss of life in the War. In the first, Philipson has taken a common saying at the time, a phrase that could signify both surprise and dismay, and the composition within film strips imparts a mock-casual approach. Crows are hanging dead along the top – alongside men hanging dead from barbed wire. Through the painting men run and march and fall; the naked body at the bottom of the painting is a woman, possibly giving birth to more of them. In *Nevermind II*, the traditional image of a general from the Napoleonic War with a map is flanked on both sides by the tied – and then shot – image of the First World War deserter; the title is the casual, throwaway remark made of an expendable life. The piercing red and blues hint at the stained glass of churches, common images in Philipson's work. There are echoes of his *Martyr* of 1966 (University of Stirling), and in the late 1960s and early 1970s he painted a series of 'Threnody' paintings (lamentations for the dead) with which this also has similarities. Both paintings are typical of his work in showing physical struggle, mind versus matter, violence hidden beneath order and formality – and the tragedy of life.

Philipson joined the staff of Edinburgh College of Art in 1947, and was later its Head of Painting; he also became President of the Royal Scottish Academy. His influence was therefore considerable, both in terms of style and in subject matter, and in his constant search for new images for recurrent themes. Towards the end of his life he painted a series of huge poppy pictures. They are both joyful and threatening,

in some cases both at once, jostling on the canvas and spilling out of their picture space, implicit references to war and its memory.

Later in the century, photographer Peter Cattrell (born 1959) looked back to the First World War in a very different way, visiting and studying the scarred landscape. His *Maize Cutting, No Man's Land, Serre, Somme, France* (1997) is one of a series about the landscapes of the First World War, especially of the Somme.[34] Many show bomb craters and other legacies of the conflict. This image, by contrast, shows the landscape renewed, though the reaping of maize is clearly a metaphor for the cutting down of ranks of soldiers. Its apparent innocence echoes the real inno-

Robin Philipson, *Nevermind II*, 1974. Oil on canvas, 123.0 × 91.5 cm. Private collection

plenty of evidence lying around in the fifties and well into the sixties … and Friday afternoon siren practice when the whole town stilled … haunted by the horror of a memory fresh in the minds of many …[35]

In his distant view, most of the canvas area is taken up by the sky, showing the tremendous force of the fire consuming the town below, a pale moon shining through a blood-red sky smeared with dark, smoky brush-strokes. This is fire out of control, humanity consumed by its force; the heavy texture of paint emphasises its violence and power. Glimpses of buildings and pinpricks of light show the scale of the buildings beneath, and indicate the presence of humanity in the firestorm.

McKendrick's *Burning Terrace* (1992) is a closer view of homes and lives destroyed. The chimney stacks, still with their pots, form uprights in a grid, the windows between shattered and open as a kind of lattice-work. Beyond, roofs still remain on tenements yet to be consumed.

cence of Muirhead Bone's *The Somme near Corbie* which he drew long before the name 'Somme' had acquired its war-time and post-war resonance (p.52).

Tom McKendrick, born in Clydebank and a resident for most of his life, is an artist who is very much identified with a subject, for he has commemorated the Clydebank Blitz of 1941 in an extensive series of paintings. He has said

Growing up in Clydebank it was impossible to avoid the fact that this small town had been subjected to a sustained and brutal attack. Only eight houses out of the twelve thousand remained intact after the raids, which lasted two nights. There was still

EUROPE RE-VISITED

The series of paintings relating to the Second World War by John Bellany (1942–2013) were the result of a journey to East Germany in 1967, where he saw the war paintings and prints by Otto Dix in Dresden, before visiting the former concentration camp of Buchenwald. His group of large paintings of concentration camp victims asks one question: why? The image reproduced here, *Pourquoi?* (1967), is stylistically linked to his paintings of subjects nearer to home and clearly refers to the Crucifixion; the skull and bones to Golgotha ('the place of the skull'), and the striped uniforms those of the concentration camp, one figure already mutilated. His *Pourquoi II?*, also 1967

(not shown here) is far more gruesome, contorted figures on crosses echoing not only the work of Dix, but painters of crucifixion scenes such as Matthias Grünewald, and above all the *Disasters of War* series by Francisco Goya.[36]

Alexander Moffat (born 1943), from Dunfermline, studied at Edinburgh College of Art and taught at Glasgow School of Art from 1979. A close colleague of Bellany, they were travelling companions to East Germany. Moffat is now best known for his portraits of writers and artists, but his *Historical Landscape with Gatehouse* (1990), showing a blood-red railway line disappearing to an all-too familiar shaped building is clearly Auschwitz without a name. It was one of series of works he made about the political changes in Eastern Europe at the time, this one looking back, perhaps as a warning to the present.[37]

Of the numerous artists who have re-visited the scenes of the Second World War in Europe, few have done so as comprehensively as Joyce W. Cairns. Born in Edinburgh in 1947, she studied at Gray's School of Art, Aberdeen, where she later taught for many years. Much of her work is autobiographical, her *War Tourist* series first following her father's footsteps in the Second World War. She then travelled beyond his War, first on a 'Third Reich Tour', and then on to Poland.

Her *Polish Journey* (1998) was her Diploma Work for the Royal Scottish Academy. The artist describes it herself:

The main figure wears the father locket and holds a poppy wreath in memory of the murdered children of Treblinka, Terezin, Auschwitz and particularly Majdanek, where there was an area of the camp specifically for children. The dolls come mainly from Majdanek, along with the tin of Zyclone B crystals, used to gas the prisoners. The doll

with the suitcase was in the museum at Terezin and the address on the case was taken from one of many piled up in Auschwitz.[38]

All the figures have a doll-like quality: innocence and vulnerability in the hands of murderers. The hands are folded discreetly, as in Bellany's *Pourquoi?*, and the manic figures that appear in the work of German inter-war artists are turned into harmless, soft figures. The artist herself seems overwhelmed, wondering how to react to it all.

LOOKING BACK AT THE CENTURY'S END

Ian Hamilton Finlay (1925–2006) appeared in the last chapter, making war on Strathclyde Region and creating artworks on a war theme at Little Sparta (see p.197). But one rather interesting work in another garden shows him as a metaphorical bringer of peace. During the Second World War, a substantial shed for the Auxiliary Territorial Service was built in the grounds of the Dean Orphanage, Edinburgh. The Orphanage and its grounds now comprise one site of the Scottish National Gallery of Modern Art, known today as *Modern Two*. The allotments, once the kitchen garden, are still in use by the Dean Allotments Association, and the shed is used by the allotment holders. In the late 1980s the Allotments Committee commissioned Finlay to produce a series of plaques to be fixed to the shed wall: Finlay obliged, and also advised on the colours of the shed door and roof, which were upgraded at the same time. The plaques are the 'Seven Idylls', the words carved (by Michael Harvey) on slates fixed to the walls.[39] The interior of the hut retains some vestiges of its earlier use, and even if not quite 'swords to ploughshares', the building has gone from 'tanks to wheelbarrows'.

Memories were celebrated more specifically in

OPPOSITE.
Terraces No. 2, 2003. Mixed media on board, 90 × 120 cm. Private collection

OVERLEAF LEFT.
John Bellany, *Pourquoi?*, 1967. Oil on board, 199.8 × 212.3 cm. The Artist's Estate

OVERLEAF RIGHT.
Joyce W. Cairns, *Polish Journey*, 1998. Oil on board, 174 × 172 cm. Royal Scottish Academy

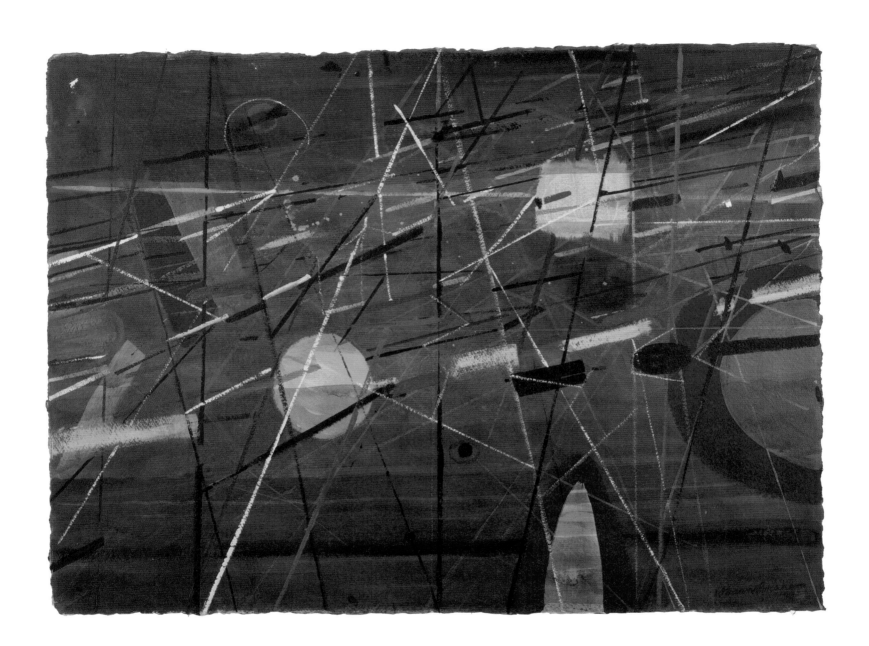

1995, the 50th anniversary of the end of the Second World War. That year, May Day Bank Holiday was moved a week later for the purpose of commemorations. Wilhelmina Barns-Graham, who had returned to live mainly in Scotland, was entering the most productive phase of her creative life, and she described in her diary on 16 May 1995 her 'purple celebration night acrylic on paper', the searchlights of the War and the joyfulness of celebration mixed together in one composition.

POSTSCRIPT

New memorials continue to be set up in Scotland. Notable individuals have died, such as Colonel Sir David Stirling (1915–1990), founder of the SAS, whose statue by Angela Conner was erected near Doune in 2002. Some new memorials rectify past lack of recognition, for example the statue by Malcolm Robertson for the Women's Timber Corps (in the Queen Elizabeth Forest Park near Aberfoyle, unveiled in 2007), or Peter Naylor's memorial for the Land Girls (at Fochabers, unveiled in 2012).

There are various civic memorials too, such as the monument commemorating the 528 Scottish civilians killed during the Clydebank Blitz, unveiled in 2009. In 2013 the Lord Provost of Glasgow unveiled a memorial stone in honour of the 602 (City of Glasgow) Squadron Auxiliary Air Force, near the Normandy Veterans' Memorial at Kelvingrove, belatedly fulfilling a pledge by the Lord Provost, Sir Patrick Dollan (see p.128), reported as saying in 1941 that the city should one day provide a suitable memorial to their gallantry. And there are many, many more.

There are new regimental memorials too, such as the Gordon Highlanders Memorial in Aberdeen, unveiled in 2011. This is a particularly interesting figurative sculpture, for it features two Gordon High-landers, one from the early days of the regiment, and the other from its closing years before amalgamation with The Queen's Own Highlanders (Seaforths and Camerons) to form The Highlanders. There have also been many new memorials on the continent too, quite a number of which have been organised by individuals or groups of enthusiasts, a notable example being the Contalmaison Cairn erected in 2004 to 'Macrae's Battalion', 16th Royal Scots.[40]

The British have erected various memorials to animals, and two prominent examples in Scotland are both twenty-first-century creations. The first is the statue of Bamse, a 14-stone St Bernard, who became the global mascot for the Royal Norwegian forces (and who also won a posthumous PDSA Gold Medal for Gallantry); a bronze sculpture of him by Alan Herriot now stands on the seafront of Montrose (unveiled 2006). And a sculpture is being made by the same artist of Wojtek, the large Syrian bear adopted by the Polish army, who served with them in Italy at the Battle of Monte Cassino and saw out his days in Edinburgh Zoo.[41] This is to be placed in Edinburgh's Princes Street Gardens.

Many monuments and memorials have been restored, and one – the Commando memorial – draws so many Commandos back that in 2012 the site has had to be expanded due to the number of tributes laid and ashes scattered. But public attitudes to traditional memorials have changed, and less respect is shown for many of them. A traffic cone usually sits on the head of the Duke of Wellington statue in Glasgow (with a public campaign to keep it there), and the pedestal of Wellington's statue in Edinburgh is often draped with a Scottish Socialist Party banner. Theft is also becoming common, with the rising value of metal. In the mid-1990s a bronze statue was stolen from the top of the war memorial at East Wemyss, Fife, later retrieved when police raided a house in Halifax. But in 2013 it was stolen again. Local people

OPPOSITE.
Wilhelmina Barns-Graham, *Celebration (VE Night)*, 1995. Acrylic on paper, 58 × 75.8 cm. The Barns-Graham Charitable Trust

offered a reward for its safe return, and it was found abandoned a few miles away.

However, some things are changing for the better. Most towns, cities and villages in Scotland have been collating their memories over the past decade, often accompanying a local exhibition and oral recording project, involving children who are being made more aware about the twentieth century's wars than their parents' and grandparents' generation ever were. In 2013 a Centenary Memorials Restoration Fund was announced, to clean and restore memorials during the centenary period of the First World War, 2014–18.[42]

Individuals are also being re-commemorated in a variety of ways. The shipyards painted by Stanley Spencer have been re-visited by artist Mark Neville in a film commissioned by Tramway, Glasgow, entitled *The Ghost of Stanley Spencer Watches over Me* (2006).

Elsie Inglis was commemorated on a series of banknotes issued by the Clydesdale Bank (2009). The artist John Bellany became interested in Elsie Inglis (prompted by his own stays in hospital for a liver transplant) and his work inspired by her life has been exhibited internationally.[43]

In 2013, Michael Ladd, the former Mayor of Southwold, issued a formal apology to the Charles Rennie Mackintosh Society for Mackintosh's arrest as a 'spy' in the First World War, concluding 'We are now very proud of our association with this great architect and his wife.' The apology has prompted the Charles Rennie Mackintosh Society to include Walberswick and Southwold on its Mackintosh Trail.[44]

New books, and new types of re-telling, constantly revise our knowledge and perceptions of the wars of the twentieth century. Several, such as Dan Todman's *The Great War: Myth and Memory* (2005), look at the way the War has been remembered and the myths that have been created. There is greater interest in the experiences of ordinary participants, which is being met by studies such as Anthony Fletcher's *Life, Death and Growing Up on the Western Front* (2013), and books which approach history in new formats.

Also recently, Earl Haig's reputation has been under discussion again. In 1995 the Douglas Haig Fellowship was formed to commemorate and study Haig's life and the forces he commanded, and anyone can now air their views on his life and legacy, on George A. Webster's daily 'Haig's War' twitter.

Using a more traditional medium, *The Great Tapestry of Scotland* (2013) includes many episodes of war in the twentieth century within its visual account of Scotland's history.[45]

There has also been further looking-back to a completely vanished world. The Glaswegian artist A. E. Haswell Miller (1887–1979) studied at Glasgow School of Art 1906–9, and then in Paris, Vienna, Munich and Berlin. He was fascinated by uniforms, and on trips to the continent had recorded the full-dress uniform of European armies in the knowledge that these might soon be the stuff of history. British and Empire soldiers seen in Glasgow at the time of the Great Exhibition of 1911 also inspired his art. He continued to sketch and paint while serving with the 7th (Blythswood) Battalion of the Highland Light Infantry in Gallipoli, Palestine and France; he rose to be a Captain, and won the Military Cross. His portraits were shown at the Royal Academy, London, and the Royal Scottish Academy, but his fame today rests on his prints and drawings of British (especially Scottish) military uniforms, and also of the European drawings that remained unpublished until 2009, when (at the behest of the Army Museums Ogilby Trust) they appeared with the title of *Vanished Armies*. Akin to this exercise in retrospection, the posthumous publication of the paintings of Lieutenant-Colonel Olaf MacLeod, a book titled with a biblical quotation, *Their Glory Shall Not Be Blotted Out*, comprises an evocative series of images illustrat-

ing the last full-dress uniforms of the old British Army before it was destroyed in 1914–15.[46]

The poppy continues as a symbol of mourning (despite a 'white' poppy pacifist reaction). Alexander Stoddart, Her Majesty's Sculptor in Ordinary in Scotland, recently made a new sculpture to replace William Birnie Rhind's eroded figure of *History* on the Scottish National Portrait Gallery (1893). Stoddart has explained:

> It is very far away from the viewer, but there are details on it that attest to it having paid homage to the dead of the Great War. My notion was that this would be a figure of History which, unlike the one before it, was 'aware' of the calamity to come, and now looked back upon that war that changed everything forever and heralded the destruction of western culture in its eventual aftermath in the rise of the Third Reich. Accordingly, this new History figure has been given a wreath of poppies – just for this purpose.[47]

But even the enduring poppies change with the times. The organisation running Lady Haig's Poppy Factory is now called Poppyscotland. The designs of its varied merchandise are constantly changing to meet modern styles and can be bought via its website, and its chimney now boasts both a poppy and a mobile phone mast.

Notes

INTRODUCTION

1 Edward Gage, *The Eye in The Wind: Scottish Painting since 1945* (London 1977), p. 11.
2 These and other points are discussed in my article, 'Scottish War Art and Artists of the 20th century: Why So neglected?', *Journal of the Scottish Society for Art History*, vol.19 (2014–15).
3 *The Letters of Charles Sorley: with a Chapter of Biography* (Cambridge 1919), p. 253.

CHAPTER 1

1 These points are made by Peter Harrington in his overview of the subject, *British Artists and War: The Face of Battle in Paintings and Prints, 1700–1914* (London 1993), pp. 249–50.
2 [Konody], *Modern War Paintings by C.R.W. Nevinson*, with an essay by P.G. Konody (London 1917), p. 13.
3 Harrington, *British Artists and War*, pp. 275–6.
4 David Octavius Hill and Robert Adamson, *92nd Gordon Highlanders at Edinburgh Castle*, 1846. Calotype. SNPG (PG HA 347).
5 Elizabeth, Lady Butler, *An Autobiography* (London 1922), p. 186. See also Paul Usherwood and Jenny Spencer-Smith, *Lady Butler: Battle Artist: 1846–1933*, exh. cat. NAM (London 1987), cat.36, pp. 81–5.
6 William Simpson, *Balaclava 1854: Commissariat Difficulties*, watercolour on paper, 27.0 × 41.9 cm, Anne S. K. Brown Collection, Brown University Library (GB-O1854mf-3).

7 Two publications by John Hannavy discuss Victorian and Edwardian photography and war coverage with numerous illustrations: *The Victorians and Edwardians at War* (Oxford 2012) and *The Way We Were: Victorian and Edwardian Scotland in Colour* (Dunbeath 2012).
8 James Craig Barr, *Home Service: The Recollections of a Commanding Officer serving in Great Britain during the War, 1914–1919* (Paisley 1920), p. 14. Reference provided by Trevor Royle.
9 *The Times*, 14 November 1854.

CHAPTER 2

1 The only monograph on the artist is *Paintings by Patrick W. Adam, RSA*, with introduction and biographical note by Patrick J. Ford (Glasgow 1920); his *War* is not discussed. However, a painting entitled *Interior – War* was exhibited at the Royal Glasgow Institute of the Fine Arts in 1916 (no. 273).
2 Angus Konstam, *There Was A Soldier: First-hand Accounts of the Scottish Soldier from 1707 to the Present Day* (London 2009), pp. 169–70.
3 Tom Hewlett and Duncan Macmillan, *F.C.B. Cadell: The Life and Works of a Scottish Colourist, 1883–1937* (Farnham 2011), pp. 59–60. See also Alice Strang, *F.C.B. Cadell*, NGS (Edinburgh 2011) for a well-illustrated survey of Cadell's work.
4 George Ogilvy Reid, *1914: The Belgians on the March*, oil on canvas, 121.9 × 167.6 cm. Glasgow Museums (2085).

5 Information on poster, IWM (ART PST 10951).

6 James W. Herries, *Tales from the Trenches: Incidents of the Allies' Campaign, with Some War-Time Impressions of France and the French* (London and Edinburgh 1915), p. 34. Several artists mention Belgian refugees in Paris and the emergency centres set up for them; in 1919 John Lavery painted *The Women's Emergency Canteen, Gare du Nord, Paris*, for the Women's Work collection of the IWM, oil on canvas, 53.3 × 64.7 cm, (ART 2890).

7 Lady Cynthia Asquith, *Diaries, 1915–1918* (London 1968), p. 487 (and p. 12, 28 April 1915, 'Eliza Wedgwood came to tea ... I gave her some clothes for the Belgians').

8 Presented in 1918 by Violet McHutchen. A relative of Adam, and a native of Edinburgh, she had married the Finnish industrialist Ossian Donner.
The couple fled to Britain during the War; Donner later became Ambassador to Britain for the newly-independent Finland.

9 William Strang, *Belgian Peasant Girl*, 1914–15, Manchester City Art Gallery (1915.2), and *Italian Girl*, East Dunbartonshire Council (MINAG:1984.70).

10 Jennifer Melville, *Pittendrigh Macgillivray, 1856–1938, artist*, exh. cat. Aberdeen Art Gallery & Museums (Aberdeen 1988), p. 36, cat. 31, Aberdeen Art Gallery & Museums (ABDAG004676).

11 Hewlett and Macmillan, *F.C.B. Cadell*, p. 62.

12 Melville, *Pittendrigh McGillivray*, p. 38, no. 33, repro. p. 25: bronze, signed and dated 'Macgillivray 1914', Aberdeen Art Gallery & Museums.

13 Melville, *Pittendrigh Macgillivray*, p. 38, no.34, repro. p. 24. p. 38, bronze, signed, inscribed and dated 'Macgillivray 1915 / The Wife of Flanders 1914 / You have lost your spurs', Glasgow Museums.

14 Melville, *Pittendrigh Macgillivray*, p. 26.

15 Selwyn Image: *Letters* (London 1932), p. 155, to Alderson Horne, proprietor of *The Londoner*.

16 Selwyn Image, *Art, Morals and the War: a lecture delivered in the Ashmolean Museum, Oxford, on Thursday, November 12, 1914* (Oxford 1914), pp. 17 and 18.

17 Selwyn Image, *Letters*, pp. 164–5, to W.H. Ansell, from a London address.

18 John Ferguson, *The Arts in Britain in World War 1* (London 1980), p. 29.

19 Noted by W. P. Mayes, 'The Origin of an Art Collection', unpub. account, 1961, IWM 97(41).961, Introduction, p. 1.

20 Sylvester Bone, *Sir Muirhead Bone: Artist and Patron* (London 2009), p. 83.

21 Keith Nicholson, 'The Artist and the Book – Conversations with Keith Henderson', *Antiquarian Book Monthly Review*, November 1975, pp. 18–28; quotation p. 25.

22 Mayes, 'Origin of an Art Collection', p. 10. Details in IWM archives (mainly ART/WA1/046).

23 Mayes, 'Origin of an Art Collection', p. 15, including material from Wellington House file (G 4014/27).

24 Photograph by Ernest Brooks: *Mr Muirhead Bone sketching the shrine of the Virgin at Montauban, 21 September 1916* (IWM Q3110); and *Mr Muirhead Bone sketching Becordel, 21 September 1916* (IWM Q 3111).

25 Mayes, 'Origin of an Art Collection', p. 15.

26 *Collected Letters of Wilfred Owen*, edited by Harold Owen and John Bell (Oxford 1967), p. 429, 19 January 1917.

27 Christopher Harvie, *No Gods and Precious Few Heroes: Twentieth-century Scotland* (first pub. 1981, this edition Edinburgh 1998), pp. 10, 15–17.

28 *The Young Rebecca: Writings of Rebecca West 1911–17*, selected and introduced by Jane Marcus (London 1983), pp. 380–3, 'The Cordite Makers', article pub. *Daily Chronicle*, 1916; quotation pp. 382–3.

29 Its history is told today in the Devil's Porridge Exhibition, Annan.

30 Kathleen Palmer, *Women War Artists*, Tate & IWM (London 2011), p. 27 (overview) and p. 81 (Airy).

31 NMS, watercolour on paper, 42.3 × 51.2 cm (M.1999.44).

32 John Lavery, *The Life of a Painter* (London 1940), p. 148.

33 Oil on canvas, 302.5 × 243.5 cm, National Gallery of Canada, Ottawa (WA-40), painted February–March 1919; exh. Canadian War Museum, Ottawa, July–August 1920.

34 Charcoal and black chalk, 38.4 × 58.0 cm. BM (1919,0208.79).

35 Merion and Susie Harries, *The War Artists: British Official War Art of the Twentieth Century* (London 1983), p. 34. Noted by Kenneth McConkey, *John Lavery: A Painter and His World* (first pub. 1993, this edition Edinburgh 2010), p. 137; McConkey's book gives the fullest account of Lavery's war work within the context of his career.

36 For a biographical account, see Roger Quarm and John Wyllie, *W.L. Wyllie: Marine Artist 1851–1931*, Chris

Beetles Gallery (London 1988). A selection of Lavery's war paintings from the IWM, relating to the sea, were shown 2011–12 in the exhibition *War at Sea*, SNPG.

37 Trevor Royle, *The Kitchener Enigma* (London 1985), pp. 362–77.

38 *Airship R34*, oil on canvas, 86 × 116 cm, coll. West Dunbartonshire Libraries and Cultural Services (WDBCS.2005.1057), and *R34 and R29 in the Shed at East Fortune, 1919*, oil on canvas, 60.9 × 91.4 cm, IWM (ART 4086).

39 Hulton Getty images, shown on SCRAN website (ref. H 9334). This vessel was not, as has sometimes been claimed, the first ever aircraft carrier.

40 Examples in exh. cat., Bourne Fine Art, Edinburgh (2013), *Scottish Pictures of the Twentieth Century*.

41 Harrington, pp. 304 and 308–9; *The Charge of The Scots Greys at St Quentin* is illustrated on p. 309.

42 Discussed by Samuel Hynes, *A War Imagined: The First World War and English Culture* (London 1990), p. 34.

43 [Konody], *Modern War Paintings*, pp. 13–14.

44 Details of the work are discussed in Michael J. Walsh, *C.R.W. Nevinson: This Cult of Violence* (New Haven and London 2002), cat. 17.

45 A study for *Shellburst*, pencil on paper, 33.6 × 38.1 cm, is held by the City Art Centre, Edinburgh Museums and Galleries (CEC 10/1979).

46 Robertson, *Cartwheels*, oil on canvas, 103 × 144 cm, SNGMA (GMA 4820).

47 John Kemplay, *The Two Companions* (Edinburgh 1991), p. 61.

48 Oil on canvas, 67.0 × 54.0 cm (private coll.), shown in the exhibition *Remembering the Great War*, SNPG 2014–15.

49 Asquith, *Diaries*, p. 171.

50 James Fox, '"Fiddling while Rome is burning": Hostility to Art During the First World War, 1914–18', *Visual Culture in Britain*, vol. 11, no.1, March 2010, pp. 49–65; quotations pp. 50 and 54.

51 Hewlett and Macmillan, *F.C.B. Cadell*, p. 74.

52 Hiram Sturdy, 'Illustrated account (c.1934) of his service on the Western Front with the Royal Regiment of Artillery (including 29th, 33rd and 31st Divisions) together with an illustrated MS novel of the Western Front in the First World War', Private Papers of Hiram Sturdy, IWM (Documents 3899).

53 Trevor Royle, ed., *In Flanders Fields: Scottish Poetry and Prose of the First World War* (Edinburgh 1990), pp. 184–6; quotation p. 186.

54 Another of Martin's full-size pictures relating to the First World War (and his best known, in the form of a print) is *Through*, held by the Royal Signals Museum; the squared-up sketch for it is held by the Scottish National War Museum (M2003.36, f.37).

55 Drawings in RSA Archive, brought to my attention by Sandy Wood, RSA Collections Curator. Gillies's work for the Scottish National War memorial is noted in Duncan Macmillan, *Scotland's Shrine: The Scottish National War memorial* (Farnham 2014), p.76. His artistic debt was noted in the draft of a speech for the Diploma ceremony at Glasgow School of Art in 1970, quoted by Joanna Soden and Victoria Keller, *William Gillies* (Edinburgh 1998), p. 22. A comment by Gillies was also recorded by T. Elder Dickson Elder, *W.G. Gillies* (Edinburgh 1974), p. 12: 'There was no one to discuss art with, no opportunity to keep your hand in. I did an occasional portrait sketch or a pencil scribble of trenches and war-blasted landscapes – that was all. It was two years of wasted time.'

56 *Adam Bruce Thomson: Painting The Century*, exh. cat. The Scottish Gallery, Edinburgh (2013).

57 J. W. Herries, *I Came, I Saw* (Edinburgh 1937), pp. 64–5.

58 Keith Henderson, *Letters to Helen: Impressions of an Artist on the Western Front* (London 1917), p. 49.

59 Henderson, *Letters to Helen*, pp. 92–3.

60 Stanley Cursiter, *Looking Back: A Book of Reminiscences* (Edinburgh 1974), p. 11.

61 Examples are illustrated in Gary Sheffield, *The First World War in 100 Objects* (London 2013), pp. 132–3.

62 See Jane Carmichael, *First World War Photographers* (London and New York 1989), for a general discussion of this subject.

63 C.W. Burrows, intro. Vice-Admiral F.S. Miller, *Scapa and a Camera: Pictorial Impressions of Five Years spent at the Grand Fleet Base* (London 1921).

64 *Cathedral Gateway, Ypres, 1917*, pencil and watercolour on paper, 20.5 × 12.9 cm, signed and dated Fred A. Farrell / 23 Dec. 1917; inscribed bottom left: 'Cathedral Gateway, Ypres' (GMA 695).

65 See *Fred A. Farrell: Glasgow's War Artist*, exh. cat. Glasgow Museums (Glasgow 2014) for a biography and updated survey of his work.

66 Eric Robertson, *Poilly*, dated 1918, watercolour, 28.5 × 22.3 cm, with Bourne Fine Art, Edinburgh, in 2013.

67 Keith Henderson, *Letters to Helen*, pp. 84–6, 12 December 1916; quotation p. 85.

68 Bill Smith and Selina Skipwith, *A History of Scottish Art*, The Fleming–Wyfold Art Foundation Collection (London 2003), p. 156.

69 Chalk carving made by Sergeant J. McIntyre of the 8th Battalion The Black Watch, 15 × 14 × 3 cm, The Black Watch Museum, Perth (A2039).

70 A summary history of Stobs camp is provided in Kevin Munro, *Scotland's First World War*, Historic Scotland (Edinburgh 2014), pp.86-9. Derek Robertson's extensive research on the camp is published online under 'Stobs Military Camp'.

71 For details of Lee's life see Bob Burrows, *Fighter Writer: The Eventful Life of Sergeant Joe Lee, Scotland's Forgotten War Poet* (Derby 2004).

72 Lady Randolph Churchill, ed., *Women's War Work* (London 1916), various references.

73 The paintings were given to the Duchess by the artist, and descended through the Sutherland family. All were painted *en plein air*, oil on panel, 21.5 × 27.2 cm, and each is signed, inscribed and dated. On sale with Abbott & Holder, London; now Florence Nightingale Museum, London, and shown as *The Hospital in the Oatfield – The Art of Nursing in the First World War* (2014).

74 For biographical details of Inglis, see Leah Leneman, *In the Service of Life: the Story of Elsie Inglis and the Scottish Women's Hospitals* (Edinburgh 1994), and Leah Leneman, *Elsie Inglis, Founder of Battlefield Hospitals run entirely by women* (Edinburgh 1998). For Royaumont's history, see Eileen Crofton, *Women of Royaumont* (East Linton 1997).

75 *Hôpital Auxiliaire d'Armée 301 – Abbaye de Royaumont*, 1918, oil on canvas, 71 × 98 cm, coll. Argyll and Bute Council (ABMUS 1998.2), probably exhibited at the RSA in 1921 as *Hospital in France – 1918* (cat. 286). The story of the paintings is also described by Mary Jane Selwood, on the *Helensburgh Heritage* website. See Kathleen Palmer, *Women War Artists*, p. 41, for the WWS interest in female doctors.

76 McConkey, *John Lavery*, p. 125.

77 The kilt was chosen as one of the *100 Items from the First World War* by Gary Sheffield, pp. 154-7.

78 McConkey, *John Lavery*, p. 125, quoting *The Studio*, vol. LXV, 1915, p. 25.

79 Asquith, *Diaries, 1915–1918*, p. 43, 15 June 1915 (quoted by McConkey, *John Lavery*, p. 125).

80 Pat Barker, *Regeneration* (London 1992).

81 *Collected Letters of Wilfred Owen*, pp. 472 and 476.

82 *Collected Letters of Wilfred Owen*, pp. 490, 497 and 498–9.

83 Kemplay, *The Two Companions*, p. 46.

84 Noted by Jack Firth in exh. cat., Aitken Dott, Edinburgh, 'The Edinburgh School': *An exhibition of painting by graduates and teachers of Edinburgh College of Art 1909–1990* (Edinburgh 1993).

85 Margaret Sackville, *Pageant of War* (London 1916); 'Nostra Culpa' pp. 36–9; quotation p. 36. Her brother was Gilbert Sackville, 8th Earl De La Warr. Portrait by Henry Lintott, *Lady Margaret Sackville*, oil on canvas, 76.10 × 63.40 cm, SNPG (PG 3401).

86 Butler, *An Autobiography*, opposite p. 332.

87 *The Times*, London, 17 June 1915.

88 *18 June, 1915: The Centenary of the battle of Waterloo: How it was commemorated in certain places in England, Scotland, Ireland, & Wales by The Royal Regiment of Artillery*, by Major J. H. Leslie, R.A. (Woolwich, Feb. 1916), pp. 1, 2 and 4.

89 *The Scotsman*, 19 June and 21 June 1915.

90 Sir Ian Standish Monteith Hamilton, *Gallipoli Diary* (London 1920), 2 vols, 1, p. 69.

91 Butler, *An Autobiography*, p. 321.

92 Butler, *An Autobiography*, pp. 325 and 327, 30 September and 2 October 1914.

93 Martin Hardie, *War Posters Issued by Belligerent and Neutral Nations 1914–1919* (London 1920), p. 1.

94 Lieut. Leonard J. Smith 1915–18: folder labelled 'Various 51 Sigs caricatures done at Div. Sigs Hqs early 1918. L. J. S.', NLS MS 10796.

95 Information provided by Nico Tyack, Museum of Edinburgh; the card is one of a collection of family items relating to the First World War.

96 Hewlett and Macmillan, *F.C.B. Cadell*, p. 81.

97 Richard Scott, *Artists at Walberswick: East Anglian Interludes 1880–2000* (Bristol 2002), pp. 65–6.

98 Roger Billcliffe, *Charles Rennie Mackintosh: The Complete Furniture, Furniture Drawings & Interior Designs* (first pub. 1979, this edition Moffat 2009), pp. 295–300. Perilla Kinchin's accounts of Glasgow tea rooms also give the patron's side of the venture, e.g. *Miss Cranston*, NMS (Edinburgh 1999), pp. 80–1.

99 David Boyd Haycock, *A Crisis of Brilliance: Five Young British Artists and the Great War* (first pub. 2009, this edition London 2010), pp. 195 and 211, notes both the general reactions of artists and several individual responses.

100 Discussed in the context of Fergusson's career by Alice Strang, Elizabeth Cumming and Sheila McGregor in *J. D. Fergusson* exh. cat. NGS (Edinburgh 2013); specific reference is made pp. 20–21.

101 Drawings relating to these paintings were recently on sale with Alexander Meaddowes, Edinburgh, '*Unseen Works' by The Scottish Colourist John Duncan Fergusson (1874–1961)*, cat. notes by Elizabeth Cumming, 2013–14, nos 86 (f) and 86 (j).

102 Both illustrated in Strang, Cumming and McGregor, *J.D. Fergusson* (2013) cats 32 & 33. Fergusson's call-up, exemptions and correspondence are held in IWM (ART/WA1/238 and file ref. 216/6).

103 J.D. Fergusson, *Modern Scottish Painting* (Glasgow 1943), pp. 98–9.

104 Of the numerous publications on this subject, two are particularly relevant: William H. Marwick, 'Conscientious Objection in Scotland in the First World War', *Scottish Journal of Science*, June 1972, vol. 1, part 3, pp. 157–64, which discusses Scots transferred to England (p. 158), and to work centres at Ballachulish and Dyce (p. 159); and Will Ellsworth-Jones, *We Will Not Fight: The Untold Story of World War One's Conscientious Objectors* (London 2008), which gives a good account of the movement, but with little mention of Scotland.

105 Janet Barnes, *Percy Horton 1879–1970: Artist & Absolutist*, exh. cat. Sheffield City Art Galleries (Sheffield 1982), p. 10.

106 See Patrick Elliott, *William McCance 1884–1970*, NGS (Edinburgh 1990) for a critical biography.

107 Photograph, Aberdeen Art Gallery & Museums (ABDAG000686.93).

108 John Russell Taylor, *Bernard Meninsky* (Bristol 1990), p. 39. In 1919 Meninsky was elected to The London Group. After a chaotic personal life he committed suicide in 1950; his memorial exhibition (Arts Council 1951–2) included none of his war paintings.

109 William Johnstone, *Points in Time: An Autobiography* (London 1980), pp. 49–50. Summarised by Douglas Hall in *William Johnstone* (Edinburgh 1980), p. 6.

110 Herries, *I Came, I Saw*, pp. 10 and 11.

111 Herries, *I Came, I Saw*, p. 9.

112 Lavery, *Life of a Painter*, p. 146.

113 For detailed accounts see Dan Van der Vat, *The Grand Scuttle: the Sinking of the German Fleet at Scapa Flow in 1919* (first pub. 1982, current edition Edinburgh 2007); and S.C. George, *Jutland to Junkyard: The Raising of the Scuttled German High Seas Fleet – The Greatest Salvage Operation of All Time* (first pub. 1973, current edition Edinburgh 1999).

114 A drawing by Gribble is reproduced by S C. George, *Jutland to Junkyard*. He painted at least one other oil version of the subject, *Scapa Flow: 21 June 1919*, 1920, oil on canvas, 125.7 × 181.5 cm, Harris Museum & Art Gallery, Preston (PRSMG: P266).

115 Some of Gribble's description is quoted by W.S. Hewison, *This Great Harbour: Scapa Flow* (first pub. 1985, this edition Edinburgh 2005), p. 135 and n. 12.

116 Discussed in Maria Tippett, *Art at the Service of War: Canada, Art and the Great War* (Toronto 1984), p. xi.

117 *Colour Magazine*, August 1918, vol. 9, no. 1, p. 1; and vol. 9, no. 2, with cover 'Special Canadian War memorials Number' and an article by Konody pp. 25–41; quotation p. 26.

118 Mayes, 'Origin of an Art Collection', pp. 39–41.

119 Etching on paper, 17.7 × 22.5 cm, dated (GMA 4298).

120 Bill Smith, *D.Y. Cameron, A Vision of the Hills* (Edinburgh 1992), pp. 81–4.

121 Hewlett and Macmillan, *F.C.B. Cadell*, pp. 164 and 169.

122 Oil on canvas, 49.5 × 59.5 cm, Dudley Museums Service (1937/217), purchased 1927.

123 See Tom Normand, *The Modern Scot: Modernism and Nationalism in Scottish Art, 1928–1955* (Aldershot 2000) in his chapter 'William McCance and Scottish Modernism', pp. 65–97.

124 William McCance, 'Idea in Art', *The Modern Scot*, vol. 1, no. 2, summer 1930, pp. 13–16; quotation p. 16.

125 Watercolour on card, 54.5 × 74.2 cm, University of St Andrews Museum Collections (HC943).

126 Hiram Sturdy papers, notebook 8, 'Aftermath', NLS DEP 279.

127 For detailed discussion see Dan Todman, *The Great War: Myth and Memory* (London 2005), and Stephen Heathorn, *Haig and Kitchener in Twentieth-century Britain: Remembrance, Representation and Appropriation* (McMaster 2013) which includes 'Haigiography' [sic]. Josh Brooman's *General Haig: Butcher or War Winner?* (Harlow 1998), written for children, poses 'for and against' arguments.

128 Gary Sheffield, *100 Objects*, pp. 42–3. The 'Sir Douglas Haig Toby Jug' has also been selected by John Hughes-Wilson, *A History of the First World War in 100 Objects* (London 2014), pp. 356–9.

129 Painted 1922, oil on canvas, 299.7 × 528.3 cm, SNPG (1954).

130 John Stansfeld, *The People's Sculptor: The Life and Art of William Lamb (1893–1951)* (Edinburgh 2013).

131 Website, *University of Edinburgh: Edinburgh's War*: Text and images by H.R. Jack, 2012.

132 Information from NMS.

133 G.V. Carey and H.S. Scott, *An Outline History of the Great War* (Cambridge 1928), Preface and pp. 259–62.

CHAPTER 3

1 Robert Graves and Alan Hodge, *The Long Week-end: A Social History of Great Britain, 1918–1939* (London 1940).

2 *Escape, Air Raid, Spain* (BGT1257) is discussed by Lynne Green, *W. Barns-Graham: a studio life* (first pub. 2001, this edition Farnham 2011), pp. 47–8. *Spanish Elegy*, acrylic on Arches paper, 57 × 77 cm, Fleming–Wyfold Collection (FWAF/RF978) was perhaps inspired by the series of *Elegies to the Spanish Republic* by the American Abstract Expressionist painter Robert Motherwell, an artist Barns-Graham much admired; see Smith and Skipwith, *A History of Scottish Art*, p. 179 (repro.). William O. Hutchison exhibited *Spanish Refugees, 1938* at the RSA in 1945.

3 The portrait had been started in peacetime, the rose in the sitter's cap and the LDV armband added in 1939. An account of the Home Guard is given in Brian D. Osborne, *The People's Army: the Home Guard in Scotland 1940–44* (Edinburgh 2009).

4 For details of Baird's life, see Patrick Elliott, *Edward Baird 1904–1949*, NGS (Edinburgh 1992) which includes photographs of Davidson's portrait in progress; and Jonathan Blackwood, *Portrait of a Young Scotsman: A Life of Edward Baird, 1904–1949*, exh. cat. Fleming Collection (London 2004).

5 Edward Baird, *Still Life*, 1940, oil on canvas, 45.90 × 61.00 cm, SNGMA (GMA 3535).

6 Alice Strang, *Consider the Lilies: Scottish Painting 1910–1980 from the Collection of the City of Dundee*, exh. cat. McManus Galleries, Dundee City Council with NGS (Dundee 2006), p. 96 and n. 37, quoting an interview with James McIntosh Patrick, *Dundee Courier*, 1967.

7 Probably the painting Hutchison exhibited at the RSA in 1943 as *Home Guard* (141).

8 Robert Sivell, *Dehydration of Herrings*, 1943, oil on canvas, 76.2 × 106.7 cm, Glasgow Museums (2769).

Presented by the WAAC through the IWM in 1948.

9 Alan Davie, *Self-Portrait [Opus D.11]*, 1939, pencil on paper, 39.00 × 26.90 cm (GMA 4255). Drawing of soldier not included here: *Gunner Finch*, dated 8 February 1942 (GMA 4258).

10 The portrait is inscribed 'To John Tonge from the above 1940' (National Portrait Gallery, London (PG 4872).

11 Keith Henderson, correspondence file 1940, IWM (ART/WA2/03/053).

12 Keith Henderson later wrote a memoir describing his Parisian years, *Till 21* (London 1970).

13 Works by Raphael Tuck and Sons Ltd. / 21 May 1941– 21 Jan 1942, IWM (GP/46/27/3).

14 Keith Nicholson, 'The Artist and the Book', pp. 18–28.

15 *Montrose*, 1940, oil on canvas, 36.0 × 50.6 cm, Aberdeen Art Gallery & Museums (HABDAG002162), presented by the Contemporary Art Society 1944.

16 Lyon & Turnbull, Edinburgh; subsequently with Sim Fine Art, London. The artist had been listed as William Macpherson, and the work misdated to June 1940; inscr: 'War Weapons Week / Paisley, Dec.1940 / Alex. Macpherson'.

17 Today Gourdie's work is best represented on two websites: *Artists' Footsteps*, Dumfries and Galloway Council, Cultural Services Department, and *Tom Gourdie's Gallery*.

18 Thomas Gourdie file, IWM (ART/WA2/03/419).

19 *Art and Industry*, Studio publications, London, March 1943, pp. 73–81, 'Artists in Uniform: The Artist, now in the Armed Forces, keeps his hand in'; and March 1944, pp. 90–1, 'Artists in Uniform: L.A.C. Tom Gourdie of the RAF'. Gourdie's obituary in *The Scotsman*, 20 February 2005, mentioned both his camouflage and map work.

20 Eadie's life and work is described in J.Y.K. Kerr, *Ian Eadie of Dundee: The Life and Work of a Scottish Artist* (pub. privately 2000).

21 *The Crescent in Wartime*, 1939, pastel, Dundee City Council (Dundee Art Galleries and Museums), (224, 1978). *The Scotsman*, 26 April 1940, described the oil painting as 'the best picture I have yet seen inspired by war conditions.'

22 Irene Young, *Enigma Variations: A Memoir of Love and War* (Edinburgh 1990), pp. 134–5.

23 White MSS, NLS Acc. 12886. Some of the Peter White material was published posthumously as *With the Jocks: A Soldier's Struggle for Europe 1944–45* (Stroud 2001).

24 Tom Harrisson, *Living Through the Blitz* (London 1976), pp. 252–65. Harrisson's Mass-Observation team, which had been sent to the Clyde to assess the industrial situation, submitted a report dated 7 March, six days before the bombardment began. An account of the bombing is given in John Macleod, *River of Fire: The Clydebank Blitz* (Edinburgh 2010).

25 *Bomb Crater, Knightswood,* oil on board, 50.5 × 60 cm, Glasgow Museums (PP. 1986.311).

26 Ian Fleming, *Air Raid Shelter*, 1940, etching, 15.6 × 21 cm; an example is held by Aberdeen Art Gallery (ABDAG000555).

27 James H. Whyte, 'The Modern Movement: A Painters' Symposium', in *The Modern Scot*, vol. 6, no.3, 1935, p. 247: an interview with Crawford, who mentioned specifically 'Giotto, Fra Angelico, Francesco, Rembrandt, El Greco'.

28 Glasgow Art Club, *Hugh Adam Crawford: Retrospective Exhibition*, exh. cat. with essay by Emilio Coia (1971), no.6. Information relating to the Royal College of Physicians and Surgeons of Glasgow provided by Carol Parry, Library and Heritage Manager.

29 *Teruel after the Bombardment*, watercolour and ink, 22.2 × 55.5 cm, RSA (1997, 153).

30 See Lesley Duncan, *James Miller RSA*, RSA (Edinburgh 1990), p. 26, in which the letter is transcribed. Correspondence in IWM (ART/WA2/03/118).

31 Miller's experience at Leith is detailed in a speech, recorded in his papers in NLS, and re-told by Sandy Wood in *Discover RSA*, vol. 95 (Spring 2014), p. 8; the resulting watercolour, entitled *'Whales': Constructing Pierheads for Mulberry Harbour*, 1944, is in IWM (ART LD 4137).

32 Correspondence in IWM (ART/WA2/01/008).

33 Haig Gordon, *Tales of the Kirkcudbright Artists* (Kirkcudbright 2006), pp. 71–4. The building later became Sivell's Bar; currently closed, the murals are formally listed and protected. Aberdeen Art Gallery holds studies and copies of the compositions.

34 Scottish Artists file, IWM (ART/WA2/01/008).

35 Correspondence file 'Suggestions by William McCance', IWM (ART/WA2/01/061).

36 Muirhead Bone, *Winter Mine-laying off Iceland*, 1942, oil on canvas, 127.9 × 160.6 cm, IWM (ART LD 1932).

37 S.J. Peploe, *Ceres, Fife*, oil on canvas, 38.5 × 31.5 cm (sight size), University of St Andrews, Museum Collections (HC 86). For a detailed history of the scheme see the chapter by Amy Dale, 'Recording Scotland' in *Recording Britain*, edited by Gill Saunders (first pub. 1990, this edition London 2011), pp. 177–203.

38 Barns-Graham, Diaries (not precisely dated), University of St Andrews, Special Collections (MS Dep. 32/4/1/2), ff. 61 and 87; and f. 114.

39 Stewart Carmichael, *Dundee from Old Steeple*, 1913, lithograph, 39.2 × 29 cm. University of St Andrews, Museum Collections (HC21), inscribed with title and date.

40 University of St Andrew, Special Collections, David Russell Papers (MS38515/2).

41 *Recording Britain*, edited with notes by Arnold Palmer (London 1946–9), 4 vols; and *Recording Scotland*, edited with notes by James B. Salmond (Edinburgh 1952).

42 Stanley Cursiter, *Looking Back*, pp. 26–7.

43 T.J. Honeyman, *Art and Audacity* (London 1971), pp. 11 and 82.

44 Benno Schotz, *Bronze in my Blood: The Memoirs of Benno Schotz* (Glasgow 1981), p. 158.

45 Honeyman, *Art and Audacity*, p. 100.

46 Wendy Ugolini has made a study of Italian Scots, her publications including *Experiencing War as the 'Enemy Other': Italian Scottish Experience in World War II* (Manchester 2011). Lesley-Anne Lettice, *'The People's War': St Andrews and the Home Front 1939–1945*, St Andrews Preservation Trust (St Andrews 2004).

47 Victoria Keller and Clara Young, *Alberto Morrocco* (Edinburgh 1993), p. 23 and pp. 30–1.

48 Keller and young, *Alberto Morrocco*, pp. 42–3.

49 Keller and Young, *Alberto Morrocco*, pp. 42–3; a cartoon is shown on p. 42.

50 Fiona Pearson, *Paolozzi* (Edinburgh 1999), p. 12.

51 David Foggie, *Grandmother Knits*, 1943, oil on canvas, 88.9 × 63.5 cm, Glasgow Museums (2358); exh. RSA 1943 (188) and purchased 1944. The verse probably first appeared in a newspaper, before being included in J. W. Herries, *Artists in Cages: and Other Light and Romantic Verse* (Edinburgh 1959), p. 19.

52 NLS MS Dep. 279/43. See Iain Gordon Brown, *Rax Me That Book: Highlights from the Collections of the National Library of Scotland* (London 2010), p. 42, which brought Sturdy's Second World War notebooks to my attention.

53 Personal papers of Francis P. Martin (family collection).

54 Artist's correspondence, IWM (ART/WA2/03/208).

55 Charcoal and pastel studies, Gray's School of Art, 68.2 × 85.2 cm (ABDRG11056a and b); oil study with Bourne Fine Art, 58.3 × 45.5 cm, sold 2013; and a pastel study, 51.7 × 36.6 cm, signed and dated 'J. Cowie 1941', Aberdeen Art Gallery & Museums (ABDAG003334).

56 *Hugh Adam Crawford: Retrospective Exhibition* (1971), Glasgow Art Club, p.4. For a biography of Dollan see Irene Maver, 'Dollan, Sir Patrick Joseph (1885–1963)', *Oxford Dictionary of National Biography* (first pub. Oxford 2004, online edition 2011).

57 Douglas Young wrote various polemics including *An Appeal to Scots Honour: A Vindication of The Right of the Scottish People to Freedom from Industrial Conscription and Bureaucratic Despotism under the Treaty of Union with England* (Glasgow 1944) and *When You reach the Polling-booth, Vote for Young and Scotland's Youth* (Kirkcaldy 1942). See also *A Clear Voice: Douglas Young, Poet and Polymath: A Selection from his Writing, with a Memoir*, edited by Clara Young and David Murison (Loanhead 1977).

58 Photographs in the IWM (H 4786 and 4788), October 1940. The legacy of the structure, no longer extant, is recorded by RCAHMS (NJ26SW 404).

59 Photograph, IWM (H4775), discussed in Gordon Barclay, *If Hitler Comes* (Edinburgh 2013), p. 110, and repro. Fig. 9.1.

60 Photographs, IWM (H 3034 and H 3037).

61 David Easton, 'The Scottish Home Front 1939–45: Gathering information on Military and Civilian Structures from RAF and Luftwaffe Aerial Coverage of Scotland', Chapter 16 of *Images of Conflict*, edited by Birger Stichelbaut, Jean Bourgeois, Nicholas Saunders and Piet Chielens (Newcastle upon Tyne 2009), pp. 259–79. For accounts of artists and camouflage see Henrietta Gooden, *Camouflage and Art: Design for Deception in World War 2* (London 2007), and Tim Newark, *Camouflage* (London 2007).

62 Bristol Museums & Art Gallery, oil on canvas, 34.4 × 70.0 cm (K4052). There is also a study for this picture in IWM (ART 15284).

63 Roger Billcliffe, *James McIntosh Patrick*, exh. cat. Fine Art Society and Dundee District Council (London 1987), pp. 25–6.

64 Many of the wartime cartoons have been published in *The Broons: Oor Willie: 1939–1945, The lighter side of World War II* (Dundee 1997). Information about Art Department staff from Norman Watson, archivist at DC Thomson.

65 The most authoritative version and account of its origin is probably that published in the *Newsletter of the Orkney Family History Society*, no. 57, March 2011, p. 9.

66 By Duncan Letters, *Lyness in Wartime*, oil on hessian, 292.5 × 140.5 cm, Scapa Flow Visitor Centre.

67 See Barclay, *If Hitler Comes*, for numerous examples.

68 *Exhibition of Twentieth Century German Art*, New Burlington Galleries, July 1938 (London 1938), pp. 6 and 7.

69 Benno Schotz, *Bronze in my Blood*, p. 126.

70 Benno Schotz, *James McBey*, bronze on polished stone base, Aberdeen Art Gallery & Museums (ABDAG004691), purchased 1926.

71 Benno Schotz, *Bronze in my Blood*, p. 163.

72 *Scottish Art*, Royal Academy of Arts (London, 1939), p. ix.

73 Roger Bristow, *The Last Bohemians: The Two Roberts Colquhoun and MacBryde* (Bristol 2010), provides a joint biography of both artists. See also the forthcoming exh. cat. *The Two Roberts: Robert Colquhoun and Robert MacBryde*, SNGMA (Edinburgh 2014) by Patrick Elliott, Adrian Clark and Davy Brown.

74 Correspondence with artists, IWM (ART/WA2/03/125). A related composition, *Ave Maria Lane*, 1941, oil on canvas, 69 x 84.5 cm, is in the collection of Russell-Cotes Art Gallery & Museum, Bournemouth (BORGM 01493); this was exhibited in the show 'Six Scottish Painters' at the Lefevre Gallery in 1942, and appeared in vol. 29 of 'Horizon' (information from Patrick Elliott).

75 Robert MacBryde, *Two Women Sewing*, oil on canvas, 100.3 × 143.5 cm, SNGMA (GMA 1588).

76 Details in Green, *W. Barns-Graham*, pp. 74 and 75.

77 Much later in life, Orr made oil paintings from these views, though they lack the energy of the etchings. One etching of 1946, entitled *Memory of the Blitz, Upper Thames Street, 1941*, was worked up (with the addition of the dome of St Paul's) as *Bombed Ruins near St Paul's, London*, City of London Corporation (2328). One of the etchings shown here, *AFS crew going into action 1941* (1946), was painted as *London Firemen in the Blitz*, City of London Corporation (2327).

78 Private papers of Major A.A. West, IWM (Documents 11984). Reproduced by Derek Niemann in *Birds in a Cage* (London 2012), p. 50; the drawing is inscribed 'A.A.W. 1940'.

79 Niemann, *Birds in a Cage*, p. 30.

80 *My Father's Son: The Memoirs of Major The Earl Haig OBE DL ARSA* (London 2000); it covers the first thirty years of Haig's life. For an account of his career as an artist, see Douglas Hall, *Haig the Painter: George Alexander Eugene Douglas (Dawyck) Haig, OBE DL MA ARSA, 2nd Earl Haig of Bemersyde: a journey from youthful privilege through hardship and aspiration to fulfilment as a painter* (Edinburgh, 2003).

81 Haig, *My Father's Son*, pp. 106–7.

82 Haig, *My Father's Son*, p. 115.

83 Haig, *My Father's Son*, pp. 110, 111 and 114. The oil portrait of Cutforth (not shown here) is reproduced by Hall, *George Alexander Eugene Douglas (Dawyck) Haig*, p. 26, Plate 9.

84 Haig, *My Father's Son*, pp. 134–5.

85 Haig, *My Father's Son*, p. 160.

86 Haig, *My Father's Son*, p. 161.

87 *Recruits Boxing 28 January 1942* (NMS M.1996).

88 Details in Kerr, *Ian Eadie*, p. 36.

89 *Officers of the Highland Division in the Museum at Leptis Magna*, 1943, watercolour, 32.0 × 25.6 cm, IWM (ART LD 2925).

90 Honeyman, *Art and Audacity*, pp. 182 and 183. By 'Keeper of Records' he meant the Keeper of the Records of Scotland.

91 Honeyman, *Art and Audacity*, p. 183.

92 Robert Graves, 'The Poets of World War II' (1942), *The Common Asphodel: Collected Essays on Poetry* (London 1949), p. 307.

93 *The New Divan* (Manchester 1997), p. 54.

94 David Buckman, 'A Biographical Essay', in *Nature and Humanity: The Work of Fyffe Christie 1918–1979*, various authors (Bristol 2004), pp. 5–7. Many of Christie's drawings are held by the Scottish National War Museum, and by the Second World War Experience centre in Leeds.

95 Ian Eadie, *Beachhead Library*, 1944, watercolour, 29.0 × 37.5 cm, NMS (M.1986.36).

96 Discussed by J. Mackay-Mure, 'The Soldier as citizen', *The Spectator*, 8 January 1943, pp. 27–8 (issue no.5976): the soldier 'retains his democratic rights as a citizen, and therefore, as an elector'. Peter White Diary, NLS Acc. 12886.

97 For example, Michael Ayrton, *Chainmakers Taking a Link Out of a Furnace*, watercolour on paper, 1942, Manchester City Art Galleries (1947.354), gift from the War Artists' Advisory Committee; and Michael Ayrton, *Broom Copse* (1945), oil on board, 29.5 × 39 cm, Colchester and Ipswich Museums Service (R.1968-64).

98 Ian Fleming, *Camp on Salisbury Plain*, 1944, pencil and watercolour, 38.2 × 52.8 cm, Aberdeen Art Gallery & Museums (ABDAG011510).

99 Peter White, *With the Jocks*, plates between pp.140 and 141.

100 Website: *Scots at War*. Mennie was amongst a group of Scottish POWs who spoke movingly of his experiences at a Scots at War Witness Seminar,1997. His sketches and diary are now in the IWM.

101 John Mennie, *Detachments of POW Gordons and Argylls going towards Burma; Thai-Burma Railway Day 1943*, linocut on Japanese tissue, 12.7 × 22.2 cm, IWM (ART LD 7297).

102 Robert Hardie, *Burma–Siam Railway: The Secret Diary of Dr Robert Hardie 1942–5* (London 1983). The diary is now held in the IWM.

103 Some were included in an exhibition at The Scottish Gallery, Edinburgh 2014, *David McClure (1926–1998), The Art of Picture Making* (2013–14).

104 Agnes Mure Mackenzie, *The Arts and the Future of Scotland* (Edinburgh 1942), pp. 12–13, 21, 23–4.

105 T.J. Honeyman, *Art and Audacity*, pp. 184 and 185.

106 The label appears to be a Diary of Transference Army Form W 3118A, used to carry the Field Medical Card Army Form (the form came into use in 1917 and continued until the end of the Second World War); the uniform is of the Second World War. Information from Mike Taylor and members of the Great War Forum.

107 John McEwen, *William Gear* (Aldershot 2003), pp. 23 and 26. The history of the rescue of works of art has been traced, from an American viewpoint, by Robert M. Edsel in two publications: *Monuments Men* (London 2009), and *Saving Italy: The Race to Rescue a Nation's Treasures from the Nazis* (New York 2013). The film *The Monuments Men* (2014) showed the American viewpoint. (For references to Gear's *Mau Mau* see Chapter 5.)

CHAPTER 4

1 William Rothenstein, *Men of the RAF* (London 1942). An account is given in Robert Speaight, *William Rothenstein: The Portrait of an Artist in his Time* (London 1962). The difficulties caused by his pre-empting of other artists are detailed in IWM (ART/WA2/03/42).

2 Russell Davies, *Ronald Searle: A Biography* (London 1990), pp. 47–50; and Haig Gordon, *Tales of the Kirkcudbright Artists*, pp. 131–2.

3 Ronald Searle, *To the Kwai – and Back: War Drawings, 1939–1945* (first pub. 1986, this edition London 2006), p. 14.

4 Details of his appointment in the artists' correspondence files of the IWM (ART/WA2/03/226).

5 Nicholas Ardizzone, 'Edward Ardizzone RA, 1900–1979: commissioned works of the Second World War', unpublished PhD thesis (copy in the IWM, copy no. 97 / 1256). This includes a catalogue raisonné of Ardizzone's work as an official War Artist.

6 *Dawn after a Raid*, 1941, watercolour, 27.6 × 27.0 cm, IWM (ART LD 1222).

7 IWM (GP/55/10:027)

8 Watercolour and ink on paper, 27.3 × 34.9 cm, Tate (N05672), presented by the WAAC 1946.

9 *Ravilious At War: The Complete Work of Eric Ravilious, September 1939–September 1942*, edited by Anne Ullmann, with contributions from Barry and Saria Viney, Christopher Whittick and Simon Lawrence; foreword Brian Sewell (Huddersfield 2002). The most recent monograph on the artist is by Alan Powers, *Eric Ravilious: Artist & Designer* (Farnham 2013).

10 Nash's spell as a war artist, and his difficulties, are detailed in the IWM correspondence file (ART/WA2/03/038).

11 Pencil and watercolour, 43.7 × 58.5 cm, sold by Liss Fine Art 2013 (verso of study for *Leaving Scapa Flow* (see n. 29 below).

12 *Convoy in Port*, 1941, pencil and watercolour, 50.9 × 55.2 cm, Manchester Art Gallery (1947/409).

13 Ullmann, *Ravilious at War*, pp. 185–7, October 1941.

14 *Convoy passing an Island*, 1941, 49.5 × 54 cm, British Council (P157), presented by the WAAC.

15 Ullmann, *Ravilious at War*, p. 198, quoting Ravilious to E. M. O'R. Dickey, from Dundee [11 Dec. 1941].

16 Watercolour, 31.6 × 48.3 cm, IWM (ART LD 3657).

17 Andrew Patrizio and Frank Little, *Canvassing the Clyde: Stanley Spencer and the Shipyards*, exh. cat. Glasgow Museums (Glasgow 1994); and Keith Bell et al., *Men of the Clyde: Stanley Spencer's Vision at Port Glasgow*, exh. cat. SNPG (Edinburgh 2000).

18 Information from the website of The MacRobert Trust.

19 For Kennington's work in the Second World War, including details of his Scottish sitters, see Jonathan Black, *The Face of Conflict: Eric Kennington, Portraiture and the Second World War* (London 2011), pp. 118–19.

20 [Joan Hassall], *Dearest Joana: a selection of Joan Hassall's lifetime letters and art*, ed. Brian North Lee, with an introduction by John Dreyfus (Huddersfield 2000), 2 vols, vol. 1, p. 106.

21 Oil on canvas, 60.9 × 91.4 cm, IWM (ART LD 714).

22 Their experiences are documented by Amos Ford, *Telling the Truth: The Life and Times of the British Honduran Forestry Unit in Scotland (1941–44)* (London 1985); and by Sam Martinez on the 'Through My Eyes' page of the IWM website.

23 For an account of the WLA in Scotland, see Affleck Gray, *Timber! Memories of Life in the Scottish Women's Timber Corps, 1942–46*, ed. Uiga and John Robertson (East Linton 1998), pp. 19–20; there are various other booklets and catalogues, and a Women's Timber Corps website.

24 Kenneth M Guichard, *British Etchers 1850–1940* (first published 1977, this edition London, 1981), p. 38.

25 Susan Thomson, *The Life and Work of Ethel Gabain* (Warrington 2008), pp. 52 and 55.

26 An account is provided by C. P. Stacy and Barbara M. Wilson, *The Half-Million: the Canadians in Britain, 1939–1946* (Toronto 1987). For well-illustrated publications on the Canadian war collections, see Dean Frederick Oliver and Laura Brandon, *Canvas of War: Painting the Canadian Experience, 1914 to 1945*, foreword by J. L. Granatstein (Vancouver 2001); Laura Brandon et al., *Shared experience: Art and War: Australia, Britain and Canada in the Second World War*, exh. cat., Canadian War Museum, Australian War Memorial, and the IWM (Canberra 2006). A more academic account is provided by Laura Brandon's *Art or Memorial? The Forgotten History of Canada's War Art* (Calgary 2006).

27 See the Russian Arctic Convoy Museum Project, Poolewe, Achnasheen, Wester Ross (and website); and the *Arctic Convoys* exhibition at the Scottish National War Museum 2013–14 (and website).

28 Charles Pears, *Convoy to Russia*, c.1944–1945, oil on canvas, 81.3 × 127 cm, National Maritime Museum (BHC1576).

29 A study for this painting was sold by Liss Fine Art (recto of the Ravilious, Channel Fisher sketch; see n. 11 above).

30 For a general overview of the subject, see Wayne D. Cocroft, Danielle Devlin, John Schofield and Roger J. C. Thomas, *War Art: Murals and Graffiti – Military Life, Power and Subversion* (York 2006).

31 Viewable online via the RCAHMS website Canmore.

32 Castletown, RCAHMS –SC 923035; Donibristle, RCAHMS. SC 44440 and SC 924138.

33 *Guide to the Shetland Museum textile collection*, compiled by Dr Carol Christiansen (Shetland Amenity Trust 2010), pp. 4 and 7; and Anna Feitelson, *The Art of Fair Isle Knitting: History, Technique & Color* (Loveland Colorado, 1996), pp. 45 and 46.

34 Richard Calvocoressi, *Kokoschka and Scotland*, exh. cat.SNGMA (Edinburgh 1990).

35 Douglas Hall, *Art in Exile: Polish Painters in Post-war Britain* (Bristol 2008). For general references to Poles in Scotland in the Second World War, see Ksawery Pruszynski, *Polish invasion* (first pub. 1941, current edition Edinburgh 2012); Allan Carswell, *For Your Freedom and Ours: Poland, Scotland and the Second World War* (Edinburgh 1993); and Diana M. Henderson, *The Lion and The Eagle: Reminiscences of Polish Second World War Veterans in Scotland* (Dunfermline 2001).

36 Letter dated 21 May 1942, correspondence file, IWM (ART/WA2/01/120).

37 Honeyman, *Art and Audacity*, p. 88.

38 The Polish Social, Cultural and Educational Society, Glasgow. Reproduced in Carswell, p. 15.

39 Schotz, *Bronze in My Blood*, pp. 125, 161 and 162.

40 Jankel Adler, *The Mutilated*, oil on canvas, 86.4 × 111.8cm, Tate (T00372).

41 Selected by Dennis Farr; shown at SNGMA and touring.

42 Douglas Hall, with intro. Cordelia Oliver, *Josef Herman, 'Memory of Memories', The Glasgow Drawings 1940–43*, Third Eye Centre, 1985; and *Josef Herman: Warsaw, Brussels, Glasgow, London, 1938–44*, exh. cat. Ben Uri Gallery (London 2011).

43 Honeyman, *Art and Audacity*, p. 56.

44 I am grateful to the IWM staff for enabling me to pursue this research during building work.

45 Edward Bawden, *Jumping-Tower for the Training of Polish Parachute Troops at Largo, Fife*, 1943, watercolour, 59.3 × 42.8cm, IWM (ART LD 3147).

46 The work of Wladzimierz Klocek, Jan Sterling and Ewaryst Jakubowski. The panel shows a Polish soldier, with St Andrew behind him offering assistance and support, and the Polish eagle. Discussed by Lesley-Anne Lettice, *'The People's War'*.

47 Made by the Croatian sculptor Oscar Nemon (1906–1985), and presented to the University of St Andrews; placed in the Park 1993.

48 See Lesley-Anne Lettice, *'The People's War'* for a general introduction. For further details see the exh. cat. Crawford Arts Centre, University of St Andrews, *Engraved in the Memory: Wood Engraving from St Andrews, including work by Annabel Kidston, Alison McKenzie, Josef Sekalski and Alyson MacNeill* (St Andrews 1984); and Aylwin Clark, *The McKenzie Sisters* (Trowbridge 1996). Images are held by the University of St Andrews, Special Collections: woodcut prints by Polish students of A. Kidstone, W. Mackenzie, A. Mackenzie, 1940–5, with woodcutting tools and pigments (MS38351). St Andrews Preservation Trust Museum also holds woodcuts and photographs of the art classes.

49 Aleksander Zyw, *Poles in Uniform: Sketches of the Polish Army, Navy and Air Force* (London and Edinburgh 1943). The drawings are now in the Polish War Museum, Warsaw. Further information is provided in the unpublished dissertation by Thomas (Tommy) Zyw, 'The Past is a Foreign Country: The Significance of World War II on the Work of Aleksander Zyw', School of Art History, University of St Andrews, 2010.

50 *Britain in Peace and War, drawn by Feliks Topolski, with an introduction by James Laver* (London 1941), p. 68, includes four drawings of the 'Polish Army in Scotland'.

51 Zyw, *Poles in Uniform*, p. 3.

52 Zyw, *Poles in Uniform*, p. 5.

53 Aleksander Zyw, 'Artist in Uniform: A Polish Artist sees the War', *Art & Industry*, April 1943, pp. 114–19; quotation p. 114.

54 Zyw, 'Artist in Uniform', p. 115.

55 I am grateful to Teresa Collins for arranging viewing.

56 Charles McCall, *Love Letters from an Artist at War* (Lewes 1992), pp. 17–18, letter of 22 February 1944; quotation p. 18.

57 David M. Hird, *The Grey Wolves of Eriboll* (Dunbeath 2010).

58 Allocations to Edinburgh, 1946–1948, IWM file (ART/WA2/09/026).

59 Dumfries and Galloway Council (DGDET 61D), purchased by Dumfriesshire Educational Trust, 1949.

CHAPTER 5

1 *Manchester Evening News*, 25 August 1947.
2 Quoted by McEwen, *William Gear*, p. 71.
3 *The Complete Poems of Edwin Muir*, ed. Peter Butter (Aberdeen 1991), pp. 226–7.
4 Printed in an edition of 75 copies by Editions Electo, 1971. See Pearson, *Paolozzi*, p. 44.
5 Statement June '76, from an unpublished transcript of journal entries from the Neil Dallas Brown Trust, SNGMA. Reproduced by permission of the Neil Dallas Brown Trust.
6 General Notes on the Ulster Series, Dec '76, from an unpublished transcript of journal entries from the Neil Dallas Brown Trust, SNGMA. Reproduced by permission of the Neil Dallas Brown Trust.
7 Conrad Atkinson, *Everywhere Oblique*, with essays by Donald Kuspit and Dan Cameron, 1987, exh. cat. Talbot Rice Art Gallery, University of Edinburgh (Edinburgh 1987).
8 Linda Kitson, *The Falklands War: A Visual Diary* (London 1982). See also Palmer, *Women War Artists*, p. 82.
9 Linda Kitson, *2nd Battalion Scots Guards in the Sheep Sheds at Fitzroy, 17 June 1982*, conté crayon on paper, 35.5 × 25.3 cm, IWM (ART 15530 52).
10 Bill Hare provides an excellent critique of Kirkwood's work in his *Contemporary Painting in Scotland* (Tortola 1992), pp. 122–5.
11 *British Sculpture 83*, pp. 17 and 20.
12 Ian Hamilton Finlay, *Et in Arcadia Ego*, 1976, SNGMA (GMA 1583)
13 Jessie Sheeler, with photographs by Andrew Lawson, *Little Sparta: The Garden of Ian Hamilton Finlay* (London 2003).
14 Charles Jencks, *The Universe in the Landscape: Landform* (London 2011), p. 162.
15 Ken Currie, *War*, 1983, acrylic on canvas, 213.4 × 320 cm, Glasgow Museums (PP. 1984.53.1).
16 See Hare, *Contemporary Painting in Scotland* for discussion of these artists; also *Passionate Paint: the Art of Lys Hansen*, edited by Giles Sutherland (Edinburgh 1998).
17 David Cohen, *Jock McFadyen: A Book about a Painter* (Aldershot 2001), pp. 40–4.
18 Jock McFadyen, *Kurfürstendamm*, 1991, oil on canvas, 203.5 × 91.5 cm, IWM (ART 16418).

19 Alan Jackson, *A Different Man: Peter Howson's Art, from Bosnia and Beyond* (Edinburgh 1997).
20 From an essay by Richard Cork in *Peter Howson, Bosnia*, IWM (London 1994), p. 40.
21 From an essay by Robert Crampton in *Peter Howson: Bosnia*, exh. cat. IWM and Flowers East (London 1994), p.14
22 *Stephen Barclay: New Paintings*, catalogue Duncan R. Miller Fine Arts, 2003, gives a good summary of his themes.
23 Robert Wilson, *Helmand* (London 2008) and *Helmand: Faces of Conflict* (2010).
24 See *Nathan Coley: There Will Be No Miracles Here*, exh. cat. Fruitmarket Gallery, Edinburgh (Edinburgh 2004), pp. 98–105. The artist's website includes discussion of the project.
25 *Toby Paterson: Consensus and Collapse*, exh. cat. Fruitmarket Gallery (Edinburgh 2010).
26 Haig, *My Father's Son*, p. 179.
27 The Armed Forces Art Society, which exists for those with purely an Army connection, is a separate organisation, although there can be an overlap of some artists.

CHAPTER 6

1 David Crane, *Empires of the Dead: How One Man's Vision Led to the Creation of WWI's War Graves* (London 2013).
2 See Elaine W. McFarland, 'Scottish Military Monuments', in Spiers, Crang and Strickland, *Military History of Scotland*, Chapter 29, pp. 748–75; p. 761, quoting *The Scotsman*, 20 February 1919.
3 Publications dealing with British war memorials tend to neglect Scotland, but a notable exception is Derek Boorman, *A Century of Remembrance: One Hundred Outstanding British War Memorials* (Barnsley 2005) which bears the Maxwelltown memorial on its front cover.
4 Details in *Public Sculpture of Glasgow*, by Ray McKenzie, with contributions by Gary Nisbet (Liverpool 2002), pp. 243–44.
5 For a full account see Duncan McDougall, *A History of the Royal Scots Club (war memorial); on the occasion of the 80th anniversary of the founding of the Club* (Glasgow 1999).

6 Duncan Macmillan, *Scotland's Shrine* (details noted above). Good summaries are also provided by Elizabeth Cumming, *Hand, Heart and Soul: The Arts and Crafts Movement in Scotland* (Edinburgh 2007), pp. 190–9; and Ian Gow, 'The Scottish National War Memorial', in *Virtue and Vision: Sculpture and Scotland 1540–1990*, ed. Fiona Pearson, exh. cat. NGS (Edinburgh 1991).

7 William Orpen, *A Highlander passing a Grave*, oil on panel, 60.9 × 50.8 cm, IWM (ART 2995).

8 The most comprehensive account of Curr's life and work is by Sandy Brewer, 'Tom Curr and Stanley Cursiter: Friendship, Art and Industry', *Journal of the Scottish Society for Art History*, vol. 15 (2010–11), pp. 17–23.

9 See his painting *Calonne, near Loos*, c.1918, oil on board, 30.3 × 38.5 cm, NAM (1998-04-50); his *A sentry at Calonne* was exhibited at the Royal Academy, London, in 1919.

10 *Visions Through Glass: The Work of Douglas Strachan (1875–1850)*, exh. cat. Crawford Arts Centre, University of St Andrews (St Andrews 2001–2), researched by Juliette MacDonald; and *Stained Glass Windows of Douglas Strachan*, compiled by A.C. Russell (first pub. 1972, current edition Forfar 2002).

11 Its development is described in Nick Haynes, *Building Knowledge: An Architectural History of the University of Glasgow* (Edinburgh 2013), pp. 116–23.

12 Marcus Witherow and Mary Witherow, *A Brief Biography of George Henry Paulin ARSA RBS HRI 1888–1962* (privately printed for Dollar Academy, 2010). I am grateful to Janet Carolan, Archivist of Dollar Academy, for providing information about Paulin's life and work.

13 For details of the commission and an account of the unveiling, see David McDowell, *Carrying On: Fettes College, War and the World, 1870–2010* (Kibworth Beauchamp 2012) pp. 290–2.

14 McDowell, *Carrying On*, p. 176.

15 *A Nest of Singing Birds: An Anthology of Fettes Poets*, edited with intro. by Gordon Jarvie (Edinburgh 1995), pp. 121–2; quotation p. 122.

16 Wardleworth, *William Reid Dick*, p. 55.

17 The bronze bust by Meštrovic, 66.0 cm high, was transferred to SNPG in 1955 (PG 1825).

18 Rosalind K. Marshall, *A Guide to the Memorials in St Giles' Cathedral, Edinburgh; with Photographs by Peter Backhouse* (Edinburgh 2011), pp. 56 and 57.

19 Butler, *An Autobiography*, pp. 323–4, 27 September 1914.

20 Harrington, 1993, p. 304, quoting from an unpublished manuscript.

21 Alan Judd and David Crane, *First World War Poets* (London 1997), pp. 22–4; quotation p. 22. The photograph of 1916 (a bromide print by John Gunston) is in the National Portrait Gallery, London 1916 (NPG P515).

22 Elizabeth Mary Keyes, *Geoffrey Keyes, VC, MC, Croix de Guerre, Royal Scots Greys, Lieut.-Colonel 11th Scottish Commando* (London 1956), provides a full biography.

23 Information from East Lothian Museums Service.

24 The Lady Haig Poppy Factory was based at Whitefoord House on Edinburgh's Royal Mile until 1965, when it moved to Canonmills. Later information about the organisation, now called Poppyscotland, is on the organisation's website.

25 Stuart Allan, *Commando Country* (Edinburgh 2007), includes a photograph of Scott Sutherland at work on the Commando Memorial (Plate 18).

26 The foundation stone was laid by Her Majesty Queen Elizabeth in 1950, and formally dedicated in the presence of Her Majesty Queen Elizabeth, The Queen Mother and Her Royal Highness The Princess Margaret on 20 August 1953; they had known Tudsbery in 1943 when he served in the Household Cavalry in the detachment guarding the Royal Family at Windsor and Balmoral. The Chapel was re-dedicated in 2013 in the presence of the Queen, the only person attending who had known him personally. The history and architectural details are described by J.W. Herries and Francis Tudsbery in *The Robin Chapel of the Thistle Foundation*, foreword by Charles L. Warr (Edinburgh, 1956). The artwork is discussed by Cumming, *Hand Heart and Soul*, pp. 214 and 216–17.

27 The information is most easily accessed via websites, such as those of the International Brigade Memorial Trust and SCRAN.

28 Details in McKenzie, *Public Sculpture of Glasgow*, pp. 75–7.

29 *Voices from the Spanish Civil War: Personal Recollections of Scottish volunteers in Republican Spain 1936–39*, edited by Ian MacDougall, with recent photographs of the veterans by Sean Hudson (Edinburgh 1986); and exh. cat. Crawford Arts Centre,

University of St Andrews (St Andrews 1987), *Voices from the Spanish Civil War: Photographs by Sean Hudson*.

30 Publications include Donald S. Murray, *And on This Rock: The Italian Chapel, Orkney* (Edinburgh 2010) and Philip Paris, *Orkney's Italian Chapel: The True Story of An Icon* (Edinburgh 2010).

31 Anne Ward, *Nothing To See Here: A Guide to the Hidden Joys of Scotland* (Moffat 1988), pp. 132–3.

32 The Map now has 'listed' status. Progress of its restoration can be followed on websites.

33 For a critical biography of Pryde's work see Ann Simpson, *James Pryde*, exh. Cat. SNGMA (Edinburgh 1992). Details discussed here are from Simpson's entry to the exh. cat., *On the Meanings of Sculpture in Painting*, ed. Penelope Curtis, Henry Moore Institute (Leeds 2009), pp. 9–10, pp. 103–5.

34 [Peter Cattrell] *Terrain: Landscapes of the Great War*, SNPG, was organised in collaboration with the Scottish Poetry Library, Edinburgh in 2003.

35 *Scotland's Art*, ed. Ian O'Riordan and David Patterson, with essays by Duncan Macmillan and Murdo Macdonald, exh. cat. Edinburgh City Art Centre (Edinburgh 1999), p. 106.

36 Keith Hartley, with Alexander Moffat, John McEwan and Paul Bellany, *John Bellany*, exh cat. SNG (Edinburgh 2012), pp. 50–1.

37 Alexander Moffat, *Historical Landscape with Gatehouse*, 1990, oil on canvas, 61 × 121.7 cm, coll. North Ayrshire Council (IRVGV1998–12); given by the artist.

38 *Joyce Cairns, War Tourist: an illustrated anthology*, edited by Arthur Watson, Aberdeen Art Gallery (Aberdeen 2006), with essays by six writers; quotation p. 104.

39 The plaque reads: 'Ian Hamilton Finlay 1925–2006 / with Michael Harvey / *Seven Idylls* / 1987. Slate. Purchased from the artist / The Dean Allotments Association, 2000. The Association gratefully acknowledges the support of / The Hope Scott Trust and Blackwall Green Ltd'.

40 Their story is told in Jack Alexander's book *Macrae's Battalion* (Edinburgh 2003), and on a website of the same title.

41 His story is told in Aileen Orr, *Wojtek the Bear: Polish War Hero* (Edinburgh 2010).

42 The War Memorials Trust manages, on behalf of Historic Scotland and the Scottish Government, the Centenary Memorials Restoration Fund (CMRF).

43 *Dr Elsie Inglis and her Scottish Angels*, a multi-media exhibition by Ian McFarlane with works by John Bellany, shown in Paris, Belgrade and Edinburgh, 2010–13.

44 The apology was reported in *The Times* (Scottish edition), 7 November 2013.

45 Alistair Moffat, *The Great Tapestry of Scotland: The Making of a Masterpiece* (Edinburgh 2013).

46 A.E. Haswell Miller, ed. John Mollo, *Vanished Armies: A Record of Military Uniform Observed and Drawn in Various European Countries During the Years 1908–1914* (Oxford 2009); and Olaf MacLeod, *Their Glory Shall Not be Blotted Out: The Last Full Dress Uniform of the British Army* (Cambridge 1986).

47 Personal communication from Alexander Stoddart.

Picture Credits

CHAPTER 1

William Skeoch Cumming, *Transvaal 1900*. Private collection. Photo copyright © Alex Hewitt

Joseph Cundall, *Crimean Heroes: William Gardner, Donald McKenzie and George Glen*, 1856. SNPG (PGP 140.9). Image and photo copyright © NGS

Fred Bremner, *Afghan Warriors*, c.1895. Platinum print made by Pradip Malde from collodion glass negative. SNPG (PGP 129.44). Image and photo copyright © NGS

Alphonse Marie de Neuville, *The Storming of Tel-el-Kebir*, 1883. NMS (M.1952.50). Photo copyright © NMS

Elizabeth, Lady Butler, *Scotland for Ever!*, 1881. Leeds Museums and Galleries (LEEAG.PA.1888.0002). Photo copyright © Leeds Museums and Galleries (Leeds Art Gallery) / Bridgeman Images

William Simpson, *Huts and Warm Clothing for the Army, 17 January 1855*. Anne S.K. Brown Military Collection (GB-01855f-1), Brown University Library, USA. Photo copyright © Anne S.K. Brown Military Collection, Brown University Library

William Skeoch Cumming, *A Gordon Highlander in the Afghan War*, 1881. The Gordon Highlanders Museum (GH 102). Photo copyright © The Gordon Highlanders Museum

William Kennedy, *Midday Rest*, c.1892–93. CSG CIC Glasgow Museums Collection (3190). Photo copyright © CSG CIC Glasgow Museums Collection

W. Birnie Rhind, *Memorial to the King's Own Scottish Borderers*, North Bridge, Edinburgh, 1906. Photo copyright © Patricia R. Andrew

W. Birnie Rhind, *Memorial to the Royal Scots Greys*, Princes Street Gardens West, Edinburgh, 1906. Photo copyright © Patricia R. Andrew

Peter Wishart, *1914* (undated). RSA collections (2006.035). Photo copyright © Courtesy of the RSA

Robert Gibb, *The Thin Red Line*, 1881. Diageo, on loan to NMS. Image copyright © By kind permission of Diageo Photo copyright © NMS

Robert Gibb, *Backs to the Wall, 1918*, painted 1929. Angus Council, Galleries & Museums (A1978.275). Photo copyright © Courtesy of Angus Council, Galleries and Museums

CHAPTER 2

Patrick William Adam, *War*, 1915. Dundee City Council (Dundee Art Galleries and Museums, 17-1918). Photo copyright © Dundee City Council (Dundee Art Galleries and Museums)

Poster: *Your King & Country Need You*, 1914. IWM (ART PST 11415). Photo © IWM

Francis P. Martin, *Infantry Brigade Signal Office, Flanders HQ*, 1915–1916. Government Art Collection (0/107). Image copyright © The Artist's Estate. Photo copyright © Government Art Collection

James McBey, *Figures in a Dug Out* Aberdeen Art Gallery & Museums Collections (ABDAG001743). Image copyright © By kind permission of the family of James and Marguerite McBey. Photo copyright © Aberdeen Art Gallery & Museums

William Gillies, *An Old Factory*, 1918. RSA (G.1991.815). Image copyright © RSA. Photo copyright © Courtesy of the RSA

William Gillies, *Our Post behind the Wire*, 1918. RSA (G.1991.816). Image copyright © RSA. Photo copyright © Courtesy of the RSA

Adam Bruce Thomson, *Royal Engineers Building a Bridge near Mons*, 1918. Image copyright © The Artist's Estate. Photo copyright © The Scottish Gallery, Edinburgh. (*This item has now been acquired by SNGMA*)

Fred Farrell, *Lieutenant J. Gillespie ...*, 1918. CSG CIC Glasgow Museums Collection (PR.1921.23.l). Photo copyright © CSG CIC Glasgow Museums Collection

Muirhead Bone, *The Château, Foucaucourt*, 1916–17. BM (1919, 0208.122). Image copyright © The Estate of Sir Muirhead Bone. All Rights Reserved, DACS 2014. Courtesy of The Trustees of the British Museum.

Muirhead Bone, *The Somme near Corbie*, 1906. BM (1919,0208.7). Image copyright © The Estate of Sir Muirhead Bone. All Rights Reserved, DACS 2014. Courtesy of The Trustees of the British Museum

Herbert James Gunn, *The Eve of the Battle of the Somme*, 1916. Fleming-Wyfold Art Foundation (FWAF/RF919). Image copyright © The Fleming-Wyfold Art Foundation / Bridgeman Images

Photograph, *William Reid Dick outside his tent with a statuette.* Reid Dick Family Archive. Image and photo copyright © Reid Dick Family Archive

Joseph Lee, *Karlsruhe Christmas*, 1917. University of Dundee, Archive Services. Image and photo copyright © University of Dundee – Archive Services. Licensor www.scran.ac.uk

Francis P. Martin, *Hospital – Camiers*. NMS (M2003.36.1-22). Image copyright © The Artist's Estate. Photo © NMS

Norah Neilson Gray, *The Scottish Women's Hospital ...*, 1920. IWM (ART 3090). Photo copyright © IWM

John Lavery, *The First Wounded in London Hospital, August, 1914*, painted 1915. Dundee City Council (Dundee Art Galleries and Museums, 2-1916). Photo copyright © Dundee City Council (Dundee Art Galleries and Museums)

Francis P. Martin, *Ward 12B – Stobhill. 5 am*. NMS (M2003.36.1-22). Image copyright © The Artist's Estate. Photo copyright © NMS

Henry John Lintott, *Avatar*, 1916. RSA Diploma Collection (1996.004). Image copyright © The Artist's Estate. Photo copyright © Courtesy of the RSA

Henry John Lintott, *Modo Crepuscolare*, 1914. City Art Centre: Edinburgh Museums and Galleries (CAC181/1964). Image copyright © The Artist's Estate. Photo copyright © City Art Centre: Edinburgh Museums and Galleries

Adrian Berrington, *Front cover, The Hydra*, 1918. The First World War Poetry Digital Archive, University of Oxford (www.oucs.ox.ac.uk/ww1lit). Copyright © English Faculty Library, The University of Oxford

Private J. Brooks, 2nd London Scottish, 'With the Jericho Jocks', from *Blighty*, Summer issue 1918, p.40. NLS 6.84/18695. Copyright © NLS. Licensor www.scran.ac.uk

Christmas card issued to troops, 1916. The Museum of Edinburgh: The City of Edinburgh Council (HH3697/6/72). Photo copyright © The City of Edinburgh Council Museums and Galleries

William Skeoch Cumming, *A Dream of Iona*. Private collection. Photo copyright © Alex Hewitt

Charles Rennie Mackintosh, *Design for a Memorial Fireplace, The Dug-Out ...*, 1917. Glasgow School of Art (MC/G/052). Image copyright © The Glasgow School of Art

Charles Rennie Mackintosh, *Design for the Dug-Out ...*, 1917. Glasgow School of Art (MC/G/49). Photo copyright © The Glasgow School of Art

John Duncan Fergusson, *Dockyard, Portsmouth*, 1918. IWM (ART 5728). Image and photo copyright © The Fergusson Gallery, Perth and Kinross Council / The Bridgeman Art Library

Joseph Denovan Adam, *The Covering Party*, 1918. NMS (M2001.130.1). Photo copyright © NMS

James McBey, *Dawn – The Camel Patrol Setting Out*, 1919. Aberdeen Art Gallery & Museums Collections (ABDAG002933). Image copyright © By kind permission of the family of James and Marguerite McBey. Photo copyright © Aberdeen Art Gallery & Museums

PICTURE CREDITS

James McBey, *An Inspection of The Cameronians (Scottish Rifles) 30 October 1917*. IWM (ART 1519). Image copyright © By kind permission of the family of James and Marguerite McBey. Photo copyright © IWM

James McBey, *The Black Watch Guard on the Church of the Holy Sepulchre, Jerusalem*, 1917. IWM (ART 1516). Image copyright © By kind permission of the family of James and Marguerite McBey. Photo copyright © IWM

Phyllis Bone, *'Remember Also the Humble Beasts': The Camel*, Scottish National War Memorial, by 1928. Photo copyright © Antonia Reeve. Reproduced by permission of the Trustees of the Scottish National War Memorial

Bernard Meninsky, *The Arrival*, 1918. IWM (ART 1186). Image and photo copyright © IWM

William Wyllie, *Surrendered Battleships in the Firth of Forth*, 1918–19. National Maritime Museum, Greenwich, London (PW1875). Photo copyright © National Maritime Museum

James Paterson, *The German Fleet after Surrender, Firth of Forth, 21 November 1918*, painted 1918. SNPG (PG 2733). Photo copyright © NGS.

John Lavery, *The End: The Fore-Cabin of HMS 'Queen Elizabeth' with Admiral Beatty …* 1918. IWM (ART 4219). Photo copyright © IWM

Bernard Gribble, *Sinking of the German Fleet … 1919*. NMS (M.2002.188.1). Image copyright © The Artist's Estate. Photo copyright © NMS

David Young Cameron, *A Garment of War*, c.1926. City Art Centre: Edinburgh Museums and Galleries (CAC105/1964). Image copyright © The Artist's Estate. Photo copyright © City Art Centre: Edinburgh Museums and Galleries

Joseph Gray, *A Ration Party of the 4th Black Watch at the Battle of Neuve Chapelle, 1915*, painted 1918–19. IWM (ART 1917). Image & photo copyright © IWM

William McCance, *Conflict*, 1922. CSG CIC Glasgow Museums Collection (3296). Image © The Artist's Estate. Photo copyright © CSG CIC Glasgow Museums Collection

Ambrose McEvoy, *Sir James Taggart, KBE, Lord Provost of Aberdeen (1914–1919)*, 1917. Aberdeen Art Gallery & Museums Collections (ABDAG002844). Photo copyright © Aberdeen Art Gallery & Museums

George Henry, *Sir William Don (1861–1926), Lord Provost of Dundee (1914–1920)*, 1920. Dundee City Council (Dundee Art Galleries and Museums, 1-1920). Photo copyright © Dundee City Council (Dundee Art Galleries and Museums

James Bell Anderson, *Portrait of Douglas Haig, 1st Earl Haig of Bemersyde* (after James Guthrie), 1928–9. University St Andrews, Museum Collections (HC 181). Photo copyright © Reproduced courtesy of the University of St Andrews

John Christian Johansen, *Sir Douglas Haig (1861–1928), FM, in His Study*, 1919. Museum of Edinburgh, Edinburgh Museums and Galleries (HH609/1964). Image copyright © The Artist's Estate. Photo copyright © Museum of Edinburgh: Edinburgh Museums and Galleries.

George Edward Wade, *Equestrian Statue of Earl Haig*, 1922–3. City of Edinburgh, at Edinburgh Castle. Photo copyright © Patricia R. Andrew, by kind permission of Historic Scotland

John Munnoch, *Jessie MacGregor*, 1913. Stirling Smith Art Gallery & Museum (20833). Photo copyright © Stirling Smith Art Gallery & Museum

John Bulloch Souter, *Portrait of an Unknown Officer*, c.1925. NMS (M.1997.9). Image copyright © The Artist's Estate. Photo copyright © NMS

Poster, *See the World and Get Paid for Doing It*, 1919. IWM (PST 7687). Photo copyright © IWM

CHAPTER 3

Keith Henderson, *Air Gunner in Action in a Turret: Night*, 1940. IWM (ART LD 633). Image and photo copyright © IWM

Wilhelmina Barns-Graham, *Escape, Air Raid, Spain*, 1936–7. The Barns-Graham Charitable Trust (BGT1257). Image and photo copyright © The Barns-Graham Charitable Trust

Edward Baird, *Local Defence Volunteer*, 1939. Aberdeen Art Gallery and Museums Collections (ABDAG013505). Image copyright © The Artist's Estate. Photo copyright © Aberdeen Art Gallery & Museums

James McIntosh Patrick, *A City Garden*, 1940. Dundee City Council (Dundee Art Galleries and Museums, 2-1940). Copyright © The Estate of James McIntosh Patrick. Image/photo provided courtesy of Dundee City Council (Dundee Art Galleries and Museums).

William Oliphant Hutchison, *Walter Rankin, Local Defence Volunteer [Home Guard]*, 1940. SNPG (PG 2719). Image copyright © The Artist's Estate. Photo © NGS

Robert Sivell, *Portrait of a Soldier* (Alistair Paterson), c.1940. Aberdeen Art Gallery & Museums Collections (ABDAG007179). Image copyright © The Artist's Estate. Photo copyright © Aberdeen Art Gallery and Museums

Alan Davie, *Gunner Jimmy Armit in the Barrack Room …* 1941. SNGMA (GMA 4257). Image copyright © The Artist's Estate. Photo © NGS

Robert Colquhoun, *Self-portrait*, 1940. National Portrait Gallery, London (NPG 4872). Image and photo copyright © The Estate of Robert Colquhoun / National Portrait Gallery, London

Keith Henderson *Wings over Scotland*, 1940. IWM (ART LD 634). Image and photo copyright © IWM

Keith Henderson, *An Air View of Montrose, Angus*, 1940. IWM (ART LD 256). Image and photo copyright © IWM

Edward Baird, *Unidentified Aircraft (over Montrose)*, 1942. CSG CIC Glasgow Museums Collections (2315). Image copyright © The Artist's Estate. Photo copyright © CSG CIC Glasgow Museums

Alexander Macpherson, *War Weapons Week, Paisley: December 1940*. IWM (ART LD 790). Image and photo copyright © IWM

Tom Gourdie, *In the Hangar at RAF Dumfries*, 1941. Image copyright © The Artist's Family Collection. Photo copyright © Dumfries and Galloway Council Museums Service

Ian Eadie, *Air Raid Shelters, Dundee*, 1940. NMS (M.1997.91). Image copyright © The Artist's Estate. Photo copyright © NMS

David Foggie, *The Crescent in Wartime*, 1940. RSA (1992.055). Image copyright © The Artist's Estate. Photo copyright © Courtesy of the RSA

Tom Purvis, *Women Munitions Workers at Weir's Factory*. CSG CIC Glasgow Museums Collection (T.2008.8). Image copyright © The Artist's Estate. Photo copyright © CSG CIC Glasgow Museums Collection

Robert Henderson Blyth, *Man and the Elements: Mountain Troops Erecting a Bell Tent*, 1943. SNGMA (GMA 3023). Image copyright © The Artist's Estate. Photo copyright © NGS

Ian Fleming, *Rescue Party, Kilmun Street (Maryhill, Glasgow)*, 1942. SNGMA (3397). Image copyright © The Artist's Family, reproduced courtesy of the Fleming family. Photo © copyright NGS

Ian Fleming, *Shelters in a Tenement Lane*, 1942. Aberdeen Art Gallery & Museums Collections (ABDAG010818). Image copyright © The Artist's Family, reproduced courtesy of the Fleming family. Photo copyright © Aberdeen Art Gallery & Museums

Ian Fleming, *Blitz, Maryhill, Glasgow*, 1942. Aberdeen Art Gallery and Museums Collections (ABDAG000557). Image copyright © The Artist's Family, reproduced courtesy of the Fleming family. Photo copyright © Aberdeen Art Gallery & Museums

Hugh Adam Crawford, *Homage to Clydebank (The Stretcher Bearers)*, 1941. The Royal College of Physicians and Surgeons of Glasgow (0078). Image copyright © The Artist's Estate. Photo copyright © Alex Hewitt

James Miller, *Queen's Park Church, Glasgow*, 1943. CSG CIC Glasgow Museums Collection Glasgow Museum (2761). Image and photo copyright © CSG CIC Glasgow Museums Collection

Robert Sivell, *Mrs Marion Patterson, GM*,1942. IWM (ART LD 3030). Image and photo copyright © IWM

Anne Spence Black, *The Tide Lamp, St Monance*. University of St Andrews, Museum Collections (HC4). Image copyright © University of St Andrews. Photo copyright © Reproduced courtesy of the University of St Andrews

Christopher Nevinson. *March of Civilisation*, 1940. CSG CIC Glasgow Museums Collection (2214). Image Nevinson, Christopher Richard Wynne / Glasgow Museums, UK / Bridgeman Images

Alberto Morrocco, *Self-Portrait*, c. 1935. Image copyright © The Artist's Family Collection. Photo copyright © Matt Pia Photography, London

Eduardo Paolozzi, *Soldiers Playing Cards*, 1944. IWM (ART LD 6508). Image and photo copyright © Trustees of the Paolozzi Foundation. Licensed by DACS 2014

Hiram Sturdy, *Home Guard Duty at Night*. NLS MSS, DEP.279, sketchbook 43. Image copyright © The Artist's Family. Photo copyright © NLS

Hiram Sturdy, *Home Guard Village Exercise*. NLS MSS, DEP. 279, sketchbook 44. Image copyright © The Artist's Family. Photo copyright © NLS

James Cowie, *Scottish Policeman*, 1941–2. CSG CIC Glasgow Museums Collection (2728). Image and photo copyright © CSG CIC Glasgow Museums Collection

Hugh Adam Crawford, *Sir Patrick Dollan (1885–1963), Lord Provost of Glasgow (1938–1941)*, 1941. CSG CIC Glasgow Museums Collection (2729). Image copyright © City of Glasgow. Photo copyright © CSG CIC Glasgow Museums Collection

CHAPTER 4

Anonymous artist, *A Scottish Piper and Two Polish Soldiers*, 1940. CSG CIC Glasgow Museums Collection (3446). Image and photo copyright © CSG CIC Glasgow Museums Collection

William Rothenstein, *First Officer Lois Butler*, 1940. Coll. IWM (LD 1982). Image and photo copyright © IWM

Stephen Bone, *Camouflaging the Pipeline at the British Aluminium Company's Works at Fort William, October 1941*. IWM (ART LD 1663). Image and photo copyright © IWM

Ronald Searle, *River Dee, Kirkcudbright from the Barracks*, January 1941. NMS (M.1992. 220.1). Image copyright © The Artist's Estate and The Sayle Literary Agency. Photo copyright © NMS

Ronald Searle, *Night Convoy*, 1941. IWM (ART 15746-8-a). Image copyright © The Artist's Estate and The Sayle Literary Agency. Photo copyright © IWM

E. Christopher Perkins, *Roll-Call of the Survivors of HM Troopship* Archangel *at Aberdeen*, 1941. IWM (ART LD 1599). Image copyright © The Artist's Estate. Photo copyright © IWM

Edward Ardizzone, *Bombed Out [Glasgow]*, 1941. IWM (LD 1344). Image and photo copyright © IWM

Edward Ardizzone, *On a Fortified Island in the Firth of Forth: Barracks*, 1941. IWM (LD 1271). Image and photo copyright © IWM

Eric Ravilious, *Channel Fisher*, 1941. Ferens Art Gallery, Hull Museums (2006.7183). Photo copyright © Ferens Art Gallery, Hull Museums, UK / Bridgeman Images

Eric Ravilious, *Storm*, 1941. British Council (P159). Photo copyright © British Council

Eric Ravilious, *RNAS Sick Bay, Dundee*, 1941. IWM (ART LD 1719). Photo copyright © IWM

Stanley Spencer, *Shipbuilding on the Clyde: Furnaces*, 1946. IWM (ART LD 5781). Image and photo copyright © IWM

Stanley Spencer, *Study for 'Shipbuilding on the Clyde'*. IWM (ART LD 6008 140). Image and photo copyright © IWM

Charles Cundall, *Stirling Bombers: The Return of The MacRobert's Reply*, 1942. Royal Air Force Museum (FA03014). Image copyright © The Estate of Charles Cundall. Photo copyright © Royal Air Force Museum

Eric Kennington, *Lance Corporal Robertson of the 11th City of Edinburgh Battalion Home Guard*, 1943. NMS (M.1992. 302). Image copyright © The Artist's Estate. Photo copyright © NMS

Joseph Lee, *Smiling Through: Whisky –'I demand to see the Manager!'*, *Evening News*, 4 Feb. 1944. The British Cartoon Archive, University of Kent (JL2586). Image copyright © British Cartoon Archive, University of Kent (www.cartoons.ac.uk)

Colin Colahan, *Rain and Bloody Misery*, 1942. Australian War Memorial (ART22311)). Image and photo copyright © Australian War Memorial

Colin Colahan, *Scottish Idyll*, 1942. Australian War Memorial (ART26224). Image and photo copyright © Australian War Memorial

Sheila Hawkins, *Working in the Snow, Australian Forestry Unit, Scotland*, 1942. Australian War Memorial (ART26918). Image copyright © The Artist's Estate. Photo copyright © Australian War Memorial

David M. Sutherland, *The Loading, Landings, Newfoundland Lumberjacks …*, 1940. Aberdeen Art Gallery and Museums Collections (ABDAG003736). Image copyright © By courtesy of Dr D.A. Sutherland and Lady J.F. Sutherland. Photo copyright © Aberdeen Art Gallery and Museums

Stephen Bone, *Highland Shepherds and Honduran Lumberjacks*. Dundee City Council (Dundee Art Galleries and Museums,12-1948). Image copyright © The Estate of Stephen Bone. All Rights Reserved, DACS 2014

Ethel Gabain, *Sorting and Flinging Logs at Pityoulish*, 1941. IWM (ART LD 1539). Image and photo copyright © IWM

Donald Kenneth Anderson, *Collision in Circuit*, 2 October 1944, Banff. Beaverbrook Collection of War Art (19710261-1314). Image and photo copyright © Canadian War Museum

Eric Ravilious, *Leaving Scapa Flow*. Bradford Art Galleries and Museums (1947-055). Photo copyright © Bradford Art Galleries and Museums, West Yorkshire, UK / Bridgeman Images

Frieze, former Officers' mess, Donibristle. © Crown Copyright: RCAHMS. Licensor www.scran.ac.uk

Tim Jeffs, *Rundi Albert, Head of the Norwegian Women's Army in Dumfries*. Dumfries & Galloway Council (DUMFM:1989.9.1). Copyright © Dumfries Museum. Reproduced by Courtesy of Dumfries Museum

Oskar Kokoschka, *Self-Portrait as a Degenerate Artist*, 1937. SNGMA on loan (GML 285). Image and photo copyright © Fondation Oskar Kokoschka / DACS 2014

Jankel Adler, *Composition* (undated). CSG CIC Glasgow Museums Collection (2981). Image and photo copyright © DACS 2014

Josef Herman, *Man Carrying Bucket* (undated). CSG CIC Glasgow Museums Collection (U 126). Image copyright © The Artist's Estate. Photo copyright © CSG CIC Glasgow Museums Collection

Witold Mars, *Polish Soldier* (self-portrait of the artist). Biggar Museums Trust (2000.64). Image and photo copyright © Biggar Museums Trust

Witold Mars, *Two Polish soldiers*, 1940–41. Biggar Museums Trust (13.20.90). Image and photo copyright © Biggar Museums Trust

General Gustaw Paszkiewicz presenting the Self-portrait by Witold Mars to the Provost of Biggar, 15 August 1940. IWM (H 3061). Image and photo copyright © IWM

The Polish mosaic panel on the wall of the Town Hall, St Andrews, 1941. Photo copyright © Patricia R. Andrew

Polish Military Students in the Art Class with Miss Winifred McKenzie, St Andrews, 1943. University of St Andrews, Library Archive Collection (ms38341-1-p-1). Photo copyright © Courtesy of the University of St Andrews Library

Aleksander Zyw, *Holyrood Palace*, 1940. University of St Andrews, Museum Collections (HC 135). Image and photo copyright © University of St Andrews

Stephen Bone, *A German U-Boat Surrenders in Loch Eriboll*, 1945. IWM (ART LD 5370). Image and photo copyright © IWM

Roland Vivian Pitchforth, *Rendezvous in Scotland*, 1944. IWM (ART LD 4843). Image and photo copyright © IWM

CHAPTER 5

John Kirkwood, *The Belgrano, 2 and 3 May*, painted 1990. IWM (ART 16583). Image copyright © The Artist. Photo copyright © IWM

William Gear, *Mau Mau*, 1953. Birmingham Museums Trust (2001P23). Image copyright © The Artist's Estate. Photo copyright © Birmingham Museums Trust

William McCance, *Hiroshima (or Atom Horizon)*, 1947. SNGMA (GMA 3613). Image copyright © The Artist's Estate. Photo copyright © NGS

Thomas Whalen, *Clown with Atom Bomb*, c.1965. RSA Diploma Collection (2000.036). Image copyright © The Artist's Estate. Photo copyright © Courtesy of the RSA

Neil Dallas Brown, *Visitor, Vietnam*, 1968. University of Dundee Fine Art collections (DUNUC ARTS:2501). Image copyright © The Artist's Estate. Reproduced by permission of the Neil Dallas Brown Trust. Photo copyright © University of Dundee Fine Art Collections

Neil Dallas Brown, *Ulster Wall*, 1979–80. SNGMA (GMA 4795). Image copyright © The Artist's Estate. Reproduced by permission of the Neil Dallas Brown Trust. Photo copyright © NGS

David Mach, *Polaris,* 1983. Mach, David (b.1956) / London, UK / Bridgeman Images

Ian Hamilton Finlay and Andrew Townsend, *Gateposts*, Little Sparta, 1990 Copyright © The Artist's Estate. Photo copyright © Andrew Lawson

Ian Hamilton Finlay and John Andrew, *Nuclear Sail*, Little Sparta, 1974 Copyright © The Artist's Estate. Photo copyright © Andrew Lawson

Ken Currie, *The Troubled City*, 1991. SNGMA (GMA 4732). Image copyright © The Artist. Photo copyright © NGS

Peter Howson, *Cleansed*, 1994. IWM (ART 16521). Image and photo copyright © IWM

Wilhelmina Barns-Graham, *Afghanistan*, 2000. The Barns-Graham Charitable Trust (BGT 410). Image and photo copyright © The Barns-Graham Charitable Trust

CHAPTER 6

Patrick William Adam, *Poppy Fields, Flanders.* East Lothian Museums Service (11141). Photo copyright © Courtesy of East Lothian Council Museums Service

Henry Price, *Maxwelltown Memorial*, 1921. Photo copyright © Newsquest (Herald & Times). Licensor www.scran.ac.uk

Philip Lindsey Clark, *Cameronians (Scottish Rifles) War Memorial*, Kelvingrove Park, Glasgow, 1924. Photo copyright © Newsquest (Herald & Times). Licensor www.scran.ac.uk

Unveiling ceremony of the war memorial at Killin … 1920. Photo copyright © NMS. Licensor www.scran.ac.uk

Robert Tait Mackenzie, *The Call*, Scottish–American Memorial, Princes Street Gardens West, Edinburgh, unveiled 1927. Photo copyright © Patricia R. Andrew

Tom Curr, *Poster to promote fundraising for the Scottish National War Memorial.* NMS (M.1936.160). Photo copyright © NMS

Scottish National War Memorial: four photographs copyright © Antonia Reeve, reproduced with kind permission of the Trustees of the Scottish National War Memorial: *Entry to the Shrine from South*, viewed through the Screen *East Panel Freize*: QMAAC; Ambulance Driver, VAD; Officer, WRNS; WRAF *East Bay*, Window above Artillery Memorial: Grenade thrower *Scottish National War Memorial, South Wall*, Autumn Window: Munitions worker

Carving of Chapel Stalls, University of Glasgow Memorial Chapel, 1929. Photo copyright © Nick Haynes

George Henry Paulin, *War Memorial at Dollar Academy, Clackmannanshire.* Photo copyright © Patricia R. Andrew, courtesy of Dollar Academy

W. Birnie Rhind, *War Memorial, Fettes College*, 1920. Photo copyright © Patricia R. Andrew, courtesy of Fettes College

William Reid Dick, *The RAF Memorial, Embankment, London*, 1923. Image copyright © The Reid Dick Family. Photo: Dennis Wardleworth

Frank Mears and Charles D'O Pilkington Jackson, *Memorial to Elsie Inglis*, 1922. Reproduced by permission of St Giles' Cathedral. Photo copyright © Peter Backhouse

Anton Abraham van Anrooy, *Captain Talbert Stevenson, MC and Bar, 4th/5th Battalion The Black Watch.* The Black Watch Museum (2009.30). Image and photo copyright © The Black Watch Museum

David Alison, *2nd Lieutenant J.P.C. Mitchell*, 1917. NMS (M.1991.195). Image and photo copyright © NMS

Cecil Jameson, *Charles Hamilton Sorley*, 1916. National Portrait Gallery, London (PG 5012). Image and photo copyright © National Portrait Gallery, London

Anonymous artist [initials A.W.], *Lieutenant Hon. Alistair Erskine, MC,* after 1945. On loan from the Earl of Mar and Kellie to The National Trust for Scotland (96.21.20). Image copyright © The Earl of Mar and Kellie. Photo copyright © National Trust for Scotland

Sydney Kendrick, *Lieutenant-Colonel Geoffrey Keyes, Royal Scots Greys and No.11 Commando*, 1942. On loan to NMS (IL.2006.69). Image copyright © Reproduced with the kind permission of the Hon. Archibald Wayland Keyes Young, great nephew of Lt Col Geoffrey Charles Tasker Keyes VC MC. Photo copyright © Josa Young

Frank Mears and Charles D'O Pilkington Jackson, *Section of The Royal Scots Memorial, Princes Street Gardens West, Edinburgh,* unveiled 1952. Photo copyright © Patricia R. Andrew

Scott Sutherland, *Commando Memorial, Spean Bridge*, 1952. Image copyright © Crown Copyright: RCAHMS. Licensor www.scran.ac.uk

Sadie McLellan, *Stained glass from the Robin Chapel, Edinburgh*, 1953. Reproduced by permission of The Robin Chapel. Photo copyright © Alex Hewitt

Arthur Dooley, *La Pasionaria,* Custom House Quay, Glasgow, 1979. Photo copyright © Patricia R. Andrew

The Italian Chapel, Lamb Holm, Orkney, 1942–4. Image © Crown Copyright: RCAHMS. Licensor www.scran.ac.uk

Hallmuir Ukrainian Chapel, near Lockerbie, begun 1947. Image © Crown Copyright: RCAHMS. Licensor www.scran.ac.uk

The Great Polish Map of Scotland, 1974. Image © Crown Copyright: RCAHMS. Licensor www.scran.ac.uk

John K. Clark, *The Lockerbie Memorial Window*, 1991, Lockerbie Town Hall. Photo copyright © John K. Clark

The Scottish Korean War Memorial, Witchcraig, West Lothian. Photo copyright © Patricia R. Andrew

James Pryde, *The Monument*, c.1916–17. Government Art Collection (16724). Photo copyright © Government Art Collection

Robin Philipson, *Stone the Crows*, 1964. RSA collections (1997.170). Image copyright © The Artist's Estate. Photo © Courtesy of the RSA

Robin Philipson, *Nevermind II*, 1974. Private collection. Image © The Artist's Estate. Photo copyright © The Scottish Gallery, Edinburgh

Peter Cattrell, *Maize Cutting, No Man's Land, Serre, Somme, France, 1997.* SNGMA (PGP 82.11). Image copyright © Peter Cattrell. Photo copyright © NGS

Tom McKendrick, *Burning Town*, 1992. West Dunbartonshire Council Collection (WDBCS.2005.1209) Image and photo copyright © The Artist

Tom McKendrick, *Terraces No. 2*, 2003. Private collection. Image and photo copyright © The Artist

John Bellany, *Pourquoi?*, 1967. The John Bellany, CBE, RA Estate. Image and photo copyright © The Estate of John Bellany, CBE, RA

Joyce W. Cairns, *Polish Journey*, 1998. RSA Diploma collection (2000.106). Image copyright © The Artist. Photo copyright © Courtesy of the RSA

Wilhelmina Barns-Graham, *Celebration (VE Night)*, 1995. The Barns-Graham Charitable Trust (BGT 477). Image and photo copyright © The Barns-Graham Charitable Trust

Index

Page numbers in **bold** refer to images.

Some countries (e.g. France and Germany) or general subjects (e.g. war, blitz) are not indexed as they feature too widely for this to be practicable.

Individual buildings, streets, etc., are entered directly under their names, not the city in which they are located.

Additional information is to be found in the un-indexed notes and references.

INDEX